Second Edition

POSTMODERN PERSPECTIVES

Issues in Contemporary Art

Edited with Introductions and Postscript by

HOWARD RISATTI

Virginia Commonwealth University

Prentice Hall, Upper Saddle River, New Jersey 07458

Library of Congress Cataloging-in-Publication Data

Postmodern perspectives : issues in contemporary art / edited by Howard Risatti.—2nd ed.

p. cm. Includes index. ISBN 0-13-614504-3 (pbk.) 1. Postmodernism. 2. Art, Modern—20th century. I. Risatti, Howard Anthony, (date). N6494.P66P67 1997 709'.04—dc21 97-36145 CIP

Editorial Director: Charlyce Jones Owen Acquisitions Editor: Bud Therien Associate Editor: Marion Gottlieb Editorial/Production supervision, interior design, and electronic page makeup: Mary Araneo Buyer: Bob Anderson Cover designer: Patricia H. Wosczyk

This book was set in 10/12 New Century Schoolbook by A & A Publishing Services, Inc., and was printed and bound by Courier Companies, Inc. The cover was printed by Phoenix Color Corp.

© 1998, 1990 by Prentice-Hall, Inc. Simon & Schuster/A Viacom Company Upper Saddle River, New Jersey 07632

All rights reserved. No part of this book may be reproduced, in any form or by any means, without permission in writing from the publisher.

Printed in the United States of America

 $10 \quad 9 \quad 8 \quad 7 \quad 6 \quad 5 \quad 4 \quad 3 \quad 2 \quad 1$

ISBN 0-13-614504-3

Prentice-Hall International (UK) Limited, London Prentice-Hall of Australia Pty. Limited, Sydney Prentice-Hall Canada Inc., Toronto Prentice-Hall Hispanoamericana, S.A., Mexico Prentice-Hall of India Private Limited, New Delhi Prentice-Hall of Japan, Inc., Tokyo Simon & Schuster Asia Pte. Ltd., Singapore Editora Prentice-Hall do Brasil, Ltda., Rio de Janeiro

For JAMES and ZOILA and CHRISTINA

Contents

PREFACE

PART ONE ART AND AESTHETICS: LATE MODERNISM AND THE FORMALIST DEBATE

1 CLEMENT GREENBERG, Modernist Painting 12

2 T. J. CLARK, Clement Greenberg's Theory of Art 20

3 MICHAEL FRIED, How Modernism Works: A Response to T. J. Clark 37

4 JÜRGEN HABERMAS, Modernity versus Postmodernity 53

xi

1

viii Contents

PART TWO ART AND SOCIETY: IDEOLOGICAL CRITICISM

- 5 LUCY R. LIPPARD, Sex and Death and Shock and Schlock: A Long Review of "The Times Square Show" 77
- 6 BENJAMIN H. D. BUCHLOH, Since Realism There Was ... (On the Current Conditions of Factographic Art) 87
- 7 HILTON KRAMER, Turning Back the Clock: Art and Politics in 1984 100
- 8 DONALD B. KUSPIT, Crowding the Picture: Notes on American Activist Art Today 108

PART THREE COGNITIVE AND COMMUNICATIVE STRUCTURE OF ART

- 9 DOUGLAS CRIMP, The Photographic Activity of Postmodernism 131
- **1 ()** THOMAS LAWSON, Last Exit: Painting 140
- 11 HAL FOSTER, Signs Taken for Wonders 153

PART FOUR FEMINIST CRITICISM

12 CRAIG OWENS, The Discourse of Others: Feminists and Postmodernism 176 121

13 KATE LINKER, Eluding Definition 197

14 MAUREEN TURIM, What Is Sexual Difference? 209

PART FIVE PSYCHOANALYTICAL CRITICISM AND ART

- 217
- 15 ELLEN HANDLER SPITZ, An Insubstantial Pageant Faded: A Psychoanalytic Epitaph for New York City Subway Car Graffiti 225
- 16 MARY MATHEWS GEDO, An Autobiography in the Shape of Alabama: The Art of Roger Brown 241
- 17 DONALD B. KUSPIT, Artist Envy 255

PART SIX MARGINALITY AND THE OTHER 265

- 18 THELMA GOLDEN, "What's White ...?" 277
- 19 ELEANOR HEARTNEY, Identity Politics at the Whitney 285
- 20 JENNIE KLEIN, Circumventing the *Center:* Identity Politics and Marginalization 292

POSTSCRIPT

INDEX

303

Preface

The study of criticism has become of increasing interest to the field of art, as indeed it has to literature and other fields, because of a new sophistication and awareness about the ways in which language and language systems (art being one of these systems) function to mediate or even construct our perceptions of reality. The manifold ways in which criticism conditions experience of art—aesthetically, morally, institutionally—have recently come under scrutiny in order to understand their economic, political, and social consequences. Because of this, rather than simply a passive, responsive activity, criticism now generally has come to be seen as a means of cultural intervention, a probing into the very nature and structure of art, society, knowledge, and the self.

This new critical awareness is part of so-called Postmodernism and has, since the mid-1970s, challenged established critical theory and paralleled the development of a pluralistic art with more diverse meanings, styles, and intentions. The single formalist theory of art that was widely identified with Modernism and was dominant in the 1950s and '60s has since been replaced with several critical positions based on interrelated theoretical and philosophical ideas. While differing in their focuses, all of these positions regard criticism as a function of a larger social and cultural apparatus.

Modernism and Postmodernism

Critics and writers on art have used the term "Modernism" to identify art that appears to be specific to our own historical period, a period that began in France in the latter nineteenth century. This term was not used simply to refer to the most recent art (that is, the most modern), but to refer

xii Preface

to art with specific qualities that set it apart from more traditional art that was primarily devoted to naturalistic representation.

With development of Modernist art and theory, attention increasingly shifted away from representational elements in art toward formal qualities—that is, the abstract qualities of shape, line, color. As a result, Modernist aesthetic values and judgments about art came to be based on these formal qualities, and the work of art began to be seen as a discrete object having its own properties that were not dependent upon imitation of nature.

While these ideas were temporarily called into question in the Great Depression of the 1930s, they continued to develop, especially during the years after World War II, a period that was characterized by the sudden emergence of influence of American art and critical theory. Because this American art and theory grew out of that of the pre-war period, it also was called Modern. However, in recent years as it has become more obvious that significant changes occurred in both art and critical thinking in America directly after the war, this period has now become identified as Late Modern to distinguish it from earlier European-centered Modernism. This Late Modern art, as it developed in America, tended to avoid the kind of social and political issues engaged in by Social Realism in the 1930s and to concentrate upon purely formal problems as vehicles of artistic expression, content, and meaning.

By the middle of the 1970s, the social and political events that followed the Vietnam protests in America and the May 1968 student protests in Paris signaled major changes in both art and critical thought. This period, more or less beginning in the mid-1970s, has now become known as Postmodern to indicate its distinctiveness from that of the Modern period in general and from the Late Modern period immediately preceding it.

In the arena of art, the immediate dissatisfaction with Modernism that promulgated the initial notion of Postmodernism began as an attack upon what was seen as too narrow and restrictive a theory of art, one that left little or no room for individual emotions and socially relevant subject matter. In other words, the strictly formal interests of Modernism seemed to be insufficient and even insensitive in the face of new social and cultural concerns such as the environment, civil rights, feminism, and Third World issues. Thus, Postmodernism in art began as a challenge to the supremacy of Modernist ideas about form, aesthetic value, and the autonomy of meaning in art. As it called into question the notion of a realm of shared cultural values, it soon developed into a wholesale critique of all of Western culture as reflected in Multicultural theory.

In little over a decade, Postmodern criticism has produced a variety of differing "critical positions." Nevertheless, it is evident that these "critical positions" are interrelated and have evolved from the general disenchantment with the aesthetics of formalist criticism, especially as developed in the Late Modern period in America in the years after World War II. Because of this, any discussion of the development of Postmodern criticism must recognize formalist critical thought as a ground against which the new ideas must be seen.

The Modernist-versus-Postmodernist debate that ensued over the question of form, aesthetic value, and the autonomy of meaning in art has generally centered on American Late Modern formalist theory and criticism, especially as this theory was articulated in the writings of American critic Clement Greenberg. Greenberg's formalism, which was the bulwark of American critical theory in the 1950s and '60s, came under attack because it seems to leave little room for social/political content in art, thereby encouraging a separation between art and everyday human experience.

In attempting to effect a reintegration of art and society, Postmodern critics and artists began to question not only the theoretical structure of art espoused by Greenberg, but also the meaning, purpose, and function of art vis-à-vis society. And, as art has come to be considered a form of knowledge and a means of communication with important consequences for the construction of sexuality and the self, Postmodern criticism has taken to scrutinizing art and its critical apparatuses, "deconstructing" them, as it were, to see how they function.

Organization of the Text

This book is intended as a guide to the general structure and focus of Postmodern critical discourse for all readers interested in the relationship between contemporary art, culture, and society. For this reason the essays reprinted here are divided into six groups delineating the main philosophical, theoretical, and critical issues of current Postmodern art and criticism. In Part One: "Art and Aesthetics-Late Modernism and the Formalist Debate," the focus is on the ideas of Clement Greenberg and the formalist theory of art. The introductory text traces the origins of formalist theory through the work of writers such as Immanuel Kant, Walter Pater, and Clive Bell; it discusses Greenberg's particular version of the theory and attempts to explain how and why, for many critics and artists, Greenberg and his theory have come to epitomize all of Modernism in art. The essays in this part include Greenberg's most cogent presentation of his theory and discussions by other writers of its relative merits. Critical attention in these essays is particularly sensitive to the emphasis Greenberg places upon abstract formal qualities at the apparent expense of issues related to everyday human experience.

The reintegration of art and wider human experience is the focus of Part Two: "Art and Society—Ideological Criticism." According to this posi-

xiv Preface

tion, art (even abstract, formalist art) has ideological implications; all art, whether specifically intended by the artist or not, supports specific social structures and therefore has economic and political ramifications. The introductory text to this part examines the basis of this position as it developed from Marxist critical thought, especially in relation to Karl Marx's theory of base/superstructure formations in capitalist societies. The essays in this part discuss the role of aesthetic values, formalism, subject matter, and art in relation to ideology, politics, society, and power.

The focus of Part Three: "Cognitive and Communicative Structure of Art" is based upon Structuralist and Post-Structuralist theory. The introductory text discusses the origins in semiology of these theoretical ideas, especially as they are used to attempt to understand art as a system of communication that not only conveys knowledge, but also acts to shape and limit the scope of knowledge as it constructs perceptions of reality. The essays expand upon these ideas, presenting varying interpretations of works of art in relation to Late Capitalist commodity culture by using "deconstructive" methods derived from Structuralist and Post-Structuralist theory.

The introductory text of Part Four: "Feminist Criticism" discusses the background of feminist critical art theory as it began in the late '60s and '70s. Special emphasis is on current ideas which apply Structuralist and Post-Structuralist methodologies, via the studies of French psychoanalyst Jacques Lacan, to Freud's ideas concerning the construction of sexuality. The essays interpret not only the political and ideological implications of sexuality as a social construction, but also the actual effects upon women by discussing the role that works of art, as visual images, play in this process.

Part Five: "Psychoanalytical Criticism and Art" involves Freudian ideas and the self. The introductory text provides a background to Freudian ideas of analysis and discusses some of the implications these ideas have for both the artist and the art object. The essays provide examples of how the psychoanalytical method can be applied to a specific category of works of art (graffiti), to the works of a specific artist (Roger Brown), and to the interpretation of the status of the artist in contemporary society.

The final section of the book, Part Six: "Marginality and the Other" focuses on the way the dominant culture relegates non-mainstream art (and ideas) to the margins of society. The introductory text of this section traces the development of these ideas in art, especially as they grow out of the concept of multiculturalism. It points out how musuems (and the idea of "exhibition") have become political sites where issues of difference and identity formation are being contested. As the essays show, multiculturalism finds a racial component underlying the very structure of Western society and its beliefs about art and aesthetics; it is this structure, many multiculturalists argue, that prevents minorities (but also women and gays) from full social, economic, and cultural participation. Analyzing the operation of this structure and its affects on non-mainstream culture has been the goal of much recent art critical writing.

Finally, a Postscript acts as a summary to the issues raised in the essays. It also speculates on the future existence of art in the Postmodern world, a world in which artistic quality and the aesthetic dimension are both under attack as ideological tools of the dominant culture.

While these essays are not intended to be a comprehensive collection of Postmodern critical writing (the literature being much too vast for the scope of this book), they do provide the reader convenient access to a range of diverse essays selected to demonstrate the complexity and interrelatedness of the issues constituting Postmodern critical discourse. Through the introductory texts and the organization of the reprinted essays, this book establishes a structure for this discourse and a framework which the reader can then use to engage in further critical seeing, reading, and thinking.

The extensive introductory text to each critical position, by discussing the philosophical and theoretical grounding of that position, acts to fill the "spaces" between essays and provide a context for the critical discussions in the essays that follow. These introductions are not, however, designed to stand apart from or to be read in place of the essays, but to complement them. Brief comments on each essay are also included to relate them to other essays and to note similarities and differences between authors in each group. An attempt has been made throughout to define specialized terminology and jargon.

Acknowledgments

For their kind permission to reprint the essays in this anthology, I would like to thank the authors and the publications in which the essays originally appeared. I would also like to acknowledge Mark Horner and my colleague Frank P. Belloni who read various parts of the manuscript. To Ann Lee Morgan—teacher, colleague, and friend from whom I have learned much over the years—and William Simeone, for their willing assistance in reading the manuscript and for their insight in matters of form, style, and content, I am grateful and extend my deep appreciation. Finally, I would like to thank my wife for her continued belief in the aesthetic object and her unwavering support of the life of the mind, two things I once accepted as unassailable in our society.

PART ONE

Art and Aesthetics: Late Modernism and the Formalist Debate

Formalist criticism is based upon an aesthetic theory that gives priority to such formal elements as line, shape, and color, rather than to representational elements involved with narrative, iconography, and iconology. The origins of this theory can be found in eighteenth-century aesthetics, most clearly and systematically in the writings of the German philosopher Immanuel Kant. What Kant attempted to resolve in his *Critique of Judgement*, written in 1790, was, according to Paul Richter,

the apparent incompatibility of the two accepted beliefs: that all judgments of aesthetic value must ultimately be founded upon subjective states . . . and that, nevertheless, such judgments are not merely expressions of personal preference but lay claim to universal assent.¹

For Kant, the reconciliation of this apparent contradiction between the subjective and the objective was to be found in the observation of certain qualities of the art object. These qualities, Kant believed, were formal:

In painting, sculpture, and in fact all the formative arts, in architecture and horticulture so far as they are fine arts, the *design* [form] is what is essential. Here it is not what gratifies in sensation but merely what pleases by its form that is the fundamental prerequisite for taste.²

Kant's ideas were reflected in a growing tendency to see abstract form as the transmitter of universal values. This became a central issue in art and criticism in the late nineteenth century with the Post-Impressionist dissolution of representation. Maurice Denis's often quoted remark of 1890 "that a picture, before being a horse, a nude or some kind of anecdote is essentially a flat surface covered with colors assembled in a certain order"³ indicates the growing importance of form in France at this time, while

2 Part One

Walter Pater's famous dictum that "all art constantly aspires towards the condition of music"⁴ demonstrates that the same tendency already existed in England several years earlier.

Interest in formal issues in England is especially identified in the twentieth century with Roger Fry and Clive Bell; they championed form and promoted the work of modern artists such as Matisse and Picasso, whose move away from representation was supported by Fry and Bell with what they called the theory of Significant Form. In 1910, Bell asked, "What quality is common to Sta. Sophia and the windows at Chartres, Mexican sculpture, a Persian bowl, Chinese carpets, Giotto's frescoes at Padua, and the masterpieces of Poussin, Piero della Francesca, and Cézanne?"⁵ Only one answer seemed possible, and that was Significant Form. "In each," wrote Bell,

lines and colours combined in a particular way, certain forms and relations of forms, stir our aesthetic emotions.... These aesthetically moving forms I call "Significant Form"; and "Significant Form" is the one quality common to all works of visual art.⁶

Bell also contended that "if representative form has value, it is as form, not as representation. The representative element . . . ," said Bell, "may or may not be harmful; always it is irrelevant."⁷

The growing importance given to form in Modernist critical and aesthetic theory can be attributed, at least in part, to artistic and historical circumstances. Formal qualities provided a theoretical and critical basis for defending and evaluating the increasingly abstract qualities of Modern art. There were also political and social aspects to the new theory. Both Fry and Bell believed that appreciation of Modern as well as other art was now no longer restricted to the social elite because it no longer required a background of extensive education in history, mythology, religion, art. According to Fry, "to admire a Matisse required only a certain sensibility" and a knowledge of the universal elements of line, color, space.⁸ While the response by the public to Modern art was to continue to be problematical, Fry and Bell nonetheless believed that the aesthetics of Significant Form were more democratic and less class bound.

Other historical circumstances also helped reinforce belief in the superiority of form over representation. Formalism, for instance, provided Westerners—who knew relatively little of the subject matter and intended meaning/purpose of the medieval, "primitive," and non-Western arts increasingly coming before the public in the early twentieth century—a way to evaluate and appreciate these arts.⁹ These were among several of the artistic and historical factors encouraging the acceptance and development of formalist theory and criticism.

This, in brief, was the state of Modern formalist theory out of which Clement Greenberg's Late Modern theory developed. Kant's ideas eventually were to become identified, not only with formalist aesthetic theory, but with Modernism itself. Greenberg was, in large part, responsible for this development. He contended that Kant was able to purify the methods of criticism. What Greenberg meant was that Kant, in his philosophical inquiry, used the methods of logic to establish the limits of the discipline of logic; logic was used to criticize logic. Greenberg called this the "self-critical" method. Greenberg also believed that Kant had shown that every discipline must do this; that every discipline must use the characteristic methods of that discipline to criticize that discipline. Painting, for example, must rely on its characteristic (idiomatic) features to determine that which is unique and irreducible in painting (for Greenberg, the irreducible feature of painting turned out to be flatness).

Greenberg saw Kant's self-critical method as the very essence of Modernism. In his 1960 essay "Modernist Painting," reprinted here with a 1978 Postscript,* Greenberg wrote that

Western civilization is not the first to turn around and question its own foundations, but it is the civilization that has gone furthest in doing so. I identify Modernism with the intensification . . . of this self-critical tendency that began with the philosopher Kant.

And because Kant "was the first to criticize the means itself of criticism," said Greenberg, "I conceive of Kant as the first real Modernist."

Greenberg's ideas were so widely accepted that Greenbergian formalism has come to be regarded as the critical basis, not only of Late Modern art, but of all of Modern art. Though Greenberg has acknowledged formalism's historical ties to early Modernism and demonstrated a formalist reading of the work of earlier artists, his approach became a dominant critical theory only during the Late Modernist period of the 1950s and '60s. Therefore, his particular formalist theory should be associated with the art of that period, and only with special care should it be applied to earlier art.

It should also be noted that Greenberg's criticism was born of particular circumstances closely connected with specific political events and social issues—the Depression, the rise of the Fascist and Nazi states, and especially the signing by Hitler and Stalin of a nonaggression pact in August of 1939. These events were part of the crisis of collapsing values Greenberg saw in "Western bourgeois society" (the Marxist phrase is his).

^{*}According to Greenberg, this essay was written as early as 1960 and appeared in a Voice of America pamphlet after its broadcast. Three years later it was published in *Art and Literature* in Paris.

4 Part One

The urgency in Greenberg's early insistence upon formalism as a way to preserve aesthetic values and, therefore, some sense of culture clearly is founded in his perception of the deteriorating condition of Western society on the eve of World War II.

In his important 1939 essay "Avant-Garde and Kitsch," Greenberg attempted to rescue culture by separating the aesthetic values of art from other social and political values. Bypassing the question of subject matter and content, he recognized form as a universal. Echoing Fry and Bell, he noted that

we may have come to prefer Giotto to Raphael, but we still do not deny that Raphael was one of the best painters of his time. There has been an agreement then, and this agreement rests, I believe, on a fairly constant distinction made between those values only to be found in art [communicated through form] and the values which can be found elsewhere.¹⁰

However, Greenberg went on to note that kitsch, what he defined as a debased form of high art for the urbanized masses, "has erased this distinction in practice."¹¹

What concerned Greenberg was that late capitalist society was debasing high art, making it into a kind of kitsch expressly to entertain the masses who, having recently been urbanized, no longer wanted folk art of the countryside. To resist this pressure to turn art into kitsch, the "avantgarde poet or artist," wrote Greenberg,

tries in effect to imitate God by creating something valid solely on its own terms, in the way nature itself is valid, in the way a landscape—not its picture—is aesthetically valid; something *given*, increate, independent of meanings, similars or originals.¹²

In this way, Greenberg believed the artist would be able to show that the experience art provided could not be duplicated by kitsch, that it was unique and, therefore, a valuable experience in its own right akin to the experience of nature itself.

From this early article, it is clear that Greenberg's formalism grows out of his perception of the declining state of culture (a perception in part based on Marxist ideas) exemplified by his view that the disappearance of the distinction between the art of mass culture (kitsch) and high art, high art being absorbed by kitsch, was a sign of the debasement of culture and of social values.

Greenberg's focus on form, reflecting the theories of Kant, Fry, and Bell, is not solely a way of appreciating high art, but also a means of ensuring aesthetic quality in future art. For him, aesthetic quality has an important new feature added to it. "Content is to be dissolved so completely into form," wrote Greenberg, "that the work of art or literature cannot be reduced in whole or in part to anything not itself."¹³ This statement, so reflective of Pater's dictum about the arts aspiring to the condition of music, is extremely important because it is the central basis for Greenberg's argument for a self-reflexive, self-critical art like Kant's "selfreflexive" critical method in philosophy.

This is the reason that Greenberg held Kant to be so important, calling him the first real Modernist. The artist, wrote Greenberg, "in turning his attention away from subject matter of common experience, . . . turns it in upon the medium of his own craft."¹⁴ Thus, for Greenberg, aesthetic quality is related to form. But, since form differs from one medium to the next, or more accurately, since all media do not have the same form (e.g., music has sound, sculpture has three-dimensional shape, painting has two-dimensional shape, and so forth), the aesthetic quality of form is not judged just in terms of its universal aspects as in Kant, Bell, and Fry, but by its idiomatic (peculiar) connection to each particular medium. Each medium should criticize itself, according to Greenberg, by stripping away any element not uniquely its own, thereby becoming "valid solely on its own terms," that is, the terms defined by each particular medium.

Defining the relationship between medium and form is the central issue of Greenberg's formalism and of the practice of Late Modern art, especially painting, in the 1950s and '60s. It is this feature of his critical theory that has come to be considered the basis of all of Modernism in art.

Greenberg's theory was much more cogent and systematic by the time he wrote "Modernist Painting" in 1960. He still maintained that the "arts could save themselves from [being assimilated to entertainment] . . . only by demonstrating that the kind of experience they provided was valuable in its own right. . . ." And he spoke of aesthetic quality being related to "purity" and claimed that in purity each art would "find the guarantee of its standards of quality as well as of its independence." However, the urgent connection to cultural crisis out of which the theory began in 1939 was no longer so apparent.

In his 1978 Postscript to "Modern Painting," Greenberg was careful to point out to his increasingly strident critics that his use of the words "pure" and "purity" had always been with quotation marks in order to qualify their meaning. He also wrote that through his critical writings he had attempted to account for "how most of the very best art of the last hundred-odd years came about," without implying that that is how it *had* to come about or would continue to come about in the future.

Today, the issue of aesthetic quality is the basis of Hilton Kramer's critical position, a position which follows from Greenberg's but is usually associated with more conservative thinking in art and politics than Greenberg's was originally. (Kramer's position will be discussed in Part Two.) In

6 Part One

contrast to Kramer's position which endorses Modern art based on Greenberg's idea of aesthetic quality, aesthetic quality has become the point of attack against Greenberg in particular and Modernism in general by "content-based" social and political writers often from the left, though not exclusively. Thus, the question of content, which is said to be lacking in Greenberg's argument for aesthetic quality, is at the heart of the disagreements with his writing. As we shall see in Part Six: "Marginality and the Other," many later writers and critics not only juxtapose formal considerations to content/subject matter as if one precluded the other, they also reject any idea of aesthetic quality, not only Greenberg's.

Marxist art historian T. J. Clark's disagreement with Greenberg is over the issue of the independence of aesthetic qualities and values. This is evident in a brief exchange between them transcribed by Paul Richter from a conference at the University of British Columbia. Clark questions Greenberg about the idea that "we have somehow to accept a situation [in formalist theory] in which there is no longer a dialectic between other values and artistic [aesthetic] values."¹⁵

In a subsequent essay, "Clement Greenberg's Theory of Art," which is reprinted here, Clark elaborates his concerns with this situation. He interprets Greenberg's Modernism as "aristocratic art in the age when the bourgeoisie abandons its claims to aristocracy." Clark goes on to ask, in the absence of an aristocracy or bourgeoisie claims to one, "how will art keep aristocracy alive?" He gives a Greenbergian answer as a way of posing the issue:

By keeping *itself* alive, as the remaining vessel of the aristocratic account of experience and its modes; by preserving its own means, its media; by proclaiming those means and media *as* its values, as meanings in themselves.

This, he felt, was "the crux of the argument" with Greenbergian formalism.

Clark goes on to point out what he sees as the paradox in Greenberg's scenario for the preservation of cultural values in bourgeois society. For Clark, artistic values must be connected with society in a larger sense, they cannot be autonomous. Artistic values become values only when they stand for something else, when they become "metaphors." There is, says Clark, "no fact without the metaphor [his example is that of flatness in nineteenth-century French painting], no medium without its being the vehicle of a complex act of meaning." Clark suggests that modern art, in its practice, is an art of negation:

it presents itself as a work of interminable and absolute decomposition, a work which is always pushing "medium" to its limits—to its ending—to the point where it breaks or evaporates or turns back into mere unworked material. That is the form in which medium is retrieved or reinvented: the fact of Art in modernism *is* the fact of negation.

It is this point in Clark's argument that critic Michael Fried refutes in his essay reprinted here titled "How Modernism Works: A Response to T. J. Clark." Fried argues that "this claim is false." For example, the supposed unintelligibility of Manet's painting of 1863, *Le Déjeuner sur l'herbe*,

far from being a value in its own right as mere negation of meaning, is in the service of aims and aspirations that have in view a new and profound and ... positive conception of the enterprise of painting.

The "enterprise of painting" is Fried's concern but is not, as Clark seems to find in Greenberg (at least according to Fried), a continuous process of reducing painting down to its *essence*. Fried believes that this idea is "gravely mistaken"; aesthetic quality is not to be discovered solely in the unique formal qualities of each medium, as Greenberg contended. Instead, according to Fried,

what the modernist painter can be said to discover in his work... is not the irreducible essence of *all* painting, but rather that which, at the present moment in painting's history, is capable of convincing him that it can stand comparison with the painting of both the modernist and the pre-modernist past whose quality seems to him beyond question.

And later, Fried notes that "unless something compels conviction as to its quality it is no more than trivially or nominally a painting." He rejects the notion that Modernism is an art of negation and, in this sense, agrees with Greenberg about aesthetic quality; however, Fried sees judgments of aesthetic quality as something stemming from the history of art, not necessarily or solely inherent in the self-criticality of the various media.

Addressing the question of the meaning of art in relation to society, the central concern of Clark, Fried states that painting in its "constantly renewed effort to discover what it must be [that is, what in painting can compel conviction] is forever driven 'outside' itself, compelled to place in jeopardy its very identity by engaging with what it is not." In this way, it is not an enterprise separated from society, but part of culture at large:

Conviction or its absence invites inquiry into what might be called the politics of conviction, . . . the countless ways in which a person's deepest beliefs about art . . . have been influenced . . . by institutional factors that . . . merge imperceptibly with the culture at large.

Clark was not swayed by Fried's argument and issued a response to it. In this response he challenged Fried's conclusions about negativity and gave a reading of Modernism as a historical enterprise using examples of works of art as Fried suggested.¹⁶

The essay reprinted here by the German philosopher Jürgen Habermas is "Modernity versus Postmodernity." In it, Habermas presents a

8 Part One

broader contextual interpretation of the issues of Modernism from which Greenberg's ideas can be seen to have evolved.

In the first part of his essay, Habermas outlines the historical origins of the term "modern," showing how our idea of "modern" began with the ideals of the French Enlightenment and the promise of science:

the idea of being "modern" by looking back to the ancients changed with the belief, inspired by modern science, in the infinite progress of knowledge and in the infinite advance towards social and moral betterment.

This belief altered the relationship between art and tradition, something exemplified by the notion of the avant-garde, and also led to the conceptions of aesthetic value that have come to be known as Modernism. Today, however, the ideas of a "post-avant-garde" and Postmodernism indicate that the conception of aesthetic modernity has begun to age, that, as Octavio Paz has written, "we are experiencing the end of the idea of modern art."

What disturbs Habermas is that a form of neoconservative anti-Modernism has developed out of this situation that is attempting to discredit the social promise of Modernism by placing blame for all the ills of current technological and industrialized society onto the realm of modern culture:

Neoconservativism shifts onto cultural modernism the uncomfortable burdens of a more or less successful capitalist modernization of the economy and society. The neoconservative doctrine blurs the relationship between the welcomed process of societal modernization on the one hand, and the lamented cultural development on the other.

In the second part of his essay, Habermas explains why the project of Modernity should not be abandoned. He recalls an idea of German sociologist Max Weber who "characterized cultural modernity as the separation of the substantive reason expressed in religion and metaphysics into three autonomous spheres"—science, morality, and art. From this separation, writes Habermas,

scientific discourse, theories of morality, jurisprudence, the production and criticism of art could in turn be institutionalized. Each domain of culture could be made to correspond to cultural professions in which problems could be dealt with as the concern of special experts.

Thus culture after the Enlightenment, according to Habermas, increasingly became fragmented into autonomous realms under the guidance of experts. In the twentieth century, these special experts became the formative basis of Modernity's culture of experts from which the larger public became more and more separated. This separation is reflected in Greenberg's theory when he calls for an art defined by and restricted to its medium, an art purposefully separated from the larger mass culture of kitsch and entertainment so as to remain pure. In this environment the artist becomes an expert (like the scientist) in an autonomous realm decentered from the larger cultural stream and split off from the realities and responsibilities of everyday communication.

The effects of this institutionalization are what troubled Clark and other Marxist and content-oriented writers. Opposition to the separation of art from life has emerged as a central theme of Postmodernity. As Habermas suggests, any plan to integrate society must address the questions of autonomous realms of knowledge and the resultant culture of experts in all fields, not just in art. While this may be a difficult enterprise, Habermas does not advocate "giving up modernity and its project as a lost cause," but rather urges that "we should learn from the mistakes of those extravagant programs which have tried to negate modernity." In sum, Habermas advocates controlling modernity and its unchecked realms of activity, especially the economic realm which seems to flourish at the expense of the cultural and social realms:

The life-world has to become able to develop institutions out of itself which set limits to the internal dynamics and imperatives of an almost autonomous economic system and its administrative complements.

While this is easier said than done, it is possible. As special-interest groups concerned with the environment and equal rights issues have demonstrated, not all values are strictly economic.

In looking back over the past century, it is clear that the development of formalist theory and criticism, as Habermas's essay indicates, paralleled the historical development of Modern society and its culture of experts. Emphasis upon rationalism and the objective methods of empirical science, essential features of modern industrial society, are reflected in the primacy given form in order to have objective, "scientific" criteria with which to evaluate art. Justification for the priority given form primarily was found in the philosophical writings of Kant. And eventually, form and formal elements in art were elevated to the position of universals that transcended any historic, cultural, gender, or ethnic/racial considerations. Formal criteria shifted discussions away from literary and representational subject matter and provided a basis to analyze and appreciate the work of Modern artists as well as pre-Modern and non-Western art.

Culminating in the critical writings of Greenberg, formalism was identified almost exclusively with him, so much so that the initial thrust of Postmodern criticism was a debate centering on his particular ideas. This debate was precipitated by the inability of formalist criticism to adequately address subject matter, an especially important consideration since figurative and representational art (with its obvious interest in subject matter) was becoming increasingly visible in art galleries in the late 1970s.¹⁷ Clark's argument with Greenberg is related to this; Clark believes that art and art criticism must not be restricted to formal concerns alone, but must seek ways to function *within* the social fabric. And unlike some later critics, this is not necessarily a call by Clark for realism in art; rather, it is a plea to "make" art meaningful to society by engaging in socially relevant and responsible dialogue.

While Greenberg's critical theories formed the backdrop for writers who questioned universality of form, deeper issues were involved, issues implicating the role of rationalism and scientific objectivity—as well as the culture of experts with its autonomous realms of knowledge—in shaping world views and directing social priorities. The role of institutional factors in the construction of meaning in art, which was broached by Fried in his essay and by Clark in his as a part of Marxist theory of culture, is an important aspect of this questioning. As the following essays demonstrate, Postmodern critics and writers have come to believe that construction of meaning is *the* major issue of today's art, culture, and society because it is an issue directly related to the individual's development of consciousness and of perceptions of reality.

Notes

- 1. Paul Richter, "Modernism and After," Vanguard (May 1981), p. 22.
- 2. Immanuel Kant, *The Critique of Judgement*, translated with Analytical Indexes by James Creed Meridith (Oxford: At The Clarendon Press, 1952), p. 67; also cited in Richter, "Modernism and After," p. 23.
- 3. Maurice Denis, as quoted in *Dictionary of 20th-Century Art* (Oxford: Phaidon Press Limited, 1973), p. 93.
- 4. Walter Pater, *The Renaissance: Studies in Art and Poetry* (Glasgow: William Collins Sons & Co. Ltd., 1961), p. 129. Pater's remark, which was first published in 1873, refers to the fusion of form and content that, he believed, was epitomized by music. Greenberg was to reiterate this idea in his essay "Avant-Garde and Kitsch" in 1939. It is this idea relating content to (abstract) form that some '90s critics have attacked because they believe content can only be expressed through representational subject matter.
- 5. Clive Bell, Art, 6th Impression (New York: Capricorn Books, G. P. Putnam's Sons, 1958), p. 17.
- 6. Bell, Art, pp. 17–18.
- 7. Bell, Art, p. 27.
- 8. For Bell's views, see his Art, pp. 73–74; for those of Roger Fry, see "Retrospect," Vision and Design (New York: Brentano's, n.d.), p. 291. It is interesting to note that Fry believed "that the accusation of revolutionary anarchism [associated with Modern art] was due to a social rather than an aesthetic prejudice." Many believed Modern art tended to level the distinctions between the classes by neutralizing the privileges of education. For more on this point, see Fry, "Retrospect," p. 291.

- 9. For information on the development of European interest in non-Western art, see Robert Goldwater, *Primitivism in Modern Art*, rev. ed. (New York: Vintage Books, A Division of Random House, 1967). It has recently been suggested that formalist theory, by ignoring individual ethnic content in art in favor of what has been called universal form, was consonant with European colonialism in effecting domination through cultural neutralization.
- Clement Greenberg, "Avant-Garde and Kitsch," Partisan Review 6 (Fall 1939), reprinted in Greenberg, Art and Culture: Critical Essays (Boston: Beacon Press, 1961), p. 13.
- 11. Greenberg, "Kitsch," p. 13.
- 12. Greenberg, "Kitsch," p. 6.
- 13. Greenberg, "Kitsch," p. 6. See also note 4 above.
- 14. Greenberg, "Kitsch," p. 6.
- 15. Paul Richter, transcript from the conference "Modernism and Modernity: A Question of Culture or Culture Called into Question?" University of British Columbia, reprinted in Richter, "Modernism and After," p. 22.
- T. J. Clark, "Arguments About Modernism: A Reply To Michael Fried," *Politics of Interpretation*, ed. W. J. T. Mitchell (Chicago & London: University of Chicago Press, 1983), pp. 239–248.
- 17. It is significant that the international influence of both Greenberg's writings and of American formal art (Color Field, Minimalism, and Pop) paralleled the rise of the economic and political power of the United States in the post–World War II period. As this power began to be challenged in the 1970s, American formal art increasingly had to share attention with a representational and figurative tradition that, despite receiving little critical attention in the previous decades, had continued to develop. In view of this, attacks on Greenbergian formalism can be seen as connected to events in the wider political, economic, and social arena.

Modernist Painting

CLEMENT GREENBERG

Modernism includes more than just art and literature. By now it includes almost the whole of what is truly alive in our culture. It happens, also, to be very much of a historical novelty. Western civilization is not the first to turn around and question its own foundations, but it is the civilization that has gone furthest in doing so. I identify Modernism with the intensification, almost the exacerbation, of this self-critical tendency that began with the philosopher Kant. Because he was the first to criticize the means itself of criticism, I conceive of Kant as the first real Modernist.

The essence of Modernism lies, as I see it, in the use of the characteristic methods of a discipline to criticize the discipline itself—not in order to subvert it, but to entrench it more firmly in its area of competence. Kant used logic to establish the limits of logic, and while he withdrew much from its old jurisdiction, logic was left in all the more secure possession of what remained to it.

The self-criticism of Modernism grows out of but is not the same thing as the criticism of the Enlightenment. The Enlightenment criticized from the outside, the way criticism in its more accepted sense does; Modernism criticizes from the inside, through the procedures themselves of that which is being criticized. It seems natural that this new kind of criticism should have appeared first in philosophy, which is critical by definition, but as the nineteenth century wore on it made itself felt in many other fields. A more rational justification had begun to be demanded of every formal social activity, and Kantian self-criticism was called on eventually to meet and interpret this demand in areas that lay far from philosophy.

This essay was published in Art and Literature 4 (Spring 1963) and is reprinted with permission of the author.

We know what has happened to an activity like religion that has not been able to avail itself of 'Kantian' immanent criticism in order to justify itself. At first glance the arts might seem to have been in a situation like religion's. Having been denied by the Enlightenment all tasks they could take seriously, they looked as though they were going to be assimilated to entertainment pure and simple, and entertainment itself looked as though it was going to be assimilated, like religion, to therapy. The arts could save themselves from this leveling down only by demonstrating that the kind of experience they provided was valuable in its own right and not to be obtained from any other kind of activity.

Each art, it turned out, had to effect this demonstration on its own account. What had to be exhibited and made explicit was that which was unique and irreducible not only in art in general, but also in each particular art. Each art had to determine, through the operations peculiar to itself, the effects peculiar and exclusive to itself. By doing this each art would, to be sure, narrow its area of competence, but at the same time it would make its possession of this area all the more secure.

It quickly emerged that the unique and proper area of competence of each art coincided with all that was unique to the nature of its medium. The task of self-criticism became to eliminate from the effects of each art any and every effect that might conceivably be borrowed from or by the medium of any other art. Thereby each art would be rendered 'pure', and in its 'purity' find the guarantee of its standards of quality as well as of its independence. 'Purity' meant self-definition, and the enterprise of self-criticism in the arts became one of self-definition with a vengeance.

Realistic, illusionist art had dissembled the medium, using art to conceal art. Modernism used art to call attention to art. The limitations that constitute the medium of painting—the flat surface, the shape of the support, the properties of pigment—were treated by the Old Masters as negative factors that could be acknowledged only implicitly or indirectly. Modernist painting has come to regard these same limitations as positive factors that are to be acknowledged openly. Manet's paintings became the first Modernist ones by virtue of the frankness with which they declared the surfaces on which they were painted. The Impressionist, in Manet's wake, abjured underpainting and glazing, to leave the eye under no doubt as to the fact that the colors used were made of real paint that came from pots or tubes. Cézanne sacrificed verisimilitude, or correctness, in order to fit drawing and design more explicitly to the rectangular shape of the canvas.

It was the stressing, however, of the ineluctable flatness of the support that remained most fundamental in the processes by which pictorial art criticized and defined itself under Modernism. Flatness alone was unique and exclusive to that art. The enclosing shape of the support was

14 Clement Greenberg

a limiting condition, or norm, that was shared with the art of the theater; color was a norm or means shared with sculpture as well as the theater. Flatness, two-dimensionality, was the only condition painting shared with no other art, and so Modernist painting oriented itself to flatness as it did to nothing else.

The Old Masters had sensed that it was necessary to preserve what is called the integrity of the picture plane: that is, to signify the enduring presence of flatness under the most vivid illusion of three-dimensional space. The apparent contradiction involved—the dialectical tension, to use a fashionable but apt phrase—was essential to the success of their art, as it is indeed to the success of all pictorial art. The Modernists have neither avoided nor resolved this contradiction; rather, they have reversed its terms. One is made aware of the flatness of their pictures before, instead of after, being made aware of what the flatness contains. Whereas one tends to see what is *in* an Old Master before seeing it as a picture, one sees a Modernist painting as a picture first. This is, of course, the best way of seeing any kind of picture, Old Master or Modernist, but Modernism imposes it as the only and necessary way, and Modernism's success in doing so is a success of self-criticism.

It is not in principle that Modernist painting in its latest phase has abandoned the representation of recognizable objects. What it has abandoned in principle is the representation of the kind of space that recognizable, three-dimensional objects can inhabit. Abstractness, or the non-figurative, has in itself still not proved to be an altogether necessary moment in the self-criticism of pictorial art, even though artists as eminent as Kandinsky and Mondrian have thought so. Representation, or illustration, as such does not abate the uniqueness of pictorial art; what does do so are the associations of the things represented. All recognizable entities (including pictures themselves) exist in three-dimensional space, and the barest suggestion of a recognizable entity suffices to call up associations of that kind of space. The fragmentary silhouette of a human figure, or of a teacup, will do so, and by doing so alienate pictorial space from the twodimensionality which is the guarantee of painting's independence as an art. Three-dimensionality is the province of sculpture, and for the sake of its own autonomy painting has had above all to divest itself of everything it might share with sculpture. And it is in the course of its effort to do this, and not so much—I repeat—to exclude the representational or the literary', that painting has made itself abstract.

At the same time Modernist painting demonstrates, precisely in its resistance to the sculptural, that it continues tradition and the themes of tradition, despite all appearances to the contrary. For the resistance to the sculptural begins long before the advent of Modernism. Western painting, insofar as it strives for realistic illusion, owes an enormous debt to sculp-

ture, which taught it in the beginning how to shade and model towards an illusion of relief, and even how to dispose that illusion in a complementary illusion of deep space. Yet some of the greatest feats of Western painting came as part of the effort it has made in the last four centuries to suppress and dispel the sculptural. Starting in Venice in the sixteenth century and continuing in Spain, Belgium, and Holland in the seventeenth, that effort was carried on at first in the name of color. When David, in the eighteenth century, sought to revive sculptural painting, it was in part to save pictorial art from the decorative flattening-out that the emphasis on color seemed to induce. Nevertheless, the strength of David's own best pictures (which are predominantly portraits) often lies as much in their color as in anything else. And Ingres, his pupil, though subordinating color far more consistently, executed pictures that were among the flattest, least sculptural done in the West by a sophisticated artist since the fourteenth century. Thus by the middle of the nineteenth century all ambitious tendencies in painting were converging (beneath their differences) in an antisculptural direction.

Modernism, in continuing this direction, made it more conscious of itself. With Manet and the Impressionists, the question ceased to be defined as one of color versus drawing, and became instead a question of purely optical experience as against optical experience modified or revised by tactile associations. It was in the name of the purely and literally optical, not in that of color, that the Impressionists set themselves to undermining shading and modeling and everything else that seemed to connote the sculptural. And in a way like that in which David had reacted against Fragonard in the name of the sculptural, Cézanne, and the Cubists after him, reacted against Impressionism. But once again, just as David's and Ingres' reaction had culminated in a kind of painting even less sculptural than before, so the Cubist counter-revolution eventuated in a kind of painting flatter than anything Western art had seen since before Cimabue—so flat indeed that it could hardly contain recognizable images.

In the meantime the other cardinal norms of the art of painting were undergoing an equally searching inquiry, though the results may not have been equally conspicuous. It would take me more space than is at my disposal to tell how the norm of the picture's enclosing shape or frame was loosened, then tightened, then loosened once again, and then isolated and tightened once more by successive generations of Modernist painters; or how the norms of finish, of paint texture, and of value and color contrast, were tested and retested. Risks have been taken with all these, not only for the sake of new expression, but also in order to exhibit them more clearly as norms. By being exhibited and made explicit they are tested for their indispensability. This testing is by no means finished, and the fact that it becomes more searching as it proceeds accounts for the radical simplifications, as well as radical complications, in which the very latest abstract art abounds.

Neither the simplifications nor the complications are matters of license. On the contrary, the more closely and essentially the norms of a discipline become defined the less apt they are to permit liberties (liberation' has become a much abused word in connection with avant-garde and Modernist art). The essential norms or conventions of painting are also the limiting conditions with which a marked-up surface must comply in order to be experienced as a picture. Modernism has found that these limiting conditions can be pushed back indefinitely before a picture stops being a picture and turns into an arbitrary object; but it has also found that the further back these limits are pushed the more explicitly they have to be observed. The intersecting black lines and colored rectangles of a Mondrian may seem hardly enough to make a picture out of, yet by echoing the picture's enclosing shape so self-evidently they impose that shape as a regulating norm with a new force and a new completeness. Far from incurring the danger of arbitrariness in the absence of a model in nature, Mondrian's art proves, with the passing of time, almost too disciplined, too convention-bound in certain respects; once we have become used to its utter abstractness we realize that it is more traditional in its color, as well as in its subservience to the frame, than the last paintings of Monet are.

It is understood, I hope, that in plotting the rationale of Modernist art I have had to simplify and exaggerate. The flatness towards which Modernist painting orients itself can never be an utter flatness. The heightened sensitivity of the picture plane may no longer permit sculptural illusion, or *trompe-l'oeil*, but it does and must permit optical illusion. The first mark made on a surface destroys its virtual flatness, and the configurations of a Mondrian still suggest a kind of illusion of a kind of third dimension. Only now it is a strictly pictorial, strictly optical third dimension. Where the Old Masters created an illusion of space into which one could imagine oneself walking, the illusion created by a Modernist is one into which one can only look, can travel through only with the eye.

One begins to realize that the Neo-Impressionists were not altogether misguided when they flirted with science. Kantian self-criticism finds its perfect expression in science rather than in philosophy, and when this kind of self-criticism was applied in art the latter was brought closer in spirit to scientific method than ever before—closer than in the early Renaissance. That visual art should confine itself exclusively to what is given in visual experience, and make no reference to anything given in other orders of experience, is a notion whose only justification lies, notionally, in scientific consistency. Scientific method alone asks that a situation be resolved in exactly the same kind of terms as that in which it is presented—a problem in physiology is solved in terms of physiology, not in those of psychology; to be solved in terms of psychology, it has to be presented in, or translated into, these terms first. Analogously, Modernist painting asks that a literary theme be translated into strictly optical, two-dimensional terms before becoming the subject of pictorial art—which means its being translated in such a way that it entirely loses its literary character. Actually, such consistency promises nothing in the way of aesthetic quality or aesthetic results, and the fact that the best art of the past seventy or eighty years increasingly approaches such consistency does not change this; now as before, the only consistency which counts in art is aesthetic consistency, which shows itself only in results and never in methods or means. From the point of view of art itself its convergence of spirit with science happens to be a mere accident, and neither art nor science gives or assures the other of anything more than it ever did. What their convergence does show, however, is the degree to which Modernist art belongs to the same historical and cultural tendency as modern science.

It should also be understood that the self-criticism of Modernist art has never been carried on in any but a spontaneous and subliminal way. It has been altogether a question of practice, immanent to practice and never a topic of theory. Much has been heard about programs in connection with Modernist art, but there has really been far less of the programmatic in Modernist art than in Renaissance or Academic art. With a few untypical exceptions, the masters of Modernism have betrayed no more of an appetite for fixed ideas about art than Corot did. Certain inclinations and emphases. certain refusals and abstinences seem to become necessary simply because the way to stronger, more expressive art seems to lie through them. The immediate aims of Modernist artists remain individual before anything else, and the truth and success of their work is individual before it is anything else. To the extent that it succeeds as art Modernist art partakes in no way of the character of a demonstration. It has needed the accumulation over decades of a good deal of individual achievement to reveal the selfcritical tendency of Modernist painting. No one artist was, or is yet, consciously aware of this tendency, nor could any artist work successfully in conscious awareness of it. To this extent-which is by far the largest-art gets carried on under Modernism in the same way as before.

And I cannot insist enough that Modernism has never meant anything like a break with the past. It may mean a devolution, an unraveling of anterior tradition, but it also means its continuation. Modernist art develops out of the past without gap or break, and wherever it ends up it will never stop being intelligible in terms of the continuity of art. The making of pictures has been governed, since pictures first began to be made, by all the norms I have mentioned. The Paleolithic painter or engraver could disregard the norm of the frame and treat the surface in both a literally and a virtually sculptural way because he made images

18 Clement Greenberg

rather than pictures, and worked on a support whose limits could be disregarded because (except in the case of small objects like a bone or horn) nature gave them to the artist in an unmanageable way. But the making of pictures, as against images in the flat, means the deliberate choice and creation of limits. This deliberateness is what Modernism harps on: that is, it spells out the fact that the limiting conditions of art have to be made altogether human limits.

I repeat that Modernist art does not offer theoretical demonstrations. It could be said, rather, that it converts all theoretical possibilities into empirical ones, and in doing so tests, inadvertently, all theories about art for their relevance to the actual practice and experience of art. Modernism is subversive in this respect alone. Ever so many factors thought to be essential to the making and experiencing of art have been shown not to be so by the fact that Modernist art has been able to dispense with them and yet continue to provide the experience of art in all its essentials. That this 'demonstration' has left most of our old value judgments intact only makes it the more conclusive. Modernism may have had something to do with the revival of the reputations of Uccello, Piero, El Greco, Georges de la Tour, and even Vermeer, and it certainly confirmed if it did not start other revivals like that of Giotto: but Modernism has not lowered thereby the standing of Leonardo, Raphael, Titian, Rubens, Rembrandt or Watteau. What Modernism has made clear is that, though the past did appreciate masters like these justly, it often gave wrong or irrelevant reasons for doing so.

Still, in some ways this situation has hardly changed. Art criticism lags behind Modernist as it lagged behind pre-Modernist art. Most of the things that get written about contemporary art belong to journalism rather than criticism properly speaking. It belongs to journalism—and to the millennial complex from which so many journalists suffer in our day—that each new phase of Modernism should be hailed as the start of a whole new epoch of art making a decisive break with all the customs and conventions of the past. Each time, a kind of art is expected that will be so unlike previous kinds of art and so 'liberated' from norms of practice or taste, that everybody, regardless of how informed or uninformed, will be able to have his say about it. And each time, this expectation is disappointed, as the phase of Modernism in question takes its place, finally, in the intelligible continuity of taste and tradition, and as it becomes clear that the same demands as before are made on artist and spectator.

Nothing could be further from the authentic art of our time than the idea of a rupture of continuity. Art is, among many other things, continuity. Without the past of art, and without the need and compulsion to maintain past standards of excellence, such a thing as Modernist art would be impossible.

Postscript, 1978

The above appeared first in 1960 as a pamphlet in a series published by the Voice of America. It had been broadcast over that agency's radio in the spring of the same year. With some minor verbal changes it was reprinted in the spring 1963 number of *Art & Literature* in Paris, and then in Gregory Battcock's anthology *The New Art* (1966), where its date of publication in *Art & Literature* was erroneously given as 1965....

I want to take this chance to correct another error, one of interpretation and not of fact. Many readers, though by no means all, seem to have taken the "rationale" of Modernist art outlined here as representing a position adopted by the writer himself: that is, that what he describes he also advocates. This may be a fault of the writing or the rhetoric. Nevertheless, a close reading of what he writes will find nothing at all to indicate that he subscribes to, believes in, the things that he adumbrates. (The quotation marks around *pure* and *purity* should have been enough to show that.) The writer is trying to account in part for how most of the very best art of the last hundred-odd years came about, but he's not implying that that's how it *had* to come about, much less that that's how the best art still has to come about. "Pure" art was a useful illusion, but this doesn't make it any the less an illusion. Nor does the possibility of its continuing usefulness make it any the less an illusion.

There have been some further constructions of what I wrote that go over into preposterousness: That I regard flatness and the inclosing of flatness not just as the limiting conditions of pictorial art, but as criteria of aesthetic quality in pictorial art; that the further a work advances the selfdefinition of an art, the better that work is bound to be. The philosopher or art historian who can envision me—or anyone at all—arriving at aesthetic judgments in this way reads shockingly more into himself or herself than into my article.

Clement Greenberg's Theory of Art

T. J. CLARK

In the issue of *Partisan Review* for Fall 1939 appeared an article by Clement Greenberg entitled "Avant-Garde and Kitsch." It was followed four issues later, in July-August 1940, by another wide-ranging essay on modern art, "Towards a Newer Laocoon."1 These two articles, I believe, stake out the ground for Greenberg's later practice as a critic and set down the main lines of a theory and history of culture since 1850—since, shall we say, Courbet and Baudelaire. Greenberg reprinted "Avant-Garde and Kitsch," making no attempt to tone down its mordant hostility to capitalism, as the opening item of his collection of critical essays, Art and Culture, in 1961. "Towards a Newer Laocoon" was not reprinted, perhaps because the author felt that its arguments were made more effectively in some of his later, more particular pieces included in Art and Culture-the essays on "Collage" or "Cézanne," for example, or the brief paragraphs on "Abstract, Representational, and So Forth." I am not sure that the author was right to omit the piece: it is noble, lucid, and extraordinarily balanced, it seems to me, in its defense of abstract art and avant-garde culture; and certainly its arguments are taken up directly, sometimes almost verbatim, in the more famous theoretical study which appeared in Art and Literature (Spring 1963) with the balder title "Modernist Painting."

The essays of 1939 and 1940 argue already for what were to become Greenberg's main preoccupations and commitments as a critic. And the arguments adduced, as the author himself admits at the end of "Towards a Newer Laocoon," are largely historical. "I find," Greenberg writes there, "that I have offered no other explanation for the present superiority of

This essay was originally published in *Critical Inquiry* 9 (September 1982). Copyright © 1982 T. J. Clark. Reprinted with permission of the author.

abstract art than its historical justification. So what I have written has turned out to be an historical apology for abstract art" ("NL," p. 310). The author's proffered half-surprise at having thus "turned out" to be composing an apology in the historical manner should not of course be taken literally. For it was historical consciousness. Greenberg had argued in "Avant-Garde and Kitsch," which was the key to the avant-garde's achievement-its ability, that is, to salvage something from the collapse of the bourgeois cultural order. "A part of Western bourgeois society," Greenberg writes, "has produced something unheard of heretofore:-avant-garde culture. A superior consciousness of history—more precisely, the appearance of a new kind of criticism of society, an historical criticism-made this possible. . . . It was no accident, therefore, that the birth of the avant-garde coincided chronologically—and geographically, too—with the first bold development of scientific revolutionary thought in Europe" ("AK," p. 35). By this last he means, need I say it, preeminently the thought of Marx, to whom the reader is grimly directed at the end of the essay, after a miserable and just description of fascism's skill at providing "art for the people," with the words: "Here, as in every other question today, it becomes necessary to quote Marx word for word. Today we no longer look toward socialism for a new culture—as inevitably as one will appear, once we do have socialism. Today we look to socialism simply for the preservation of whatever living culture we have right now" ("AK," p. 49).

It is not intended as some sort of revelation on my part that Greenberg's cultural theory was originally Marxist in its stresses and, indeed, in its attitude to what constituted explanation in such matters. I point out the Marxist and historical mode of proceeding as emphatically as I do partly because it may make my own procedure later in this paper seem a little less arbitrary. For I shall fall to arguing in the end with these essays' Marxism and their history, and I want it understood that I think that to do so *is* to take issue with their strengths and their main drift.

But I have to admit there are difficulties here. The essays in question are quite brief. They are, I think, extremely well written: it was not for nothing that *Partisan Review* described Clement Greenberg, when he first contributed to the journal early in 1939, as "a young writer who works in the New York customs house"—fine, redolent avant-garde pedigree, that! The language of these articles is forceful and easy, always straightforward, blessedly free from Marxist conundrums. Yet the price paid for such lucidity, here as so often, is a degree of inexplicitness—a certain amount of elegant skirting round the difficult issues, where one might otherwise be obliged to call out the ponderous armory of Marx's concepts and somewhat spoil the flow of the prose from one firm statement to another. The Marxism, in other words, is quite largely implicit; it is stated on occasion, with brittle and pugnacious finality, *as* the essays' frame of reference, but it remains to the reader to determine just how it works in the history and theory presented—what that history and theory depend on, in the way of Marxist assumptions about class and capital or even base and superstructure. That is what I intend to do in this paper: to interpret and extrapolate from the texts, even at the risk of making their Marxism declare itself more stridently than the "young writer" seems to have wished. And I should admit straight away that there are several points in what follows where I am genuinely uncertain as to whether I am diverging from Greenberg's argument or explaining it more fully. This does not worry me overmuch, as long as we are alerted to the special danger in this case, dealing with such transparent yet guarded prose, and as long as we can agree that the project in general—pressing home a Marxist reading of texts which situate themselves within the Marxist tradition—is a reasonable one.²

I should therefore add a word or two to conjure up the connotations of "Marxism" for a writer in 1939 in Partisan Review. I do not need to labour the point. I hope, that there was a considerable and various Marxist culture in New York at this time; it was not robust, not profound, but not frivolous or flimsy either, in the way of England in the same years; and it is worth spelling out how well the pages of *Partisan Review* in 1939 and 1940 mirrored its distinction and variety and its sense of impending doom. The issue in which the "Newer Laocoon" was published began with an embattled article by Dwight MacDonald entitled "National Defense: The Case for Socialism," whose two parts were headed "Death of a World" and "What Must We Do to Be Saved?" The article was a preliminary to the "Ten Propositions on the War" which MacDonald and Greenberg were to sign jointly a year later, in which they argued—still in the bleak days of 1941-for revolutionary abstention from a war between capitalist nationstates. It was a bleak time, then, in which Marxist convictions were often found hard to sustain, but still a time characterized by a certain energy and openness of Marxist thought, even in its moment of doubt. MacDonald had just finished a series of articles—an excellent series, written from an anti-Stalinist point of view-on Soviet cinema and its public. (It is one main point of reference in the closing sections of "Avant-Garde and Kitsch.") Edmund Wilson in Fall 1938 could be seen pouring scorn on "The Marxist Dialectic," in the same issue as André Breton and Diego Rivera's "Manifesto: Towards a Free Revolutionary Art." Philip Rahv pieced out "The Twilight of the Thirties" or "What Is Living and What Is Dead" in Marxism. Victor Serge's Ville Conquise was published, partly, in translation. Meyer Schapiro took issue with To the Finland Station, and Bertram Wolfe reviewed Boris Souvarine's great book on Stalin.

And so on. The point is simply that this *was* a Marxist culture—a hectic and shallow-rooted one, in many ways, but one which deserved the name. Its appetite for European culture—for French art and poetry in particular—is striking and discriminate, especially compared with later New

York French enthusiasms. This was the time when Lionel Abel was translating Lautréamont and Delmore Schwartz, *A Season in Hell*. The pages of *Partisan Review* had Wallace Stevens alongside Trotsky, Paul Eluard next to Allen Tate, "East Coker"—I am scrupulous here—following "Marx and Lenin as Scapegoats." No doubt the glamour of all this is misleading; but at least we can say, all reservations made, that a comparable roster of names and titles from any later period would look desultory by contrast, and rightly so.

Greenberg's first contribution to the magazine, in early 1939, was a review of Bertolt Brecht's *Penny for the Poor*, the novel taken from *The Threepenny Opera*. In it he discussed, sternly but with sympathy, the "nerve-wracking" formal monotony which derived, so he thought, from Brecht's effort to write a parable—a *consistent* fiction—of life under capitalism. In the same issue as "Avant-Garde and Kitsch" there appeared an account of an interview which Greenberg had had, the previous year, with Ignazio Silone. The interviewer's questions told the tale of his commitments without possibility of mistake: "What, in the light of their relations to political parties," he asked, "do you think should be the role of revolutionary writers in the present situation?"; and then, "When you speak of liberty, do you mean *socialist* liberty?"; and then, "Have you read Trotsky's pamphlet, *Their Morals and Ours*? What do you think of it?"³

I am aware of the absurdity of paying more heed to Greenberg's questions than to Silone's grand replies; but you see the point of all this for anyone trying in the end to read between the lines of the "Newer Laocoon." And I hope that when, in a little while, I use the phrase "Eliotic Trotskyism" to describe Greenberg's stance, it will seem less forced a coinage. Perhaps one should even add Brecht to Eliot and Trotsky here, since it seems that the example of Brecht was especially vivid for Greenberg in the years around 1940, representing as he did a difficult, powerful counterexample to all the critic wished to see as the main line of avant-garde activity: standing for active engagement in ideological struggle, not detachment from it, and suggesting that such struggle was not necessarily incompatible with work on the *medium* of theatre, making that medium explicit and opaque in the best avant-garde manner. (It is a pity that Greenberg, as far as I know, wrote only about Brecht's novels and poetry.⁴ Doubtless he would have had critical things to say also about Brecht's epic theatre, but the nature of his criticism—and especially his discussion of the tension between formal concentration and political purpose-might well have told us a great deal about the grounds of his ultimate settling for "purity" as the only feasible artistic ideal.)

All this has been by way of historical preliminary: if we are to read Greenberg's essays of 1939 and 1940, it is necessary, I think, to bear this history in mind.

Let me begin my reading proper, then, by stating in summary form

what I take to be the arguments of "Avant-Garde and Kitsch" and the "Newer Laocoon." They are, as I have said, historical explanations of the course of avant-garde art since the mid-nineteenth century. They are seized with the strangeness of the avant-garde moment-that moment in which "a part of Western bourgeois society . . . produced something unheard of heretofore"; seized with its strangeness and not especially optimistic as to its chances of survival in the face of an ongoing breakdown of bourgeois civilization. For that is the context in which an avant-garde culture comes to be: it is a peculiar, indeed unique, reaction to a far from unprecedented cultural situation—to put it bluntly, the decadence of a society, the familiar weariness and confusion of a culture in its death throes. "Avant-Garde and Kitsch" is explicit on this: Western society in the nineteenth century reached that fatal phase in which, like Alexandrian Greece or late Mandarin China, it became "less and less able . . . to justify the inevitability of its particular forms" and thus to keep alive "the accepted notions upon which artists and writers must depend in large part for communication with their audiences" ("AK," p. 34). Such a situation is usually fatal to seriousness in art. At the end of a culture, when all the verities of religion, authority, tradition, and style-all the ideological cement of society, in other words-are either disputed or doubted or believed in for convenience' sake and not held to *entail* anything much—at such a moment "the writer or artist is no longer able to estimate the response of his audience to the symbols and references with which he works." In the past that had meant an art which therefore left the really important issues to one side and contented itself with "virtuosity in the small details of form, all larger questions being [mechanically, listlessly] decided by the precedent of the old masters" ("AK," pp. 34-35).

Clearly, says Greenberg, there has been a "decay of our present society"—the words are his—which corresponds in many ways to all these gloomy precedents. What is new is the course of art in this situation. No doubt bourgeois culture is in crisis, more and more unable since Marx "to justify the inevitability of its particular forms"; but it has spawned, half in opposition to itself, half at its service, a peculiar and durable artistic tradition—the one we call modernist and what Greenberg then called, using its own label, avant-garde. "It was to be the task of the avant-garde to perform in opposition to bourgeois society the function of finding new and adequate cultural forms for the expression of that same society, without at the same time succumbing to its ideological divisions and its refusal to permit the arts to be their own justification" ("NL," p. 301).

There are several stresses here worth distinguishing. First, the avantgarde is "part of Western bourgeois society" and yet in some important way estranged from it: needing, as Greenberg phrases it, the revolutionary gloss put on the very "concept of the 'bourgeois' in order to define what they were *not*" ("AK," p. 35) but at the same time performing the function of finding forms "for the expression" of bourgeois society and tied to it "by an umbilical cord of gold." Here is the crucial passage: "it is to the [ruling class] that the avant-garde belongs. No culture can develop without a social basis, without a source of stable income. [We might immediately protest at this point at what seems to be the text's outlandish economism: "social basis" is one thing, "source of income" another; the sentence seems to elide them. But let it pass for the moment.] In the case of the avant-garde this [social basis] was provided by an elite among the ruling class of that society from which it assumed itself to be cut off, but to which it has always remained attached by an umbilical cord of gold" ("AK," p. 38).

That is the first stress: the contradictory belonging-together-in-opposition of the avant-garde and its bourgeoisie; and the sense—the pressing and anxious sense—of that connection-in-difference being attenuated, being on the point of severance. For "culture is being abandoned by those to whom it actually belongs—our ruling class" ("AK," p. 38): the avantgarde, in its specialization and estrangement, *had always been* a sign of that abandonment, and now it seemed as if the breach was close to final.

Second, the avant-garde is a way to protect art from "ideological divisions." "Ideological confusion and violence" are the enemies of artistic force and concentration: art seeks a space of its own apart from them, apart from the endless uncertainty of meanings in capitalist society ("AK," p. 36). It is plain how this connects with my previous wondering about Greenberg on Brecht, and I shall not press the point here, except to say that there is a special and refutable move being made in the argument: to compare the conditions in which, in late capitalism, the meanings of the ruling class are actively disputed with those in which, in Hellenistic Egypt, say, established meanings stultified and became subject to skepticism-this is to compare the utterly unlike. It is to put side by side a time of economic and cultural dissolution-an epoch of weariness and unconcern-and one of articulated and fierce class struggle. Capital may be uncertain of its values, but it is not weary; the bourgeoisie may have no beliefs worth the name, but they will not admit as much: they are hypocrites, not skeptics. And the avant-garde, I shall argue, has regularly and rightly seen an advantage for art in the particular conditions of "ideological confusion and violence" under capital; it has wished to take part in the general, untidy work of negation and has seen no necessary contradiction (rather the contrary) between doing so and coming to terms once again with its "medium."

But I shall return to this later. It is enough for now to point to this second stress, and to the third: the idea that one chief purpose of the avantgarde was to oppose bourgeois society's "refusal to permit the arts to be their own justification." This is the stress which leads on to the more familiar—and trenchant—arguments of the essays in question, which I shall indicate even more briefly: the description of the ersatz art produced for mass consumption by the ruling classes of late capitalism as part of their

26 T. J. Clark

vile stage management of democracy, their pretending—it becomes perfunctory of late—"that the masses actually rule"; and the subtle account of the main strands in the avant-garde's history and the way they have all conspired to narrow and raise art "to the expression of an absolute" ("AK," p. 36). The pursuit has been purity, whatever the detours and self-deceptions. "The arts lie safe now, each within its 'legitimate' boundaries, and free trade has been replaced by autarchy. Purity in art consists in the acceptance . . . of the limitations of the medium. . . . The arts, then, have been hunted back [the wording is odd and pondered] to their mediums, and there they have been isolated, concentrated and defined" ("NL," p. 305). The logic is ineluctable, it "holds the artist in a vise," and time and again it overrides the most impure and ill-advised intentions:

A good many of the artists—if not the majority—who contributed importantly to the development of modern painting came to it with the desire to exploit the break with imitative realism for a more powerful expressiveness, but so inexorable was the logic of the development that in the end their work constituted but another step towards abstract art, and a further sterilization of the expressive factors. This has been true, whether the artist was van Gogh, Picasso or Klee. All roads lead to the same place. ["NL," pp. 309–10]

This is enough of summary. I do not want now, whatever the temptation, to pitch in with questions about specific cases. (Is that *true* of van Gogh? What is the balance in collage between medium and illusion? etc.) Greenberg's argument of course provokes such questions, as arguments should do, but I want to restrict myself, if I can, to describing its general logic, inexorable or not, choosing my examples for their bearing on the author's overall gist.

Let me go back to the start of "Avant-Garde and Kitsch." It seems to be an unstated assumption of that article—and an entirely reasonable one. I believe-that there once was a time, before the avant-garde, when the bourgeoisie, like any normal ruling class, possessed a culture and an art which were directly and recognizably its own. And indeed we know what is meant by the claim: we know what it means, whatever the provisos and equivocations, to call Chardin and Hogarth bourgeois painters or Samuel Richardson and Daniel Defoe novelists of the middle class. We can move forward a century and still be confident in calling Balzac and Stendhal likewise, or Constable and Géricault. Of course there are degrees of difference and dissociation always-Balzac's politics, Géricault's alienation, Chardin's royal clientele-but the bourgeoisie, we can say, in some strong sense possessed this art: the art enacted, clarified, and criticized the class' experiences, its appearance and values; it responded to its demands and assumptions. There was a distinctive bourgeois culture; this art is part of our evidence for just such an assertion.

But it is clear also that from the later nineteenth century on, the dis-

tinctiveness and coherence of that bourgeois identity began to fade. "Fade" is too weak and passive a word. I think. I should say that the bourgeoisie was obliged to dismantle its focused identity, as part of the price it paid for maintaining social control. As part of its struggle for power over other classes, subordinate and voiceless in the social order but not placated, it was forced to dissolve its claim to culture—and in particular forced to revoke the claim, which is palpable in Géricault or Stendhal, say, to take up and dominate and preserve the absolutes of aristocracy, the values of the class it displaced. "It's Athene whom we want," Greenberg blurts out in a footnote once, "formal culture with its infinity of aspects, its luxuriance, its large comprehension" ("AK," p. 49 n.5). Add to those qualities intransigence, intensity and risk in the life of the emotions, fierce regard for honour and desire for accurate self-consciousness, disdain for the commonplace, rage for order, insistence that the world cohere: these are, are they not, the qualities we tend to associate with art itself, at its highest moments in the Western tradition. But they are specifically feudal ruling-class superlatives: they are the ones the bourgeoisie believed they had inherited and the ones they chose to abandon because they became, in the class struggles after 1870, a cultural liability.

Hence what Greenberg calls kitsch. Kitsch is the sign of a bourgeoisie contriving to lose its identity, forfeiting the inconvenient absolutes of *Le Rouge et le noir* or *The Oath of the Horatii*. It is an art and a culture of instant assimilation, of abject reconciliation to the everyday, of avoidance of difficulty, pretence to indifference, equality before the image of capital.

Modernism is born in reaction to this state of affairs. And you will see, I hope, the peculiar difficulty here. There had once been, let me say again, a bourgeois identity and a classic nineteenth-century bourgeois culture. But as the bourgeoisie built itself the forms of mass society and thereby entrenched its power, it devised a massified pseudoart and pseudoculture and destroyed its own cultural forms-they had been, remember, a long time maturing, in the centuries of patient accommodation to and difference from aristocratic or absolutist rule. Now, Greenberg says, I think rightly, that some kind of connection exists between this bourgeoisie and the art of the avant-garde. The avant-garde is engaged in finding forms for the expression of bourgeois society: that is the phrase again from the "Newer Laocoon." But what could this mean, exactly, in the age of bourgeois decomposition so eloquently described in "Avant-Garde and Kitsch"? It seems that modernism is being proposed as bourgeois art in the absence of a bourgeoisie or, more accurately, as aristocratic art in the age when the bourgeoisie abandons its claims to aristocracy. And how will art keep aristocracy alive? By keeping *itself* alive, as the remaining vessel of the aristocratic account of experience and its modes; by preserving its own means, its media; by proclaiming those means and media as its values, as meanings in themselves.

28 T. J. Clark

This is, I think, the crux of the argument. It seems to me that Greenberg is aware of the paradox involved in his avant-garde preserving *bourgeoisie*, in its highest and severest forms, for a bourgeoisie which, in the sense so proposed, no longer existed. He points to the paradox, but he believes the solution to it has proved to be, in practice, the density and resistance of artistic values per se. They are the repository, as it were, of affect and intelligence that once inhered in a complex form of life but do so no longer; they are the concrete form of intensity and self-consciousness, the only one left, and therefore the form to be preserved at all costs and somehow kept apart from the surrounding desolation.

It is a serious and grim picture of culture under capitalism, and the measure of its bitterness and perplexity seems to me still justified. Eliotic Trotskyism, I called it previously; the cadencies shifting line by line from "Socialism or Barbarism" to "Shakespeare and the Stoicism of Seneca." (And was Greenberg a reader of Scrutiny, I wonder? It was widely read in New York at this time. I believe.)⁵ From his Eliotic stronghold he perceives. and surely with reason, that much of the great art of the previous century. including some which had declared itself avant-garde and anti-bourgeois. had depended on the patronage and mental appetites of a certain fraction of the middle class. It had in some sense *belonged* to a bourgeois intelligentsia-to a fraction of the class which was self-consciously "progressive" in its tastes and attitudes and often allied to the cause not just of artistic experiment but of social and political reform. And it is surely also true that in late capitalism this independent, critical, and progressive intelligentsia was put to death by its own class. For late capitalism—by which I mean the order emerging from the Great Depression—is a period of cultural uniformity: a leveling-down, a squeezing-out of previous bourgeois élites, a narrowing of distance between class and class and between fractions of the same class. In this case, the distance largely disappears between bourgeois intelligentsia and unintelligentsia: by our own time one might say it is normally impossible to distinguish one from the other.

(And lest this be taken as merely flippant, let me add that the kind of distance I have in mind—and distance here does not mean detachment but precisely an active, uncomfortable difference from the class one belongs to—is that between Walter Lippmann's salon, say, and the American middle class of its day; or that between the circle around Léon Gambetta and the general ambience of Ordre Moral. This last is especially to the purpose, since its consequences for culture were so vivid: one has only to remember the achievement of Antonin Proust in his brief tenure of the Direction des Beaux-Arts or Georges Clemenceau's patronage of and friendship with Claude Monet.)⁶

This description of culture is suitably grim, as I say, and finds its proper echoes in Eliot, Trotsky, F. R. Leavis, and Brecht. And yet—and here at last I modulate into criticism—there seem to me things badly wrong with its final view of art and artistic value. I shall offer three, or perhaps four, kinds of criticism of the view: first, I shall point to the difficulties involved in the very notion of art itself becoming an independent source of value: second, I shall disagree with one of the central elements in Greenberg's account of that value, his reading of "medium" in avant-garde art; and third. I shall try to recast his sketch of modernism's formal logic in order to include aspects of avant-garde practice which he overlooks or belittles but which I believe are bound up with those he sees as paramount. What I shall point to here—not to make a mystery of it—are practices of negation in modernist art which seem to me the very form of the practices of purity (the recognitions and enactments of medium) which Greenberg extols. Finally, I shall suggest some ways in which the previous three criticisms are connected, in particular, the relation between those practices of negation and the business of bourgeois artists making do without a bourgeoisie. I shall be brief, and the criticisms may seem schematic. But my hope is that because they are anyway simple objections to points in an argument where it appears palpably weak, they will, schematic or not, seem quite reasonable.

The first disagreement could be introduced by asking the following (Wittgensteinian) question: What would it be *like*, exactly, for art to possess its own values? Not just to have, in other words, a set of distinctive effects and procedures but to have them somehow be, or provide, the standards by which the effects and procedures are held to be of worth? I may as well say at once that there seem, on the face of it, some insuperable logical difficulties here, and they may well stand in the way of ever providing a coherent reply to the Wittgensteinian question. But I much prefer to give—or to sketch—a kind of *historical* answer to the question, in which the point of asking it in the first place might be made more clear.

Let us concede that Greenberg may be roughly right when he says in "Avant-Garde and Kitsch" that "a fairly constant distinction" has been made by "the cultivated of mankind over the ages" "between those values only to be found in art and the values which can be found elsewhere" ("AK," p. 42). But let us ask how that distinction was actually made-made and maintained, as an active opposition-in practice, in the first heyday of the art called avant-garde. For the sake of vividness, we might choose the case of the young speculator Dupuy, whom Camille Pissarro described in 1890 as "mon meilleur amateur" and who killed himself the same year. to Pissarro's chagrin, because he believed he was faced with bankruptcy. One's picture of such a patron is necessarily speculative in its turn, but what I want to suggest is nothing very debatable. It seems clear from the evidence that Dupuy was someone capable of savouring the separateness of art, its irreducible difficulties and appeal. That was what presumably won him Pissarro's respect and led him to buy the most problematic art of his day. (This at a time, remember, when Pissarro's regular patrons, and dealers, had quietly sloped off in search of something less odd.) But I would suggest

30 T. J. Clark

that he also saw—and in some sense insisted on—a kind of consonance between the experience and value that art had to offer and those that belonged to his everyday life. The consonance did not need to be direct and, indeed, could not be. Dupuy was not in the market for animated pictures of the Stock Exchange—the kind he could have got from Jean Béraud—or even for scenes à la Degas in which he might have been offered back, dramatically, the shifts and upsets of life in the big city. He purchased landscapes instead and seems to have had a taste for those painted in the neo-impressionist manner—painted, that is, in a way which tried to be tight, discreet, and uniform, done with a disabused orderliness, seemingly scientific, certainly analytic. And all of these qualities, we might guess, he savoured and required as the signs of art's detachment.

Yet surely we must also say that his openness to such qualities, his ability to understand them, was founded in a sense he had of some play between those qualities occurring in art and the same occurring in life occurring in his life, not on the face of it a happy one but one at the cutting edge of capitalism still. And when we remember what capitalism *was* in 1890, we are surely better able to understand why Dupuy invested in Georges Seurat. For this was a capital still confident in its powers, if shaken; and not merely confident, but scrupulous: still in active dialogue with science; still producing distinctive rhetorics and modes of appraising experience; still conscious of its own values—the tests of rationality, the power born of observation and control; still, if you wish, believing in the commodity as a (perplexing) form of freedom.

You see my point, I hope. I believe it was the interplay of these values and the values of art which made the distinction between them an active and possible one—made it a distinction at all, as opposed to a rigid and absolute disjunction. In the case of Dupuy, there was difference-yet-consonance between the values which made for the bourgeois' sense of himself in practical life and those he required from avant-garde painting. The facts of art and the facts of capital were in active tension. They were still negotiating with each other; they could still, at moments, in particular cases like Dupuy's, contrive to put each other's categories in doubt.

This, it seems to me, is what is meant by "a fairly constant distinction [being] made between those values only to be found in art and the values which can be found elsewhere." It is a negotiated distinction, with the critic of Diderot's or Baudelaire's or Félix Fénéon's type the active agent of the settlement. For critics like these, and in the art they typically address, it is true that the values a painting offers are discovered, time and again and with vehemence, as different and irreducible. And we understand the point of Fénéon's insistence; but we are the more impressed by it precisely because the values are found to be different as part of a real cultural dialectic, by which I mean that they are visibly under pressure, in the text, from the demands and valuations made by the ruling class in the business of ruling—the meanings it makes and disseminates, the kinds of order it proposes as its own. It is this pressure—and the way it is enacted in the patronage relation or in the artist's imagining of his or her public—which keeps the values of art from becoming a merely academic canon.

I hope it is clear how this account of artistic standards—and particularly of the ways in which art's separateness as a social practice is secured—would call into question Greenberg's hope that art could become a provider of value in its own right. Yet I think I can call that belief in question more effectively simply by looking at one or another of the facts of art which Greenberg takes to have become a value, in some sense: let me look, for simplicity's sake, at the notorious fact of "flatness." Now it is certainly true that the literal flatness of the picture surface was recovered at regular intervals as a striking fact by painters after Courbet. But I think that the question we should ask in this case is *why* that simple, empirical presence went on being interesting for art. How could a fact of effect or procedure stand in for value in this way? What was it that made it vivid?

The answer is not far to seek. I think we can say that the fact of flatness was vivid and tractable-as it was in the art of Cézanne, for example, or that of Matisse-because it was made to stand for something: some particular and resistant set of qualities, taking its place in an articulated account of experience. The richness of the avant-garde, as a set of contexts for art in the years between 1860 and 1918, say, might thus be redescribed in terms of its ability to give flatness such complex and compatible values-values which necessarily derived from elsewhere than art. It could stand, that flatness, as an analogue of the "popular"-something therefore conceived as plain, workmanlike, and emphatic. Or it could signify "modernity," with flatness meant to conjure up the mere two dimensions of posters, labels, fashion prints, and photographs. Equally, unbrokenness of surface could be seen-by Cézanne, for example-as standing for the truth of seeing, the actual form of our knowledge of things. And that very claim was repeatedly felt, by artist and audience, to be some kind of aggression on the latter: flatness appeared as a barrier to the ordinary bourgeois' wish to enter a picture and dream, to have it be a space apart from life in which the mind would be free to make its own connections.

My point is simply that flatness in its heyday *was* these various meanings and valuations; they were its substance, so to speak; they were what it was seen *as*. Their particularity was what made it vivid—made it a matter to be painted over again. Flatness was therefore in play—as an irreducible, technical "fact" of painting—with all of these totalizations, all of these attempts to make it a metaphor. Of course in a sense it resisted the metaphors, and the painters we most admire insisted also on it as an awkward, empirical quiddity; but the "also" is the key word here: there was no fact without the metaphor, no medium without its being the vehicle of a complex act of meaning.

32 T. J. Clark

This leads me directly to my third criticism of Greenberg's account. It could be broached most forcefully, I think, by asking the question, How does the medium most often *appear* in modernist art? If we accept (as we ought to, I feel) that avant-garde painting, poetry, and music are characterized by an insistence on medium, then what kind of insistence has it been, usually? My answer would be—it is hardly an original one—that the medium has appeared most characteristically as the site of negation and estrangement.

The very way that modernist art has insisted on its medium has been by negating that medium's ordinary consistency—by pulling it apart, emptying it, producing gaps and silences, making it stand as the opposite of sense or continuity, having matter be the synonym for resistance. (And why, after all, should matter be "resistant"? It is a modernist piety with a fairly dim ontology appended.) Modernism would have its medium be *absence* of some sort—absence of finish or coherence, indeterminacy, a ground which is called on to swallow up distinctions.

These are familiar avant-garde strategies; and I am not for a moment suggesting that Greenberg does not recognize their part in the art he admires. Yet he is notoriously uneasy with them and prepared to declare them extrinsic to the real business of art in our time-the business of each art "determin[ing], through the operations peculiar to itself, the effects peculiar and exclusive to itself."⁷ It is Greenberg's disdain for the rhetoric of negation which underlies, one supposes, the ruefulness of his description of Jackson Pollock as, after all, a "Gothic" whose art harked back to Faulkner and Melville in its "violence, exasperation and stridency."⁸ It is certainly the same disdain which determines his verdict on Dada, which is only important, he feels, as a complaisant topic for journalism about the modern crisis (or the shock of the new). And one does know what he means by the charge; one does feel the fire of his sarcasm, in 1947, when, in the middle of dealing well with Pollock's unlikely achievement, he writes: "In the face of current events, painting feels, apparently, that it must be more than itself: that it must be epic poetry, it must be theatre, it must be an atomic bomb, it must be the rights of Man. But the greatest painter of our time, Matisse, preeminently demonstrated the sincerity and penetration that go with the kind of greatness particular to twentieth-century painting by saying that he wanted his art to be an armchair for the tired business man."9

It is splendid, it is salutary, it is congenial. Yet surely in the end it will not quite do as description. Surely it is part of modernism's problem even Matisse's—that the tired businessman be so weary and vacant and so little interested in art as his armchair. It is this situation—this lack of an adequate ruling class to address—which goes largely to explain modernism's negative cast. I think that finally my differences with Greenberg centre on this one. I do not believe that the practices of negation which Greenberg seeks to declare mere *noise* on the modernist message can be thus demoted. They are simply inseparable from the work of self-definition which he takes to be central: inseparable in the case of Pollock, for certain, or Miro or Picasso or, for that matter, Matisse. Modernism is certainly that art which insists on its medium and says that meaning can henceforth only be found in *practice*. But the practice in question is extraordinary and desperate: it presents itself as a work of interminable and absolute decomposition, a work which is always pushing "medium" to its limits—to its ending—to the point where it breaks or evaporates or turns back into mere unworked material. That is the form in which medium is retrieved or reinvented: the fact of Art, in modernism, *is* the fact of negation.

I believe that this description imposes itself: that it is the only one which can include Mallarmé alongside Rimbaud, Schoenberg alongside Webern, or (dare I say it?) Duchamp beside the Monet of the *Nymphéas*. And surely that dance of negation has to do with the social facts I have spent most of my time rehearsing—the decline of ruling-class élites, the absence of a "social base" for artistic production, the paradox involved in making bourgeois art in the absence of a bourgeoisie. Negation is the sign inside art of this wider decomposition: it is an attempt to *capture* the lack of consistent and repeatable meanings in the culture—to capture the lack and make it over into form.

I should make the extent of this, my last disagreement with Greenberg, clear. The extent is small but definite. It is not, of course, that Greenberg fails to recognize the rootlessness and isolation of the avant-garde; his writing is full of the recognition, and he knows as well as anyone the miseries inherent in such a loss of place. But he does believe-the vehemence of the belief is what is most impressive in his writing-that art can substitute *itself* for the values capitalism has made valueless. A refusal to share that belief-and that is finally what I am urging-would have its basis in the following three observations. First, to repeat, negation is inscribed in the very practice of modernism, as the form in which art appears to itself as a value. Second, that negativity does not appear as a practice which guarantees meaning or opens out a space for free play and fantasy-in the manner of the joke, for example, or even of irony-but, rather, negation appears as an absolute and all-encompassing fact, something which once begun is cumulative and uncontrollable; a fact which swallows meaning altogether. The road leads back and back to the black square, the hardly differentiated field of sound, the infinitely flimsy skein of spectral colour, speech stuttering and petering out into etceteras or excuses. ("I am obliged to believe that these are statements having to do with a world, . . . but you, the reader, need not. . . . And I and You, oh

34 T. J. Clark

well.... The poem offers a way out of itself, hereabouts.... But do not take it, wholly.... "And so on.) On the other side of negation is always emptiness: that is a message which modernism never tires of repeating and a territory into which it regularly strays. We have an art in which ambiguity becomes infinite, which is on the verge of proposing—and does propose—an Other which is comfortably ineffable, a vacuity, a vagueness, a mere mysticism of sight.¹⁰

There is a way—and this again is something which happens within modernism or at its limits-in which that empty negation is in turn negated. And that brings me back finally to the most basic of Greenberg's assumptions; it brings me back to the essays on Brecht. For there is an art—a modernist art—which has challenged the notion that art stands only to suffer from the fact that now all meanings are disputable. There is an art-Brecht's is only the most doctrinaire example-which says that we live not simply in a period of cultural decline, when meanings have become muddy and stale, but rather in a period when one set of meanings-those of the cultivated classes-is fitfully contested by those who stand to gain from their collapse. There is a difference, in other words, between Alexandrianism and class struggle. The twentieth century has elements of both situations about it, and that is why Greenberg's description, based on the Alexandrian analogy, applies as well as it does. But the end of the bourgeoisie is not, or will not be, like the end of Ptolemy's patriciate. And the end of its art will be likewise unprecedented. It will involve, and has involved, the kinds of inward turning that Greenberg has described so compellingly. But it will also involve-and has involved, as part of the practice of modernism-a search for another place in the social order. Art wants to address someone, it wants something precise and extended to do: it wants resistance, it needs criteria; it will take risks in order to find them, including the risk of its own dissolution.¹¹ Greenberg is surely entitled to judge that risk too great and, even more, to be impatient with the pretense of risk so dear to one fringe of modernist art and its patrons-all that stuff about blurring the boundaries between art and life and the patter about art being "revolutionary." Entitled he is; but not in my opinion right. The risk is large and the patter odious; but the alternative, I believe, is on the whole worse. It is what we have, as the present form of modernism: an art whose object is nothing but itself, which never tires of discovering that that self is pure as only pure negativity can be, and which offers its audience that nothing, tirelessly and, I concede, adequately made over into form. A verdict on such an art is not a matter of taste-for who could fail to admire, very often, its refinement and ingenuity-but involves a judgment, still, of cultural possibility. Thus while it seems to me right to expect little from the life and art of late capitalism, I still draw back from believing that the best one can hope for from art, even in extremis, is its own singular and perfect disembodiment.

Notes

- See Clement Greenberg, "Avant-Garde and Kitsch," Partisan Review 6 (Fall 1939), pp. 34–49, and "Towards a Newer Laocoon," Partisan Review 7 (July-August 1940), pp. 296–310; all further references to these essays, abbreviated "AK" and "NL" respectively, will be included in the text.
- This carelessness distinguishes the present paper from two recent studies of Greenberg's 2. early writings, Serge Guilbaut's "The New Adventures of the Avant-Garde in America," October 15 (Winter 1980), and Fred Orton and Griselda Pollock's "Avant-Gardes and Partisans Reviewed," Art History 3 (September 1981). I am indebted to both these essays and am sure that their strictures on the superficiality-not to say the opportunism-of Greenberg's Marxism are largely right. (Certainly Mr. Greenberg would not now disagree with them.) But I am nonetheless interested in the challenge offered to most Marxist, and non-Marxist, accounts of modern history by what I take to be a justified, though extreme, pessimism as to the nature of established culture since 1870. That pessimism is characteristic, I suppose, of what Marxists call an ultraleftist point of view. I believe, as I say, that a version of some such view is correct and would therefore wish to treat Greenberg's theory as if it were a decently elaborated Marxism of an ultraleftist kind, one which issues in certain mistaken views (which I criticize) but which need not so issue and which might still provide, cleansed of those errors, a good vantage for a history of our culture.
- Greenberg, "An Interview with Ignazio Silone," Partisan Review 6 (Fall 1939), pp. 23, 25, 27.
- 4. See Greenberg, "Bertolt Brecht's Poetry" (1941), Art and Culture (Boston, 1961).
- 5. Mr. Greenberg informs me the answer here is yes and points out that he even once had an exchange with F. R. Leavis, in *Commentary*, on Kafka—one which, he says, "I did not come out of too well!" ("How Good Is Kafka?," *Commentary* 19 (June 1955).
- I think this state of affairs lies at the root of those ills of present-day Marxist criti-6. cism to which Edward Said refers in "Opponents, Audiences, Constituencies, and Community." In the years around 1910, for example, it was possible for Marxist intellectuals to identify a worthwhile enemy within the ranks of the academy—there was a group of progressive bourgeois intellectuals whose thought and action had some real effect in the polity. That state of things was fortunate in two regards. It enabled middle-class Marxist intellectuals to attain to some kind of lucidity about the limits of their own enterprise-to see themselves as bourgeois, lacking roots in the main earth of class struggle. It meant they did not spend much of their time indulging in what I regard as the mainly futile breast-beating represented so characteristically by Terry Eagleton's bathetic question, which Said quotes: "'How is a Marxist-structuralist analysis of a minor novel of Balzac to help shake the foundations of capitalism?" (p. 21). Those earlier Marxists did not need this rhetoric, this gasping after class positions which they did not occupy, because there was an actual job for them to do, one with a measure of importance, after all-the business of opposing the ideologies of a bourgeois élite and of pointing to the falsity of the seeming contest between that élite and the ordinary, power-wielding mass of the class. (I am thinking here, e.g., of the simple, historical ground to Georg Lukács' battle with positivism in science, Kantianism in ethics, and Weberianism in politics. It was the evident link between that circuit of ideas and an actual, cunning practice of social reform that gave Lukács' essays their intensity and also their sense of not having to apologize for intellectual work.) I believe it is the absence of any such bourgeois intelligentsia, goading and supplying the class it belongs to-the absence, in other words, of a bourgeoisie worth attacking in the realm of cultural production-that lies behind the quandary of Eagleton et al. And let me be clear: the quandary seems to me at least worth being in, which is more than I can say for

most other academic dilemmas. I just now applied the adjective "bathetic" to Eagleton's question, and perhaps it will have seemed a dismissive choice of word. But bathos implies an attempt at elevation and a descent from it; and of the general run of contemporary criticism—the warring solipsisms and scientisms, the exercises in spot-the-discourse or discard-the-referent—I think one can fairly say that it runs no such risk. Its tone is ludicrously secure.

- 7. Greenberg, "Modernist Painting," Art and Literature 4 (Spring 1963), p. 194.
- Greenberg, "The Present Prospects of American Painting and Sculpture," Horizon 16 (October 1947), p. 26.
- 9. Greenberg, "Art," Nation 8 (March 1947), p. 284.
- 10. The editor of *Critical Inquiry* suggested that I say a little more about the negative cast I ascribe to modernism and give an example or two. Too many examples crowd to mind, and I ought to avoid the more glamorous, since what I am referring to is an *aspect* or *moment* of modernist art, most often mixed up with other purposes or techniques, though often, I would argue, dominating them. Nevertheless a phrase from Leavis' *New Bearings* occurs, in which the critic describes T. S. Eliot's "effort to express formlessness itself as form," and the lines (among others) which that phrase applies to: "Shape without form, shade without colour,/Paralysed force, gesture without motion." Yet we would do best to descend from these obvious heights and, if glamour is what is wanted, contemplate Ad Reinhardt's description of his own black painting in 1962:

A square (neutral, shapeless) canvas, five feet wide, five feet high, as high as a man, as wide as a man's outstretched arms (not large, not small, sizeless), trisected (no composition), one horizontal form negating one vertical form (formless, no top, no bottom, directionless), three (more or less) dark (lightless) non-contrasting (colorless) colors, brushwork brushed out to remove brushwork, a matt, flat, free-hand painted surface (glossless, textureless, non-linear, no hard-edge, no soft-edge) which does not reflect its surroundings—a pure, abstract, non-objective, timeless, space-less, changeless, relationless, disinterested painting—an object that is self-conscious (no unconsciousness), ideal transcendent, aware of no thing but art (absolutely no anti-art). [Art, USA, Now (New York, 1963), p. 269.]

This pretends to be ironical, of course, and the art it gives rise to is negligible now, I dare say, even by received modernist standards; but the passage only puts into words a kind of attitude and practice which is by no means eccentric since Baudelaire and which has often issued in art of peculiar forcefulness and gravity.

11. This is not to smuggle in a demand for realism again by the back door; or at least, not one posed in the traditional manner. The weakness or absence I have pointed to in modern art does not derive, I think, from a lack of grounding in "seeing" (for example) or a set of realist protocols to go with that; rather, it derives from its lack of grounding in some (any) specific practice of representation, which would be linked in turn to other social practices—embedded in them, constrained by them. The question is not, therefore, whether modern art should be figurative or abstract, rooted in empirical commitments or not so rooted, but whether art is now provided with sufficient constraints of any kind-notions of appropriateness, tests of vividness, demands which bring with them measures of importance or priority. Without constraints, representation of any articulateness and salience cannot take place. (One might ask if the constraints which modernism declares to be its own and sufficient-those of the medium or of an individual's emotions and sense of inner truth—are binding or indeed coherent; or, to be harsh, if the areas of practice which it points to as the sites of such constraint-medium, emotion, even "language" [sacred cow]-are existents at all, in the way that is claimed for them.)

How Modernism Works A Response to T. J. Clark

MICHAEL FRIED

In the remarks that follow, I challenge the interpretation of modernism put forward in T. J. Clark's provocative essay, "Clement Greenberg's Theory of Art." As will become clear, my aim in doing so is not to defend Greenberg against Clark's strictures. On the contrary, although my own writings on recent abstract art are deeply indebted to the example of Greenberg's practical criticism (I consider him the foremost critic of new painting and sculpture of our time), I shall suggest that Clark's reading of modernism shares certain erroneous assumptions with Greenberg's, on which indeed it depends. I shall then go on to rehearse an alternative conception of the modernist enterprise that I believe makes better sense of the phenomena in question than does either of theirs, and, in an attempt to clinch my case, I shall conclude by looking briefly at an interesting phase in the work of the contemporary English sculptor Anthony Caro, whose achievement since 1960 I take to be canonical for modernism generally.

1

At the center of Clark's essay is the claim that the practices of modernism in the arts are fundamentally practices of negation. This claim is false.

Not that there is nothing at all to the view he espouses. In the first place, there is a (Gramscian?) sense in which a given cultural expression may be thought of as occupying a social space that might otherwise be occupied by another and, therefore, as bearing a relation to that other that

This essay was originally published in *Critical Inquiry* 9 (September 1982). Copyright © 1982 by The University of Chicago Press. All rights reserved. Reprinted with permission of the author and publisher.

might loosely be characterized as one of negation. Furthermore, particular modernist developments in the arts have often involved a negative "moment" in which certain formal and expressive possibilities were implicitly or indeed explicitly repudiated in favor of certain others, as when, for example, Edouard Manet in the early 1860s rejected both dramatic miseen-scène and traditional sculptural modelling as vehicles of pictorial coherence, or as when Caro almost a century later came to feel the inadequacy to a dawning vision of sculptural possibility of the techniques of modelling and casting in which he had been trained.¹

It is also true that entire episodes in the history of modern art—Dada, for example, or the career of Marcel Duchamp—can be construed as largely negative in motivation, and it is part of Clark's critique that Greenberg gives those episodes short shrift, treating them, Clark says, as mere noise on the surface of the modernist message. But Clark goes far beyond these observations to insist that "negation is inscribed in the very practice of modernism, as the form in which art appears to itself as a value," or, as he more baldly puts it, "the fact of Art, in modernism, *is* the fact of negation" (p. 218). And these claims, to the extent that I find them intelligible, seem to me mistaken.

Now it is a curious feature of Clark's essay that he provides no specific examples for his central argument. Instead, he merely cites the names Mallarmé, Rimbaud, Schoenberg, Webern, Duchamp, and Monet (of the *Nymphéas*), and in footnote 10, added, we are told, at the request of the editor, he quotes (irrelevantly in my view) a phrase of F. R. Leavis' on two lines by T. S. Eliot, along with a description by Ad Reinhardt—a distinctly minor figure who cannot be taken as representative of modernism—of his own black paintings. (The latter are evidently the "black square" to which, Clark asserts, "the road leads back and back"—except it doesn't [p. 218].)

How are we to understand this refusal to discuss specific cases? In an obvious sense, it makes Clark's position difficult to rebut: one is continually tempted to imagine what he would say about particular works of art—Manet's Déjeuner sur l'herbe, or Cézanne's Gulf of Marseilles Seen from L'Estaque, or Matisse's Blue Nude, or Picasso's Ma Jolie, or Jackson Pollock's Lavender Mist, or David Smith's Zig IV, or Caro's Prairie-and then to argue against those invented descriptions. I found myself doing this again and again in preliminary drafts of this response until I realized that it was pointless. For the burden of proof is Clark's, the obligation is his, to establish by analyzing one or more indisputably major works of modernist art (I offer him the short list I have just assembled) that negation functions in those works as the radical and all-devouring principle he claims it is. And here it is worth stipulating that it will not be enough to say of Manet's Déjeuner (I'm anticipating Clark again) that it represents a situation or an action that is psychologically and narratively unintelligible; not enough because it would still be possible to argue, as I would wish to

argue, that unintelligibility in Manet, far from being a value in its own right as mere negation of meaning, is in the service of aims and aspirations that have in view a new and profound and, for want of a better word, positive conception of the enterprise of painting.² I would make the same sort of argument about the violation of ordinary spatial logic in Cézanne, or the distorted drawing and bizarre color in Matisse, or the near dissolution of sculptural form in Picasso, or the embracing of abstraction and the exploration of new means of picture-making in Pollock, or the use of industrial materials and techniques in Smith and Caro. In all these instances of "mainstream" modernism-a notion Clark is bound to reject as reinstituting the very distinction he wishes to collapse-there is at most a negative "moment," the significance of which can only be understood (and the form of that understanding can only be historical, which is to say, provisional or at any rate not final) in terms of a relation to a more encompassing and fundamental set of positive values, conventions, sources of conviction.³ If Clark disagrees with this, and I'm sure he does, let him accept the challenge and offer examples that prove his point. Otherwise his sweeping generalizations lack all force.

2

Clark's essay stages itself as a critique of Greenberg's theory of modernism; yet the gist of Clark's argument, his equation of modernism with negation, involves a largely uncritical acceptance of Greenberg's account of how modernism works.

The story Greenberg tells is this.⁴ Starting around the middle of the nineteenth century, the major arts, threatened for the first time with being assimilated to mere entertainment, discovered that they could save themselves from that depressing fate "only by demonstrating that the kind of experience they provided was valuable in its own right and not to be obtained from any other kind of activity." (The crucial figure in painting is Manet, whose decisive canvases belong to the early 1860s.)

Each art, it turned out, had to effect this demonstration on its own account. What had to be exhibited and made explicit was that which was unique and irreducible not only in art in general but also in each particular art. Each art had to determine, through the operations peculiar to itself, the effects peculiar and exclusive to itself. By doing this, each art would, to be sure, narrow its area of competence, but at the same time it would make its possession of this area all the more secure.

It quickly emerged that the unique and proper area of competence of each art coincided with all that was unique to the nature of its medium. The task of self-criticism became to eliminate from the effects of each art any and every effect that might conceivably be borrowed from or by the medium of

40 Michael Fried

every other art. Thereby each art would be rendered "pure," and in its "purity" find the guarantee of its standards of quality as well as of its independence. "Purity" meant self-definition, and the enterprise of self-criticism in the arts became one of self-definition with a vengeance.⁵

As described by Greenberg, the enterprise in question involved testing a wide range of norms and conventions in order to determine which were inessential, and therefore to be discarded, and which on the contrary constituted the timeless and unchanging essence of the art of painting. (Greenberg doesn't use either of the last two adjectives, but both are implicit in his argument.) By the early 1960s, the results of this century-long project, Greenberg's famous modernist "reduction," appeared to be in:

It has been established by now, it would seem, that the irreducibility of pictorial art consists in but two constitutive conventions or norms: flatness and the delimitation of flatness. In other words, the observance of merely these two norms is enough to create an object which can be experienced as a picture: thus a stretched or tacked-up canvas already exists as a picture—though not necessarily as a *successful* one.⁶

Greenberg may have been somewhat uneasy with this conclusion; at any rate, he goes on to state that Barnett Newman, Mark Rothko, and Clyfford Still, three of the most advanced painters of the postwar period, "have swung the self-criticism of Modernist painting in a new direction by dint simply of continuing it in its old one. The question now asked in their art is no longer what constitutes art, or the art of painting, as such, but what constitutes *good* art as such. What is the ultimate source of value or quality in art?" (The answer he gives, or finds their art to give, is "conception.")⁷ But here, too, the governing notion is one of reduction to an essence, to an absolute and unchanging core that in effect has been there all along and which the evolution of modernist painting has progressively laid bare.

I don't say that Clark swallows Greenberg whole. In particular he refuses to accept the proposition that with the advent of modernism art becomes or is revealed to be "a provider of value in its own right" (p. 215), arguing instead that modernist art has always reflected the values of modern society (more on this presently). But I do suggest that Clark's insistence that modernism proceeds by ever more extreme and dire acts of negation is simply another version of the idea that it has evolved by a process of radical reduction—by casting off, negating, one norm or convention after another in search of the bare minimum that can suffice. Indeed I believe that it is because Clark accepts Greenberg's reductionist and essentialist conception of the modernist enterprise that he is led to characterize the medium in modernism as "the site of negation and estrangement"—as pushed continually "to the point where it breaks or evaporates or turns back into mere unworked material"—and to assert that in modernism "negation appears as an absolute and all-encompassing fact, something which once begun is cumulative and uncontrollable" (pp. 216, 217–18, 218). From this perspective, Clark's attitude toward the developments to which he alludes is less important than the assumptions underlying his interpretation of those developments. His attitude, of course, is the reverse of Greenberg's, but his assumptions derive directly from Greenberg's schema.

3

As long ago as 1966–67 I took issue with what I called a reductionist conception of modernism. In an essay on a group of paintings by Frank Stella, I wrote:

I take a reductionist conception of modernist painting to mean this: that painting roughly since Manet is seen as a kind of cognitive enterprise in which a certain quality (e.g., literalness), set of norms (e.g., flatness and the delimiting of flatness), or core of problems (e.g., how to acknowledge the literal character of the support) is progressively revealed as constituting the *essence* of painting—and, by implication, as having done so all along. This seems to me gravely mistaken, not on the grounds that modernist painting is *not* a cognitive enterprise, but because it radically misconstrues the *kind* of cognitive enterprise modernist painting is. What the modernist painter can be said to discover in his work—what can be said to be revealed to him in it—is not the irreducible essence of *all* painting, but rather that which, at the present moment in painting's history, is capable of convincing him that it can stand comparison with the painting of both the modernist and the pre-modernist past whose quality seems to him beyond question.⁸

And in another essay written later that year I quoted Greenberg's remarks about a tacked-up canvas already existing as a picture though not necessarily as a successful one and commented:

It is not quite enough to say that a bare canvas tacked to a wall is not "necessarily" a successful picture; it would, I think, be more accurate to say that it is not *conceivably* one. It may be countered that future circumstances might be such as to *make* it a successful painting; but I would argue that, for that to happen, the enterprise of painting would have to change so drastically that nothing more than the name would remain. . . . Moreover, seeing something as a painting in the sense that one sees the tacked-up canvas as a painting, and being convinced that a particular work can stand comparison with the painting of the past whose quality is not in doubt, are altogether different experiences: it is, I want to say, as though unless something compels conviction as to its quality it is no more than trivially or nominally a painting. . . . This is not to say that painting *has no* essence; it *is* to claim that

42 Michael Fried

essence—i.e., that which compels conviction—is largely determined by, and therefore changes continually in response to, the vital work of the recent past. *The essence of painting is not something irreducible*. Rather, the task of the modernist painter is to discover those conventions which, at a given moment, alone are capable of establishing his work's identity as painting.⁹

My aim in quoting these passages is not to spare myself the trouble of formulating afresh the thoughts they express but rather to show that a sharply critical but emphatically pro-modernist reading of Greenberg's reductionism and essentialism has been available for some considerable time. And my aim in showing *this* is not to suggest that Clark ought to have felt obliged to come to grips with or at least to acknowledge that reading (though I tend to think he should have) so much as to underscore his dependence on Greenberg's theory of modernism, even perhaps his solidarity with Greenberg in the face of certain criticisms of the latter's ideas. In any case, I hope it is evident that the conception of modernism adumbrated in the passages just quoted is consistent with the arguments I have already mounted against Clark's essay. The following observations will help spell this out.

1. The less inclined we are to accept the view that modernism proceeds by discarding inessential conventions in pursuit of a timeless constitutive core, the more improbable we are bound to find the claim that negation in modernism is "cumulative and uncontrollable," that (to quote Clark in full) "the road leads back and back to the black square, the hardly differentiated field of sound, the infinitely flimsy skein of spectral colour, speech stuttering and petering out into etceteras and excuses" (p. 218). There is no road, if by that one means a track laid down in advance and ending in a predetermined destination, which is to say that there are no theoretical grounds for believing (or inclining to believe) that the evolution of modernist painting or sculpture or any other art will be from greater to lesser complexity, from differentiation to nondifferentiation, from articulateness to inarticulateness, and so on. (Nor are there theoretical grounds for believing the reverse.) Of course, it may simply be the case that some such evolution has occurred, but that is precisely what I dispute. Try understanding the history of Impressionism in those terms, or the art of Picasso and Braque between 1906 and 1914, or the emergence in the past seventy years of a tradition of constructed sculpture culminating in Smith and Caro, or the sequence of recent modernist painters Pollock-Helen Frankenthaler-Morris Louis-Kenneth Noland-Jules Olitski-Larry Poons (more challenges to Clark). My point here, however, is not that Clark's account of modernism belies the facts so much as that it is captive to an idea of how modernism works that all but screens the facts from view.

2. To the extent that we acknowledge the need for a putative work

of modernist art to sustain comparison with previous work whose quality or level, for the moment anyway, is not in doubt, we repudiate the notion that what at bottom is at stake in modernism is a project of negation. For it is plainly not the case that the art of the old masters-the ultimate term of comparison—can usefully be seen as negative in essence: and implicit in my account is the claim that the deepest impulse or master convention of what I earlier called "mainstream" modernism has never been to overthrow or supersede or otherwise break with the pre-modernist past but rather to attempt to equal its highest achievements. under new and difficult conditions that from the first were recognized by a few writers and artists as stacking the deck against the likelihood of success.¹⁰ (For Baudelaire in 1846, those conditions included the disappearance of the great schools of painting that in the past had sustained relatively minor talents and, more broadly, the advent of an extreme form of individualism that in effect threw the modern artist solely on his personal resources and thereby ensured that only the most gifted and impassioned natures could hope to create lasting art.)¹¹ Here too, of course, someone might wish to argue that the various measures and strategies by which the modernist arts have sought to measure up to the great works of the past have been cumulatively and overwhelmingly negative in import. But this would require serious discussion of specific works, careers, movements, and so on, and once again I would bet heavily against the persuasiveness of the result.

3. The interpretation of modernism that I have been propounding implies a view of the relation of the artistic enterprise to the wider culture in which it is situated that differs from both Greenberg's and Clark's. According to Greenberg, modernism gets started at least partly in response to sociopolitical developments, but once under way its evolution is autonomous and in the long run even predetermined.¹² According to Clark, on the other hand, artistic modernism must be understood as something like a reflection of the incoherence and contradictoriness of modern capitalist society. In his words, "Negation is the sign inside art of this wider decomposition: it is an attempt to *capture* the lack of consistent and repeatable meanings in the culture—to capture the lack and make it over into form" (p. 218).

Now it may seem that my own views on this topic are closer to Greenberg's than to Clark's, and in a sense they are. I find Clark's thumbnail analysis of the sociopolitical content of modernism both crude and demeaning, quite apart from the absurdity of the idea that this culture or any culture can be said to lack "consistent and repeatable meanings." What on earth can he be thinking of? Furthermore, the modernist artist—say, the modernist painter—is represented in my account as primarily responsible to an exalted conception or at any rate to an exacting practice of the enterprise of painting. And this, in addition to perhaps striking some readers as elitist and inhumane (their problem, not mine),¹³ may appear to commit me to a view of art and society as mutually exclusive, forever sealed off from one another without possibility of interpenetration or even communication. But this would be wrong: in the first place because my argument expressly denies the existence of a distinct *realm* of the pictorial—of a body of suprahistorical, non-context-specific, in that sense "formalist," concerns that define the proper aims and limits of the art of paintingmaintaining on the contrary that modernist painting, in its constantly renewed effort to discover what it must be, is forever driven "outside" itself. compelled to place in jcopardy its very identity by engaging with what it is not. (The task of understanding modernism politically is itself misunderstood if it is thought of as constructing a bridge over an abyss.)¹⁴ And in the second place because my emphasis on the utterly crucial role played in modernism by conviction or its absence invites inquiry into what might be called the politics of conviction, that is to say, the countless ways in which a person's deepest beliefs about art and even about the quality of specific works of art have been influenced, sometimes to the point of having been decisively shaped, by institutional factors that, traced to their limits, merge imperceptibly with the culture at large. In a particular instance this may result in the undermining of certain beliefs and their replacement by others (a state of no belief is impossible). But it doesn't follow merely from the recognition of influence, even powerful influence, that the original beliefs are not to be trusted. A host of institutional factors must have collaborated long ago to incline me to take Manet seriously; but I can no more imagine giving up my conviction about the greatness of his art than I can imagine losing interest in painting altogether. (Both events could happen and perhaps will, but if they do I will scarcely be the same person. Some convictions are part of one's identity.)

4. To repeat: my insistence that the modernist painter seeks to discover not the irreducible essence of all painting but rather those conventions which, at a particular moment in the history of the art, are capable of establishing his work's nontrivial identity as painting leaves wide open (in principle though not in actuality) the question of what, should he prove successful, those conventions will turn out to be. The most that follows from my account, and I agree that it is by no means negligible, is that those conventions will bear a perspicuous relation to conventions operative in the most significant work of the recent past, though here it is necessary to add (the relation of perspicuousness consists precisely in this) that significant new work will inevitably transform our understanding of those prior conventions and moreover will invest the prior works themselves with a generative importance (and isn't that to say with a measure of value or quality?) that until that moment they may not have had. Thus the evolution since the early 1950s of what is often called color-field painting has entailed a continual reinterpretation of Pollock's allover drip paintings of 1947–50 as well as an ever more authoritative identification of those pictures as the fountainhead of an entire tradition of modernist painting.¹⁵

So intensely perspectival and indeed so circular a view of the modernist enterprise—both the meaning and the value of the present are conceived as underwritten by a relation to a past that is continually being revised and reevaluated by the present—has close affinities with modern antifoundationalist thought both in philosophy proper and in theory of interpretation. (Recent discussions of Wittgenstein's treatment in the *Philosophical Investigations* of "following a rule," with its problematizing of how we "go on in the same way"—e.g., making objects capable of eliciting conviction as paintings—are pertinent here.) But what I want to emphasize at this juncture is that insofar as the practice I have just described involves something like radical self-criticism, the nature of that self-criticism is altogether different from what Greenberg means by the term; and insofar as the process in question may be figured as a version of the dialectic, it throws into relief just how *un*dialectical Clark's reading of modernism is.¹⁶

4

Toward the close of his essay, Clark writes that the end (in the sense of death) of the art of the bourgeoisie will involve, in fact has already involved (he is thinking of Brecht), "a search for another place in the social order." He continues: "Art wants to address someone, it wants something precise and extended to do; it wants *resistance*, it needs criteria; it will take risks in order to find them, including the risk of its own dissolution" (p. 217). And in a footnote to this he adds:

This is not to smuggle in a demand for realism again by the back door; or at least, not one posed in the traditional manner. The weakness or absence I have pointed to in modern art does not derive, I think, from a lack of grounding in "seeing" (for example) or a set of realist protocols to go with that; rather, it derives from its lack of grounding in some (any) specific practice of representation, which would be linked in turn to other social practices—embedded in them, constrained by them. The question is not, therefore, whether modern art should be figurative or abstract, rooted in empirical commitments or not so rooted, but *whether art is now provided with sufficient constraints of any kind*—notions of appropriateness, tests of vividness, demands which bring with them measures of importance or priority. Without constraints, representation of any articulateness and salience cannot take place. [Pp. 219–20 n. 11; my emphasis]

Here as elsewhere Clark's argument is unpersuasive. For one thing, to personify art itself as "wanting" to do certain things that are now not being done is palpably absurd. (Need I add that it is also alien to a materialist view of the subject?) For another, Clark's use of notions like resistance and criteria is obscure. Is it his considered view that in modernist art literally anything goes? Does he simply dismiss the insistence by Greenberg and others on the need to distinguish between the large mass of ostensibly difficult and advanced but in fact routine and meretricious work—the product, according to those critics, of an ingratiating and empty avant-gardism and the far smaller and often less obviously extreme body of work that really matters, that can survive comparison with what at that juncture they take to be the significant art of the past?¹⁷ True, the distinction is not enforced by appeal to objective criteria—but are those what Clark is asking for? Does he think, against Kant and Wittgenstein, that such criteria have a role to play in the arts? In any case, despite his disclaimers, the whole passage bears witness to an uneasiness with abstract art that makes Clark a dubious guide to the events of the past century or more.

My strongest objection to his remarks, however, is that they fail to recognize not just the magnitude of the achievement of modernist painters and sculptors I admire but also, more to the point, the formative importance in their art of what can only be called constraints. I shall conclude with a brief example.

In 1966 Caro, who had been making abstract sculptures in welded steel since 1960, became interested in making *small* sculptures—pieces that would extend no more than a foot or two in any dimension and thus would tend to be placed on a table or other convenient locus for small portable objects rather than directly on the ground, the compulsory (i.e., the only right) siting for his abstract pieces until that moment.¹⁸ Now it may seem that this ought not to have presented a problem: Why not simply make small (i.e., tabletop) versions of the larger sculptures that normally would have been placed on the bare ground, and let it go at that? But the fact of the matter is that such a solution was unacceptable to Caro, by which I mean that even without giving it a try he knew with perfect certainty that it would not do, that it was incapable of providing the basis for proceeding that he sought. But why?

Here I want to say, because it failed to respond to the *depth of Caro's need* for something, call it a convention,¹⁹ that would articulate smallness in a manner consistent with the prior logic of his art, that would be faithful to his commitment to a particular mode of thinking, feeling, and willing sculpture, in short that would not run counter to his acceptance (but that is too contractual a term: his internalization, his appropriation) of a particular set of constraints, the initial and at first only partial unearthing of which roughly six years before had been instrumental in his sudden emergence as a major artist (itself a characteristically modernist phenomenon).²⁰ I associate those constraints with a radical notion of *abstract*-

ness, which I contrast not with figurativeness, an uninteresting opposition, but rather with *literalness*, in the present context a compelling one.²¹ Reformulated in these terms, the problem of smallness that Caro found so challenging may be phrased quite simply. How was he to go about making pieces whose modest dimensions would strike the viewer not as a contingent, quantitative, in that sense merely literal fact about them but rather as a crucial aspect of their identity as abstract works of art-as internal to their "form," as part of their very essence as works of sculpture? To put this another way, by what means was he to make small sculptures that could not be seen, that would effectively defeat being perceived, either as models for or as reduced versions of larger ones? In obvious respects, the task he faced involved departing from norms that had been operative in his art up to that time. More importantly, however, his task was one of remaining responsible to a particular vision of his art (may we not lift a phrase from Clark and say to a particular vision of "cultural possibility"?) according to which a sculpture's scale—indeed all its features that matter, including its mode of self-presentation-must be secured abstractly. made part of its essence, in order to convince the viewer (in the first instance the sculptor) of their necessity or at any rate their lack of arbitrariness.

Caro's solution to this problem involved two distinct steps, the first of which soon proved dispensable. First, he incorporated handles of various sorts in a number of pieces in an attempt to key the "feel" of each work to that of graspable and manipulable objects. The chief precedent for this was Picasso's Glass of Absinthe (1914), a small painted bronze sculpture that incorporates a real silver sugar strainer. (Recognizable handles disappear from Caro's art around 1968.) Second, as in Table Piece XXII of 1967. Caro ran at least one element in every piece below the level of the tabletop or other elevated plane surface on which it was to be placed. This had the effect of precluding the transposition of the sculpture, in fact or in imagination, to the ground-of making the placement of the sculpture on (i.e., partly off) the tabletop a matter not of arbitrary choice but of structural necessity. And it at once turned out that tabling or precluding grounding the sculptures in this way was tantamount to establishing their smallness in terms that are not a function of actual size. More precisely, the distinction between tabling and grounding, determined as it is by the sculptures themselves, makes itself felt as equivalent to a qualitative as opposed to quantitative, essential as opposed to contingent, or abstract as opposed to literal difference in scale. (Not only did the abstract smallness of the table sculptures later prove compatible with surprising largeness of actual size: it soon became apparent that a certain minimum size, on the order of feet rather than inches, was required for their tabling to be experienced in these terms.) 22

48 Michael Fried

Caro's table sculptures thus embody a sense of scale for which there is no obvious precedent in earlier sculpture. And although it seems clear that our conviction on this score relates intimately to the fact that in everyday life smallish objects of the sort we grasp, manipulate, and shift casually from place to place tend to be found on tables, within easy reach, rather than on the ground, it is also true that we encounter nothing quite like the abstract smallness of Caro's table sculptures in our ordinary dealings with the world. From this point of view, an ontological one, the table sculptures are endlessly fascinating. And the source of that fascination could not have less to do with everything Clark means by negation, decomposition, absence, emptiness—the entire battery of concepts by means of which he tries to evoke the futility of modernism as he sees it.

A further glance at Table Piece XXII and I am done. The sculpture consists of three primary elements-a section of curved, broad-diameter pipe, a longer section of straight, narrow-diameter pipe, and a handlewelded together in a configuration, a structure of relations, that subtly, abstractly, asserts not only the disparateness but also the separateness of the two sections of pipe. (The pipe sections strike us as above all disjoined from one another by the handle that runs between them.) And one consequence of this is that, far from being tempted to reach out and grasp the handle, we sense as if subliminally that we are being invited to take hold of a gap, a spacing, and we draw back. In short, the everyday, literal function of a handle is here eclipsed by this handle's abstract function of enforcing a separation and thereby attuning us all the more finely to apprehending Table Piece XXII abstractly rather than literally, as a work of art and not, or not merely, a physical object. A Marxist critic might wish to say that this last distinction and indeed my larger advocacy of abstractness versus literalness are epitomes of bourgeois ideology. But he would have to grant that my analysis of Caro's table sculptures could hardly be further from Clark's fantasy of the medium in modernism reverting to the state of "mere unworked material."

Finally, beyond and embracing the considerations I have so far invoked, the convincingness of *Table Piece XXII* as art depends on something that defies exhaustive analysis, namely, the sheer rightness of *all* the relevant relations at work in it, including the appropriateness of its color, a metallic gray-green, to everything else. Intuition of that rightness is the critic's first responsibility as well as his immediate reward, and if Clark shared more than a fraction of that intuition, about this Caro or any Caro, or any Smith, Pollock, Frankenthaler, Louis, Noland, Olitski, or Poons, not to mention the antecedent masters whose painting and sculptures, continually reinterpreted, stand behind theirs, his understanding of the politics of modernism would be altogether different from what it is.

Notes

- Clark writes in his n. 10 (p. 218) that "what I am referring to is an *aspect or moment* of modernist art, most often mixed up with other purposes or techniques, though often, I would argue, dominating them." This introduces a hint of qualification, almost of moderation, that can be found nowhere else in his essay. The present response addresses the hard, unqualified position taken by his essay as a whole, which stands virtually as it was read aloud at the "Politics of Interpretation" conference in Chicago. Perhaps I ought to add, inasmuch as my assessment of his views on modernism will be severe, that I think highly of his studies of French art during the Second Republic, *Image of the People* (Princeton, N.J., 1973) and *The Absolute Bourgeois* (Princeton, N.J., 1973).
- 2. I associate those aims and aspirations with the search for a new and more perspicuous mode of pictorial unity as well as with the desire to achieve a specific relation between painting and beholder (two aspects of the same undertaking). This is not the place for a detailed discussion of these matters, but I will simply note that the unintelligibility of the action or situation promotes an effect of *instantaneousness*, not of the action itself so much as of one's perception of the scene, the painting, as a whole. For more on Manet's aims in the first half of the 1860s, see my "Manet's Sources: Aspects of His Art, 1859–1865," *Artforum* 7 (March 1969), pp. 28–82. In that essay I suggest that the *Déjeuner* combines elements of several genres of painting (e.g., landscape, portraiture, still life) and that this too is to be understood in terms of Manet's pursuit of a more radical and comprehensive mode of unification than was provided by the pictorial culture of his day.
- 3. On the distinction between "mainstream" modernism and its shadow, the phenomenon Greenberg calls avant-garde*ism*, see n. 17 below.
- My presentation of Greenberg's theory of modernism is based chiefly on two of his later essays, "Modernist Painting" (1960), in *The New Art: A Critical Anthology*, ed. Gregory Battcock (New York, 1966), pp. 100–110, and "After Abstract Expressionism" (1962), in *New York Painting and Sculpture: 1940–1970*, ed. Henry Geldzahler (New York, 1969), pp. 360–71.
- 5. Greenberg, "Modernist Painting," p. 102.
- 6. Greenberg, "After Abstract Expressionism," p. 369.
- 7. Ibid. Greenberg spells out what he means by "conception" when he says of Newman's paintings: "The onlooker who says his child could paint a Newman may be right, but Newman would have to be there to tell the child *exactly* what to do" (p. 370).
- 8. Fried, "Shape as Form: Frank Stella's New Paintings" (1966), in *New York Painting and Sculpture*, p. 422.
- 9. Fried, "Art and Objecthood" (1967), in *Minimal Art: A Critical Anthology*, ed. Battcock (New York, 1968), pp. 123–24 n. 4 (with a few minor changes). The Wittgensteinian view of essence and convention propounded in these passages and indeed the basic conception of the modernist enterprise outlined in them were worked out during a period of close intellectual comradeship with Stanley Cavell; see, e.g., Cavell, "The Availability of Wittgenstein's Later Philosophy," "Music Discomposed," and "A Matter of Meaning It," *Must We Mean What We Say?* (New York, 1969), as well as his *The Claim of Reason: Wittgenstein, Skepticism, Morality, and Tragedy* (New York, 1979), esp. pp. 86–125. For a highly intelligent, at once sympathetic and deconstructive, reading of my account of modernism, see Stephen Melville, "Notes on the Reemergence of Allegory, the Forgetting of Modernism, the Necessity of Rhetoric, and the Conditions of Publicity in Art and Criticism," *October* 19 (Winter 1981), pp. 55–92.
- 10. That the historical mission of modernism has been to preserve the standards of the high art of the past is one of Greenberg's major themes. The closing words of "Mod-

ernist Painting" are these: "Nothing could be further from the authentic art of our time than the idea of a rupture of continuity. Art is, among many other things, continuity. Without the past of art, and without the need and compulsion to maintain past standards of excellence, such a thing as Modernist art would be impossible" (p. 110).

- 11. See Charles Baudelaire, "The Salon of 1846," Art in Paris 1845–1862: Salons and Other Exhibitions, trans. and ed. Jonathan Mayne (Ithaca, N.Y., 1981), pp. 115–16. What the great schools chiefly provided to artists belonging to them was "faith" or, as Baudelaire shrewdly goes on to say, "the impossibility of doubt" (p. 115). In the same vein, Baudelaire writes of Delacroix more than a decade later: "He is as great as the old masters, in a country and a century in which the old masters would not have been able to survive" ("The Salon of 1859," p. 168).
- 12. Let me emphasize that I am speaking here of the implications of his theoretical essays (or of primarily theoretical passages in essays like "After Abstract Expressionism"); as a practical critic, Greenberg is at pains to eliminate all suggestion of predetermination and in fact would surely claim that he wished to do so in his theoretical writings as well. As we have seen, however, the terms of his analysis—reduction to an essence—make such a suggestion unavoidable.
- 13. I say that it is their problem because it is based on unexamined assumptions or simply wishful thinking about what art (and life) should be like. This is perhaps the place to mention that in a lecture at a conference on art criticism and social theory held at Blacksburg, Virginia (9-11 October 1981), Donald Kuspit of the State University of New York at Stony Brook (author of a study of Greenberg) characterized my views on modernism as "authoritarian" and even as "fascistic." These are hard words. Presumably what justifies them is my insistence that some art is better than other art and my claim to know, to be able to tell, which is which. (Sometimes, of course, what I am able to tell is that previously I was wrong.) But what would be the use of a critic who regarded all art as equally indifferent, or who claimed not to be able to distinguish good from bad, or who considered all such questions beside the point? Moreover, my emphasis on the primacy of conviction means precisely that the reader of my criticism is barred from being persuaded, simply by reading me, of the rightness (or wrongness) of the judgments I make; rather, he *must* test those judgments against his firsthand experience of the works in question if he is to arrive at a view of the matter that is truly his. Is this authoritarianism? Fascism? Only, it seems to me, if we are prepared to characterize in those terms the assertion that while "the doors of the temple stand open, night and day, before every man, and the oracles of this truth cease never, it is guarded by one stern condition; this namely; It is an intuition. It cannot be received at second hand" (Ralph Waldo Emerson, "The Divinity School Address," Nature, Addresses, and Lectures, ed. Robert E. Spiller and Alfred R. Ferguson [Cambridge, Mass., 1979], p. 80).
- 14. Early in his essay, Clark cites Bertolt Brecht as a modern artist for whom "active engagement in ideological struggle . . . was not necessarily incompatible with work on the *medium* of theatre, making that medium explicit and opaque in the best avantgarde manner" (p. 207), and again toward the end he mentions Brecht with approval. This is true as far as it goes, but it fails to consider the possibility that it was precisely Brecht's prior concern with problems and issues relating to what might be called the inescapable theatricality of the theatrical arts that enabled him to make an engagement in ideological struggle *count* artistically. Brecht himself describes his discovery of Marx as that of an ideal audience: "When I read Marx's *Capital* I understood my plays.... It wasn't of course that I found I had unconsciously written a whole pile of Marxist plays; but this man Marx was the only spectator for my plays I'd ever come across" (*Brecht on Theater*, trans. and ed. John Willett [New York, 1964], pp. 23–24). (A similar line of argument might be pursued in connection with Godard.) The question as regards modernist painting and sculpture is therefore whether the present state of

those arts is such as to facilitate an analogous development. I think the answer is no, but not because of any fact of *closure*.

15. See, e.g., my Morris Louis (New York, 1970), pp. 13-22 and passim.

- 16. Two further ramifications of my account of modernism should at least be mentioned. First, it implies that the conviction of quality or value is always elicited by putative paintings and sculptures and not by putative works of art as such. The way I put this in "Art and Objecthood" was to claim that "the concepts of quality and value-and to the extent that these are central to art, the concept of art itself—are meaningful . . . only within the individual arts. What lies between the arts is theatre" (p. 142). (See n. 18 below, and cf. Greenberg, "Intermedia," Arts 56 [October 1981]: 92-93.) Second, the situation of the critic is analogous to that of the modernist artist in that criticism has no neutral, context-free, in that sense suprahistorical, descriptive categories at its disposal (not even, or especially not, "painting" and "sculpture") but rather must seek to elicit the conviction that the concepts it finds itself motivated to deploy actually illuminate the works under discussion. Moreover, as the context changes, largely as the result of subsequent artistic developments, even the concepts in widest use will require modification. For example, during the past fifteen or twenty years the concept "flatness" that at least since the late nineteenth century had been indispensable to the construal of modernist painting has lost much of its urgency; which is not to say that ambitious painting in our time has been freed from the demand that it come to terms with issues on the *surface*—if anything the pressure there is more intense than before. Larry Poons' recent "pour" paintings incorporating bits and pieces of styrofoam, shown at the Emmerich Gallery in New York in April 1982, are a case in point.
- 17. In a lecture delivered at the University of Sydney in 1968, Greenberg distinguishes between the authentic avant-garde, which he sees as dedicated to preserving the values of the high art of the past, and the "popular" avant-garde—the invention of Duchamp and Dada—which he characterizes as seeking to evade the issue of quality altogether (see Greenberg, "Avant-Garde Attitudes: New Art in the Sixties," The John Power Lecture in Contemporary Art, 17 May 1968 [Sydney, 1969], pp. 10–11). (One recurrent tactic of evasion has been to raise the pseudoquestion of art as such.) In that lecture too Greenberg notes the emergence in the 1960s of what he calls "novelty" art, in which the "easiness" of the work—its failure to offer a significant challenge to advanced taste—"is . . . knowingly, aggressively, extravagantly masked by the guises of the difficult" (p. 12). And in a subsequent essay, Greenberg substitutes the pejorative term "avant-gardism" for that of the "popular" avant-garde ("Counter Avant-Garde," Art International 15 [May 1971], pp. 16–19).

In my "Art and Objecthood" I argue that the best contemporary painting and sculpture seek an ideal of self-sufficiency and what I call "presentness" whereas much seemingly advanced recent work is essentially *theatrical*, depending for its effects of "presence" on the staging, the conspicuous manipulation, of its relation to an audience. (In the years since "Art and Objecthood" was written, the theatrical has assumed a host of new guises and has acquired a new name: post-modernism.) Recently Melville has challenged the hardness of this distinction, arguing, for example, that the desire to defeat the theatrical can find satisfaction only in a theatrical space, or at any rate in circumstances that cannot wholly escape the conditions of theater (I make this point in my writings on pre-modernist art), and going on to claim that today "the field we call 'painting' includes, and cannot now be defined without reference to, its violations and excesses-performance work in particular" ("Notes," p. 80). In this connection he cites figures such as Rauschenberg and Acconci, whose endeavors I continue to see as trivial. But the fact that I am unimpressed by his exemplary artists by no means deflects the force of his general argument, which compels an awareness that, as he puts it, neatly paraphrasing me on Diderot, the art of painting is inescapably addressed to an audience that must be gathered (see p. 87). On the other hand, as Melville is aware,

52 Michael Fried

the impossibility of a pure or absolute mode of antitheatricality by no means implies that I am mistaken in my assessment of the best work of our time or even, by and large, in the terms in which I have described it. (Effects of presentness can still amount to grace.)

On theatricality as an issue for pre-modernist art, see my Absorption and Theatricality: Painting and Beholder in the Age of Diderot (Berkeley, 1980); "Thomas Couture and the Theatricalization of Action in Nineteenth-Century French Painting," Artforum 8 (June 1970): 36–46; "The Beholder in Courbet: His Early Self-Portraits and Their Place in His Art," Glyph 4 (1978): 85–129; "Representing Representation: On the Central Group in Courbet's Studio," in Allegory and Representation: Selected Papers from the English Institute, 1979–80, ed. Stephen J. Greenblatt (Baltimore, 1981), pp. 94–127, rpt. in Art in America 69 (September 1981): 127–33, 168–73; and "Painter into Painting: On Courbet's After Dinner at Ornans and Stonebreakers," Critical Inquiry 8 (Summer 1982), pp. 619–49. Theatricality in Manet is discussed in my "Manet's Sources," pp. 69–74.

- 18. On Caro, see, e.g., my introduction to the exhibition catalog, Anthony Caro, Hayward Gallery, London, 1969; Richard Whelan et al., Anthony Caro (Baltimore, 1974); and William Rubin, Anthony Caro (New York, 1975). The Whelan book contains additional texts by Greenberg, John Russell, Phyllis Tuchman, and myself. The following discussion of Caro's table sculptures is based on my essay in the catalog to the travelling exhibition, Anthony Caro: Table Sculptures, 1966–77, British Council, 1977–78 (rpt. in Arts 51 [March 1977], pp. 94–97).
- 19. "It is as if this expressed the essence of form—I say, however: if you talk about essence you are merely noting a convention. But here one would like to retort: there is no greater difference than that between a proposition about the depth of the essence and one about—a mere convention. But what if I reply: to the *depth* that we see in the essence there corresponds the *deep* need for the convention" (Ludwig Wittgenstein, *Remarks on the Foundations of Mathematics*, ed. G. H. Von Wright, R. Rhees, and G. E. M. Anscombe, trans. Anscombe [Oxford, 1956], p. 23e).
- See my discussion of Louis' "breakthrough" to major achievement in *Morris Louis*, pp. 10–13.
- 21. The opposition between abstractness and literalness is developed in my essays "Shape as Form" and "Art and Objecthood," as well as in two short reviews, "Two Sculptures by Anthony Caro" and "Caro's Abstractness," both available in Whelan et al., Anthony Caro, pp. 95–101 and 103–10; see also in this collection Greenberg's remarks on Caro's abstractness or "radical unlikeness to nature" ("Anthony Caro," pp. 87–93, esp. p. 88).
- 22. Between 1966 and 1974, Caro made roughly two hundred table sculptures of this type. Around 1974–75, however, he began making table sculptures that no longer dipped below the level of the tabletop, without loss of quality. It is as though by then Caro had acquired a mastery of what might be called table scale that enabled him to give up anchoring the pieces to the tabletop and nevertheless to establish abstractly the specificity of their dimensions and mode of presentation. (On the other hand, many of these pieces also "work" on the ground and in that sense are presentationally looser than the earlier pieces.)

Modernity Versus Postmodernity

JÜRGEN HABERMAS

In 1980, architects were admitted to the Biennial in Venice, following painters and filmmakers. The note sounded at this first Architecture Biennial was one of disappointment. I would describe it by saying that those who exhibited in Venice formed an avant-garde of reversed fronts. I mean that they sacrificed the tradition of modernity in order to make room for a new historicism. Upon this occasion, a critic of the German newspaper, *Frankfurter Allgemeine Zeitung*, advanced a thesis whose significance reaches beyond this particular event; it is a diagnosis of our times: "Postmodernity definitely presents itself as Antimodernity." This statement describes an emotional current of our times which has penetrated all spheres of intellectual life. It has placed on the agenda theories of postenlightenment, postmodernity, even of posthistory.

From history we know the phrase, "The Ancients and the Moderns." Let me begin by defining these concepts. The term "modern" has a long history, one which has been investigated by Hans Robert Jauss. The word "modern" in its Latin form "modernus" was used for the first time in the late 5th century in order to distinguish the present, which had become officially Christian, from the Roman and pagan past. With varying content, the term "modern" again and again expresses the consciousness of an epoch that relates itself to the past of antiquity, in order to view itself as the result of a transition from the old to the new.

Some writers restrict this concept of "modernity" to the Renaissance,

This essay was delivered as a James Lecture of The New York Institute for the Humanities at New York University on March 5, 1981. It had first been delivered in German in September 1980 under the title "Modernity—An Incomplete Project" when Habermas was awarded the Theodor W. Adorno prize by the city of Frankfurt. It is reprinted here from *New German Critique* 22 (Winter 1981) with permission of the author and publisher.

but this is historically too narrow. People considered themselves modern during the period of Charles the Great in the 12th century, as well as in France of the late 17th century at the time of the famous "Querelle des Anciens et des Modernes." That is to say, the term "modern" appeared and reappeared exactly during those periods in Europe when the consciousness of a new epoch formed itself through a renewed relationship to the ancients—whenever, moreover, antiquity was considered a model to be recovered through some kind of imitation.

The spell which the classics of the ancient world cast upon the spirit of later times was first dissolved with the ideals of the French Enlightenment. Specifically, the idea of being "modern" by looking back to the ancients changed with the belief, inspired by modern science, in the infinite progress of knowledge and in the infinite advance towards social and moral betterment. Another form of modernist consciousness was formed in the wake of this change. The romantic modernist sought to oppose the antique ideals of the classicists; he looked for a new historical epoch and found it in the idealized Middle Ages. However, this new ideal age, established early in the 19th century, did not remain a fixed ideal. In the course of the 19th century, there emerged out of this romantic spirit that radicalized consciousness of modernity which freed itself from all specific historical ties. This most recent modernism simply makes an abstract opposition between tradition and the present; and we are, in a way, still the contemporaries of that kind of aesthetic modernity which first appeared in the midst of the 19th century. Since then, the distinguishing mark of works which count as modern is "the new" which will be overcome and made obsolete through the novelty of the next style. But, while that which is merely "stylish" will soon become outmoded, that which is modern preserves a secret tie to the classical. Of course, whatever can survive time has always been considered to be a classic. But the emphatically modern document no longer borrows this power of being a classic from the authority of a past epoch; instead, a modern work becomes a classic because it has once been authentically modern. Our sense of modernity creates its own self-enclosed canons of being classic. In this sense we speak, e.g., in view of the history of modern art, of classical modernity. The relation between "modern" and "classical" has definitely lost a fixed historical reference.

The Discipline of Aesthetic Modernity

The spirit and discipline of aesthetic modernity assumed clear contours in the work of Baudelaire. Modernity then unfolded in various avant-garde movements and finally reached its climax in the Café Voltaire of the dadaists and in surrealism. Aesthetic modernity is characterized by attitudes which find a common focus in a changed consciousness of time. This time consciousness expresses itself through metaphors of the vanguard and the avant-garde. The avant-garde understands itself as invading unknown territory, exposing itself to the dangers of sudden, shocking encounters, conquering an as yet unoccupied future. The avant-garde must find a direction in a landscape into which no one seems to have yet ventured.

But these forward gropings, this anticipation of an undefined future and the cult of the new mean in fact the exaltation of the present. The new time consciousness, which enters philosophy in the writings of Bergson, does more than express the experience of mobility in society, of acceleration in history, of discontinuity in everyday life. The new value placed on the transitory, the elusive and the ephemeral, the very celebration of dynamism, discloses a longing for an undefiled, immaculate and stable present.

This explains the rather abstract language in which the modernist temper has spoken of the "past." Individual epochs lose their distinct forces. Historical memory is replaced by the heroic affinity of the present with the extremes of history—a sense of time wherein decadence immediately recognizes itself in the barbaric, the wild and the primitive. We observe the anarchistic intention of blowing up the continuum of history, and we can account for it in terms of the subversive force of this new aesthetic consciousness. Modernity revolts against the normalizing functions of tradition; modernity lives on the experience of rebelling against all that is normative. This revolt is one way to neutralize the standards of both morality and utility. This aesthetic consciousness continuously stages a dialectical play between secrecy and public scandal; it is addicted to a fascination with that horror which accompanies the act of profaning, and yet is always in flight from the trivial results of profanation.

On the other hand, the time consciousness articulated in avant-garde art is not simply ahistorical; it is directed against what might be called a false normativity in history. The modern, avant-garde spirit has sought to use the past in a different way; it disposes those pasts which have been made available by the objectifying scholarship of historicism, but it opposes at the same time a neutralized history which is locked up in the museum of historicism.

Drawing upon the spirit of surrealism, Walter Benjamin constructs the relationship of modernity to history in what I would call a posthistoricist attitude. He reminds us of the self-understanding of the French Revolution: "The Revolution cited ancient Rome, just as fashion cites an antiquated dress. Fashion has a scent for what is current, whenever this moves within the thicket of what was once." This is Benjamin's concept of the *Jetztzeit*, of the present as a moment of revelation; a time in which splinters of a messianic presence are enmeshed. In this sense, for Robespierre, the antique Rome was a past laden with momentary revelations.

Now, this spirit of aesthetic modernity has recently begun to age. It has been recited once more in the 1960s; after the 1970s, however, we must admit to ourselves that this modernism arouses a much fainter response today than it did fifteen years ago. Octavio Paz, a fellow-traveller of modernity, noted already in the middle of the 1960s that "the avant-garde of 1967 repeats the deeds and gestures of those of 1917. We are experiencing the end of the idea of modern art." The work of Peter Bürger has since taught us to speak of "post-avant-garde" art; this term is chosen to indicate the failure of the surrealist rebellion. But what is the meaning of this failure? Does it signal a farewell to modernity? Thinking more generally, does the existence of a post-avant-garde mean there is a transition to that broader phenomenon called postmodernity?

This is in fact how Daniel Bell, the most brilliant of the American neoconservatives, interprets matters. In his book, The Cultural Contra*dictions of Capitalism*, Bell argues that the crises of the developed societies of the West are to be traced back to a split between culture and society. Modernist culture has come to penetrate the values of everyday life; the life-world is infected by modernism. Because of the forces of modernism, the principle of unlimited self-realization, the demand for authentic self-experience and the subjectivism of a hyperstimulated sensitivity have come to be dominant. This temperament unleashes hedonistic motives irreconcilable with the discipline of professional life in society, Bell says. Moreover, modernist culture is altogether incompatible with the moral basis of a purposive, rational conduct of life. In this manner, Bell places the burden of responsibility for the dissolution of the Protestant ethic (a phenomenon which had already disturbed Max Weber) on the "adversary culture." Culture in its modern form stirs up hatred against the conventions and virtues of everyday life, which has become rationalized under the pressures of economic and administrative imperatives.

I would call your attention to a complex wrinkle in this view. The impulse of modernity, we are told on the other hand, is exhausted; anyone who considers himself avant-garde can read his own death warrant. Although the avant-garde is still considered to be expanding, it is supposedly no longer creative. Modernism is dominant but dead. For the neoconservative the question then arises: how can norms arise in society which will limit libertinism, reestablish the ethic of discipline and work? What new norms will put a brake on the levelling caused by the social welfare state so that the virtues of individual competition for achievement can again dominate? Bell sees a religious revival to be the only solution. Religious faith tied to a faith in tradition will provide individuals with clearly defined identities and existential security.

Cultural Modernity and Societal Modernization

One can certainly not conjure up by magic the compelling beliefs which command authority. Analyses like Bell's, therefore, only result in an attitude which is spreading in Germany no less than in the States: an intellectual and political confrontation with the carriers of cultural modernity. I cite Peter Steinfels, an observer of the new style which the neoconservatives have imposed upon the intellectual scene in the 1970s:

The struggle takes the form of exposing every manifestation of what could be considered an oppositionist mentality and tracing its "logic" so as to link it to various forms of extremism: drawing the connection between modernism and nihilism . . . between government regulation and totalitarianism, between criticism of arms expenditures and subservience to communism, between Women's liberation or homosexual rights and the destruction of the family . . . between the Left generally and terrorism, anti-semitism, and fascism. . . .¹

The *ad hominem* approach and the bitterness of these intellectual accusations have also been trumpeted loudly in Germany. They should not be explained so much in terms of the psychology of neoconservative writers; rather, they are rooted in the analytical weaknesses of neoconservative doctrine itself.

Neoconservatism shifts onto cultural modernism the uncomfortable burdens of a more or less successful capitalist modernization of the economy and society. The neoconservative doctrine blurs the relationship between the welcomed process of societal modernization on the one hand, and the lamented cultural development on the other. The neoconservative does not uncover the economic and social causes for the altered attitudes towards work, consumption, achievement and leisure. Consequently, he attributes all of the following—hedonism, the lack of social identification, the lack of obedience, narcissism, the withdrawal from status and achievement competition—to the domain of "culture." In fact, however, culture is intervening in the creation of all these problems in only a very indirect and mediated fashion.

In the neoconservative view, those intellectuals who still feel themselves committed to the project of modernity are then presented as taking the place of those unanalyzed causes. The mood which feeds neoconservatism today in no way originates from discontent about the antinomian consequences of a culture breaking from the museums into the stream of ordinary life. This discontent has not been called into life by modernist intellectuals. It is rooted in deep-seated reactions against the process of *societal* modernization. Under the pressures of the dynamics of economic growth and the organizational accomplishments of the state, this social modernization penetrates deeper and deeper into previous forms of human existence. I would describe this subordination of the life-worlds under the system's imperatives as a matter of disturbing the communicative infrastructure of everyday life.

Thus, for example, neopopulist protests only express in pointed fashion a widespread fear regarding the destruction of the urban and natural environment and of forms of human sociability. There is a certain irony

58 Jürgen Habermas

about these protests in terms of neoconservatism. The tasks of passing on a cultural tradition, of social integration and of socialization require adherence to what I call communicative rationality. But the occasions for protest and discontent originate precisely when spheres of communicative action, centered on the reproduction and transmission of values and norms, are penetrated by a form of modernization guided by standards of economic and administrative rationality—in other words, by standards of rationalization quite different from those of communicative rationality on which those spheres depend. But neoconservative doctrines turn our attention precisely away from such societal processes: they project the causes, which they do not bring to light, onto the plane of a subversive culture and its advocates.

To be sure, cultural modernity generates its own aporias as well. Independently from the consequences of *societal* modernization and within the perspective of *cultural* development itself, there originate motives for doubting the project of modernity. Having dealt with a feeble kind of criticism of modernity—that of neoconservatism—let me now move our discussion of modernity and its discontents into a different domain that touches on these aporias of cultural modernity—issues that often serve only as a pretense for those positions which either call for a postmodernity, recommend a return to some form of premodernity, or throw modernity radically overboard.

The Project of Enlightenment

The idea of modernity is intimately tied to the development of European art. but what I call "the project of modernity" comes only into focus when we dispense with the usual concentration upon art. Let me start a different analysis by recalling an idea from Max Weber. He characterized cultural modernity as the separation of the substantive reason expressed in religion and metaphysics into three autonomous spheres. They are: science, morality and art. These came to be differentiated because the unified world-views of religion and metaphysics fell apart. Since the 18th century, the problems inherited from these older world-views could be arranged so as to fall under specific aspects of validity: truth, normative rightness, authenticity and beauty. They could then be handled as questions of knowledge, or of justice and morality, or of taste. Scientific discourse, theories of morality, jurisprudence, and the production and criticism of art could in turn be institutionalized. Each domain of culture could be made to correspond to cultural professions in which problems could be dealt with as the concern of special experts. This professionalized treatment of the cultural tradition brings to the fore the intrinsic structures of each of the three dimensions of culture. There appear the structures of cognitive-instrumental, of moral-practical and of aesthetic-expressive rationality, each of these under the control of specialists who seem more adept at being logical in these particular ways than other people are. As a result, the distance grows between the culture of the experts and that of the larger public. What accrues to culture through specialized treatment and reflection does not immediately and necessarily become the property of everyday praxis. With cultural rationalization of this sort, the threat increases that the life-world, whose traditional substance has already been devalued, will become more and more impoverished.

The project of modernity formulated in the 18th century by the philosophers of the Enlightenment consisted in their efforts to develop objective science, universal morality and law, and autonomous art according to their inner logic. At the same time, this project intended to release the cognitive potentials of each of these domains from their esoteric forms. The Enlightenment philosophers wanted to utilize this accumulation of specialized culture for the enrichment of everyday life—that is to say, for the rational organization of everyday social life.

Enlightenment thinkers of the cast of mind of Condorcet still had the extravagant expectation that the arts and sciences would promote not only the control of natural forces but also understanding of the world and of the self, moral progress, the justice of institutions and even the happiness of human beings. The 20th century has shattered this optimism. The differentiation of science, morality and art has come to mean the autonomy of the segments treated by the specialist and their separation from the hermeneutics of everyday communication. This splitting off is the problem that has given rise to efforts to "negate" the culture of expertise. But the problem won't go away: should we try to hold on to the *intentions* of the Enlightenment, feeble as they may be, or should we declare the entire project of modernity a lost cause? I now want to return to the problem of artistic culture, having explained why, historically, aesthetic modernity is only a part of cultural modernity in general.

The False Programs of the Negation of Culture

Greatly oversimplifying, I would say that in the history of modern art one can detect a trend towards ever greater autonomy in the definition and practice of art. The category of "beauty" and the domain of beautiful objects were first constituted in the Renaissance. In the course of the 18th century, literature, the fine arts and music were institutionalized as activities independent from sacred and courtly life. Finally, around the middle of the 19th century an aestheticist conception of art emerged, which encouraged the artist to produce his work according to the distinct consciousness of art for art's sake. The autonomy of the aesthetic sphere could then become a deliberate project: the talented artist could lend authentic expression to those experiences he had in encountering his own de-centered subjectivity, detached from the constraints of routinized cognition and everyday action.

In the mid-19th century, in painting and literature, a movement began which Octavio Paz finds epitomized already in the art criticism of Baudelaire. Color, lines, sounds and movement ceased to serve primarily the cause of representation; the media of expression and the techniques of production themselves became the aesthetic object. Theodor W. Adorno could therefore begin his Aesthetic Theory with the following sentence: "It is now taken for granted that nothing which concerns art can be taken for granted any more: neither art itself, nor art in its relationship to the whole, nor even the right of art to exist." And this is what surrealism then denied: das Existenzrecht der Kunst als Kunst. To be sure, surrealism would not have challenged the right of art to exist, if modern art no longer had advanced a promise of happiness concerning its own relationship "to the whole" of life. For Schiller, such a promise was delivered by aesthetic intuition, but not fulfilled by it. Schiller's Letters on the Aesthetic Education of Man speaks to us of a utopia reaching beyond art itself. But by the time of Baudelaire, who repeated this promesse de bonheur via art, the utopia of reconciliation with society had gone sour. A relation of opposites had come into being; art had become a critical mirror, showing the irreconcilable nature of the aesthetic and the social worlds. This modernist transformation was all the more painfully realized. the more art alienated itself from life and withdrew into the untouchableness of complete autonomy. Out of such emotional currents finally gathered those explosive energies which unloaded in the surrealist attempt to blow up the autarkical sphere of art and to force a reconciliation of art and life.

But all those attempts to level art and life, fiction and praxis, appearance and reality to one plane; the attempts to remove the distinction between artifact and object of use, between conscious staging and spontaneous excitement; the attempts to declare everything to be art and everyone to be an artist, to retract all criteria and to equate aesthetic judgment with the expression of subjective experiences—all these undertakings have proved themselves to be sort of nonsense experiments. These experiments have served to bring back to life, and to illuminate all the more glaringly, exactly those structures of art which they were meant to dissolve. They gave a new legitimacy, as ends in themselves, to appearance as the medium of fiction, to the transcendence of the artwork over society, to the concentrated and planned character of artistic production as well as to the special cognitive status of judgments of taste. The radical attempt to negate art has ended up ironically by giving due exactly to these categories through which Enlightenment aesthetics had circumscribed its object domain. The surrealists waged the most extreme warfare, but two mistakes in particular destroyed their revolt. First, when the containers of an autonomously developed cultural sphere are shattered, the contents get dispersed. Nothing remains from a desublimated meaning or a destructured form; an emancipatory effect does not follow.

Their second mistake has more important consequences. In everyday communication, cognitive meanings, moral expectations, subjective expressions and evaluations must relate to one another. Communication processes need a cultural tradition covering all spheres—cognitive, moralpractical and expressive. A rationalized everyday life, therefore, could hardly be saved from cultural impoverishment through breaking open a single cultural sphere—art—and so providing access to just one of the specialized knowledge complexes. The surrealist revolt would have replaced only one abstraction.

In the spheres of theoretical knowledge and morality, there are parallels to this failed attempt of what we might call the false negation of culture. Only they are less pronounced. Since the days of the Young Hegelians, there has been talk about the negation of philosophy. Since Marx, the question of the relationship of theory and practice has been posed. However, Marxist intellectuals joined a social movement; and only at its peripheries were there sectarian attempts to carry out a program of the negation of philosophy similar to the surrealist program to negate art. A parallel to the surrealist mistakes becomes visible in these programs when one observes the consequences of dogmatism and of moral rigorism.

A reified everyday praxis can be cured only by creating unconstrained interaction of the cognitive with the moral-practical and the aestheticexpressive elements. Reification cannot be overcome by forcing just one of those highly stylized cultural spheres to open up and become more accessible. Instead, we see under certain circumstances a relationship emerge between terroristic activities and the over-extension of any one of these spheres into other domains: examples would be tendencies to aestheticize politics, or to replace politics by moral rigorism or to submit it to the dogmatism of a doctrine. These phenomena should not lead us, however, into denouncing the intentions of the surviving Enlightenment tradition as intentions rooted in a "terroristic reason." Those who lump together the very project of modernity with the state of consciousness and the spectacular action of the individual terrorist are no less short-sighted than those who would claim that the incomparably more persistent and extensive bureaucratic terror practiced in the dark, in the cellars of the military and secret police, and in camps and institutions, is the raison d'être of the modern state, only because this kind of administrative terror makes use of the coercive means of modern bureaucracies.

62 Jürgen Habermas

Alternatives

I think that instead of giving up modernity and its project as a lost cause, we should learn from the mistakes of those extravagant programs which have tried to negate modernity. Perhaps the types of reception of art may offer an example which at least indicates the direction of a way out.

Bourgeois art had two expectations at once from its audiences. On the one hand, the layman who enjoyed art should educate himself to become an expert. On the other hand, he should also behave as a competent consumer who uses art and relates aesthetic experiences to his own life problems. This second, and seemingly harmless, manner of experiencing art has lost its radical implications exactly because it had a confused relation to the attitude of being expert and professional.

To be sure, artistic production would dry up, if it were not carried out in the form of a specialized treatment of autonomous problems and if it were to cease to be the concern of experts who do not pay so much attention to exoteric questions. Both artists and critics accept thereby the fact that such problems fall under the spell of what I earlier called the "inner logic" of a cultural domain. But this sharp delineation, this exclusive concentration on one aspect of validity alone and the exclusion of aspects of truth and justice, break down as soon as aesthetic experience is drawn into an individual life history and is absorbed into ordinary life. The reception of art by the layman, or by the "everyday expert," goes in a rather different direction than the reception of art by the professional critic.

Albrecht Wellmer has drawn my attention to one way that an aesthetic experience which is not framed around the experts' critical judgments of taste can have its significance altered: as soon as such an experience is used to illuminate a life-historical situation and is related to life problems, it enters into a language game which is no longer that of the aesthetic critic. The aesthetic experience then not only renews the interpretation of our needs in whose light we perceive the world. It permeates as well our cognitive significations and our normative expectations and changes the manner in which all these moments refer to one another. Let me give an example of this process.

This manner of receiving and relating to art is suggested in the first volume of the work *The Aesthetics of Resistance* by the German-Swedish writer Peter Weiss. Weiss describes the process of reappropriating art by presenting a group of politically motivated, knowledge-hungry workers in 1937 in Berlin. These were young people who, through an evening highschool education, acquired the intellectual means to fathom the general and social history of European art. Out of the resilient edifice of this objective mind, embodied in works of art which they saw again and again in the museums in Berlin, they started removing their own chips of stone, which they gathered together and reassembled in the context of their own milieu. This milieu was far removed from that of traditional education as well as from the then existing regime. These young workers went back and forth between the edifice of European art and their own milieu until they were able to illuminate both.

In examples like this which illustrate the reappropriation of the expert's culture from the standpoint of the life-world, we can discern an element which does justice to the intentions of the hopeless surrealist revolts, perhaps even more to Brecht's and Benjamin's interests in how art works, which having lost their aura, could yet be received in illuminating ways. In sum, the project of modernity has not yet been fulfilled. And the reception of art is only one of at least three of its aspects. The project aims at a differentiated relinking of modern culture with an everyday praxis that still depends on vital heritages, but would be impoverished through mere traditionalism. This new connection, however, can only be steered in a different direction. The life-world has to become able to develop institutions out of itself which set limits to the internal dynamics and imperatives of an almost autonomous economic system and its administrative complements.

If I am not mistaken, the chances for this today are not very good. More or less in the entire Western world a climate has developed that furthers capitalist modernization processes as well as trends critical of cultural modernism. The disillusionment with the very failures of those programs that called for the negation of art and philosophy has come to serve as a pretense for conservative positions. Let me briefly distinguish the antimodernism of the "young conservatives" from the premodernism of the "old conservatives" and from the postmodernism of the neoconservatives.

The "young conservatives" recapitulate the basic experience of aesthetic modernity. They claim as their own the revelations of a decentered subjectivity, emancipated from the imperatives of work and usefulness, and with this experience they step outside the modern world. On the basis of modernistic attitudes they justify an irreconcilable antimodernism. They remove into the sphere of the far-away and the archaic the spontaneous powers of imagination, self-experience and emotion. To instrumental reason they juxtapose in Manichean fashion a principle only accessible through evocation, be it the will to power or sovereignty, Being or the Dionysiac force of the poetical. In France this line leads from Georges Bataille via Michel Foucault to Jacques Derrida.

The "old conservatives" do not allow themselves to be contaminated by cultural modernism. They observe the decline of substantive reason, the differentiation of science, morality and art, the modern world view and its merely procedural rationality, with sadness and recommend a withdrawal to a position *anterior* to modernity. Neo-Aristotelianism, in particular, enjoys a certain success today. In view of the problematic of ecology,

64 Jürgen Habermas

it allows itself to call for a cosmological ethic. (As belonging to this school, which originates with Leo Strauss, one can count the interesting works of Hans Jonas and Robert Spaemann.)

Finally, the neoconservatives welcome the development of modern science, as long as this only goes beyond its sphere to carry forward technical progress, capitalist growth and rational administration. Moreover, they recommend a politics of defusing the explosive content of cultural modernity. According to one thesis, science, when properly understood, has become irrevocably meaningless for the orientation of the life-world. A further thesis is that politics must be kept as far aloof as possible from the demands of moral-practical justification. And a third thesis asserts the pure immanence of art, disputes that it has a utopian content, and points to its illusory character in order to limit the aesthetic experience to privacy. (One could name here the early Wittgenstein, Carl Schmitt of the middle period, and Gottfried Benn of the late period.) But with the decisive confinement of science, morality and art to autonomous spheres separated from the life-world and administered by experts, what remains from the project of cultural modernity is only what we would have if we were to give up the project of modernity altogether. As a replacement one points to traditions which, however, are held to be immune to demands of (normative) justification and validation.

This typology is like any other, of course, a simplification, but it may not prove totally useless for the analysis of contemporary intellectual and political confrontations. I fear that the ideas of antimodernity, together with an additional touch of premodernity, are becoming popular in the circles of alternative culture. When one observes the transformations of consciousness within political parties in Germany, a new ideological shift (*Tendenzwende*) becomes visible. And this is the alliance of postmodernists with premodernists. It seems to me that there is no party in particular that monopolizes the abuse of intellectuals and the position of neoconservatism. I therefore have good reason to be thankful for the liberal spirit in which the city of Frankfurt offers me a prize bearing the name of Theodor Adorno, a most significant son of this city, who as philosopher and writer has stamped the image of the intellectual in our country in incomparable fashion, who, even more, has become the very image of emulation for the intellectual.

Translated by Seyla Ben-Habib

References

1. Peter Steinfels, The Neoconservatives (New York: Simon and Schuster, 1979), p. 65.

PART TWO

Art and Society: Ideological Criticism

On the subject of ideology in art, critic Lucy R. Lippard writes that

it is understood by now that all art is ideological and all art is used politically by the right or the left, with the conscious and unconscious assent of the artist. There is no neutral zone.¹

What Lippard contends is that political meaning is attributed to all art, regardless of subject matter or intention of the artist. She also observes that

the word "ideological" is used in the artworld interchangeably with the word "political" to describe art from the left, as though the center and right were so secure in their dominance that they had no need of such things.²

In the art world the term "ideological" has become politicized by being made synonymous with the political Left; it has become coded to imply pro-Marxist and even anti-democratic thinking. At times the result has been not only to reduce ideological art to the level of political propaganda (usually Leftist), but also to suggest that propaganda is something in which the center and right do not engage. The effect has been, according to Lippard, to make

Bourgeois ideology—that propaganda so thoroughly encompassing us that we barely recognize it as such—. . . appear more passive, downright harmless, like the dictionary definition of "ideology"—"the science of ideas."³

Coding of the term "ideological" to make it refer exclusively to the Left is itself an ideological act intended to undermine any art to which it is applied. It is likewise an ideological act to masquerade bourgeois ideology (ideol-

66 Part Two

ogy of the center and the right) as the "science of ideas" rather than recognizing it as another kind of propaganda.

Today, anyone seriously concerned with art cannot ignore the question of how art functions socially and politically. This question is fundamental to the ideas of the nineteenth-century German philosopher Karl Marx. So much so, in fact, that it is impossible to discuss ideological criticism without examining Marx (who actually wrote little specifically about art) and the Marxist critical tradition that developed from his ideas.

Unfortunately, as Lippard's remarks indicate, the deep-seated partisan political issues involved have often made this difficult. Anti-communist sentiment, which was already apparent in America by 1920, reached a new level of intensity with the division of the world's military powers into confrontational blocs (communist or socialist versus capitalist) after World War II. In the years following the war, political propaganda has been mobilized by respective sides to champion their social and economic systems. For the United States, this meant the denunciation of Marxism and Communism, something that led to the "Red Scare" hearings of Senator Joseph McCarthy in the early 1950s and participation in the Korean and Vietnam wars, wars waged against "world" communism and what Ronald Reagan in his early presidency called the "evil empire."

Such relations belied the fact that Marxism has had a strong influence on Western European and even American thought, especially in the years before the Nazi-Soviet Non-Aggression Pact of 1939 (signed by Hitler and Stalin) disillusioned most American intellectuals previously sympathetic to communism. By the late 1970s, in the aftermath of Vietnam, the influence of Marxist ideas became more widely recognized, and Marxism has since experienced a resurgence, most notably in the area of culture studies where it has been recognized by many scholars and critics as a legitimate and sophisticated philosophical method of critique.

Marx, whose philosophy developed in the climate of mid nineteenthcentury industrialism, saw man's relation to the physical world, particularly to modes of production, as the driving force of history. In this sense, his is a philosophy of materialism centered on economics. According to former Marxist art critic Peter Fuller,

in contrast to the classical economists, Marx described the historicity of the economy and demonstrated that, broadly speaking, changes in the mode of production produced changes in social, political, and cultural life. Marx came to describe the economy as a base, or structure, upon which a superstructure was erected consisting of such elements as law, politics, philosophy, religion, art, etc., the specific ideological forms of which were determined by the base.⁴

Marx believed society is best understood as a class struggle along economic

lines—proletariat or working class and bourgeoisie or owners of factories (the means of production). Since these classes have differing economic interests (e.g., the workers wanting higher wages and the owners lower wages), they were in conflict. Thus, while the exact relationship between economic base and superstructural elements (legal, political, philosophical, religious, artistic) is complicated, these elements nevertheless play a role in class conflict (economic struggle). As a result, Marx reasoned, the superstructure must be an instrument, however disguised or unconscious, economically benefiting the dominant, controlling class (the wealthy) at the expense of the weaker, working class (the proletariat).

Developments in the means of production, Marx pointed out, caused fundamental changes in social relations and attitudes.⁵ Marx defined early (precapitalistic) societies as organic, naturally developed communities based/dependent upon nature. In developed capitalist societies, individuals become dependent upon (subjected to) the economic system of the marketplace where commodity production (production of goods for the creation of surplus value—profit) dominates. The result of this is that society, which had existed as personal relationships between individuals, is transformed into a relationship governed by the needs/laws of commodity production. Older traditions and values that had given the individual purpose and life meaning are replaced by the values of efficiency and profit. Technical mastery and efficiency in the name of profit cause a loss of personal autonomy, leaving the individual psychologically alienated so that ultimately, in developed capitalist society, social relations become relationships of things, or "reified" ("thingified").

Furthermore, Marx noted, as the commodity production system develops, it appears to have a life of its own; it seems to initiate economic change (uncontrollable cycles of economic booms and depressions) as if it were, in fact, a natural force. This perception is usually called fetishism or fetishisation, while the belief that commodities have an active, inherent value is called commodity fetishism.⁶

From Marx's conception of base/superstructure are derived the most important features of Marxist thought. As Maynard Solomon writes,

many of Marxism's decisive formulations deal with various aspects of the veils which conceal economic and material reality from consciousness; the fetishism of commodities, reification, . . . false consciousness, ideology . . . all of these are aspects of the illusory consciousness which constitute the negative reality of class society.⁷

He adds:

the Marxist critique of capitalism aims to pierce the disguise, to make known this negativity, to liberate consciousness and thereby to move closer to the

68 Part Two

abolition of the prevailing mode of production and beyond it toward the self-realization of humanity. $^{\rm 8}$

In other words, Marxist critiques seek to expose the ways in which disguised superstructural elements function, especially through cultural modes, to create false notions of reality (false consciousness) for the benefit of one class in domination of another.⁹

The belief that this scenario could be reversed, that changes in the superstructure could be effective in producing changes in the base, had important consequences for art. Rather than simply studying art as a way to analyze the superstructure, attempts were made by Marxists such as Lenin and Stalin to change art, to make art politically committed so as to affect or stabilize changes in the base. "Let us rid ourselves of men of letters without a party! Let us rid ourselves of literary supermen!" Lenin, father of the Russian Revolution, wrote in 1905. "The cause of literature must become a part of the general cause of the proletariat, ...,"¹⁰ This attitude against "uncommitted literature" was directed at Modern literature (and art) having formalist, abstract tendencies; later it was invoked during the Stalinist era in the Soviet Union to suppress Modern art and to promote a Social Realist style of art that was figurative and narrative and readily understandable to the masses. Such a style, it was hoped, could become an ideological element of the superstructure reinforcing the changes in the economic base initiated by the Bolshevik Revolution.

Leon Trotsky, though a friend of Lenin, took an opposing position on this issue. Supporting artistic and aesthetic freedom, he wrote in 1924 that

it is quite true that a work of art should never be judged, accepted, or rejected on the basis of Marxist principles. The products of artistic creation must be evaluated first and foremost on the basis of their own laws, that is to say the laws of art. 11

Trotsky's position in support of aesthetic freedom represented a challenge to the dogmatic Marxist conception of art associated with Stalin and to the later repression of Modern art in the Eastern bloc.¹²

With the collapse of the Soviet Union and the Eastern bloc countries in the early 1990s, Marxists have had to confront some serious and uncomfortable issues regarding Marxist theory and the Communist social order. As Marxist art historian Andrew Hemingway notes, there is the question of the failure of Marxist "historical materialism to account for the resilience of capitalism, the non-appearance in the [industrialized] West of a revolutionary proletariat . . . , and the repressive character of those societies in which there was, at least formally, collective ownership of the means of production."¹³ In other words, while the working class in the capitalist West has flourished, in the Soviet Union and the Eastern bloc countries life had been characterized by severe economic deprivation and Draconian repression by the state. Marxist theorists have also had to contend with the possibility that Marx's concept of economic class struggle, as the basic force operative in all social relations, may be too simple a construction to be useful. As the current political arena in America (with its various coalitions organized along gender, racial, ethnic, and religious lines) makes clear, groups do not identify and define themselves solely along economic lines.

Because of this, today, the Marxist tradition, when used to critique modern, developed societies, increasingly centers on cultural modes rather than aspects of economic class and industrial means of production. In such societies culture, viewed in the larger sense of the word (encompassing kitsch, popular, and high art), has become increasingly visible, pervasive, and economically important because it is the site where commercial interests, status, and power often collide. It is this "culture industry," operating in conjunction with art institutions and the media, that is now playing a crucial role in the formation of social and political reality/consciousness rather than solely economic interests.¹⁴

In her review of the "underground" art exhibition called "The Times Square Show," which is reprinted here, Lucy R. Lippard reveals the complexities involved in such critiques, especially as they relate to aesthetic issues. Exhibiting in a deteriorating building, not an official art space, she believes, was an act of rebellion against the art "establishment." "By virtue of its location alone TTSS was 'political," says Lippard. But in terms of specific imagery, "even though the general issues were easily identifiable it was often impossible to tell where the artists stood on them." Do pictures of guns, money, sex constitute statements in themselves, asked Lippard, or are they a kind of media kitsch, "middle-class TV terrorism"? Are these images signs of art's corruption by kitsch (as foretold by Greenberg) or are they seriously engaging social issues?

This is difficult to tell, says Lippard. It seems "these images are rarely meant as satire or protest, but intend rather to focus if not on the object then on the act—of dancing on the razor's edge...." This attitude toward art is possible because, as Lippard laments, it is believed that art "is supposed to be either above it all or below it all but not part of it all"; it is believed art should be a special realm of "purified" aesthetic experience— "fantasy without action." "I keep coming back," writes Lippard,

to the way "politics" floats so politely in this iconoclastic but still "art" context. I've complained before about the assumption that style alone (as opposed to image) can make a political statement—the idea that badly printed photos and harsh tabloid graphics attached to no matter what kind of irresponsible or undigested imagery is "political."

70 Part Two

Lippard concluded that style—in this case punk—quickly became ineffective politically because it became art-world chic; the seriousness of its imagery was quickly absorbed as fashion. She did note that exhibiting in art-world institutions has advantages; the work of art is provided with a contextual discourse (involving the history of art and critical thought) which the artist uses; also, art-world institutions provide informed audiences who are generally aware of this contextual discourse. These are elements usually absent in the outside world of Times Square where images of nudes and guns have a different interest and effect; as Lippard observes, "a socioeconomically mixed audience gets mixed signals" from works of art. On the other hand, however, art-world institutions resist attempts to create genuine political contexts and discourse for works of art by encouraging works to be seen and discussed solely in terms of style and form.

Aside from the many questions raised, the "Times Square Show" did have positive aspects. By its being outside the art mainstream and by the "disenfranchised art" it showed, the "Times Square Show" did hint at a way to make art less exclusive by offering the possibility of "mass production [of art] by the masses instead of *for* the masses."

In his essay reprinted here, "Since Realism There Was . . . (On the current conditions of factographic art)," Benjamin H. D. Buchloh confronts the issue of how art can be politically effective given the complicated structure of art-world institutions. He poses the opposition "ideological art" versus "aesthetic art" as a way of examining how art can be both. Like Lippard, Buchloh believes political subject matter is not enough. The artist must be aware of the ways in which art-world institutions function as part of the superstructure and thus are forces shaping the meaning of art. Truly ideologically effective art must take this into account and examine the conditions under which it is produced and distributed. Artists in this exhibition—such as Fred Lonidier and Allen Sekula—writes Buchloh,

can reflect upon the actual situation of their work in relation to the ideological apparatus: the social institution of art within which it is contained and the forms of discourse within which it is determined. They can realize that condition as a determining factor and gauge its importance—in comparison with the work's actual claims for political reality, operational interference, and substitution of aesthetic knowledge for ideology.

Artists must question how art functions in the special, aestheticized realm of the art world (that is, how that world constructs and conditions the meaning of their work) and how art functions outside that realm in relation to mass audiences and real life.

Like Clark, Buchloh attributes the influence of what he calls "Kant's rigorous confinement of the aesthetic to the disembodied and the disinterested" as the cause of both art's elevated status and its separation from life as an autonomous realm of the specialist, the avant-garde artist. In such a system as this in which universal elements of form are elevated over iconographical and narrative elements, political art (despite its interest in subject matter and discursive content) becomes subsumed to the pleasure of aesthetic contemplation as a mere art experience. If Picasso's *Guernica* were used as an example of this, it would mean that the image, not the historical event to which it refers—the German bombing of the Basque town of Guernica during the Spanish civil war—would become the aesthetic focus of attention, effectively depoliticizing the work. Writes Buchloh:

We recognize, after all, that it is our desires and our pleasures as they can be fulfilled by contemporary art production which are the most secret and reliable agents of dominant ideology: like all other superstructural instances (the moral and legal code, religious belief, family structure and the construction of sexuality), it is the attachment to aesthetic desire and aesthetic pleasure that guarantee . . . our archaic modes of perceptual and cognitive behavior.

Buchloh believes that the aesthetic distancing of art from economic, political, and social reality is being countered by an anti-aesthetic position.

This position which Lonidier and Sekula assume in their work refuses to see artistic practice as being disembodied from the matter of the social and political reality upon which it is imposed as a superstructural function and it insists on a dialectical critique and tries to dismantle the very centralizing institutions within which it is constituted, contained, and isolated as a discursive practice.

An anti-aesthetic strategy, Buchloh suggests, is a way of avoiding neutralization of art's content by developing a dialectical critique exposing the inherent contradictions between the representation of things in art and the representation of things in real-life situations. In Sekula's work, it is the "analytical approach to the construction of representation and its mediations that justifies . . . the work's . . . insertion into an aesthetic context."

The "factographic" nature of the work, which Buchloh defines as the need "to expose and clarify the construction and operation of representation within present day reality," distinguishes work of this type from much contemporary aesthetic practice. Because critique in "factographic" work is directed toward representations, it can function both inside and outside the art world; it can engage audiences in both art and real-life spaces (schools, union halls, subways). Buchloh anticipates that "the first argument that will of course be leveled against this type of work is that this work simply cannot be 'art'..." This is indeed the position of neo-conservative critic Hilton Kramer.

Lippard identifies the definition of "ideology" used by Buchloh and

72 Part Two

others as the "activist definition"; she says it is fundamentally critical in that "it analyzes what *affects* us in words and images—what it hides and whom it serves by what it says and what it hides, and how it can be used to our own ends."¹⁵ Following this, to most critics on the Left, aesthetic purity (in the Kantian sense) is seen as promoting an ideology of disinterestedness and conformity. Because of this it must be avoided so that the real relation between facts and perceptions of reality can be revealed and understood. Contradictions between what is thought to be inevitable and actually is inevitable must become apparent to the spectator to awaken critical consciousness, demystify power, and demonstrate that change is possible.

It is such ideas as these, especially as they pertain to art's aesthetic dimension, that Hilton Kramer questions in his essay reprinted here and titled "Turning Back the Clock: Art and Politics in 1984." Through a wave of exhibitions, symposia, and publications, the exhortation is being made, writes Kramer, to abandon artistic criteria and aesthetic considerations.

The message is invariably the same: in art, priority must now be given to a politically inspired "content," . . . ; and in criticism, the governing assumption is a belief that all claims to aesthetic quality are to be regarded as mere sub-terfuge, masking some malign political purpose.

Here Kramer clearly intends an attack on Marxist ideas concerning the connections between art and culture in the foundation of social/political reality. In particular, he registers a complaint about political content being given such priority as to lead to a rejection of aesthetic quality as a primary element of art.

Kramer's ideas about aesthetic quality echo those of Greenberg and are fundamental to his very definition of art. Works such as those of Nancy Spero, Hans Haacke, Fred Lonidier "are not only devoid of any discernible artistic quality, they are pretty much devoid of any discernible artistic existence." For Kramer, they not only cannot be experienced as art in any traditional sense, but are not intended to be. So why are they placed in the art context?

Their purpose in being entered into the art context, . . . is not only to score propaganda points but to undermine the very idea of art as a realm of aesthetic discourse. President Reagan . . . may be the immediate object of attack, but the more fundamental one is the idea of art itself.

As Kramer sees it, we are now witnessing an attempt to force a return "to the radicalism of the Thirties when so much American cultural life was dominated by the hypocritical 'social consciousness' of the Stalinist ethos." This is being done, Kramer believes, in order to confine the life of the artistic imagination to a contemporary version of this "social consciousness."

Kramer's aesthetic position toward art (one of disinterested contemplation in the Kantian sense) forms the basis of his opposition to the work of artists such as Haacke, Spero, Francesc Torres, and Sekula. This opposition is presented as nonpartisan, nonpolitical support for continuing aesthetic quality in art. If, as critics such as Buchloh contend, defense of a status quo serves to support an existing social and political structure through the formation of consciousness (something such structures require in order to function), then Kramer's insistence on continuation of aesthetic quality as the criterion of judgment in art cannot be viewed simply as a defense of art. It must be seen, as Buchloh demonstrates with the work of Sekula and Lonidier, as supporting the existing social and political order. In this sense, Kramer's emphasis upon aesthetic quality would not be a disinterested position. And, as Lippard points out concerning the ideological uses to which art is put, however veiled or disguised these uses might be, they serve political and social interests and make art (and the aesthetic positions which lend art support) complicit in the formation of ideology.¹⁶

However, Kramer's point may not be totally ideological or without merit. For, if artists abandon all interest in aesthetic qualities in an effort to be activists, loading their work with written texts and photo and video documentation, how will their work be distinguishable from journalistic reportage and documentation? In short, regardless of its political leanings, can work without an aesthetic component still be considered art? This is an important issue, one that was widely debated when the *1993 Whitney Biennial* exhibition presented the video of the Rodney King beating as part of the exhibition.

In "Crowding the Picture: Notes on American Activist Art Today," which is reprinted here, Donald B. Kuspit raises concerns about this issue and what he sees as a split between the so-called *vita contemplativa* and *vita activa* (i.e., formalist art and activist art). He begins by asking, "What if the integrity proposed by the esthetic [formalist] position is insufficient, and the kind of change demanded by the activist approach is disingenuously inhumane?" In response to this question, he notes that today "the traditional notion of a singular heroic identity no longer does justice to the complexity of our social relationships, nor to the subtleties of our moral situation." Because of this, he advocates an art that "synthesizes the esthetic and activist impulses—one that addresses our humanness with depth and fullness...."

To do this, however, is not a simple proposition because, in American society today, though one identifies with the "crowd," one also has a sense of being isolated and alone. For, as Kuspit points out, "loneliness is the umbilical bond to the crowd. One cannot think of mass man without thinking of the loneliness that is innate to him. To be of the lonely crowd is to feel both an irreducible isolation and an irresistible belonging."

74 Part Two

It is this situation that art must address. Yet, Kuspit doubts whether typical activist art can; he doubts whether typical activist art can rouse the lonely crowd to action in the name of some cause, to get it to throw off the chains of loneliness to create a community. Following the thinking of Jacques Ellul, he argues that for art to do this, to inspire such a response, it "must 'penetrate through the common experience to the actual situation,' [it] must grasp social reality creatively, that is, 'from within . . . as a situation with a human being in it,' [it] must wed insights to 'the potency of form' that goes 'beyond mere talk'" rather than reinforcing, however inadvertently, "the very structures it seeks to undermine."

This is something he believes much contemporary activist art does not do. Critiquing the work of various activist artists including Leon Golub, Martha Rosler, Jenny Holzer, and May Stevens, he points out how a true activist art must question *all* stereotypes (not just convenient ones), how it must work for true change (not just acquire the look of change acceptable to the gallery/art world), and how it must be careful not to offer new myths of conformity in place of old ones. As instructive examples, he cites the late work of Goya and David's *Death of Marat* as truly creative activist art. They break through the "lonely crowd" mentality offering a mode of intimate identification with another human being, a mode, Kuspit believes, "by which one can achieve significant change, both personal and social."

Today, piercing the veils that disguise the functioning of superstructural elements which conceal economic, political, and social reality from consciousness, creating false consciousness, has turned out to be one of the most important tasks that criticism has established for itself. As in the issue of aesthetic quality versus activist art, it is recognized that culture (especially in the wider, more popular sense of the word) plays a vital role in the creation of consciousness; thus, criticism has shifted attention in this direction. Critics such as Lippard, Buchloh, and Kuspit, using Marxist-influenced methodologies, and Kramer, using more traditional ones. examine how culture, cultural institutions, and cultural attitudes are powerful ideological mechanisms. In particular, they focus on how the structure of art-world institutions, even what today has become the "institution" of activist art itself (by the attitudes and presumptions it engenders, by the artists and kinds of art it selects, by the type of criticism it supports) is an apparatus that fosters beliefs directly affecting perceptions of reality, status, power, and money.

Notes

- 1. Lucy R. Lippard, "Give and Take: Ideology in the Art of Suzanne Lacy and Jerry Kearns," *Art & Ideology*, exhibition catalogue, The New Museum of Contemporary Art, New York, 1984, p. 29.
- 2. Lippard, "Give and Take," p. 29.

- 3. Lippard, "Give and Take," p. 29.
- 4. Peter Fuller, "In Defence of Art," *Beyond the Crisis in Art* (London: Writers and Readers Publishing Cooperative Ltd., 1980), p. 239.
- 5. Economic connections between means of production and the concept of commodity production indicate something of the complexities involved in base/superstructure relationships. For example, in a simple barter economy, the commodity (any "useful" object) is traded for other useful objects. With the development of industrialism (and costly machinery), such great quantities and varieties of commodities are produced that money becomes the "commodity" exchanged for goods and labor. Price is a factor of cost of production, not usefulness or use-value. If the price of goods is greater than cost of production, money is left over (surplus value) that usually goes to the owner of the machinery. Class conflict often arises between owner and laborer over surplus value; it is for this reason that Marxists speak of the desirability of workers owning "the means of production." Eventually, in advanced capitalist societies, labor and goods become equated with, are "abstracted" into, money. Money, in this way, becomes the defining principle of social relations.
- 6. The use of the term "fetish" in Marxist contexts should not be confused with the Freudian term "fetish" which refers to any object to which one is attracted as a sexual substitute.
- 7. Maynard Solomon, *Marxism and Art: Essays Classic and Contemporary* (New York: Vintage Books, A Division of Random House, 1974), p. 19.
- 8. Solomon, Marxism and Art, p. 19.
- 9. The idea that consciousness not only was a cultural construction, but that it was constructed to serve class interests, stems directly from Marx's ideas. Marx, who believed that men "begin to distinguish themselves from animals as soon as they begin to *produce* their means of subsistence," attempted to demonstrate that developments and changes in society and its thinking (consciousness) are caused by changes in means of production (subsistence). As these changes occur, men also change "their thinking and the products of their thought [consciousness]," wrote Marx. Thus, "it is not consciousness that determines life, but life that determines consciousness." Karl Marx and Friedrich Engels, *German Ideology* (1845–46), reprinted in *A Handbook of Marxism*, ed. Emile Burns (New York: Haskell House Publishers Ltd., 1970), pp. 211–213.
- Lenin, as quoted in Henri Arvon, Marxist Esthetics, trans. Helen R. Lane (Ithaca & London: Cornell University Press, 1973), p. 15.
- 11. Leon Trotsky, *Literature and Resolution* (1924), as quoted in Arvon, *Marxist Esthetics*, p. 18.
- 12. Trotsky's views were responsible for his exile from the Soviet Union in 1929 and his murder, believed to have been at the instigation of Stalin, in Mexico in 1940. His ideas in support of aesthetic freedom were known by American intellectuals in the mid-'30s and have an obvious connection to the ideas of aesthetic purity that Clement Greenberg began developing in the late '30s.
- 13. Andrew Hemingway, "Marxism and Art History After the Fall of Communism," Art Journal (Summer 1996), p. 20.
- 14. Today, myriad factors are recognized as affecting social relations and the base/superstructure. Marxism has had to progress beyond a model based simply on use-value and need in order to explain the way fabrication/falsification of need occurs through psychological and other means. It is especially evident in late capitalist society that need is being replaced by desire; because of this, the word "desire" often replaces "need" in later Marxist writing. Advertising is only the most obvious device through which desire is created.
- 15. Lippard, "Give and Take," p. 29.
- 16. An instructive example is the work of Hans Haacke which has come under attack by Kramer for aesthetic reasons. In 1971 Haacke was offered a solo exhibition at the

76 Part Two

Guggenheim Museum in New York. One of the works he intended to show was Sol Goldman & Alex Dilorenzo Manhattan Real Estate Holdings: A Real Time Social System, as of May 1, 1971. An investigation of actual real estate holdings, the work became sensitive to the museum because prominent community members were involved, and eventually the exhibition was cancelled. To attribute this cancellation to artistic/aesthetic factors and not social/political factors betrays the difficulty in believing a purely aesthetic position separates art from ideology. In actuality it is context, not formal aesthetics, that makes art ideological (this is clear from the contradictory aesthetic positions held by Stalin and Trotsky).

Sex and Death and Shock and Schlock A Long Review of "The Times Square Show" by Anne Ominous

LUCY R. LIPPARD

Overheard in downtown art territory: "Have you seen The Times Square Show?" "Not yet, but I hear it's the best thing around." "That's not what I heard."

The Show

Well, by now everybody's heard something about "The Times Square Show"-a sleazy, artist-organized extravaganza in a deteriorating former massage parlor on Forty-first Street and Seventh Avenue in New York City. Abundant press coverage has been as contradictory as the show itself. Word of mouth to mouth has often been tongue in cheek. What makes TTSS noteworthy, no matter what one thinks of the art in it, is the levels it offers. TTSS is an organizational feat-an object lesson in object organizing by artists. It is a weird kind of cultural colonization that worked because colonizers and colonized had something in common; an exhibition of "unsalable" works accompanied by a gifte shoppe that managed to sell just such works-cheap; a constantly changing panorama of esthetic neuroses; a performance and film festival; a throwback to the early '60s happenings-and-store-front syndrome; a sunny apotheosis of shady sexism; a cry of rage against current art-worldliness and a ghastly glance into the future of art. It's also a lot of knives and guns and money and dirt and cocks and cunts and blood and gore housed in four wrecked floors (plus basement) donated to the organizers by the landlord.

Copyright © *Artforum*, October 1980, "Sex and Death and Shock and Schlock: A Long Review of "The Times Square Show"," Lucy Lippard. Reprinted with permission of the author and publisher.

78 Lucy R. Lippard

The extraordinary transformation of the space over two weeks was noticeable only to those who saw it both before and after, because after imitated before, littering the floors with sawdust, the corridors with broken glass, the walls with graffiti, despite preshow cleaning and repainting and putting in windows. Neat art was out, and those who risked it made art that stood out. Every inch of the space was tarted up with art or an unreasonable facsimile. Some of it was barely recognizable as such, which is how you knew it was avant garde. At the same time, works came and went and changed places and evolved. There were some 100 artists included, with the makers of the "Exotic Events" that took place several times a week. At the beginning the organizers (the artists' group Collaborative Projects, Inc., or Co-Lab, and friends and some enemies) asked for "proposals" like any self-respecting institution. Because of the success of their previous shows (including the "Manifesto Show," the "Doctors and Dentists Show," the "Money Show" and "The Real Estate Show"), they were swamped with would-be exhibitors. The result was the kind of chaos in which the group operates best anyway. Artists who persisted made work that existed—as far as I can tell from the experience of an Australian friend of mine, unknown to and not exactly well-received by the organizers, but with the self-confidence not to slink off rejected. I shudder to think about how the various spaces were appropriated, but people found their niches-in closets, dark halls, toilet stalls, ceilings and stairways. (No list of artists appeared, most of the work wasn't signed, and there were no nice typed labels.)

A huge banner on Seventh Avenue announced the show. Below it from a row of unglassed windows, taped music and laughter wafted in the Fashion Avenue breezes, mixing with the fast-food odors of the diner below them. Around the corner was a big store window and a bright yellow "naïve" mural by a Czech and German group called NORMAL on the walls of "The Gift Shop," which was in some ways TTSS's most innovative aspect. The average price was five dollars, and there was plenty to buy for a quarter or a dollar ninety-nine; the idea was that if something didn't sell in the first few days it would have disappeared; featured were chatchkas for the downwardly mobilized: a winged penis, a pornographic fan, pill capsules with messages, books, posters, etc. The usually silver lobby with its blasting jukebox, bandstand, shabby plastic couch and miscellaneous artworks, including a large montage drawing of a beaten Black man hung by chains, offered a certain casual reception. But dim stairs beckoned up and down.

The Art

It would take longer to describe than to see. Here are some of the things I was moved by or involved by:

A red-painted stairway ending in a huge comic-graphic gun/arrow

bent around a corner; phrases and photos (and deaf alphabet translations) on walls and stairs. Descending you got "We all lose in the end" on the wall; going up you got "But the loss is kept obscure" and on the steps "Quick with your lip bite your tongue."

The dark, low-ceilinged basement room totally covered with blackon-white handprints ("in touch with the space") inhabited by an ambiguously sexed, painted figure wielding a circular beam of light; vantage points marked in the room; the piece not an "alien" as some would have it, but an illusive/allusive statement about control by a male feminist. Back in the shadows, another artist's wax paper "ghost."

A room wallpapered with money and rats.

"Marginal Economy," a miniature board fence plastered with photos of Black people and vacant lots.

The "Portrait Gallery" containing, among other things, ceramic heads of the eight U.S. soldiers killed in the "rescue attempt" in Iran, the ubiquitous and exuberant painted plaster heads of South Bronx residents, and some conventional paintings that gained interest from their context.

Varnished and garnished with marbles, wooden clubs hanging overhead in a short corridor.

A room (most effective at night) with a chicken-wire woman on bed springs holding a prayer book, an ominously gleaming gold plaster bust of a Black man "seated" in a shoddy armchair; an altar to violence in the closet; a skillfully painted pink pig labeled "The pig is the only domestic animal raised exclusively for slaughter"; a videotape of the Panthers on TV and "Revolutionary People's Communications Networks Voodoo Comics" wallpaper.

A tawdry "nest" in an upstairs closet filled with cloth, tinsel, satin, leopardskin smelling of stale perfume and makeup and of the loneliness and ugliness of a whore's fantasy and reality.

Some quite traditional, or just the opposite, figure paintings not on black velvet but on large cowhides.

Ceramic snakes' heads jutting over a stairway door.

Black-and-white raw cartoon montages self-critically parodying Macho and festooned (coincidentally) with dainty blinking Xmas lights ("MACHO ME, ME ME"; "MACHO PLAY, BANG BANG BANG"; "MACHO WORK, BOOM BOOM BOOM"; MACHO MACHO, HOT CHA CHA"—a message also echoed in a big "Stupid Victor" mural by the same artist).

A room of collage installation protesting the Virgin/Whore image of women and the violence promoted by porn, complete with mermaid, bride, witch, nurse, madonna and little girl stereotypes crudely daubed with paint and arrayed with pink plastic tits and accompanied by porn magazine collages.

A long funny sad narrative revealed sequentially between the black bars of a manually cranked "peep show" machine.

80 Lucy R. Lippard

A punching bag hung before an open black wall labeled "Diletante Guerillas" (*sic*) and enthusiastically chalked with audience responses.

A fringed white "rug" (under the punching bag) with advertising images of money inscribed "Chase Man" and "publicity is the culture of the consumer society" and "when times are hard, capitalists display images of money to make self-determination by the poor appear impossible" and "Walk Over Capitalism." Behind it, out the window, is a view of Chase Manhattan itself, Times Square Branch (is its money dirtier than money elsewhere?).

And a hand sink overflowing with grimy salt crystals, and some terrific feminist comic-strip posters, and a room of painted clothes, and SAMO's critical graffiti, and "Take Back the Night" scrawled here and there, and a scab-picker's bathroom of peeling red paint I liked better than the work in it, and a garbage and rat fountain and the ubiquitous decorated machines and a lot of other Indescribable Things. . . . You get the picture?

The Issues

TTSS was ostensibly about Times Square—that is, about sex and money and violence and human degradation. It was also about artists banding together as pseudoterrorists and identifying with the denizens of this chosen locale—envying them and imitating them at the same time as colonizing them, thus rebelling against the cleanliness and godlessness of the artworld institutions, "alternate" and otherwise. It was also about artists making a microcosmic strike for economic independence and control of their products through the store, and the more-or-less "open" exhibition. (It is an illusion that Co-Lab is some sort of pariah working "outside the funding structure" when in fact they have a persuasive touch for or on official funds and a talent for PR that Show World should envy.)¹ Most important, TTSS, like all the other Co-Lab "theme shows," was about art being about something other than art.

While the energy of the whole heady mixture was a much-needed antidote to the mechanical novelty of today's art world, I didn't admire the contents of TTSS as much as I enjoyed them. As a whole the show did successfully appeal to a fairly varied audience—locals as well as disillusioned sophisticates, cynical radicals and chic seekers. This accomplishment can't be underestimated. It is very rare that even the best-intentioned artworld offspring communicate outside their own yards. What I worry about is the depth of commitment even in that work I got my kicks out of. (Maybe I shouldn't ask for more? Gift horses and all that?)

I know from TTSS's organizers' past activities that "politics" was a major impetus. (However, the word was not mentioned on the press release, which was all fun and games; it did appear on the jazzier street poster, listed generically with "art, performance, film, video, store and music.") By virtue of its location alone TTSS was "political." But even though the general issues were easily identifiable it was often impossible to tell where the artists stood on them. Many seem to have thought that pictures of guns, pictures of dollars, pictures of sex (actually pictures of *women*, since women and sex are interchangeable, right?) constitute a statement in themselves. This is a sort of reverse Magrittean situation ("This is not a pipe") in which the image carries all the weight no matter how fragile it may be. Or is this just the middle-class TV terrorism which, with S & M, is the dominant subject matter for so much new-no-nuwave art?

There's a lot of random violence—"I'm going to kill you" scrawled out of context on a wall; "How to Stop a Bullet and Live" on a poster—and a horrendous arsenal of weaponry aimed nowhere, unless it's at the spectator. Social criticism this is not, though it is a loud and clear expression of alienation. As far as I can tell, these images are rarely meant as satire or protest, but intend rather to focus if not on the object then on the act—of dancing on the razor's edge, coming down left or right with the risk of straddling the middle. A game of American roulette is being played with art as the itchy trigger finger. This is possible because art is supposed to be either above it all or below it all but not part of it all. Art, like pornography itself, is fantasy without action.² But TTSS—as a collaged whole—has managed to be very much a part of it all. Although more appropriately secretive than "The Real Estate Show," it is out of the white-walled isolation ward. Its madness is up front, upstairs and downstairs and in milady's chamber.

The studied crudity that is so much a part of TTSS is also a part of the pervasive level of political naïveté. Whether self-conscious or manipulative or innocent or consciously critical, it is the cutting edge these mostly young artists are looking for (in sex as well as art and politics, it seems; one participant suggested that the best review of this show might be from an informed psychosexual viewpoint). I keep coming back to the way "politics" floats so politely in this iconoclastic but still "art" context. I've complained before about the assumption that style alone (as opposed to image) can make a political statement-the idea that badly printed photos and harsh tabloid graphics attached to no matter what kind of irresponsible or undigested imagery is "political."³ And after some three years of the "punk" posters that paper SoHo, Tribeca and the Lower East Side, I'm getting sick of all the guns and skulls and racist/sexist slurs. (The latest is something about "Japs" and was included in TTSS events; it is presumably by someone for whom World War II only existed in the comic strips.) Even though these posters are often witty and eye-catching and an improvement on the Hallmark variety, it doesn't seem to me that the world situation is such that games around war and killing and race hatred are very funny. (Maybe it's just gallows humor, or shallows, or callow humor?) I'm

82 Lucy R. Lippard

angered that the *urgency* of so much of this art, in and out of TTSS, is being wasted on superficial fantasies—which is why Times Square is a sadly apt location.⁴

Those artists with an image of themselves as the daring agents of an esthetic catharsis would do well to listen to a 1939 statement by René Magritte, himself soon to become the darling of the bourgeois collectors:

The very special value accorded to art by the bourgeoisie brutally unmasks the vanity of its esthetic concepts under the pressure of class interests totally foreign to cultural preoccupations. The artist does not practice the priesthood that bourgeois duplicity tries to attribute to him [*sic*]. Let him not lose sight of the fact that his effort, like that of every worker, is necessary to the dialectic development of the world.⁵

There are also plenty of lessons to be learned from the historical fate of Dada, which seems to be a rather unfamiliar but approved source of much new art. A warning from George Grosz in 1925:

Dada was the breakthrough, taking place with bawling and scornful laughter; it came out of a narrow, overbearing and overrated milieu and, floating in the air between classes, knew no responsibility to the general public. We saw the insane end products of the ruling order of society and burst into laughter. We had not yet seen the system behind this insanity.

The impending revolution brought gradual understanding of this system. There were no more laughing matters, there were more important problems than those of art; if art was still to have a meaning it had to submit to those problems.⁶

"We're interested in taking up situations that activate people outside the art world," says one of TTSS's organizers. And Richard Goldstein of the Village Voice claims that TTSS "lets a certain class of artists in for the first time." Actually, Fashion Moda has been providing this model for two years, showing "nonart" and "street art" and mass-produced art in an open context and confusing the boundaries between high and low culture more consistently than any single situation can.⁷ In fact, to go back further, TTSS might have been concocted in the early '60s, along with Oldenburg's storefront on the Lower East Side, the grungy early Happenings, French "neo-Dada" (an unclean Pop or dirty old man), the March Gallery group's "Doom Show," Sam Goodman's "Shit Show," some Fluxus events and, more recently, the Guerrilla Art Action Group, the "Flag Show" (which landed three artists under arrest), the feminists' tampons and eggs in the Whitney, the Art Workers' Coalition's break into the Metropolitan Museum's trustees' dinner and so forth. So it's been Done Before. So What? The illusion of the new, like that of obsolescence, is fostered by competitive commercial interests.

That's what.

But the inclusion of "disenfranchised art" in both Fashion Moda and TTSS raised some other interesting questions about class which I can only suggest here. Goldstein called TTSS "three chord art anyone can play."⁸ Its ineptness, and the ramifications of that ineptness, were among its most endearing and significant attributes. It is becoming clearer daily to more and more people that rather than the lucky few making art so unsuccessfully for the unlucky many, the artists' role may be to open up the making and distribution of art to everyone as an *exchange* rather than an imposition, with empathy rather than condescension as the bridge. Mass production by the masses instead of *for* the masses. The do-it-yourself esthetic extended to art-making makes especially good sense in the economically depressed '80s and it is one of the goals of progressive artists today.⁹

So if schlock art is as valuable as shock art and if supermarket and sidewalk art is not to be looked down on—then what proportion of shows like TTSS should be just that kind of so-called kitsch? How much interclass and interculture leavening is necessary to get across the message? Would TTSS have been twice as successful in "activating people outside the art world" if it had consisted primarily of street art? Of dimestore art? Of calendar art? Of hobby art? Of straight porn? A marvelously ugly abstract sculpture in TTSS was made, I believe, by someone who had never shown in art places before. S/he probably wasn't interested in "ugliness," and would I like it so much if the whole show were nothing else? How eclectic can you get without losing the provocative point? How far from political issues can you stray, even with the best intentions, before you are "apolitical" like you're supposed to be?

For instance, TTSS's focus on sex had to include consideration of gender-a ticklish subject in these days of right-wing backlash against feminist strengths (and feminist moralizing). With a few exceptions, it was in fact neglected, along with significant contradictions raised around pornography by Women Against Pornography and its opponents in and out of the Women's Movement. Significant issues of exploitation were also ignored not merely that of the women who are made into disposable sex objects, but that of the men whose manipulated desires are also pretty pathetic. (One artist in the show wore a "sex for profit" T-shirt on opening night; his misogynous peep show had disappeared by the next time I was there.) Somewhere in the process, issues of censorship versus selection must have been confronted by the organizers, though as Richard Goldstein remarked, the solution was apparently to assure an antithesis for every thesis, rather than to reject "politically incorrect" art. But underlying such solutions is also the notion that any moral stance is uncool. Some disturbing aspects are illuminated by Deirdre English's definition of porn, which could double as a definition not only of "punk art" and of retrochic, but even of the valid goals of all avant-garde art:

84 Lucy R. Lippard

Pornography depends on shock value. It lives to violate taboos. Porn, by definition, undermines the norms, attacks our values, attacks respectability. Pornography is what you're ashamed of enjoying. Porn is the devil. Porn says, here is what I really think. You don't like it? So what?¹⁰

Artists with esthetic integrity usually get around such problems by using codes understandable to their audiences. But this dependence on context doesn't work when art, as in TTSS, moves out into the world; a socioeconomically mixed audience gets mixed signals. Take the evolution of the sexually exploited woman image. In the '60s (Pop Art), several male artists made bundles on nonsatirical blowups of soft-core porn. In the '70s, with the advent of feminism, it was safe to say that such an image was intended to be read one of two ways—as belligerent sexism or as satire/protest against that same sexism. With a little help from critics, curators and dealers, artworld audiences knew, more or less, where the artists stood, and read the images more or less as they were intended. By the end of the '70s, however, backlash and retrochic had confused matters again, giving rise to more thoughtful analyses of how art uses life and where the lines should be drawn. (Viz. the reprehensibly titled "Nigger Drawings" exhibition, which brought a crucial issue to the surface of art dialogue: Is art by nature merely neutral or can and must it mean something and take responsibility for that meaning or lack thereof?)

TTSS's images of hard and soft porn may have seemed quite daring and "real life" to an art audience. To the street audience they were probably downright opaque. On opening night two feminist women periodically performed a horrifying off-the-cuff five-minute piece with one of those lifesize inflatable female nudes one can buy around the corner. She has three useful orifices and the two performers, strapped onto huge dildos, used them in the most brutal ways possible, yelling things like "She likes it. She loves it. Don't you, dearie?" Two men kept muttering, "All you women ever think about is sex," and to the repeated question "Is This Turning You On?" one finally cried out, "NO. It's disgusting!" A woman in the audience yelled, "You got it, Baby." And the point of the performance was made.

Or was it! I could barely stand to watch it, even though my politics are those of the performers. A small boy watched the piece several times in rapt fascination. I don't know what the Times Square locals thought about it, but I do know that one of the performers, after thinking it over, decided they had made a terrible mistake in disregarding coding and context; they *were* turning men on. Similar conflicts haunted the otherwise lively virgin/whore room, made in collaboration by two young women. The stated message was the same: "Pornography Lies About Women." Women artists all over the country for a decade now have been making very similar collage and installation pieces, so the main interest of this room was the fact that it existed not in an art gallery or a woman's center but in the heart of

"enemy territory." Parts of it were strong enough to make the most hardened viewer shudder: the little girl's party dress adorned with nippleshaped colored candies, and the porn collage of split beavers labeled "Is This Sexy?" But again, I'm not at all sure that everyone who saw it answered with an unqualified "No." For those who don't share the artists' views, it had to be either scarv, cute, obvious, or-ves, sexv. Men came in for some degradation, too. A pair of cleanly professional photographs show a man being tortured—into the image of a woman, pincers pulling up breasts, etc.; a dancing Black puppet recalls the minstrel stereotype Black (James Brown notwithstanding). The show included a larger percentage of Third World artists than usual (which isn't saying that much), and women were well represented among its organizers and exhibitors. Yet after ten years of outraged satire, impressive women's erotic art, performances and pieces in which women overtly and covertly exploit their own bodies in an effort to liberate certain notions of sexuality from the vise of the dominant culture, and a still unabated plethora of works about the image of women in the media, much of the art in TTSS seemed pretty ineffective. It seemed mainly to exorcise individual esthetic taboos and cultural constrictions. maybe to pave the way for a more directly powerful statement. The same thing can be said, alas, for a great deal of current American "political art." I, for one, am so encouraged that such things exist at all that I find it hard to be harsh on them. However, if we don't have enough respect for these attempts to question their success and to urge them on to more expressive forms, then we so-called political artworkers are also failing at our tasks.

Speaking of which, I had planned to tape the responses of the various TTSS audiences and to use the comments as the basis of this "review." Life interfered and I didn't do it. Perhaps the analysis that could emerge from such raw material will come from the organizing group itself, which has, I hope, spent some time evaluating its own process and experience now that the show is down. What next? "The Death of Equal Rights Show" at the Statue of Liberty? Or the "Inflation Unemployment Show," which could take place in hot air balloons over City Hall? Or "The Whole Earth Show" at the Mudd Club featuring the Great Goddess? Or another "Sex and Death Show" by Hooker at Love Canal? Or the "Marathon Show" at Three Mile Island? Or the "Terrorist Show" (at last) at your local railway station? "The WASP Show" at Artists' Space? "The Class Show" at P.S. 1? Or maybe even "The Art Show" as a collaboration between Exxon and Mobil?

Notes

1. Richard Goldstein, "The First Radical Art Show of the '80s," *The Village Voice* (June 16, 1980); the sources acknowledged on TTSS's "Exotic Events" program are: New York

State Council on the Arts, National Endowment for the Arts, Beard's Fund, Robert Burden, Anfour Corporation, National Video Industries, Department of Cultural Affairs, Spectacolor, Inc., Sandra Devlin, Richard Savitsky, and II2 Workshop, as well as Anonymous.

- 2. Deirdre English, "The Politics of Porn," Mother Jones (April 1980), p. 20.
- Cf. Lucy R. Lippard, "Retrochic, Looking Back in Anger," *The Village Voice* (Dec. 1979); and "Some Propaganda for Propaganda," *Heresies*, no. 9 (1980).
- 4. Another bad pun on the locale emerges from the fact that some of these artists are, quite naturally, on the make and take. What about the embossed card I got admitting me to a "private reception" for TTSS, from 6 TO 9 P.M. on a Tuesday—traditional uptown gallery opening hours? How square are the times showing themselves to be? Note Rudy Burckhardt's 1967 film, *Square Times*. I understand this is already getting to be a problem for Co-Lab. It's a shame that artists have to take the brunt of a crisis of conscience that should be laid squarely on the lap of a society that has no idea what to do with artists and consequently dumps them in this no-person's land between a reasonable desire to support themselves by doing what they do best and "selling out." Nobody put this conflict better than Ad Reinhardt in his writings and cartoons. I hate to see this generation confronted with the same problem that has smothered previous political ardors in visions of sugarplums.
- René Magritte and Jean Scutenaire, "L'Art Bourgeois," in *Surrealists on Art*, ed. Lucy R. Lippard (Englewood Cliffs, N.J.: Prentice-Hall, 1970), p. 156.
- George Grosz, "Art Is in Danger," in Lucy R. Lippard, Dadas on Art, (Englewood Cliffs, N.J.: Prentice-Hall, 1971), p. 81.
- 7. See Lucy R. Lippard, "Real Estate and Real Art à la Fashion Moda," *Seven Days* (April 1980).
- 8. Richard Goldstein, "First Radical Art Show."
- 9. The notion of empathy's replacing condescension emerged from a symposium on social change art that took place in Cincinnati, June 1980.
- 10. Deirdre English, "Politics of Porn."

Since Realism There Was (On the Current Conditions of Factographic Art)

BENJAMIN H. D. BUCHLOH

The title of the exhibition "Art & Ideology" seems to invite misconceptions: first of all that the work in this exhibition differs from all other currently produced art in its relationship to ideology. Either the work in this exhibition is the kind of investigation that confronts ideology head on (as opposed to the one that "bathes in it"), or it is, due to its obsessive confrontational involvement with ideology, close to a point of merging with it. It is *ideological* art, as opposed to *aesthetic* art. In any case, the title offers us a liberal choice: we can be, but do not have to be, involved with ideology when we produce/receive art. If, however, we do focus on the ideological nature within which we are constituted, we risk depriving ourselves of the essentially aesthetic experience: the pleasure of symbolic liberation from ideology.

To participate in a venture with this title offers a moment of truth to the artists and to the curator. The artists can reflect upon the actual situation of their work in relation to the ideological apparatus: the social institution of art within which it is contained and the forms of discourse within which it is determined. They can realize that condition as a determining factor and gauge its importance—in comparison with the works' actual claims for political reality, operational interference, and substitution of aesthetic knowledge for ideology. They can, at the same time, reflect upon the degree to which the work has actually taken those determining conditions into account, or whether in its claim for a political confrontation with the conditions of ideology, it has in fact neglected to examine the very root of its proper existence in ideology and therefore has blindly fallen

This essay originally appeared in the catalogue to the exhibition Art & Ideology. Copyright © 1984 The New Museum of Contemporary Art. Reprinted with permission of the author and publisher.

88 Benjamin H. D. Buchloh

prey to the particular ideological conditions of the apparatus of art and its specific history and discursive features. They can reflect whether the truly ideological moment of the work then might not be the claim to deconstruct ideology effectively, not on the site of its constitution and operation, but outside of it, in a realm of pure intelligibility and practice, whether or not it has been contaminated by the inversion and transformation of meaning that the production of representation entails when it operates without reflection upon the conditions of production and distribution.

For the curator, the confrontation with the work opens a different perspective, the opposite in fact. In flagrante, so to speak, the curator can observe his/her operation within the institutional apparatus of art: most prominently the procedure of abstraction and centralization that seems to be an inescapable consequence of the work's entry into the superstructural apparatus, its transformation from *practice to discourse*. That almost seems to have become the curator's primary role: to function as an agent who offers exposure and potential prominence—in exchange for obtaining a moment of actual practice that is about to be transformed into myth/superstructure.

When one of the founding fathers of American Modernism and the first director of the institution that taught the American Neo-avant-garde arrived in the Soviet Union in 1927 on a survey journey to take stock of international avant-garde activities for their possible import into the United States, he saw himself confronted with a situation of seemingly unmanageable conflicts.¹ On the one hand, there was the extraordinary productivity of the modernist avant-garde in the Soviet Union (extraordinary by the numbers of its constituency, men and women, its modes of production, ranging from Malevich's late Suprematist work through the laboratory period of the Constructivists to the Lef Group and the Productivist Program, from Agit Prop-theatre productions to avant-garde film production for mass audiences). On the other hand, there was the obvious general awareness among artists and cultural producers, critics and theorists that they were participating in a final transformation of the modernist aesthetic, which would irretrievably and irrevocably alter the conditions of production and reception as they had been inherited from bourgeois society and its institutions (from Kant's aesthetics and the modernist practices that originated in them). Moreover, there was the growing fear that the process of that successful transformation might be aborted by the emergence of totalitarian repression from within the very system that had generated the foundations for a new socialist collective culture. Last of all and crucial, there was Alfred Barr's own disposition of interests and motivations of action within that situation: searching for the most advanced modernist avant-garde in a moment and place where that social group was just about to dismantle itself and its specialized activities in order to

assume a new role and function in the newly-defined collective process of a social production of culture.²

The reasons why Alfred Barr, one of the first "modern" art historians, then just about to discover and establish the modern avant-garde in the United States, was determined (in the literal sense) to fail in comprehending the radical change that those artists and theoreticians introduced into the history of aesthetic theory and production in the twentieth century, are obviously too complex to be dealt with in this context. One point, however, has to be developed since it applies immediately to the questions that are generated in regard to the work of Fred Lonidier and Allan Sekula, the contemporary artists in this exhibition, who, as we suggest, have decided to continue and expand the tradition of factographic production.

The paradigmatic change that occurs in the emergence of productivist factography is the reversal of the Kantian conception of Modernist art production as an essentially disinterested activity that opposes all other forms of activities of human labor and production. With the productivist position, modernism entered a stage where the activity of the artist was not only equated with all other social forms of production, but was no longer and in no way considered desirable or virtuous to support the special activity of the unique concentration of talent. Furthermore, it was supposed to programmatically merge with the social forms of production and integrate itself in the collective where the artist as chosen individual and specialist would take his/her role side by side with all other professions and functions in society.

The present social and political situation differs drastically from that in which the Productivist avant-garde found itself, for example, in regard to its audience relationship. The Bolshevik revolution of 1917 was not only a radical political and socio-economic transformation of the feudal society of Russia, it also introduced the delayed industrial revolution. We can in fact assume that artists such as Eisenstein and Vertov, Rodchenko and Lissitzky who insisted on the technology of their production as much as on the actual dissemination of their work to a mass audience, reached an audience that was not only eager to learn and share the new representations and meanings that the cultural revolution produced and disseminated, but were also physically, emotionally, and intellectually enchanted with the new images and sounds that photography, radio, and film had to offer.

Even when Brecht and Benjamin developed productivist aesthetics for the historical conditions of the Weimar Republic—such as Brecht's "Radiotheory"³ or Benjamin's major theoretical tractatus "The Author as Producer," both of which were a direct outcome of the authors' confrontations with these theories during their visits to the Soviet Union and their encounter with Tretyakov—they were not simply proposing utopian phan-

90 Benjamin H. D. Buchloh

tasms as strategies, but they argued for an understanding of the actual conditions for the transformation of hitherto passive, receptive audiences into active participants and producers, the transformation of art from catering to an existing apparatus to dismantling and changing that existing apparatus, and their theories were based on a materialist study of the actual and potential realities of the historical moment.

One has to be very careful in even establishing a reference to those circumstances from a contemporary perspective, especially one that operates from within the artworld, which has a habit of pilfering historically available positions, extracting them from their context and transplanting them onto a contemporary avant-garde production which in itself is in constant need of renovating its instantly bought-off radicality. Obviously the situation is entirely different in the present moment, where mass audiences are not only locked up firmly in the terminal grip of the media, but where the access that artists have to the actual apparatus of ideological production is at very best that of a parasite who mimics and excels in the strategies of the consciousness industry and who is furbishing new stylistic gadgets to the producers who need avant-garde creativity to renovate their rapidly worn out strategies and styles. On the other hand, artists who position themselves in relation to analysis and criticism with respect to the monolithic institutions become quickly aware that marginalization seems to be the alternative option to becoming a parasitical beneficiary of the consciousness industry. They have to take into consideration that the claim for a position and practice of criticism of ideology that might be made in the work itself is ultimately falsified by the fact that the work remains passively confined to the position of powerlessness to which it is relegated by the centralized institutions of the ideological apparatus. That instant falsification-which is expressed already in the term "political art." a categorization most often used to contain and frame practice in a type of art that connotes "obsolescence, isolation, inefficiency," is obviously not-as it seems at least to most at the present moment-the condition of those artists who deliberately remain with their production inside the traditional framework of the modernist high art avant-garde. They do not engage in the argument with the totalitarian institutions of television and advertising, of corporate and state power, but they remain safely installed within the controllable confines of the traditional setup of the discourse of the artistic individual producer, the modes of production that go along with it (painting, sculpture, drawing, etc.), the distribution forms by which these objects are disseminated (the individual dealer, the individual collector, the museum institution) and the position of the discourse itself (its universality as art—as opposed to the vulgarity of the culture industry or the nebulous realm of ideology-by implication and tradition therefore instantly associated with the inevitability of truth content).

In the world of art—as opposed to that of the media and ideology—

one operates under the assumption that social relations are still transparent and that the forms and means of production and distribution are owned and controlled by the artist/producer and, for example, the individual dealer. Furthermore, the social institution that legitimizes and contains the discourse of art production, the museum, is assumed to be beyond doubt and it is venerable in its universal commitment to cultural truth. and as a nonprofit organization, it does not serve anybody's particular economic or political interests. These bucolic conditions of art production. however, appear gradually in a different light with the realization that most of the assumptions with which the mythology of these conditions of the production of aesthetic knowledge have been maintained—as opposed to the collective falsity of ideology and the consciousness industry-are in their own way constantly falsified by the operations of the apparatus of the institutions that support and contain the discourse of art production. The fact is that the hieratic image of individual knowledge and social truth content constructed in the name of art, does by no means find its way through the liberal institution of the market into the hands of the individual devoted to the furthering and sustaining of the conditions of individual knowledge as they are evidenced in the work of art, but that more often than not the individually-crafted artifact enters the anonymous corporate collection or the art investment bank, and it becomes the subject of systematic tax evasion schemes and fulfills political purposes within the legitimization process of museum institutions. As Hans Haacke has clarified frequently and convincingly in his work, one does not have to dig very deep to discover the intersection between cultural devotion and ideological political and massive economic interests.⁴

Signs without referents, practice without matter, discourse without institution-these seem to be the ideal conditions of contemporary aesthetic production, or more correctly, the conditions that exclusively generate aesthetic *pleasure*, which after all, has been the criterion to establish the specificity of the aesthetic experience against all other experiential modes. Aesthetic pleasure (as in the play of the signifier or the rupture of the symbolic system) is defined in opposition to all other pleasures and certainly even more so in opposition to all other physiological, perceptual or psychological interactions with the objects of reality and their material transformation, in the process of labor, or learning, and in the production of knowledge. Kant's rigorous confinement of the aesthetic to the disembodied and the disinterested became the cornerstone of the prisonhouse of modernism. It corresponded to the increasing need for the division of labor in the process of industrialization and the necessity of specialization and legitimized the foundation of the modernist avant-garde as a group of specialists of vision, perceptual exploration, construction of representation, and innovators of perceptual codes. This group was in itself disembodied from the totality of productive processes in society, opposing in

92 Benjamin H. D. Buchloh

heroic acts of negation and refusal of the totalitarian subjection of the forces of production to utilitarian interests, i.e., the maximization of profit. This opposition resulted in the formation of a social character, the avantgarde artist and the "exclusive concentration of artistic talent in the individual and the corresponding repression of artistic talent in the masses.⁵ That confinement of the aesthetic to the anti-utilitarian and that delegation of artistic production to the artistic specialist have governed the notion of aesthetic experience and pleasure and have placed it in opposition to all other forms of social production.

Yet this privilege of disembodiment (literally the freedom from manual labor and the utilitarian function, but not from the commodity form and the market), has throughout the history of modernism been perceived by artists as the stigma that tainted their claims for the essentially realistic nature of their pursuits. Hence we witness the history of the disavowal of the aesthetic within the modernist work itself, its constantly reiterated quests to abolish the aesthetic status of the constructs, the antiartistic impulse that distinguishes the relevant art of modernism from Courbet onwards and insists on its association with the paradigms of science (as, for example, in the case of the Impressionists) or on its association with the general conditions of production in society (the paradigm of the industrial mode as opposed to the individual craft production, e.g. Duchamp and Constructivism). The anti-aesthetic impulse not only insisted on the potential equality of all social forms of production and tried to abolish the special status that had been assigned to the aesthetic construct, but also on the essential reality (i.e., the labor of production) of the sign, as well as that of the referent. This position which Lonidier and Sekula assume in their work refuses to see artistic practice as being disembodied from the matter of the social and political reality upon which it is imposed as a superstructural function and it insists on a dialectical critique and tries to dismantle the very centralizing institutions within which it is constituted, contained, and isolated as a discursive practice. Their work, once placed in the institutional context of an exhibition, asks: what potential of oppositional practice is historically still inherent in the discourse of art? And what is the need to define oppositional practice in terms of art, and place it inside the social institution of art and address its particular limited audience and what is the need to accept the confinement that those attachments imply? Why should artists not attempt to define the practice of cultural resistance outside of the existing institutions, outside of the historicity of the discourse and thereby address different audiences altogether?

If Althusser's argument is correct that the aesthetic constitutes itself viably only inside the ideological, what then is the nature of the practice of those artists who, as we are suggesting, are in fact trying to develop a practice that is operative outside and inside of the ideological apparatus? The first argument that will of course be leveled against this type of work is that it simply cannot be "art"-and this accusation has in fact been made against artists like Lonidier, Hatch, Rosler and Sekula (in the verv same way that the work of the Productivists and the factographic writings, or the production of John Heartfield have been excluded-perhaps to their advantage after all-from acceptance into the history of modernist art production). Furthermore it will be argued that this work lacks the essential quality that has defined art throughout its history: the experience of disinterested pleasure—which the interested didacticism of this work opposes by its explicitness in taking positions, its clarity of informational instruction, the concreteness of its actual involvement with the particular segment of reality that it has chosen to be engaged with in an approach of interference and operational transformation. If we follow Althusser's definition of ideology as a system of representations in which real relations are transformed into imaginary relations, and, furthermore, that these imaginary relations are endowed with a material existence, then the question of the interrelationship between art and ideology assumes in fact a degree of complexity that the forthright claims to a dimension of practice in this contemporary political art will have to confront.⁶ We do not have to mention of course, that the opposite kind of work, that which seems to resolve the dialectic by simply aligning itself in its entirety with the ideological apparatus (the traditions of the discourse, the position within the institution, its conventions of audience address), and the power of the governing conditions would have resolved any aspect of that question. Quite the contrary, its very existence, its modes of reading and reception, as well as its forms of production and circulation are entirely exhausted and compressed into the dominant practices of ideological representations.

Simply put, the question could read as follows: How progressive can aesthetic production be under the historical conditions of aggressive conservatism? Or, otherwise: Can this production be perceived as "aesthetic" if it denies the validity and deliberately ignores the essential historical material reality of those conditions that produce the representations of ideology? Hoelderlin's famous question "Why would there be poets in sinister times?" pointed to the contradictory nature of the situation: if aesthetic production is a discourse that is contained within a society at any particular moment in history (which implies that the discourse of art is always legible only by the oppressor and is only directed at the oppressor) and if its historical reality (i.e., its legibility and efficiency of meaning) is dependent upon that audience-not upon the utopian anticipation of different social and political conditions and representations of the oppressed-then what can the "reality" of an aesthetic production be that in fact addresses a different audience altogether, but within the system and the language of art and with the means of the apparatus that the bourgeois definition of art has provided for the contemporary producer?

This dichotomy can probably only be resolved by realizing that it is

94 Benjamin H. D. Buchloh

precisely our perceptual apparatus (that domain of the primary process where we are constituted in ideology and where aesthetic perception is anchored and generated) by which we abide most solidly to the social demands that guarantee the continuation of the order of the relations of production. It seems therefore that it is precisely the dimension of aesthetic pleasure which will have to be sacrificed in the perceptual system that provides the basis for ideological reproduction in art that should be seriously questioned. In a way we should be grateful to those contemporary artists who currently receive the attention of the apparatus that they offer us such blatant and profound insight into the relations between "aesthetic pleasure" and reactionary power that the apparatus of art production as a subsection of the general ideological apparatus is capable of producing at this point in history. They help us in fact to gradually disentangle and disassociate ourselves from the seemingly insurmountable fixations upon those primary pleasures of aesthetic experiences. We recognize, after all. that it is our desires and our pleasures as they can be fulfilled by contemporary art production which are the most secret and reliable agents of dominant ideology: like all other superstructural instances (the moral and the legal code, religious belief, family structure and the construction of sexuality), it is the attachment to aesthetic desire and aesthetic pleasure that guarantee the continuation of our archaic modes of perceptual and cognitive behavior.

As in all instances where the self seems to be most secure in desire and where identity seems to be guaranteed in gratification and pleasure, one might have to realize that what applies to the narcissistic pleasures and gratifications of fashion and consumption in which the self is most clearly constituted in ideology and where the ideological apparatus is most successfully at work, by now applies equally to the traditional modes of generating aesthetic pleasure. They have historically become the most effective maneuvers to inscribe the order of the relations of production into the representations of identity and imbue them with the authority of legitimation that only high art seems to offer. In the era of corporate state power where the consciousness industry is systematically organized to prohibit and destroy individuality and identity, the public notion of individuality itself becomes a strategy of oppression and the means to achieve a semblance of the fetishized concept of individuality must by necessity be the fetishistic production procedures and materials that Arvatov identified so clearly in 1926:

While the entire technique of capitalist society is based on the most advanced and most recent achievements and represents a technique of mass production ... bourgeois art has remained in principle on the level of crafts and therefore it has been removed from the general social practice of mankind and shifted into the realm of pure aesthetics.... The lonely master—that is the only type of artist in capitalist society, the type of that specialist of "pure art," who works outside of the immediately utilitarian practice since it is based on advanced machine technology. From here we derive the illusion of art being its own purpose, from here its bourgeois fetishism.⁷

This need for the supply of mythical images of individuality and identity, which dominant ideology currently imposes on aesthetic production, would also explain the miraculous rediscovery of European art by the section of the ideological state apparatus that is called the "artworld." As in late nineteenth- and early twentieth-century "primitivism" as an inspirational force for the definition of the "modern idiom," when African and Asian artifacts were "discovered" for the practice of high art at a moment when imperialist politics had successfully eradicated authentic cultural practice in the colonies, so now do the old European nation states supply idioms for the fetishized concept of individuality at a moment when multi-national corporate state power and its consciousness industry have successfully deleted the last vestiges of practices of representation, learning and knowledge in the sphere of collective public experience. At a historical moment when there is every reason to be terrified at the perspectives that Reaganism opens up economically and politically and every evidence that there is no national autonomy when it comes to vital questions such as missile deployment and nuclear armament-at that moment we are told by German Neo-Expressionist artists and their critical spokesmen that they have successfully performed the labor of mourning about fascism in their paintings and that they have thus established the images of a new national identity. Thus:

The new German painters perform an extraordinary service for the German people. They lay to rest the ghosts—profound as only the monstrous can be—of German style, culture and history, so that the people can be authentically new. They are collectively given the mythical opportunity to create a fresh identity. . . . Thus to see these pictures is to be confronted with the special necessity and special freedom of the Germanic today.⁸

Allan Sekula's work, *Sketch for a Geography Lesson* (1983), offers us a different picture of what links contemporary American politics with the mythical tendencies as they originated in the German Romantic past of the nineteenth century. It negates the mythification of historical fact in the guise of the aesthetic and his work provides the synecdochic information that has since the inception of Realism asked the viewer/reader to confront the reality of the referent as much as the reality of the sign. The false globality and universality with which contemporary paintings treat historical subject matter (e.g., the mourning of the unfathomable German past) is substituted here with concrete information about the global inter-

96 Benjamin H. D. Buchloh

relationships of present day American politics. The myth of the national character (from which the original need for expression supposedly springs) appears here in a detail that reminds us of the transition from agricultural production and its close affiliation with mythical and religious practices and their lasting impact on the formation of a national character that is historically ill-equipped to come to terms with the industrial reality of corporate capitalism. As Theodor Adorno once pointed out, it is the discrepancy between scientific and technological progress on the one hand and the retardation of social progress and political participation on the other hand that generates the cyclical reoccurrence of the need for mythical and religious explanations in advanced capitalist societies. In the juxtaposition of the rural slaughtering ritual in a German village with the American television images choosing that very landscape as "theatre" for wargames. that discrepancy of an uneven development of technology and social and political consciousness becomes obvious. The terror of irrationality here, however, is emanating from the corporate television's wargame, not from the expressive imagery of the rural slaughtering. In the same manner as the color photographs of the "German Romantic" landscape that seems to have endured from Caspar David Friedrich's vision onwards, are devalidated not only by the presence of signs that remind us of the actual situation of that landscape (to function as wargame terrain for the American forces in Germany), but also in the way that they reveal the irretrievable moment of history when landscape imagery could still carry the meaning of the conflict between the mythical and the rational. Sekula's work addresses the reality of a contemporary experience—that which links the American public actually, rather than aesthetically, to the geopolitical reality of West Germany (a strategic and economic ally at the forefront of the border with the rivalling economic and political system, the war theatre where a potential conflict between the two superpowers could be possibly resolved without actually involving the American population on its own terrain). The work assembles the elements of representation (past and present) through which this experience is mediated: the photographs of the romantic German landscape and its preindustrial agrarian rituals. the Cold War "popular imagery" from Sekula's high school textbook that depicts the Madonna as being assaulted by the masses of Red Army soldiers and the photographs from an American TV program of a wargame that is situated in the rural area in West Germany, near the East German border that Sekula depicts also in his tourist photographs. It is this analytical approach to the construction of representation and its mediations that justifies and requires the work's display and insertion into an aesthetic context (such as this exhibition). On the other hand, it is the work's "factographic" approach-its insistence on the necessity to explore and clarify the construction and operation of representation within present day reality and to make that reality transparent rather than mythify it, which

distinguishes the work of Allan Sekula from most contemporary aesthetic practice. It is therefore neither confined or limited to the traditional institutions of art mediation nor is it restricted in its reception to the exclusivity of an artworld audience. Without assuming or suggesting the falseness of a popularization of high-art traditions, it addresses a concrete instant in the conditions of contemporary experience and its constitution in ideological representations. Thus the work becomes both accessible as an analysis of ideological representations to multiple audiences and it takes its place in the necessary formation of a culture of resistance. To develop a more specific audience relationship is a crucial interest of Allan Sekula's and Fred Lonidier's work. That means to address the specific needs and interests of a particular audience as much as it implies to move out of the institutional confines of the artworld. Both artists have produced work that operates primarily in situations that are not part of the existing exhibition and distribution system, not in order to emphasize the problematic legitimization of that system, but more so to actually enter the spaces where the concerns of the new audiences are at stake. As Tretyakov suggested in his essay "From the Photographic Series to the Systematic Investigation" in 1931, this involvement with a new audience will have to gradually increase their participation and emphasize the necessity of self-representation of these audiences. That requires more than the token commitment that previous art practices have offered to different audiences by splashing the work with hints of popular culture, for example, participatory gadgets, or by dressing it up in a crude "proletarian" materiality. Allan Sekula's work, School Is a Factory (1979-80), for example, was primarily conceived for display and interaction with the audiences of students at community colleges, since the work investigated the interrelationships between the interests and needs of corporations in certain areas of California and the educational programs that the community colleges in that area offered. Fred Lonidier's work, The Health and Safety Game: Fictions Based on Fact (1976), a documentation and analysis of individual experiences of work-related injuries and the neglect with which the victims are treated by the responsible corporations, was shown primarily at spaces where large numbers of workers would regularly pass through, such as labor council halls, shopping malls, a museum of Science and Industry and union halls. His more recent work which is his contribution to this exhibition, L.A. Public Workers Point to Some Problems: Sketches Of The Present For Some, Point To the Future For All? was published in excerpts in two issues of the weekly paper The Citizen, the official publication of the Los Angeles County Federation of Labor, AFL-CIO and was exhibited in both union halls and at the Los Angeles Institute of Contemporary Art.⁹ The work addresses the questions of the detrimental impact, not to say disastrous consequences of federal and state legislation in favor of corporate and entrepreneurial interests on those sectors of pub-

98 Benjamin H. D. Buchloh

lic life and culture, that we would not normally be confronted with as a museum- or gallery-visiting art audience, since the system of representation that we traditionally refer to as "the aesthetic" by definition extracts itself-as it seemed-from the economic and the political reality of the basis of culture in everyday life, in order to construct the aesthetic mirage that generates pleasure due to its mysterious capacity to disembody and disassociate our perception from the weights and demands of the real. Lonidier's work successfully counteracts that tendency—which is as compulsive in aesthetic production as it is firmly embedded in the conventions of aesthetic reception—by not only systematically exploring the basis of culture, i.e., labor, but also by specifying the connections where the global system of political and economical determinations concretely manifests itself in the conflicts of individual existence. Self-representation of those individuals is as important in Lonidier's work as is his interference in the construction of what he calls "Fictions based on Facts" (what Brecht said about the insufficiency of the photograph of the factory is also true, much more so, for the portrayal of the individual working in the factory: its "truth" has to be constructed). That strategy of self-representation is not only one of the many necessary steps to develop different and multiple audiences for the production of cultural interference in the seemingly hermetically closed system of ideological representation, it is also a necessary condition for that practice to resist centralization and the immediate extraction from practice by the cultural apparatus. Perhaps even more than the difficulty of successfully developing new modes of presentation, display and interaction with different audiences, the work of Lonidier and Sekula faces the problem of how to protect itself from the effects that the traditional audience of the cultural apparatus has to offer. Marginalizing the central authority of the apparatus of "Art," and its institutions, the critics and the magazines as much as the museums, the galleries, and the collectors, seems for the time being one of the successful strategies that these artists and others working with similar means and intentions have employed.

Notes

- 1. For detailed information on Barr's unsuccessful search for easel paintings in the homes of the Soviet avant-garde, his encounters with Rodchenko, Lissitzky, and Tretyakov in particular, see: Alfred H. Barr, Jr., "Russian Diary 1927–28," in *October* 7, Winter 1978, p. 21.
- 2. What happened instead was predicted in 1926 by Boris Arvatov, along with Tretyakov and Taraboukine, the third of the Productivist theoreticians, when he wrote about the painters who did not join the group of the Productivists: "Those on the right gave up their positions without resistance . . . either they stopped painting altogether or they emigrated to the foreign countries in the West, in order to astonish Europe with home-

made Russian Cézannes or with patriotic-folkloric chicken paintings." Boris Arvatov, *Kunst und Produktion*, Munich, 1978, p. 43.

- See for example: Bertolt Brecht, "Radio as a Means of Communication." English translation in *Screen*, vol. XX, Winter 1979–80. Recently reprinted in *Communication and Class Struggle*, vol. II, edited by Armand Mattelart and Seth Siegelaub (New York: 1983).
- Hans Haacke, *The Master Chocolate Maker* (Toronto: 1983) as well as Mobil Observations (Saskatoon: 1982), and, of course, *Framing and Being Framed* (Halifax/New York: 1976).
- 5. K. Marx/F. Engels, "Die Deutsche Ideologie," in Marx, Engels, Lenin ueber Kultur, Aesthetik, Literatur (Leipzig: 1968), p. 113.
- Louis Althusser, Lenin and Philosophy (London: 1971). Particularly the essay: "Ideology and Ideological State Apparatuses," p. 127 ff.
- 7. Arvatov, loc. cit. p. 12.
- 8. Donald Kuspit, "The American Case Against German Expressionism," *Expressions* (St. Louis: 1983), p. 46 and passim.
- 9. The Los Angeles Citizen, vol. 83, no. 17 and 18, September 1979.

Turning Back the Clock Art and Politics in 1984

HILTON KRAMER

It is understood by now that all art is ideological and all art is used politically by the right or the left, with the conscious and unconscious assent of the artist. There is no neutral zone. Artists who remain stubbornly uninformed about the social and emotional effects of their images and their connections to other images outside the art context are most easily manipulated by the prevailing systems of distribution, interpretation, and marketing.

> —Lucy R. Lippard, in the catalogue of the "Art & Ideology" exhibition at the New Museum of Contemporary Art in New York

Everyone who follows the course of current events in the art world must nowadays be aware of a troubling development that has lately manifested itself with increasing frequency. This is the concerted attempt now being made by a dedicated alliance of artists, academics, and so-called "activists" to politicize the life of art in this country. Not since the heyday of the antiwar movement in the Sixties and early Seventies have we seen anything quite like the present effort to impose a sectarian political standard on both the creation and the criticism of art. In more and more exhibitions, publications, symposia, and other public events, we are once again being exhorted to abandon artistic criteria and aesthetic considerations in favor of ideological tests that would, if acceded to, reduce the whole notion of art to little more than a facile, preprogrammed exercise in political propaganda.

The tone in which these exhortations are articulated varies from the

This essay was originally published in *The New Criterion* 2, no. 8 (April 1984). Copyright © 1984 Hilton Kramer. Reprinted with permission of the author.

stridently militant to the earnestly "concerned." But the message is invariably the same: in art, priority must now be given to a politically inspired "content," as it is called; and in criticism, the governing assumption is a belief that all claims to aesthetic quality are to be regarded as mere subterfuge, masking some malign political purpose. It (almost) goes without saving that the politics being served by this effort to discredit all disinterested artistic activity is the politics of the radical Left. Its favored themes at the moment are nuclear disarmament, radical feminism, and support for revolutionary movements in Central America. The favored targets, of course, are the policies of the United States government in particular and the political and cultural institutions of democratic capitalism in general. Adding some piquancy to the whole shabby endeavor is the fact that a sizable part of this blatant political activity is funded, precisely because it claims to speak in the name of art, by such public agencies as the National Endowment for the Arts, the New York State Council on the Arts, and the Department of Cultural Affairs of the City of New York-yet another example, I suppose, of supplying the rope to those who are eager to see us hanged.

Thus, since early December-to look no further back than that-the art calendar has been fairly crowded with these unlovely political events. The busiest sponsor of them has no doubt been the New Museum of Contemporary Art in New York. In a four-month period (December through March) it has organized, with the aid of federal, state, and municipal funds, two full-scale exhibitions on the requisite themes: "The End of the World: Contemporary Visions of the Apocalypse" and "Art & Ideology." "The End of the World" was mainly (though not entirely) devoted to the cause of nuclear disarmament, and, while paying ceremonial lip service to George Orwell's Nineteen Eighty-Four as a source of inspiration, actually derived its political rationale from Jonathan Schell's The Fate of the Earth. In "Art & Ideology" we were offered a more explicitly Marxist account of American society together with arguments (in the catalogue) calling for the political criticism of all cultural activity. The New Museum would appear to have embraced Lucy R. Lippard's dictum—that "There is no [politically] neutral zone" for art in our society-as a fundamental principle, and one naturally wonders if anyone involved in the governing of this institution understands that the principle itself is totalitarian in its very essence.

Meanwhile, the mall of the Graduate Center of the City University of New York, another institution supported by public funds, was given over to a more specialized political event—a show of objects and installations produced (as it was said) "by artists who are concerned about current U.S. policy in Central America." This was an undisguised propaganda effort in support of the Marxist-Leninist revolutionary movement in Central America, and staged to coincide with a program of exhibitions and speaking events, both in New York and elsewhere, organized by a group calling itself

102 Hilton Kramer

"Artists Call Against U.S. Intervention in Central America." In January this "Artists Call" group also won the support of a number of private art galleries, which gave over their space to its activities, and the eager cooperation of publications such as Arts Magazine, Art in America, The Nation, The Village Voice, and sundry "alternative" journals around the country. At the same time, the Edith C. Blum Art Institute on the campus of Bard College chimed in with a political exhibition called "Art as Social Conscience," which, not surprisingly, included many of the same artists featured in the shows at the New Museum and the City University mall and praised in the pages of Art in America and The Village Voice. There was also a show devoted to "Women & Politics" at the Intar Latin American Gallery—another event, by the way, supported by funds from the NEA. the New York State Council on the Arts, and New York City's Department of Cultural Affairs. And then, lest the point of all this effort be lost on us. two of our leading art schools-Cooper Union and the Pratt Institutejoined in sponsoring a symposium in the Great Hall at Cooper Union on the theme of "War in Art." The speakers, of course, were mainly those prominently represented in the exhibitions and publications already mentioned. Their basic message is easily summarized: Since war is a terrible thing. we should all take up a position of radical pacifism and leave military victory to our enemies.

No doubt there have been other similar events which have escaped our attention. In the midst of such a well-organized campaign, one cannot be expected to keep track of every episode. But one other exhibition should be mentioned here-the show called "Dreams and Nightmares: Utopian Visions in Modern Art" at the Hirshhorn Museum in Washington. This, too, claimed Nineteen Eighty-Four as its ostensible inspiration, and was not only more historical in its outlook but a good deal more circumspect than the other shows I have mentioned in keeping a discreet distance from the kind of open political commitment that is now standard policy, for example, at the New Museum of Contemporary Art. Yet "Dreams and Nightmares" was, all the same, a political exhibition. Careful as it was to exclude anything that might contain an explicit condemnation of current U.S. government policy-the Hirshhorn Museum is itself, after all, a government institution-the whole conception of the exhibition was pacifist in spirit, and clearly owed its inspiration to the antinuclear movement. It certainly showed no interest in distinguishing artistic quality from the most facile exploitation of political emotion, especially in its selection of contemporary examples.

I do not propose to attempt a detailed critical evaluation of all of the art which has been offered to us in these political exhibitions and extolled in the various texts and speeches written to advance its fortunes. Except for the historical examples included in the "Dreams and Nightmares" exhibition at the Hirshhorn, most of the art brought together in this ideological extravaganza exists on such a low level of artistic discourse that almost any critical analysis, even the most negative, would inevitably have the effect of suggesting a higher degree of aesthetic seriousness than, in fact, can be found in the work itself. The whole notion of artistic achievement is, in any case, what most of this art is specifically intended to repudiate, and it would therefore violate the spirit of the art—as well as the function of criticism itself—to pretend otherwise. Linda Weintraub, director of the Blum Art Institute at Bard College and organizer of the "Art as Social Conscience" exhibition, made the point herself with admirable candor in declaring that "The works are designed, unabashedly, for political and societal ends." Whether or not the show could claim any aesthetic merit was not a question she found it appropriate to address.

She was right not to do so, of course. Where aesthetic merit, or even aesthetic intelligence, is not the issue, the discriminations appropriate to the study of art are clearly not called for. Yet what, then, was the show doing in the Bard College art gallery, which exists (we may presume) for the purpose of educating students in the experience of art? The whole point of an exhibition like "Art as Social Conscience" is not to illuminate the experience of art but, in Linda Weintraub's words, to "jolt the viewer into a new awareness of today's most pressing social issues." The exhibition announcement, gotten up to resemble the front page of a newspaper, helpfully enumerated what these "pressing social issues" were assumed to be: "nuclear war, unemployment, toxic waste, feminism, Reaganomics, and other timely social issues." (The list was by no means complete, by the way. It omitted, among other things, the subject matter of a particularly odious little video tape in which the purposes of the American CIA and the Soviet KGB were presented as very much alike, quite as if the political systems they serve were equally evil.) It is theoretically conceivable, perhaps, that there might somewhere exist an artist capable of making a significant work of art out of such materials, but I frankly doubt it. What we can be certain of is that neither Linda Weintraub nor anyone else has vet discovered such an artist-and the awful fact is that she doesn't even know that she hasn't, so eager has she been to present these political substitutes as if they were artistic achievements.

It may be worth adding that the artistic nullity of the work in this and similar exhibitions would not, in my opinion, have been affected in any degree *as art* if its political content had been designed to promote the interests of President Reagan's economic program or an increase in the defense budget or his re-election campaign. (It's not likely that it would have been so designed, of course—or, if it had been, that Bard College would have exhibited it.) Bad art is bad art, whatever its political purpose, and only the most zealous supporter of the "no neutral zone" doctrine could seriously believe otherwise. I frankly doubt that Linda Weintraub is a true

104 Hilton Kramer

believer in this pernicious doctrine. Unlike the folks at the New Museum of Contemporary Art, who seem to believe in little else, she is probably not keenly interested in most of these issues or terribly well-informed about them, but has only succumbed to a current cultural fashion—but that, alas, is precisely the way the politicization of art is hastened on its course. Every militant "activist" like Lucy R. Lippard needs a great many Linda Weintraubs in order for her political goals to be realized.

Let us look a little more closely at some representative objects that have been presented to us in these exhibitions as works of art. In the show at the City University mall we were shown, among much else, a huge, square, unpainted box constructed of wood and standing approximately eight feet high. On its upper sides there were some small openings and further down some words stencilled in large letters. A parody of the Minimalist sculpture of Donald Judd. perhaps? Not at all. This was a solemn statement, and the words told us why: "Isolation Box As Used by U.S. Troops at Point Salines Prison Camp in Grenada." The creator of this inspired work was Hans Haacke, who was also represented in the "Art as Social Conscience" exhibition by a photographic light-box poster attacking President Reagan. Such works are not only devoid of any discernible artistic quality, they are pretty much devoid of any discernible artistic existence. They cannot be experienced as art, and they are not intended to be. Yet where else but in an art exhibition would they be shown? Their purpose in being entered into the art context, however, is not only to score propaganda points but to undermine the very idea of art as a realm of aesthetic discourse. President Reagan and his policies may be the immediate object of attack, but the more fundamental one is the idea of art itself.

If it were possible to entertain any doubts on this score, they would surely be put to rest by several of the essays which the guest curators of the "Art & Ideology" exhibition at the New Museum have contributed to its catalogue. Benjamin H. D. Buchloh, for example, who teaches art history at the State University of New York at Westbury, defends the propaganda materials he has selected for this exhibition by, among other things, attacking the late Alfred H. Barr, Jr., for his alleged failure to comprehend "the radical change that [modern] artists and theoreticians introduced into the history of aesthetic theory and production in the twentieth century." What this means, apparently, is that Alfred Barr would never have accepted Professor Buchloh's Marxist analysis of the history of modern art, which appears to be based on Louis Althusser's Lenin and Philosophy. (Is this really what is taught as modern art history at SUNY Westbury? Alas, one can believe it.) On this point, at least, Professor Buchloh is surely correct, for what he offers us as art in this exhibition would probably never have been accepted by Alfred Barr as any sort of work of art at all. Here is Professor Buchloh describing one of the propaganda items that he has selected

for the show—a series of photographs and printed documents assembled by Fred Lonidier and given the title, *L.A. Public Workers Point to Some Problems: Sketches Of The Present For Some, Point To The Future For All?*:

L.A. Workers Point to Some Problems ... was published in excerpts in two issues of the weekly paper *The Citizen*, the official publication of the Los Angeles County Federation of Labor, AFL-CIO and was exhibited in both union halls and at the Los Angeles Institute of Contemporary Art. The work addresses the questions of the detrimental impact, not to say disastrous consequences of federal and state legislation in favor of corporate and entrepreneurial interests on those sectors of public life and culture, that we would not normally be confronted with as a museum- or gallery-visiting art audience, since the system of representation that we traditionally refer to as "the aesthetic" by definition extracts itself—as it seemed—from the economic and the political reality of the basis of culture in everyday life, in order to construct the aesthetic mirage that generates pleasure due to its mysterious capacity to disembody and dissociate our perception from the weights and demands of the real. Lonidier's work successfully counteracts that tendency...

We can at least be grateful that Professor Buchloh is not employed to teach expository writing, but this still leaves students of the history of modern art at SUNY Westbury in quite a lurch.

The situation at SUNY Stony Brook appears to be no better. Another guest curator of the "Art & Ideology" exhibition is the redoubtable Donald Kuspit, professor of art history at SUNY Stony Brook, and here are his concluding remarks on the two artists—Nancy Spero and Francesc Torres—he had selected for this show:

The works of Spero and Torres deal with martyrdom in the cause of freedom, humanity, and justice, a cause which seems uncertain because we see it only in critical, oppositional form, as a kind of protest against existing reality. We do not see what a world without torture of women and war would be like. Spero and Torres do not want us to see that future, for that would be to offer the utopian in place of the critically effective—the critical as social action. Such critical action is the only kind that can heal the split of spirit, for it alone shows us the futility of administrative control—the planned bombing missions, the planned murder of women—of destructive dominance.

I should explain, perhaps, that when Professor Kuspit refers early on in his essay for the catalogue to "the totalitarian mentality"—which he does repeatedly—he appears to have in mind the "existing reality," as he calls it, of American life.

This, then, is the kind of mentality—to use Professor Kuspit's term—that characterizes not only the "Art & Ideology" exhibition but the larger drift

toward politicization we see making such headway on the art scene today. The notion that "There is no neutral zone" for art in our society has by no means become the dominant point of view of the art world. Far from it. At the moment it remains the program and commitment of a dedicated and well-organized minority faction. Yet to judge by the position lately won by an institution like the New Museum of Contemporary Art, it is now an *accepted* notion—quite as if it represented little more than an aesthetic option—and this is itself a frightening prospect. It is to the New Museum, strangely enough, that the Reagan administration has entrusted responsibility for representing American art at the 1984 Venice Biennale. This is a development so bizarre that it quite takes one's breath away. Having worked its way up from an "alternative" space to an established institution, enjoying the patronage of government agencies and private foundations, the New Museum has now become a power in the art world, and that is very bad news indeed.

Yet the role of the New Museum, dismaying as that may be, and the other events I have been describing here, ghastly as they are, are finally less important in themselves than for the larger historical impulse they represent. For what we are now witnessing in this movement toward the politicization of art in this country is an attempt to turn back the cultural and political clock. And it is not to the radical counterculture of the Sixties that this movement looks back for its model and inspiration, despite the many resemblances it may bear to the outlook of the Sixties, but to the radicalism of the Thirties when so much of American cultural life was dominated by the hypocritical "social consciousness" of the Stalinist ethos. It is to a contemporary version of this old "social consciousness" that the protagonists of this political movement in the art world wish to confine the life of the artistic imagination. Hence the attacks on modernism and on such champions of the modernist aesthetic as Alfred Barr. For this new generation of radicals, it is the cultural life of the Forties and Fiftieswhen American art and literature finally vanquished the last respectable traces of the Stalinist ethos-that can never be forgiven. The Forties marked a great turning point not only in the history of American art but in the life of the American imagination, and any attempt to return American culture to the ideological straitjackets of the Thirties must inevitably attempt to discredit both the achievements and the values that belong to the post-World War II period. Hence, too, the increasingly raucous attempts to dismiss the accomplishments of the Forties and Fifties as nothing more than the political products of the Cold War.

Reflecting on this curious turnabout in our artistic affairs and on the apocalyptic note that is sounded again and again, ever more insistently, as the battle cry of the new cultural radicals in their campaign to politicize the life of art, I am reminded of a passage in one of the last of Lionel Trilling's many essays on this theme. In "Some Notes for an Autobiographical Lecture," which was posthumously published in a volume called *The Last Decade: Essays and Reviews, 1967–1975,* Trilling gave us a glimpse into the train of thought that had led him to devote so much of his critical attention to what he described as the "unmasking" of "Stalinist-colored liberal ideas."

Behind my sense of the situation [Trilling wrote] was, I think, a kind of perception that I might call novelistic—that there was in the prevailing quality of the intellectual-political life a kind of self-deception: an impulse toward moral aggrandizement through the taking of extreme and apocalyptic positions which, while they *seemed* political, actually expressed a desire to transcend the political condition—which, as I saw things, and still do, meant an eventual acquiescence in tyranny.

It is, once again, toward precisely such "an eventual acquiescence in tyranny" that the doctrine announced in the statement, "There is no neutral zone," promises to lead us.

Crowding the Picture Notes on American Activist Art Today

DONALD B. KUSPIT

Revolt today has no more content than buying a bus ticket. Any genuine attack on society today must occur on the level of abstraction. . . . The only true wrestle is with abstraction: the credo, the slogan, the symbol. —Harold Rosenberg, "Themes"

Politics in the United States consists of the struggle between those whose change has been arrested by success or failure, on one side, and those who are still engaged in changing themselves, on the other.

-Harold Rosenberg, "Themes"

Along this rocky road to the actual it is only possible to go Indian file, one at a time, so that "art" means "breaking up the crowd"—not "reflecting" its experience.

-Harold Rosenberg, "The Herd of Independent Minds"

This seems a good time to analyze activist art—art that claims to be a kind of action rather than a kind of reflection. In the last decades, many American artists have joined the ranks of what was once an underdog troop. In this palace revolution that seeks to overthrow the ruling elite of formalism, even "revisions" of artistic language—experimental manipulations of the concepts and terms of high art—are considered valuable only if they serve the "higher" purpose of social change. And so where formalism offers art a certain hermetic integrity, activism promises it worldly influence and power.

But what if the proverbial choice between an art of the vita contem-

[©] Artforum, May 1988, "Crowding the Picture: Notes on American Activist Art Today," by Donald Kuspit.

plativa and an art of the *vita activa* is no longer a valid one? What if the integrity proposed by the esthetic position is insufficient, and the kind of change demanded by the activist approach is disingenuously inhumane? The old bifurcation of life into sectors of being and doing now seems obsolete. The traditional notion of a singular heroic identity no longer does justice to the complexity of our social relationships, nor to the subtleties of our moral situation. Today, one needs the Solomon's wisdom and stamina to create an art that synthetizes the esthetic and activist impulses—one that addresses our humanness with depth and fullness, one that rearticulates a humanness that we feel has been obscured, even obliterated by society. A number of European artists (particularly in Germany and Italy) have risen to this challenge. In America, however, too many of our artists are settling for less, perhaps because they have not adequately recognized the rigorous demands of this enterprise.

America is above all a pluralistic society, a highly differentiated yet consummately interdependent organism. In our society, which has come to be termed the administered society, the psychopolitical tensions of class struggle, while far from irrelevant, are not all-relevant. The situation "of the 'lonely crowd,' or of isolation in the mass,"¹ as Jacques Ellul points out, is the basic social situation today.² The "lonely man" is the essential man, "and the larger the crowd in which he lives, the more isolated he is."³ This is pluralism in action, ingeniously nondisruptive for all its discontinuities. For whenever a member of this lonely crowd tries to understand, articulate, or assert his or her *individual* loneliness, he or she comes up against the overwhelming evidence of togetherness with all others in the crowd, and personal loneliness seems a fantasy. (Or a neurosis.) And whenever, conversely, the individual tries to give himself or herself over completely to the crowd's trends and passions, he or she finds this untenable too, for the individual only reexperiences isolation within the crowd. Loneliness, then, even as it may be regarded as a sign of individuality, of separate and special selfhood, and/or resistance to the crowd, is in fact only the experience that confirms the inextricable interdependence that characterizes the crowd. Loneliness is the umbilical bond to the crowd. One cannot think of mass man without thinking of the loneliness that is innate to him. To be of the lonely crowd is to feel both an irreducible isolation and an irresistible belonging.

This is why the American lonely crowd assumes an eternally melioristic society, with a perhaps nominally utopian outlook: why should the crowd work for revolution when the world, however lonely, seems to be getting better and better—or at least getting to be a better place in which to negotiate loneliness, to hide from oneself? The lonely crowd fetishizes its slack "live and let live" philosophy (be lonely and let others be lonely), believing it to be—and this is no doubt correct—preferable to the authoritarian "live and think and be like me or be destroyed by me" philosophy. But of course neither philosophy helps one realize life fully or tells why one should continue to live; and each is as full of grievances against life as the other, if more obviously so in the latter.

This is the lonely world that contemporary activist art enters into, speaks to. And such art is designed to confront rather than to console. Is the lonely crowd capable of accepting such artistic and activist urgency? Can it find the art contagious, be roused to action in the name of its cause? Can it throw off the chains of loneliness to create a community rather than a crowd?

It seems unlikely. For to inspire such response, this art must "penetrate through the common experience to the actual situation," must grasp social reality creatively, that is, "from the inside . . . as a situation with a human being in it,"⁴ must wed insights to "the potency of form" that goes "beyond mere talk."⁵ However, much of today's activist art plays to the common-crowd-experience, and thereby reinforces the very structures it seeks to undermine. We can look back at the social realism of the '30s as a forerunner of this. In the history-splashed panoramic murals of Thomas Hart Benton and Diego Rivera or the delineations of social suffering in the works of Philip Evergood and Ben Shahn, for example, the misery or nobility of the individual is posited as the reflection of a collective condition. Or, to put it in the terms of the lonely crowd, the individual simply echoes the voice of the crowd. A number of artists today believe they, too, are demythologizing reality, pulling back the curtain for us for a clear look at the social conditions that enslave us, define us. But just as the social realists of the '30s implicitly appropriated the big-screen techniques of the most formidable crowd-pleaser of their time-the movies-many of today's American artists mimic or employ techniques from advertising and TV. They believe this is the best way to reach the crowd—and perhaps they're right. But is it, in Rosenberg's words, the best way to "break up the crowd"? Is it the best way to move the individual to take the risk of autonomy,⁶ to begin the struggle of transforming his or her own identity, a process essential to genuine social transformation?

In fact, much of today's activist art does send a message, but not the one its makers intend. Often, this art's call for social change and/or social unity relies on familiar codes, with just enough overlay of allusion to some topical situation or event to suggest political urgency. And so even viewers who may be only nominally interested in the revolutionary implications of the struggle in Nicaragua referred to in Leon Golub's paintings, for example, can feel secure in believing that in their viewing of these works they have had a political experience. The paintings' larger-than-life size, their agitated surfaces, the theatrical grandeur of their figures, who make war not love (even those who are on the same side seem to make war, perhaps in order not to have to make love), all resuggest the idea of the Hero, in whatever grotesque form. Such an idea caters to the lonely crowd, which, if it looks for salvation, looks for it in the miracle of the Great Man, be he tender or tyrannical.

Similarly, Martha Rosler's documentaries, with their apparently gritty, reportorial directness, use predetermined scenarios of misery. Rosler's intensity of focus is admirable, and she does meet a certain social reality. Her art's "factographic character," as it has been called by Benjamin Buchloh, is liberating—to a point. There's a problem, however, with her synecdochic expression of that reality. By representing a person's life with "the facts," Rosler shaves away the interior life, and the individual is flattened, once again, into cliché: "the abused women," "the working woman," etc.

Truly creative critical art, on the other hand, can go beyond, to question not just one stereotype, or the predominant stereotype, but *all* stereotypes. In this way, the very notion of common or uniform experience—the underpinning for lonely crowd passivity—would begin to crumble. Such an art does not require a retreat from social reality, but a deeper engagement with it. Rosenberg, using war as an example, suggests the power and potential of such a deeper engagement:

the moment an artist, ignoring the war as an external fact known to all, approaches it as a possibility that must be endured in the imagination by anyone who would genuinely experience it, he . . . arouse[s] not only hostility on the part of officials who have a stake in the perpetuation of some agreed-upon version of the war, but also a general distrust and uneasiness. For the work of art takes away from its audience its sense of knowing where it stands...suggests to the audience that its situation might be quite different than it has suspected, that the situation is jammed with elements not yet perceived and lies open to the unknown, even though the event has already taken place.⁷

A number of our artists today do not thoroughly scrutinize mass conceptions of political reality, but unwittingly submit to them. And more problematically, they implicitly conform to stock notions of the way social change and/or social solidarity can be achieved. The work of Hans Haacke, Barbara Kruger, and Alexis Smith is to the point here. All rely on more or less familiar, easily readable images and language in a more or less tense state of juxtaposition. But after an initial surge, their art is victimized by its own media, sinks back into its sources, and what is left is the message that we can trust common experience to point the way to social transformations.

As suggested, the problem shared by many of our activist artists today lies in the way they understand—one might say in the credit they give—their viewer. At issue is whether the works of these artists engage the isolated individual within the lonely crowd in order to encourage selfawareness, independence, thoughtful examination, and action, or whether

112 Donald B. Kuspit

these works serve as propaganda for a myth (even though an alternative one). It's a slippery question, as Ellul understands, for propaganda for an alternative myth often seems to do both:

just because men are in a group, and therefore weakened, receptive, and in a state of psychological regression, they pretend all the more to be "strong individuals." The mass man . . . is more suggestible, but insists he is more forceful, he is more unstable, but thinks he is firm in his convictions. If one openly treats the mass as a mass, the individuals who form it will feel themselves belittled and will refuse to participate. . . . On the contrary, each one must feel individualized, each must have the impression that *he* is being looked at, that *he* is being addressed personally. Only then will he respond and cease to be anonymous (although in reality remaining anonymous). Thus all modern propaganda profits from the structure of the mass, but exploits the individual's need for self-affirmation; and the two actions must be conducted jointly, simultaneously.⁸

What's more, Ellul makes a useful distinction between the propaganda of agitation and the propaganda of integration.⁹ The propaganda of agitation

has the stamp of opposition. It is led by a party seeking to destroy the government or the established order. [It] tries to stretch energies to the utmost, obtain substantial sacrifices, and induce the individual to bear heavy ordeals. It takes him out of his everyday life, his normal framework, and plunges him into enthusiasm and adventure; it opens to him hitherto unsuspected possibilities, and suggests extraordinary goals that nevertheless seem to him completely within reach. Propaganda of agitation thus unleashes an explosive movement; it operates inside a crisis or actually provokes the crisis itself.¹⁰

I would argue that much of today's direct-action art lends itself to or is a species of the propaganda of agitation. It enjoys seeing all of social reality—the status quo on all fronts—as forever and completely "in crisis." As Ellul points out, the propaganda of agitation generally "can obtain only effects of relatively short duration."¹¹ But the "agitated" look and intention remain. What counts most, what one remembers most, about Jenny Holzer's flashing sentences on electronic message boards, for example, is their seemingly irrational relationship to one another, the digitalized fragmentation of the words themselves, their rapid movement past the eye. Disruption, structurally as well as conceptually, is the aim of Holzer's art (as it is with a number of others'). Disruption becomes an end in itself it *is* the revolution. (And an old one at that.)

It is possible to interpret such agitational art as at once an anxious response to and rejection of what seems fated. More specifically, it may be a manic defense against oppressive fears of "death, chaos, and mystery."¹² This is not unrelated to José Ortega y Gasset's notion that the "universal

pirouetting" of the modern artist can be seen as "an attempt to instill youthfulness into an ancient world."¹³ But unfortunately, this universal pirouetting may be only spinning us back to the artist, not to the world.

There is another strain of activist art today that falls into the category of what Ellul calls the propaganda for integration. This art "aims at stabilizing the social body, at unifying and reinforcing it."¹⁴ It accomplishes this by offering

a complete system for explaining the world, and [providing] immediate incentives to action. We are here in the presence of an organized myth that tries to take hold of the entire person. Through the myth it creates, propaganda imposes a complete range of intuitive knowledge, susceptible of only one interpretation, unique and one-sided, and precluding any divergence. This myth becomes so powerful that it invades every area of consciousness, leaving no faculty or motivation intact.¹⁵

In short, this type of art calls for a new status quo—a new myth or conformity. This is what I take the work of Judy Chicago, and some of the works of May Stevens, for example, to offer. The decadent, oppressive capitalism, these works suggest, should be replaced by the wholesome new other-ism. But this is really the same old lonely crowd in new ideological clothing. The social harmony that such integration propaganda aims at can be as ruthlessly exclusive and as oppressive as the marginalizing structures it seeks to overthrow. It corresponds to the modern need

to create and hear fables. . . . It also responds to man's intellectual sloth and desire for security. 16

It also becomes a solution to the problem of passivity.

The individual becomes less and less capable of acting by himself; he needs the collective signals which integrate his actions into the complete mechanism. Modern life induces us to wait until we are told to act. Here again propaganda comes to the rescue.¹⁷

But it is the individual struggling for autonomy¹⁸ within the crowd that art must try to reach, cultivate, encourage, support, draw out. Goya remains an examplar for such nonpropagandistic activist art. I am speaking, particularly, of the Goya of "Los Desastres de la Guerra," the "pinturas negras" of the Quinta del Sordo, and the "Disparates," all conceived between 1810 and 1820. With every touch, every gesture, every choice, Goya reminds us of Romanticism's discovery that life "is not a reality which encounters a greater or lesser number of problems, but that it consists exclusively in the problem of itself."¹⁹ Goya's sensitivity to nuance, his transfigurations of light and dark, his leap away from the symbolic distortions of his earlier

114 Donald B. Kuspit

works, all make it possible for the viewer to experience horrific human catastrophes *from the inside*. In Goya, we are beyond figures of good and evil in any conventional sense: both the soldiers and their victims are miserable. The sociopolitical reality of war becomes, in these works, the vehicle for an unfolding of what human beings are capable of, what *individuals* are capable of. Without forsaking reportorial witnessing of the actual event, and yet without advocating *any* myth of man, society, or state, these works allow for freedom of insight as well as freedom of sight.

It was in a 1919 Berlin exhibition that the slogan "DADA stands on the side of the revolutionary Proletariat" was first posted.²⁰ And it was George Grosz and Wieland Herzfelde, John Heartfield's younger brother, who wrote:

The pending revolution brought gradual understanding of this [social] system. There were no more laughing matters, there were more important problems than those of art; if art was still to have a meaning, it had to submit to those problems.²¹

But the anticipated revolution did *not* happen in Germany. That is no doubt why, 40 years later, Hannah Höch would describe the German Dadaists' relationship with the communists as "innocent and truly unpolitical."²² Asked whether "dada had been, in a way, a kind of parody of a typically German *Reformbewegung*,"²³ Höch acknowledged that it had. Non-theless, she did point out, Dada shocked people into realizing "that things could also be done differently, and that many of our unconventional ways of thinking, dressing, or reckoning are no less arbitrary than others which are generally accepted."²⁴

Germany's *Neue Sachlichkeit* (New objectivity), Bernard S. Myers points out, was "another form of protest against the times ... a bitter but dry and hard realism that is strongly emotional in character and social in content."²⁵ *Neue Sachlichkeit* was informed by a subliminal romantic yearning for social intimacy—"brotherhood" or "sisterhood"—as an alternative to the compulsory alienation of contractual, capitalist society. This yearning took the form of identification with one's fellow sufferer, the implicit assumption being that through such communion a new society might be forged.

In fact, both these endeavors were premised on *ressentiment*,²⁶ intensified by the promises of imminent revolution. This *ressentiment* has deep Romantic roots, going back at least to Shelley's assertion that "poets are the unacknowledged legislators of the world,"²⁷ and is a manifestation of what Abraham Maslow has called "the arrogance of creativeness."²⁸

Now, with a revolution permanently pending and never arriving, a revolution permanently on hold, the seeds of German Romanticism and

revolt, transplanted, have brought forth, paradoxically, a naive American "media-ated" realism. And so here, the desire to shock is what remains of German Dadaism. The major message is that everything can be done differently, which is a parody of the idea of revolution—a loss of any sense of purpose or direction. The problem is that this polymorphously perverse carnival of a world upside down, the sense of the chance character of all our engagements, becomes an enchantment in itself.

Artists like Ronnie Cutrone, Richard Hambleton, Keith Haring, Mike Kelley, Kenny Scharf, and Julie Wachtel, just to name a few, revel in their abilities to shock the viewer with supposedly "unexpected" comparisons and contrasts. But who is really shocked? As I suggested earlier, though it's true that such works provide an initial ironical spark, that spark is no greater than that provided by these artists' sources—in this case, the funny papers, Saturday-morning cartoons, '50s situation comedies and detective series. In fact, the modern viewer has grown accustomed to being momentarily "jarred." So these artists, rather than effectively commenting on or critiquing this state of affairs, satisfy what has become an addiction for the lonely crowd.

Similarly, what was for *Neue Sachlichkeit* a visionary possibility now runs the risk of becoming an insidious invitation to the "one society" of the neo-*Neue Sachlichkeit*. This art, rather than suggesting how individuals might identify their real inner needs and condition, enforces common experience, crowd mentality. Much of it shows little of the emotional sensitivity to the other—little of the fellow feeling—that informed *Neue Sachlichkeit*.

Among American activist artists today, Leon Golub seems the one with the most complex yearning for community, and with the most acute awareness of its aborted character in modern society. But, as Theodor Adorno suggested, one always has to wonder whether "the artistic attitude of howling and crudeness"29 truly denounces, or instead identifies with, the forces of social oppression. The problem with Golub's work is that it implies that there is no socially feasible alternative to the allpowerful, totalitarian figure. In his earlier paintings from the "Mercenaries" and "Gigantomachies" series, Golub seems to be struggling imaginatively with his human figures as they act out their deadly games of dominance and submission: their bodies become raw tendons of paint. But the blacks of his more recent South Africa paintings-torturers and tortured-are flattened out. Through their clothes and limbs, the surface of the canvas appears, reiterating their status as social signifiers. Rather than urgent physical presences, they become emblems of the inevitable and inescapable evil of the crowd.

Similarly, Jenny Holzer's installation for the "Skulptur Projekte in Münster 1987" exhibition mocks that city's memorial to the fallen German dead of World War I by amplifying the notion of the soldier as an inhuman violator. But this stereotype does not cancel out the martyr stereotype, it only tightens the stranglehold that stereotypes have on us. Holzer militantly refuses to see man *from the inside*, and thus forecloses on that possibility for the viewer as well. Let Holzer manipulate a war memorial in her own world, the one at Fifth Avenue and Sixty-Fifth Street in New York, for example, and perhaps she would be obliged to examine issues of war—and man—with more complexity, to imagine and present the "human" aspects of inhumanity.

May Stevens' work is an important example of the propaganda of feminist integration. In *Mysteries and Politics*, 1978, or her "Ordinary/Extraordinary" series, beginning in 1980, the artist has achieved something valuable. In these works, Stevens brings female characters from radically different worlds into dialogue with one another. Stevens and her viewers are surely entitled to this feminist fantasy as an ideal to strive for. But when she in effect presents femaleness as exhaustive of humanness, Stevens seems to be suggesting that only one sex should be permitted admission to this Garden of Eden. (It is incidentally worth noting that the conception of woman as the eternally enigmatic and mysterious has contributed to male inability to see woman as fully human. There is little evidence that Stevens has adequately explored the implications of this problem.)

Hans Haacke's protests of the corporate world's appropriations of culture rely on an elegant editorial selection and presentation of images to score their points, to tell us that high culture is as politically naive as business is politically clever. Haacke stands foremost among the very few artists who have had the courage to remind us of the socially oppressive realities that art enters into; his interventionary works represent an important contribution. But in his dependence on the same "distorting" techniques as those employed by corporate public relations, by choosing some "facts" and omitting others, he manipulates the viewer into accepting his version of reality. Unfortunately, however, that version of reality strips art of its multifaceted complex nature and manifestations, so that Haacke's work can be seen as social realism raised to a higher level of abstraction—with culture taking the place of the undifferentiated individual.

Many more examples of today's activist art could be presented. My point remains that a significant amount of it, so full of *ressentiment*, runs the risk of symbolizing society's arrested metamorphosis, and, simultaneously, society's lonely-crowd way of looking at things, experiencing things, (mis)understanding things. As a result, it can end up serving the purposes of what I would call "gallery leftism"—the establishment of a political identity in the art world that has an ambiguous significance in the larger world. Just as the gallery estheticism of formalist art may have served as an attempt to "prove" that art is more likely to afford a genuine, memorable purer—experience than nature or life, so the gallery leftism of agitation or integration serves to prove that radicalism and social criticism are purer in the art world than in the lifeworld. But is this the vision, the goal, for which so many of our activist artists are reaching? I think not. In fact, the pretentiousness and self-privileging of either position—esthetic or activist is self-defeating, a betrayal of the real needs of the individual members of the lonely crowd, and a betrayal of the potential of art to meet those needs.

But we can look to the best works of the artists I have discussed in this essay, as well as to the works of a number of other artists today, to see that activist art has not reached a dead end in America. Sue Coe's renderings of social atrocities, whether grand or intimate, violent or grieving, speak from the inside of life in order to give voice to the many oppressed and miserable. With his gorgeously frightening drawings from the "Firestorm" series, 1982, Robert Morris approaches a "known" catastrophe with enormous imagination. Nancy Spero's Torture of Women, 1976. in its outspoken rage, in its range of gestures from delicate to savage, presents images of women in pain, but simultaneously in action. Twisted and pulled, but also buoyantly leaping and determinedly striding, they affirm multiple possibilities while acknowledging the devastating effects of oppression. Vito Acconci and Bill Viola have both used mass-media tools to promote a more complex understanding and experience of the individual human being in the social world. In Acconci's Sub-Urb at Artpark, 1983, the viewer/participant's intense isolation in underground "rooms," coupled with the experience of collective address as evoked by the printed, posterlike words on the walls, serves to acknowledge both the tension and the relationship between the realms of public and private. Viola produces a kind of internal Sensurround in his Reasons for Knocking at an Empty House, 1982, dedicated to a worker injured by a blow to the head. While the viewer faces, up close, a videotape of Viola, and while Viola swallows, breathes, while his heart beats, the earphones the viewer is wearing amplify those sounds, and one seems to be entering the body of the man who suffered that pain. And the exuberant yet elegant work of Tim Rollins and K.O.S. asks its audience to go beyond questions of formalist eloquence to arrive at a larger definition of what constitutes effective activist artmaking.

Finally, we can also look again to the past, to David's *The Death of Marat*, 1793, as a beacon for the rich possibilities of creative activist art. David has risked a very special kind of displacement here: he has taken the fiery orator out of his familiar "crowd" context. The viewer finds Marat in the most intimate setting possible, his bath. And Marat is rendered in all his vulnerable humanness: his head, relaxed in death, bears the traces of both pain and peace; his limp hand, dropped to the floor, still clings to, but can no longer clutch, the pen. Body is not abstract here, but defined, palpable. David has stripped the scene of all the conventional codes and symbols of political struggle, the viewer and Marat "meet" one another one-

118 Donald B. Kuspit

to-one, yet we know we are in the presence of a powerful political picture. Intimate identification, rather than aggressive assertion, *The Death of Marat* suggests, is the mode by which one can achieve significant change, both personal and social. It is true that the activist that the artist shows us is dead. But Marat's existence, his political efforts, are all the more present as a subject for contemplation. Our hushed dialogue with David's Marat—a single, naked, dead human being—is the most radical and resonant example I know of for suggesting the human and political potential of activist art.

Notes

- Jacques Ellul, Propaganda: The Formation of Men's Attitudes (first published in France, as Propagandes, 1962), New York: Alfred A. Knopf, 1972, pp. 8–9.
- 2. See also David Riesman, *The Lonely Crowd: A Study of the Changing American Character*, New Haven: Yale University Press, 1973. The notion of the "lonely crowd" derives from Gustave le Bon's idea of the crowd, which was utilized by Freud and carried forward by Riesman and Ellul. It also involves Nietzsche's concept of "the [human] herd."
- 3. Ellul, p. 147.
- 4. Harold Rosenberg, *Discovering the Present: Three Decades in Art, Culture, and Politics,* Chicago: University of Chicago Press, 1973, p. 19.
- 5. Ibid., p. 53.
- 6. I am using "autonomy" in a modified Freudian sense, as the ability to withstand trauma from exterior as well as interior sources. David Shapiro, in his *Autonomy and Rigid Character*, New York: Basic Books, 1981, p. 16, describes autonomy as "a new kind of self-regulation...in the form of increasingly articulated conscious aims, and...a new kind of behavior, intentional, planful action—self-directed action in the proper sense." On pp. 17–18 he says that "the human sense of autonomy" derives from "active mastery of the environment." It involves an "advance, in the Marxist phrase, 'from the realm of necessity to the realm of freedom.""
- 7. Rosenberg, p. 19.
- 8. Ellul, p. 8. Lucy R. Lippard's "Some Propaganda for Propaganda," in *Get the Message?* A Decade of Art for Social Change, New York: E. P. Dutton, 1984, pp. 114–23, totally ignores these issues. Her notion of "good propaganda" (p. 116) is a contradiction in terms.
- 9. Ellul acknowledges that this distinction echoes Lenin's well-known distinction between agitation and propaganda proper, and the equally well-known distinction between the "propaganda of subversion" and the "propaganda of collaboration" (p. 71).
- 10. Ibid., pp. 71-72.
- 11. Ibid.
- D. W. Winnicott, "The Manic Defence," *Collected Papers*, London: Tavistock Publications, 1958, p. 132.
- José Ortega y Gasset, "The Dehumanization of Art," The Dehumanization of Art and Other Writings on Art and Culture, Garden City, N.Y.: Doubleday & Company, 1956, pp. 46–47.
- 14. Ellul, p. 75.

- 15. Ibid., p. 11.
- 16. Ibid., p. 148.
- 17. Ibid. Ellul is describing what has come to be called the "diffusion of responsibility" that occurs in the lonely crowd. There is an inability to decide to take personal responsibility for anything that occurs. See C. Mynatt and S. J. Sherman, "Responsibility Attribution in Groups and Individuals: A Direct Test of the Diffusion of Responsibility Hypothesis," *Journal of Personality and Social Psychology* 32, 1975, pp. 1111–18. See also B. Latane and J. M. Darley, *The Unresponsive Bystander*, New York: Appleton-Century-Crofts, 1970.
- This returns us to Shapiro, who connects the "fixed purposiveness of the rigid person" 18.(p. 75) with "his or her continued emulation and identification with images of superior authority derived from the child's image of the superior authority of the adult" (p. 74). Shapiro thinks this a "miscarriage" of the development of "volitional direction and control," not its "overdevelopment." "Flexibility-not rigidity-of behavior stands at the opposite pole from the immediacy and passivity of reaction of early childhood. Flexibility-not rigidity-reflects an active self-direction. Furthermore, flexibilitynot rigidity—reflects a genuinely objective attitude toward the world" (pp. 74-75). Truly creative critical art participates in the individual's autonomy. Propaganda (and the media) encourages the emulation and identification with superior authority. Ellul's discussion (p. 149) of the way the individual in the lonely crowd "feels himself diminished" is also worth noting in this context. "He gets the feeling that he is under constant supervision and can never exercise his independent initiative . . . he thinks he is always being pushed down to a lower level. He is a minor in that he can never act with full authority." This strongly resembles Shapiro's discussion of the difference between the rigid character and autonomy, and suggests a social rationale for it.
- Ortega y Gasset, "In Search of Goethe from Within," *The Dehumanization of Art*, pp. 136–37.
- Hannah Höch, quoted in Lucy R. Lippard, ed., *Dadas on Art*, Englewood Cliffs, N.J.: Prentice-Hall, 1971, p. 72.
- 21. Quoted in ibid., p. 81.
- 22. Quoted in ibid., p. 71.
- 23. Quoted in ibid., p. 77. Lippard, in "Dada in Berlin: Unfortunately Still Timely," *Get the Message?*, pp. 67–73, sidesteps this critical recognition. She notes that the German art of the time can be distinguished from other European art "by the depth of its bitterness," then goes on to add that, ironically, "Berlin Dada art, for all its disorientation, appears more hopeful and positive" (p. 72). Thus Lippard avoids considering how the varying degrees of frustration that underlay the art of the time may nevertheless have implied an unconscious awareness of the impossibility of social revolution in the Germany of the day, as well as an unconscious recognition of the necessity of profound personal revolution as a precondition for social revolution.
- 24. Quoted in ibid.
- 25. Bernard S. Myers, *The German Expressionists: A Generation in Revolt*, New York: Frederick A. Praeger, 1966, p. 227.
- 26. Max Scheler, in his *Ressentiment*, New York: The Free Press of Glencoe, 1961, pp. 45–46, describes *ressentiment* as "a self-poisoning of the mind . . . a lasting mental attitude, caused by the systematic repression of certain emotions and affects which, as such, are normal components of human nature. Their repression leads to the constant tendency to indulge in certain kinds of value delusions and corresponding value judgments. The emotions and affects primarily concerned are revenge, hatred, malice, envy, the impulse to detract, and spite." None of these feelings, writes Scheler, neces-

120 Donald B. Kuspit

sarily leads to *ressentiment*. It develops "only if there occurs neither a moral self-conquest...nor an act or some other adequate expression of emotion . . . and if this restraint is caused by a pronounced awareness of impotence. . . . Through its very origin, *ressentiment* is therefore chiefly confined to those who *serve* and are *dominated* at the moment, who fruitlessly resent the sting of authority . . . the spiritual venom of *ressentiment* is extremely contagious" (p. 48).

- 27. This is the last line of Shelley's *A Defence of Poetry*, 1821. For an account of Shelley's revolutionary interests see Kenneth Neill Cameron, *The Young Shelley: Genesis of a Radical*, New York: Crowell-Collier, Collier Books, 1962.
- Abraham H. Maslow, "Neurosis as a Failure of Personal Growth," *The Farther Reaches of Human Nature*, New York: Penguin Books, 1976, p. 39.
- 29. Theodor Adorno, Aesthetic Theory, London: Routledge & Kegan Paul, 1984, p. 327.

PART THREE

Cognitive and Communicative Structure of Art

The perception of society as a cultural, human construction (not a development of some natural order) has resulted in a reexamination of the concept of nature and led to investigations of the ideological reasons for disguising culture as nature. As a consequence, both the natural and cultural world have been thrown open to scrutiny. This scrutiny, related to a more general trend that Terence Hawkes has identified as "the 'new' perception," involves the realization that it is impossible to perceive or understand the world objectively, that is, free from any cultural bias. "In fact," writes Hawkes,

every perceiver's *method* of perceiving can be shown to contain an inherent bias which affects what is perceived to a significant degree. A wholly objective perception of individual entities is therefore not possible: any observer is bound to *create* something of what he observes.¹

Hawkes adds that

accordingly, the *relationship* between observer and observed achieves a kind of primacy. It becomes the only thing that *can* be observed. It becomes the stuff of reality itself. . . . In consequence, the true nature of things may be said to lie not in things themselves, but in the relationships which we construct, and then perceive, *between* them.²

To Hawkes, this is a "structuralist" way of thinking because the importance of things, of discrete entities can only be determined when they are integrated into the structure of which they form a part. In effect, emphasis shifted from discussions of things, to investigations of how structures make meaning possible.

122 Part Three

Structuralist ideas have played an important role in contemporary art criticism. The discipline in which they first and most clearly took shape was linguistics. Ferdinand de Saussure, a Swiss linguist, among the first to develop what would come to be called structuralist ideas at the University of Geneva around 1906, examined the way language sounds acquire meaning through a relationship based on differences. It is generally believed by Structuralists that Saussure argued that meaning was not communicated through discrete word sounds, but through differences in sounds from one word to another.³ He also formulated the concept of what he called *signs, signifiers,* and *signifieds*. A sign he identified as the structural relationship between a signifier and a signified. The written/spoken word "reed," for example, is a signifier; reed, the plant growing in the marsh, is what is referred to and is the object that is signified. Together they form a linguistic sign.

The American philosopher C. S. Peirce, a contemporary of Saussure, refined the concept of signs by identifying three types: iconic, indexical, and symbolic. An *iconic* sign is one in which the signifier resembles its subject (the thing it signifies) the way a painting of a tree resembles an actual tree or the sound "woof" resembles a dog's bark. An *indexical* sign is one that has a causal relationship with its subject, as smoke is an indication of fire or thunder is an indication of lightning, one being caused by the other. A *symbolic* sign is one that has an arbitrary relationship to its subject as the word/sound "red" has to the color red or the color red has to passionate emotions.⁴

By the 1960s, these ideas were adapted to other areas of study using language and a rather rigid notion of binary opposition supposedly inherited from Saussure as the model structure. The result, as exemplified by the work of French anthropologist Claude Lévi-Strauss, was the elevation of language to the level of a universal ordering or structuring principle that patterned all thought and action, even at the unconscious behavioral level. According to Mark C. Taylor,

Structuralists like Claude Lévi-Strauss argue that "language" designates the complex structure of symbols, codes and conventions that, existing prior to and independent of any particular subject, guides all thought and action. Language functions like a template that patterns human behavior. The self-conscious subject does not deliberately create or intentionally construct the linguistic structures that direct his life. To the contrary, language, the intricate symbolic order, constitutes every subject.⁵

While giving such primacy to language that it is said to control unconscious human behavior has come under attack by deconstructive philosophers such as Jacques Derrida,⁶ Hawkes's observation about the culturebound aspect of the "relationships which we construct, and then *perceive*" is nonetheless fundamental to Postmodern criticism. Much attention has been devoted to the careful analysis of texts (that is to say, literature, visual arts, music) in an effort to understand how culture shapes perception. What has become clear is that perceptions of reality are in large part dependent upon and constructed through systems of communication of which the arts are primary exemplars. Thus, it can be said that, because of cultural attitudes or biases, reading about the world and looking at pictures of the world unconsciously shape perceptions and create world views. It is also apparent that perception of what has been written and depicted is affected by the perceiver's inherent (pre-existing) cultural attitudes or biases.

Such attitudes or biases are usually unconscious and therefore hidden within cultural codes. For example, it has been argued by feminists that in language, words such as "craftsman," "chairman," and "statesman" are culturally biased, coded words promoting male domination of society. As in language, the work of art is not free of such cultural codes; it functions through codes to communicate and validate a culture's views/biases.

The prominence given originality in art in the Modern period has come to be seen as a kind of cultural code promoting progress and change while rejecting traditional values and modes of thinking. In writing of S/Z, a book by French philosopher and critic Roland Barthes, Rosalind E. Krauss observes how Barthes, through an examination of literary texts, calls into question this perception of originality. Barthes's book, she writes,

is a demonstration of the way that systems of connotation, stereotype, cliché, gnomic utterance—in short, [the way] the always already-known, already-experienced, already-given-within-a-culture—concatenate to produce a text.⁷

In this scenario, the text (or image) is produced by linking together already existent, already created (written or depicted) descriptions and images. To Barthes, texts and images are based on already coded models (not originals) that are existent within culture, their meanings (to a great extent) already established as part of a pre-formed, coded system. Thus following Barthes, it can be argued that perception of the world (landscape, people, events, politics) is in large measure already done *before* perceiving takes place, having been formed by images already seen, texts already read.

In reference to artistic and literary practice, Barthes came to the conclusion that

to depict is to unroll the carpet of the codes, to refer not from a language to a referent [a thing in the world], but from one code to another. Thus, realism consists not in copying the real but in copying a (depicted) copy of the real... This is why realism cannot be designated a "copier" but rather a "pasticheur" (through secondary mimesis, it copies what is already a copy).⁸

124 Part Three

According to Barthes, it is impossible to see the "real" because the copy is always there in its place. Pictures and texts are pasted together (pastiched) from copies, from existing texts and images which are not original but received already made.⁹

The question of representation, codes, and originals is identified by critic Douglas Crimp in his essay that is reprinted here, "The Photographic Activity of Postmodernism," as central to the concerns of Postmodernism. He views the strategy used by some artists to undermine attempts to make photography-as-art as a way of exposing the notion of originality as a myth of Modern culture.

It is important to note that the photographic sign is special because it has both an *iconic* and an *indexical* relationship to the world to which it refers: iconic because it is a signifier that looks like the thing it signifies the tree in the photograph looks like the tree in nature; *indexical* because it is caused (to come into existence) by the thing it signifies—the light reflecting from the tree strikes the photographic plate making an "impression." Thus, photography occupies a singular position regarding originality, reproduction, realism, and representation, as German writer Walter Benjamin already realized in the 1930s.

Benjamin, as Crimp notes in his essay, used the word "aura" to describe the special quality works of art acquired over time because of age, history, circumstance. Aura was a quality that only the original, authentic work could have, a quality that could not be faked. He reasoned that with the invention of mechanical means to reproduce works of art (photography), this special aura would fade away. Familiarity with the original through copies would make the original seem less "unique," less special; a part of the original would be *present* in each copy, depleting the original. It is in this way, alleges Crimp, that the aura of the *Mona Lisa* "has been utterly depleted by the thousands of times we've seen its reproduction, and no degree of concentration will restore its uniqueness for us."

However, Benjamin also realized that primitive photographs, in spite of being mechanically made, had an aura that was evidenced through the subject. This occurred because of their long exposure time and "the unique, unmediated relationship between the photographer . . . and his sitter." That is, the iconic and indexical features in these photographs were strongly evident in the images of the sitters, giving them a sense of presence; this was a result of not disguising the iconic and indexical features (as later photographers were wont to do) in attempts to make photographs look like paintings.

To Benjamin, it was noteworthy that aura could be achieved in this way, through the presence of the subject rather than through the presence of the hand of the photographer. For in painting, aura was connected to the presence of the hand of the painter and helped define the work as unique and authentic. From this kind of aura which emphasized the presence of the artist was created the myth of artistic genius, conferring special status upon the artist and making a valuable commodity (because oneof-a-kind) of the art object. The result was an emphasis upon style and a reduction in the importance of the subject; it was this, Benjamin believed, that had caused the loss of art's social significance.

All of this would change in the "age of mechanical reproduction," Benjamin prophesied. The art commodity (the precious, salable object of individual expression) would be emptied, depleted of aura. Everything in the radical artistic practice (from Rauschenberg and Warhol to the Minimal sculptors), Crimp writes, "seemed to conspire in that liquidation of traditional cultural values that Benjamin spoke of." But suddenly expressionism (painting in which the hand of the individual artist predominates through brushstroke) and photography-as-art (in which the hand of the individual photographer is valued in place of the subject) appeared as modes attempting to recuperate aura.

It is because of these attempts that Crimp postulates the photographic activity of Postmodernism as an operation to subvert expressionism and photography-as-art, to displace their attempts to recuperate aura, "to show that it [aura] too is now only an aspect of the copy, not the original." He goes on to write, echoing Barthes, that

a group of young artists working with photography have addressed photography's claims to originality, showing those claims for the fiction they are, showing photography to be always a *re*presentation, always-already-seen. Their images are purloined, confiscated, appropriated, *stolen*. In their work, the original cannot be located, is always deferred; even the self which might have generated an original is shown to be itself a copy.

Demonstrating that photography is about copies, Sherrie Levine re-photographs the work of other photographers. Cindy Sherman's self-portraits imitate movie stills; she assumes the guise of feminine movie stereotypes to show that there is no *real* Cindy Sherman, only copies. Richard Prince's photographs are reproductions of isolated fragments of commercial images.

None of these artists lay claim to unique visions, to originality. To the contrary, they show how the proliferation of images in modern society helps to manipulate and control behavior; identities and modes of behavior are copied from already created images, something Hal Foster addresses in his essay "Signs Taken for Wonders." All of this is to show that originality and objectivity, the basis of attempts to recuperate aura in expressionism and photography-as-art, are impossible, even for photography.

In his essay reprinted here, "Last Exit: Painting," Thomas Lawson responds to the idea prevalent in much criticism today that "there i no point in continuing to make art since it can only exist insulated from the real world or as an irresponsible bauble." He takes Barbara Rose's exhibition "American Painting: The Eighties," (organized, it should be noted, in

126 Part Three

1979) as a point of departure to discuss the condition of Modernist painting. "Painter after painter included there," he writes, "had done his or her best to reinvest the basic tenets of modernist painting with some spark of life, while staying firmly within the safe bounds of dogma." Because of this, he dismisses the exhibition, characterizing it as a "funeral procession of tired clichés. . . .

The exhibition, Lawson contended, showed that Modernism, which in the form of the avant-garde—had fought against the bourgeoisie in an attempt to change society, had been coopted by it. Becoming a part of the bourgeoisie, Modernism was now lending credibility to bourgeois society:

It is not just that its [art's] tactics and procedures have been borrowed by the propaganda industries—advertising, television, and the movies—it has become a part of them, lending authority and authenticity to the corporate structures that insistently form so much of our daily lives.

What Lawson is arguing is not only about the influence of the media, but how the purchasing of *contemporary* art (not just older art) has become a viable means to validate claims of social responsibility and human concern. Today, in contrast to the recent past, contemporary art is readily accepted as a sign of cultural respectability.

Among those artists called "post-modern" because they appropriate styles and imagery from other art and other cultures are what Lawson calls the "pseudoexpressionists"—namely, Sandro Chia, Francesco Clemente, Enzo Cucchi, Rainer Fetting, Salomé, Julian Schnabel. They "ingratiate themselves," writes Lawson,

by pretending to be in awe of history. Their enterprise is distinguished by an homage to the past, and in particular by a nostalgia for the early days of modernism. But what they give us is a pastiche of historical consciousness, an exercise in bad faith.

An exception, Lawson believes, is the work of David Salle which is effective because in it "metaphors refuse to gel," and "meaning is tantalizingly withheld." Salle "follows a strategy of infiltration and sabotage, using established conventions against themselves in the hope of exposing cultural repression." In other words, Salle uses the art of painting to expose cultural stereotypes and received images, even those of art itself. Salle's paintings

take the most compelling sign for personal authenticity that our culture can provide [painting, especially painting in which the hand of the artist is visible], and attempt to stop it, to reveal its falseness. The paintings look real, but they are fake. They operate by stealth, insinuating a crippling doubt into the faith that supports and binds our ideological institutions. It is this question of doubt that Lawson considers critical. For this reason, he disagrees with Crimp about the effectiveness of photographic artists such as Levine, Sherman, and Prince.

While Levine's work seems to confirm that "there is nothing to be done, that creative activity is rendered impossible," Sherman and Prince offer an art that uses the photographic media to reveal the "hidden structures of desire that persuade our thoughts." In spite of their attempts to show how culture makes people desire things and also makes those desires appear to be genuine needs, their works are so declarative, so straightforward, argues Lawson, that they "can do little to stimulate the growth of a really troubling doubt" in the mind of the perceiver about their intention and purpose. Without doubt, the works are "too easily dismissed as yet another avant-garde art strategy" and are simply absorbed into the esoteric and self-contained world of art.

According to Lawson, painting is better able to avoid this cooptation, better able to cause doubt. "The discursive nature of painting is persuasively useful, due to its characteristic of being a never-ending web of representations." It also allows one to place "critical esthetic activity at the center of the marketplace, where it can cause the most trouble"; like Buchloh, Lawson acknowledges that to be heard, one cannot be outside the mainstream of art. The ability to work from the inside, then, is what he sees as one of painting's advantages.

In "Signs Taken for Wonders," the essay by Hal Foster reprinted here, Foster expresses doubts about the identity, originality, and intention of the work of a group of "new abstractionists" who seem to oppose the Neo-Expressionists. He questions the ability of the painting of these "new abstractionists" to be critically effective in late-capitalist society. In speaking of the work of this diverse group, Foster notes that their work is mostly derived from "appropriation art (i.e., art engaged in a sometimes critical, sometimes collusive reframing of high-artistic and mass-cultural representations)." But, he asks, is this work by these "new abstractionists" really what it appears to be—abstract?

According to Foster, the abstract paintings of Jack Goldstein, for example, stress what Michael Fried had called the "objecthood" of painting.¹⁰ But to Foster, this "objecthood" is gratuitous, beside the point; it serves only as a *sign* of abstraction. "In effect," writes Foster, "Goldstein suggests that critical abstract painting à la Ryman has become all but reified in its conventions, that it is, in short, a readymade."¹¹ In other words, Foster believes that this new painting is not really abstraction because it does not engage the issues of abstraction; it is only a code for abstraction.

Simulating modern abstraction rather than appropriating it, "the paintings," observes Foster, "are simulacra [simulations] rather than copies [as in appropriation], and as such they function in a strategically different way." He quotes French writer Gilles Deleuze about the implications of simulation:

128 Part Three

"the copy is an image endowed with resemblance, the simulacrum is an image without resemblance"; whereas the copy produces the model *as* original, the simulacrum "calls into question the very notions of the copy and of the model."

The point being made is that a copy is modeled after something in the world; it is an image that resembles (looks like) the thing to which it refers (its model). On the other hand, the simulacrum simulates a model in the world by giving the appearance of having copied something and having something to which it refers; but having no actual referent, it is a free-floating sign. With the realization of simulation's power to convey the appearance of reality (that is, to disguise the fact that it is a free-floating sign), the identities of copy and model, the real and the false are no longer secure.

To Foster, painting that is the "readymade reduction of serious abstraction, a campy recycling of outré abstraction," is painting as the *sign* of painting; such "duplication of painting literally abstracts it—empties its historical form of content, reduces its material practice to a set of conventions. . . ." This plays into the mass-media economy of the sign, says Foster, for

this economy performs a similar operation on all cultural expressions, whereby the specific, ambivalent content of an expression (e.g., graffiti) is first abstracted as a general, equivalent style (graffiti art) and then circulated as so many commodity-signs (graffiti boutiques).

The example of graffiti referred to by Foster—illegally spraypainted subway cars—is particularly apt, for it began as an act of protest; soon it was made into art by being brought into galleries and painted on canvases, neutralizing all sense of protest; finally, like punk, it became a fashion.

Foster notes another aspect of the new abstraction. Artists such as Meyer Vaisman, Peter Halley, Oliver Wasow are involved in an abstraction that attempts representation of the abstract technological modes of control prevalent in contemporary society. Foster continues that "in one way or another, most of these artists seek to picture abstractive tendencies in late-capitalist life: in science, technology, telecommunications, image and commodity production." But to Foster, the question is whether or not these tendencies *can* be represented, especially by the art of painting which is an art based on preindustrial craft.¹² Are not the pictures of these "new abstractionists" fabricating a cultural bias that clouds by mystifying, simplifying, or beautifying rather than exposing problems of the systems under scrutiny?

Foster warns of the risks inherent in simulation. "Along with the delirium of commodity-signs let loose into our world by serial production, the duplication of events by simulated images is an important form of social control," and he suggests a more sinister, more illusive danger connected with capitalism, simulation, and reality: "how can one intervene politically in events when they are so often simulated or immediately replaced by pseudo-events?"

The question of relationships that Hawkes discussed as part of the "new perception" clearly has become a factor in Postmodern critical thinking. Explorations which began with semiotics turned to the structure of language, raising language to the level of a pervasive ordering system. Eventually, as focus shifted to the cognitive and ideological function of language as a system to fabricate world views, it became apparent that any system of communication could be seen as a language, including literature, music, architecture, and art.

As a communication system, the identity, status, intent, and function of art in contemporary society has become a major concern of critics and artists. As the essays by Crimp, Lawson, and Foster demonstrate, art (exemplified by the work of younger, Postmodern artists) is now viewed as part of a complex communicative and cognitive structure in which meaning is established by conscious manipulation of this structure. These critics point to Postmodern artists who make works of art that raise questions about the very possibility of communication itself through art.

The attitudes of such artists toward making art must be seen in light of the effects of late-capitalist society's emphasis upon commodity production in which free-floating signs mask reality; in response to this environment, the work of younger Postmodern artists can be seen to entail a questioning of art from various diverse, but not unrelated, perspectives. As Crimp suggests in his discussion, it is the originality of the work of art that is under scrutiny in the photographic work of Levine, Sherman, and Prince. Lawson emphasizes appropriation as a technique, especially in painting such as that of Salle, as the only way to critique from within the structure of art by stimulating doubt concerning painting's meaning. And finally, the question of representation/ simulation and copy/original in art is raised by Foster in relation to the work of abstractionists such as Goldstein, Vaisman, Halley, and others.

Notes

- 1. Terence Hawkes, *Structuralism and Semiotics* (Berkeley & Los Angeles: University of California Press, 1977), p. 17. Marx's ideas about base/superstructure are part of this "new perception" and have had an important influence on structuralist ways of thinking.
- 2. Hawkes, Structuralism, p. 17.
- 3. With Structuralism, this idea of difference evolved into the concept of binary opposition or binary difference whereby it was believed that a term could only be defined in relationship to its opposite—i.e., life/death, nature/culture, male/female, good/evil. Saus-

sure, however, seems to indicate that differences in sounds are important, not for meaning, but to recognize/distinguish words from each other. This is something Hawkes and other Structuralists and Poststructuralist writers have failed to acknowledge. See Hawkes, *Structuralism*, p. 23.

- 4. For more on this, see Hawkes, Structuralism, p. 129.
- 5. Mark C. Taylor, "Descartes, Nietzsche and the Search for the Unsayable," *The New York Times Book Review* (February 1, 1987), p. 34.
- 6. Deconstructive philosophers see this primacy as an attempt to "impose" a system of total control—based on language as a model—upon all knowledge with the result that that which cannot be embraced by such a model is repressed by simply being defined as unimportant, peripheral. Lévi Strauss's view should not only be viewed as an attempt to "discover" an over-arching principle with which to explain human "nature," but also as a last, but nonetheless characteristic, Modernist attempt to discover universal governing principles. Such belief in universal truth is greeted with skepticism by Deconstructionists—a skepticism that has come to characterize the Postmodern condition.
- 7. Rosalind E. Krauss, "Poststructuralism and the 'Paraliterary'," *October*, 13 (Summer 1980), p. 39.
- 8. Roland Barthes, S/Z, trans. Richard Miller, preface by Richard Howard (New York: Hill and Wang, A Division of Farrar, Straus and Giroux, 1974), p. 55, as quoted in Krauss, "Poststructuralism," p. 39. Barthes's method, and in this it is typical of Deconstruction, shifts attention from the signified to the signifier and the system of signification; that is, he shifts attention away from meaning outside the text to an investigation of how meaning lurks within/behind the text.
- 9. This, Krauss believes, forms the basis of the theory known as Poststructuralism. Like Lévi-Strauss, she gives primacy to language as a model for cultural reality. This theory, she writes, "is grounded in the fundamental perception that nothing cultural escapes writing—that everything is modeled on the structure of language and the process of inscription. Cultural reality is thus linguistic and grammatological. . . ." Rosalind Krauss as quoted by Michael Starenko, "What's an Artist to Do? A Short History of Postmodernism and Photography," *Afterimage* (January 1983), p. 4. Krauss's view of Poststructuralism is more consistent with the Structuralism of Lévi-Strauss and differs radically from the early deconstructive ideas of Poststructuralists Jacques Derrida and Michele Foucault as well as those of later writers Jean-François Lyotard, Jean Baudrillard, Gilles Deleuze, and Felix Guattari.
- See Michael Fried, "Art and Objecthood," Artforum (Special Issue, Summer 1967), pp. 12–23.
- 11. In this sense, "reified" refers to the belief that abstractions actually exist as entities prior to or even separate from their referents; employed in this way, abstraction is a style devoid of content and meaning.
- 12. Here Foster raises the Marxist issue that concerned Buchloh: that art—in its materials, methods, and procedures—should be related to the "means of production" dominant in the society in which it is being made. Can painting, an art form little changed since antiquity, adequately reflect the complex cybernetic systems of modern society? Or, is this only possible to do through media like video that are related to these systems?

The Photographic Activity of Postmodernism

DOUGLAS CRIMP

It is a fetishistic, fundamentally antitechnical notion of art with which theorists of photography have tusseled for almost a century, without, of course, achieving the slightest result. For they sought nothing beyond acquiring credentials for the photographer from the judgment-seat which he had already overturned.

> ---Walter Benjamin, "A Short History of Photography"

That photography had overturned the judgment-seat of art is a fact which the discourse of modernism found it necessary to repress, and so it seems that we may accurately say of postmodernism that it constitutes precisely the return of the repressed. Postmodernism can only be understood as a specific breach with modernism, with those institutions which are the preconditions for and which shape the discourse of modernism. These institutions can be named at the outset: first, the museum; then, art history; and finally, in a more complex sense, because modernism depends both upon its presence and upon its absence, photography. Postmodernism is about art's dispersal, its plurality, by which I certainly do not mean pluralism. Pluralism is, as we know, that fantasy that art is free, free of other discourses, institutions, free, above all, of history. And this fantasy of freedom can be maintained because every work of art is held to be absolutely unique and original. Against this pluralism of originals, I want to speak of the plurality of copies.

This paper was first presented at the colloquium "Performance and Multidisciplinarity: Postmodernism" sponsored by *Parachute* in Montreal, October 9–11, 1980 and subsequently published in *October* 15 (Winter 1980). Copyright © 1980 Massachusetts Institute of Technology and October Magazine Ltd.

132 Douglas Crimp

Nearly two years ago in an essay called "Pictures," in which I first found it useful to employ the term *postmodernism*, I attempted to sketch in a background to the work of a group of younger artists who were just beginning to exhibit in New York.¹ I traced the genesis of their concerns to what had pejoratively been labeled the theatricality of minimal sculpture and the extensions of that theatrical position into the art of the seventies. I wrote at that time that the aesthetic mode that was exemplary during the seventies was performance, all those works that were constituted in a specific situation and for a specific duration; works for which it could be said literally that you had to be there; works, that is, which assumed the presence of a spectator in front of the work as the work took place, thereby privileging the spectator instead of the artist.

In my attempt to continue the logic of the development I was outlining, I came eventually to a stumbling block. What I wanted to explain was how to get from this condition of presence—the *being there* necessitated by performance—to that kind of presence that is possible only through the absence that we know to be the condition of representation. For what I was writing about was work which had taken on, after nearly a century of its repression, the question of representation. I effected that transition with a kind of fudge, an epigraph quotation suspended between two sections of the text. The quotation, taken from one of the ghost tales of Henry James, was a false tautology, which played on the double, indeed antithetical, meaning of the word *presence*: "The presence before him was a presence."

What I just said was a fudge was perhaps not really that, but rather the hint of something really crucial about the work I was describing, which I would like now to elaborate. In order to do so, I want to add a third definition to the word *presence*. To that notion of presence which is about being there, being in front of and that notion of presence that Henry James uses in his ghost stories, the presence which is a ghost and therefore really an absence, the presence which is not there, I want to add the notion of presence as a kind of increment to being there, a ghostly aspect of presence that is its excess, its supplement. This notion of presence is what we mean when we say, for example, that Laurie Anderson is a performer with presence. We mean by such a statement not simply that she is there, in front of us, but that she is more than there, that in addition to being there, she has presence. And if we think of Laurie Anderson in this way, it may seem a bit odd, because Laurie Anderson's particular presence is effected through the use of reproductive technologies which really make her quite absent, or only there as the kind of presence that Henry James meant when he said, "The presence before him was a presence."

This is precisely the kind of presence that I attributed to the performances of Jack Goldstein, such as *Two Fencers*, and to which I would now add the performances of Robert Longo, such as *Surrender*. These performances were little else than presences, performed tableaux that were there in the spectator's space but which appeared ethereal, absent. They had that odd quality of holograms, very vivid and detailed and present and at the same time ghostly, absent. Goldstein and Longo are artists whose work, together with that of a great number of their contemporaries, approaches the question of representation through photographic modes, particularly all those aspects of photography that have to do with reproduction, with copies, and copies of copies. The extraordinary presence of their work is effected through absence, through its unbridgeable distance from the original, from even the possibility of an original. Such presence is what I attribute to the kind of photographic activity I call postmodernist.

This quality of presence would seem to be just the opposite of what Walter Benjamin had in mind when he introduced into the language of criticism the notion of the aura. For the aura has to do with the presence of the original, with authenticity, with the unique existence of the work of art in the place in which it happens to be. It is that aspect of the work that can be put to the test of chemical analysis or of connoisseurship, that aspect which the discipline of art history, at least in its guise as *Kunstwissenschaft*, is able to prove or disprove, and that aspect, therefore, which either admits the work of art into, or banishes it from, the museum. For the museum has no truck with fakes or copies or reproductions. The presence of the artist in the work must be detectable; that is how the museum knows it has something authentic.

But it is this very authenticity, Benjamin tells us, that is inevitably depreciated through mechanical reproduction, diminished through the proliferation of copies. "That which withers in the age of mechanical reproduction is the aura of the work of art," is the way Benjamin put it.² But, of course, the aura is not a mechanistic concept as employed by Benjamin, but rather a historical one. It is not something a handmade work has that a mechanically-made work does not have. In Benjamin's view, certain photographs had an aura, while even a painting by Rembrandt loses its aura in the age of mechanical reproduction. The withering away of the aura, the dissociation of the work from the fabric of tradition, is an *inevitable* outcome of mechanical reproduction. This is something we have all experienced. We know, for example, the impossibility of experiencing the aura of such a picture as the *Mona Lisa* as we stand before it at the Louvre. Its aura has been utterly depleted by the thousands of times we've seen its reproduction, and no degree of concentration will restore its uniqueness for us.

It would seem, though, that if the withering away of the aura is an inevitable fact of our time, then equally inevitable are all those projects to recuperate it, to pretend that the original and the unique are still possible and desirable. And this is nowhere more apparent than in the field of photography itself, the very culprit of mechanical reproduction.

134 Douglas Crimp

Benjamin granted a presence or aura to only a very limited number of photographs. These were photographs of the so-called primitive phase. the period prior to photography's commercialization after the 1850s. He said, for example, that the people in these early photographs "had an aura about them, a medium which mingled with their manner of looking and gave them a plenitude and security."³ This aura seemed to Benjamin to be a product of two things: the long exposure time during which the subjects grew, as it were, into the images; and the unique, unmediated relationship between the photographer who was "a technician of the latest school," and his sitter, who was "a member of a class on the ascendant, replete with an aura which penetrated to the very folds of his bourgeois overcoat or bow-tie."⁴ The aura in these photographs, then, is not to be found in the presence of the photographer in the photograph in the way that the aura of a painting is determined by the presence of the painter's unmistakable hand in his picture. Rather it is the presence of the subject, of what is photographed, "the tiny spark of chance, of the here and now, with which reality has, as it were, seared the character of the picture."⁵ For Benjamin, then, the connoisseurship of photography is an activity diametrically opposed to the connoisseurship of painting: it means looking not for the hand of the artist but for the uncontrolled and uncontrollable intrusion of reality, the absolutely unique and even magical quality not of the artist but of his subject. And that is perhaps why it seemed to him so misguided that photographers began, after the commercialization of the medium, to simulate the lost aura through the application of techniques imitative of those of painting. His example was the gum bichromate process used in pictorial photography.

Although it may at first seem that Benjamin lamented the loss of the aura, the contrary is in fact true. Reproduction's "social significance, particularly in its most positive form, is inconceivable," wrote Benjamin, "without its destructive, cathartic aspect, its liquidation of the traditional value of the cultural heritage."⁶ That was for him the greatness of Atget: "He initiated the liberation of the object from the aura, which is the most incontestable achievement of the recent school of photography."⁷ "The remarkable thing about [Atget's] pictures . . . is their emptiness."⁸

This emptying operation, the depletion of the aura, the contestation of the uniqueness of the work of art, has been accelerated and intensified in the art of the past two decades. From the multiplication of silkscreened photographic images in the works of Rauschenberg and Warhol to the industrially manufactured, repetitively structured works of the minimal sculptors, everything in radical artistic practice seemed to conspire in that liquidation of traditional cultural values that Benjamin spoke of. And because the museum is that institution which was founded upon just those values, whose job it is to sustain those values, it has faced a crisis of considerable proportions. One symptom of that crisis is the way in which our museums, one after another, around 1970, abdicated their responsibility toward contemporary artistic practice and turned with nostalgia to the art that had previously been relegated to their storerooms. Revisionist art history soon began to be vindicated by "revelations" of the achievements of academic artists and minor figures of all kinds.

By the mid-1970s another, more serious symptom of the museum's crisis appeared, the one I have already mentioned: the various attempts to recuperate the auratic. These attempts are manifest in two, contradictory phenomena: the resurgence of expressionist painting and the triumph of photography-as-art. The museum has embraced both of these phenomena with equal enthusiasm, not to say voraciousness.

Little, I think, needs to be said about the return to a painting of personal expression. We see it everywhere we turn. The marketplace is glutted with it. It comes in all guises—pattern painting, new-image painting, neoconstructivism, neoexpressionism; it is pluralist to be sure. But within its individualism, this painting is utterly conformist on one point: its hatred of photography. Writing a manifesto-like text for the catalogue of her *American Painting: The Eighties*—that oracular exhibition staged in the fall of 1979 to demonstrate the miraculous resurrection of painting—Barbara Rose told us:

The serious painters of the eighties are an extremely heterogeneous group some abstract, some representational. But they are united on a sufficient number of critical issues that it is possible to isolate them as a group. They are, in the first place, dedicated to the preservation of painting as a transcendental high art, and an art of universal as opposed to local or topical significance. Their aesthetic, which synthesizes tactile with optical qualities, defines itself in conscious opposition to photography and all forms of mechanical reproduction which seek to deprive the art work of its unique "aura." It is, in fact, the enhancement of this aura, through a variety of means, that painting now self-consciously intends—either by emphasizing the artist's hand, or by creating highly individual visionary images that cannot be confused either with reality itself or with one another.⁹

That this kind of painting should so clearly see mechanical reproduction as the enemy is symptomatic of the profound threat to inherited ideas (the only ideas known to this painting) posed by the photographic activity of postmodernism. But in this case it is also symptomatic of a more limited and internecine threat: the one posed to painting when photography itself suddenly acquires an aura. Now it's not only a question of ideology; now it's a real competition for the acquisition budget and wall space of the museum.

But how is it that photography has suddenly had conferred upon it an aura? How has the plenitude of copies been reduced to the scarcity of originals? And how do we know the authentic from its reproduction?¹⁰

136 Douglas Crimp

Enter the connoisseur. But not the connoisseur of photography, of whom the type is Walter Benjamin, or, closer to us, Roland Barthes. Neither Benjamin's "spark of chance" nor Barthes's "third meaning" would guarantee photography's place in the museum. The connoisseur needed for this job is the old-fashioned art historian with his chemical analyses and, more importantly, his stylistic analysis. To authenticate photography requires all the machinery of art history and museology, with a few additions, and more than a few sleights of hand. To begin, there is, of course, the incontestable rarity of age, the vintage print. Certain techniques, paper types, and chemicals have passed out of use and thus the age of a print can easily be established. But this kind of certifiable rarity is not what interests me, nor its parallel in contemporary photographic practice, the limited edition. What interests me is the subjectivization of photography. the ways in which the connoisseurship of the photograph's "spark of chance" is converted into a connoisseurship of the photograph's style. For now, it seems, we can detect the photographer's hand after all, except of course that it is his eye, his unique vision. (Although it can also be his hand; one need only listen to the partisans of photographic subjectivity describe the mystical ritual performed by the photographer in his darkroom.)

I realize of course that in raising the question of subjectivity I am reviving the central debate in photography's aesthetic history, that between the straight and the manipulated print, or the many variations on that theme. But I do so here in order to point out that the recuperation of the aura for photography would in fact subsume under the banner of subjectivity all of photography, the photography whose source is the human mind and the photography whose source is the world around us, the most thoroughly manipulated photographic fictions and the most faithful transcriptions of the real, the directorial and the documentary, the mirrors and the windows, Camera Work in its infancy, Life in its heyday. But these are only the terms of style and mode of the agreed-upon spectrum of photography-as-art. The restoration of the aura, the consequent collecting and exhibiting, does not stop there. It is extended to the carte-de-visite, the fashion plate, the advertising shot, the anonymous snap or polaroid. At the origin of every one there is an Artist and therefore each can find its place on the spectrum of subjectivity. For it has long been a commonplace of art history that realism and expressionism are only matters of degree, matters, that is, of style.

The photographic activity of postmodernism operates, as we might expect, in complicity with these modes of photography-as-art, but it does so only in order to subvert and exceed them. And it does so precisely in relation to the aura, not, however, to recuperate it, but to displace it, to show that it too is now only an aspect of the copy, not the original. A group of young artists working with photography have addressed photography's claims to originality, showing those claims for the fiction they are, showing photography to be always a *re*presentation, always-already-seen. Their images are purloined, confiscated, appropriated, *stolen*. In their work, the original cannot be located, is always deferred; even the self which might have generated an original is shown to be itself a copy.

In a characteristic gesture, Sherrie Levine begins a statement about her work with an anecdote that is very familiar:

Since the door was only half closed, I got a jumbled view of my mother and father on the bed, one on top of the other. Mortified, hurt, horrorstruck, I had the hateful sensation of having placed myself blindly and completely in unworthy hands. Instinctively and without effort, I divided myself, so to speak, into two persons, of whom one, the real, the genuine one, continued on her own account, while the other, a successful imitation of the first, was delegated to have relations with the world. My first self remains at a distance, impassive, ironical, and watching.¹¹

Not only do we recognize this as a description of something we already know—the primal scene—but our recognition might extend even further to the Moravia novel from which it has been lifted. For Levine's autobiographical statement is only a string of quotations pilfered from others; and if we might think this a strange way of writing about one's own working methods, then perhaps we should turn to the work it describes.

At a recent exhibition, Levine showed six photographs of a nude youth. They were simply rephotographed from the famous series by Edward Weston of his young son Neil, available to Levine as a poster published by the Witkin Gallery. According to the copyright law, the images belong to Weston, or now to the Weston estate. I think, to be fair, however, we might just as well give them to Praxiteles, for if it is the *image* that can be owned, then surely these belong to classical sculpture, which would put them in the public domain. Levine has said that, when she showed her photographs to a friend, he remarked that they only made him want to see the originals. "Of course," she replied, "and the originals make you want to see that little boy, but when you see the boy, the art is gone." For the desire that is initiated by that representation does not come to closure around that little boy, is not at all satisfied by him. The desire of representation exists only insofar as it never be fulfilled, insofar as the original always be deferred. It is only in the absence of the original that representation may take place. And representation takes place because it is always already there in the world as representation. It was, of course, Weston himself who said that "the photograph must be visualized in full before the exposure is made." Levine has taken the master at his word and in so doing has shown him what he really meant. The a priori Weston had in mind was not really in his mind at all; it was in the world, and Weston only copied it.

This fact is perhaps even more crucial in those series by Levine where that a priori image is not so obviously confiscated from high culture—by

138 Douglas Crimp

which I intend both Weston and Praxiteles—but from the world itself, where nature poses as the antithesis of representation. Thus the images which Levine has cut out of books of photographs by Andreas Feininger and Elliot Porter show scenes of nature that are utterly familiar. They suggest that Roland Barthes's description of the tense of photography as the "having been there" be interpreted in a new way. The presence that such photographs have for us is the presence of déjà vu, nature as already having been seen, nature as representation.

If Levine's photographs occupy a place on that spectrum of photography-as-art, it would be at the farthest reaches of straight photography, not only because the photographs she appropriates operate within that mode but because she does not manipulate her photographs in any way; she merely, and literally, takes photographs. At the opposite end of that spectrum is the photography which is self-consciously composed, manipulated, fictionalized, the so-called directorial mode, in which we find such auteurs of photography as Duane Michaels and Les Krims. The strategy of this mode is to use the apparent veracity of photography against itself, creating one's fictions through the appearance of a seamless reality into which has been woven a narrative dimension. Cindy Sherman's photographs function within this mode, but only in order to expose an unwanted dimension of that fiction, for the fiction Sherman discloses is the fiction of the self. Her photographs show that the supposed autonomous and unitary self out of which those other "directors" would create their fictions is itself nothing other than a discontinuous series of representations, copies, fakes.

Sherman's photographs are all self-portraits in which she appears in disguise enacting a drama whose particulars are withheld. This ambiguity of narrative parallels the ambiguity of the self that is both actor in the narrative and creator of it. For though Sherman is literally self-created in these works, she is created in the image of already-known feminine stereotypes; her self is therefore understood as contingent upon the possibilities provided by the culture in which Sherman participates, not by some inner impulse. As such, her photographs reverse the terms of art and autobiography. They use art not to reveal the artist's true self, but to show the self as an imaginary construct. There is no real Cindy Sherman in these photographs; there are only the guises she assumes. And she does not create these guises; she simply chooses them in the way that any of us do. The pose of authorship is dispensed with not only through the mechanical means of making the image, but through the effacement of any continuous, essential persona or even recognizable visage in the scenes depicted.

That aspect of our culture which is most thoroughly manipulative of the roles we play is, of course, mass advertising, whose photographic strategy is to disguise the directorial mode as a form of documentary. Richard Prince steals the most frank and banal of these images, which register, in the context of photography-as-art, as a kind of shock. But ultimately their rather brutal familiarity gives way to strangeness, as an unintended and unwanted dimension of fiction reinvades them. By isolating, enlarging, and juxtaposing fragments of commercial images, Prince points to their invasion by these ghosts of fiction. Focusing directly on the commodity fetish, using the master tool of commodity fetishism of our time, Prince's rephotographed photographs take on a Hitchcockian dimension: the commodity becomes a clue. It has, we might say, acquired an aura, only now it is a function not of presence but of absence, severed from an origin, from an originator, from authenticity. In our time, the aura has become only a presence, which is to say, a ghost.

Notes

- 1. Douglas Crimp, "Pictures," October, no. 8 (Spring 1979), 75-88.
- 2. Walter Benjamin, "The Work of Art in the Age of Mechanical Reproduction," in *Illuminations*, trans. Harry Zohn, New York, Schocken Books, 1969, p. 221.
- Walter Benjamin, "A Short History of Photography," trans. Stanley Mitchell, Screen, vol. 13, no. 1 (Spring 1972), 18.
- 4. Ibid., p. 19.
- 5. Ibid., p. 7.
- 6. Benjamin, "Work of Art," p. 221.
- 7. Benjamin, "Short History," p. 20.
- 8. Ibid., p. 21.
- 9. Barbara Rose, American Painting: The Eighties, Buffalo, Thoren-Sidney Press, 1979, n.p.
- The urgency of these questions first became clear to me as I read the editorial prepared by Annette Michelson for October, no. 5, A Special Issue on Photography (Summer 1978), 3-5.
- 11. Sherrie Levine, unpublished statement, 1980.

Last Exit: Painting

THOMAS LAWSON

The paintings have to be dead; that is, from life but not a part of it, in order to show how a painting can be said to have anything to do with life in the first place.

-David Salle, Cover, May 1979

It all boils down to a question of faith. Young artists concerned with pictures and picture-making, rather than sculpture and the lively arts, are faced now with a bewildering choice. They can continue to believe in the traditional institutions of culture, most conveniently identified with easel painting, and in effect register a blind contentment with the way things are. They can dabble in "pluralism," that last holdout of an exhausted modernism, choosing from an assortment of attractive labels-Narrative Art, Pattern and Decoration, New Image, New Wave, Naive Nouveau, Energism-the style most suited to their own, self-referential purposes. Or, more frankly engaged in exploiting the last manneristic twitches of modernism, they can resuscitate the idea of abstract painting. Or, taking a more critical stance, they can invest their faith in the subversive potential of those radical manifestations of modernist art labelled Minimalism and Conceptualism. But what if these, too, appear hopelessly compromised, mired in the predictability of their conventions, subject to an academicism or a sentimentality every bit as regressive as that adhering to the idea of Fine Art?

Such is the confused situation today, and everyone seems to be getting rather shrill about it. At one extreme, René Ricard, writing in these pages

Copyright © Artforum, October 1981, "Last Exit: Painting," Thomas Lawson. Reprinted with permission of the author and publisher.

on Julian Schnabel, has offered petulant self-advertisement in the name of a reactionary expressionism, an endless celebration of the author's importance as a champion of the debasement of art to kitsch, fearful that anything more demanding might be no fun. The writing was mostly frivolous, but noisy, and must be considered a serious apologia for a certain antiintellectual elite. On the other hand the periodical October has been publishing swingeing jeremiads condemning, at least by implication, all art produced since the late '60s, save what the editors consider to be permissible, which is to say art that owes a clear and demonstrable debt to the handful of Minimal and Conceptual artists they lionize as the true guardians of the faith. From a position of high moral superiority these elitists of another sort, intellectual but antiesthetic, condemn the practice of "incorrect" art altogether, as an irredeemably bourgeois activity that remains largely beneath their notice. Both approaches, of the esthete and the moralist, leave distinctions blurred, and art itself is conveniently relegated to an insignificant position as background material serving only to peg the display of self or of theory. From both sides we receive the same hopeless message: that there is no point in continuing to make art since it can only exist insulated from the real world or as an irresponsible bauble. This is only a partial truth. It would be more accurate, although a good deal more complicated, to argue that while there may be no point in continuing to make certain kinds of art, art as a mode of cultural discourse has not yet been rendered completely irrelevant.

Today . . . modern art is beginning to lose its powers of negation. For some years now its rejections have been ritual repetitions: rebellion has turned into Procedure, criticism into rhetoric, transgression into ceremony. Negation is no longer creative. I am not saying that we are living the end of art: we are living the end of the idea of modern art.

-Octavio Paz, Children of the Mire: Modern Poetry from Romanticism to the Avant-Garde

Despite the brouhaha, the numerous painting revivals of the latter part of the '70s, from New Abstraction to Pattern and Decoration, proved to be little more than the last gasps of a long overworked idiom, modernist painting. (The diversionary tactics of so many bemused critics hid this truth under a blanket eventually labelled "pluralism," but as the decade closed that blanket became more and more of a shroud.) These revivals were embalmed and laid to rest in Barbara Rose's poignantly inappropriately titled show "American Painting: The Eighties." That exhibition, presented in 1979, made the situation abundantly clear, and for that we should be thankful. Painter after painter included there had done his or her best to reinvest the basic tenets of modernist painting with some spark of life,

142 Thomas Lawson

while staying firmly within the safe bounds of dogma. The result was predictably depressing, a funereal procession of tired clichés paraded as if still fresh; a corpse made up to look forever young.

While it was still a creative force modernism worked by taking a programmatic, adversary stance toward the dominant culture. It raged against order, and particularly bourgeois order. To this end it developed a rhetoric of immediacy, eschewing not only the mimetic tradition of Western art, but also the esthetic distance implied by the structure of representation the distance necessarily built into anything that is to be understood as a picture of something else, a distance that sanctions the idea of art as a discursive practice. With modernism, art became declarative, we moved into the era of the manifesto and the artist's statement, justifications which brook no dissent.

Modernism's insistence on immediacy and the foreclosure of distance inevitably resulted in a denial of history, in an ever greater emphasis on not just the present, but the presence of the artist. Expressive symbolism gave way to self-expression; art history developed into autobiography. Vanguard art became a practice concerned only with itself, its own rules and procedures. The most startling result was the liberation of technique; the least useful result was the pursuit of novelty. As the modernist idea became debased, its deliberate sparseness worn through overuse, the acting-out of impulse, rather than the reflective discipline of the imagination, became the measure of satisfaction and value. As a result the modernist insistence on an essential meaninglessness at the center of artistic practice came actually to mean less and less. From being a statement of existential despair it degenerated into an empty, self-pitying, but sensationalist, mannerism. From being concerned with nothingness, it became nothing. The repudiation of mimesis, and the escalating demands for impact, for new experience beyond traditional limits, inevitably loosened the connections between artistic discourse and everyday life. Art became an abstraction, something of meaning only to its practitioners. On the whole modernist artists acted as though alienated from bourgeois society-it was the only posture that gave their work a significance transcending its own interiority. But for the most part this remained only a posture, rarely developing into a deeper commitment to social change. In a manner that foretold the final decline of the moral authority of modernism. radically individualist artists all too often found comfortable niches in the society they professed to despise, becoming little more than anxious apologists for the system.

Of course there had been one important moment that saw a possibility for a more truly revolutionary activity, and that was in Moscow in the years immediately following the Russian Revolution. This period not only pushed modernism to its logical expression in abstraction, but turned that abstraction away from the personal toward a more significant critique of production. Developing implications nascent in the work of Cézanne and the Cubists, it concentrated on the basic ingredients, ideological and material, involved in the production of art. This moment, abandoned by the artists themselves (only partly because of political pressures) in favor of a totally reactionary antimodernism, saw the first stirrings of a seed that, when later conjoined with the very different, but equally radical, activity of Marcel Duchamp, came to fruition just as the modernist hegemony seemed unassailable—demonstrating that it was not.

That fruition has been called Minimalism, and the Minimalist artists subverted modernist theory, at that time most ably articulated by the followers of Clement Greenberg, simply by taking it literally. If modernist art sought to concern itself with its own structures, then the Minimalists would have objects made that could refer to nothing but their own making. This absurdist extremism worked by dramatizing the situation, which in turn reinjected a sense of distance, and a critical discourse was once again possible. (It is no accident that it was this generation of artists—Donald Judd, Robert Morris, Robert Smithson, Art & Language, Joseph Kosuth, and Mel Bochner—who reintroduced the idea that an artist might be more than a sensitive person with talent, might in fact be both intelligent and articulate, might have something to say.)

All the while, countless other artists continued as if the ground had not been opened up in front of them, even adopting some of the superficial characteristics of the very modes that were rendering their practice obsolete and moribund. Some, of course, continued to paint, and it was those whom Rose chose to celebrate in her exhibition. And if that show seemed to lack all conviction, Rose's catalogue essay more than compensated with the vehemence of its language. Defending a denatured modernism that had become so divorced from historical reality that it could pretend to celebrate "eternal values," she lashed into Minimalism and Conceptualism as though they were the agents of the Anti-Christ. Which, for the true believer, they are.

Rose made it clear that procedure had indeed become ritual, and criticism mere rhetoric. Modernism has been totally coopted by its original antagonist, the bourgeoisie. From adversary to prop, from subversion to bastion of the status quo, it has become a mere sign of individual liberty and enterprise, freed entirely from the particular history that once gave it meaning. It is not just that its tactics and procedures have been borrowed by the propaganda industries—advertising, television, and the movies—it has become a part of them, lending authority and authenticity to the corporate structures that insistently form so much of our daily lives. We need change, we need it fast Before rock's just part of the past Oh-oh... It's the end, the end of the 70's It's the end, the end of the century

> -The Ramones, from the song, "Do You Remember Rock 'n' Roll Radio?" 1979

The end of the century. If modernist formalism seems finally discredited, hopelessly coopted by the social structures it purportedly sought to subvert, its bastard progeny continue to fill the galleries. We all want to see something new, but it is by no means clear that what we have been getting so far has any merit beyond a certain novelty. As Antonio Gramsci so presciently observed in his prison notebooks, a period lacking certainty is bedeviled by a plethora of morbid symptoms. Following the lead of architectural critics these symptoms have been hailed, rather carelessly, as "post-modern," with that term standing for a nostalgic desire to recover an undifferentiated past. According to this understanding any art that appropriates styles and imagery from other epochs, other cultures, qualifies as "post-modern." Ironically, the group that has been enjoying the most success, to date, as the exemplification of this notion is made up of pseudoexpressionists like Jonathan Borofsky, Luciano Castelli, Sandro Chia, Francesco Clemente, Enzo Cucchi, Rainer Fetting, Salomé, and Julian Schnabel. Despite the woolly thinking behind this usage, the claim does have some merit, but in the end the work of these artists must be considered part of a last, decadent flowering of the modernist spirit. The reasons for this initial success are quite straightforward. The work of these artists looks very different from the severe respectability of recent modernist production in New York, yet it is filled with images and procedures that are easily recognized as belonging to art, or at least to art history. As their champions are quick to point out, their work can be keyed, at least superficially, to a strain of activity that stretches from Conceptual art back to Dada. And on top of that they appear personal, idiosyncratic in a period during which lip service has been paid to the idea of individual liberty. even as that liberty is being systematically narrowed by the constraints of law and commerce.

These young painters ingratiate themselves by pretending to be in awe of history. Their enterprise is distinguished by an homage to the past, and in particular by a nostalgia for the early days of modernism. But what they give us is a pastiche of historical consciousness, an exercise in bad faith. (Even Borofsky's integrity becomes implicated here as a result of his relentless mystification.) For by decontextualizing their sources and refusing to provide a new, suitably critical frame for them, they dismiss the particularities of history in favor of a generalizing mythology, and thus succumb to sentimentality.

Chia and Cucchi hanker after the excitements of neoprimitivism, especially as understood by the likes of Marc Chagall, nurturing a taste for assumed naiveté. Castelli, Fetting, and Salomé hark back to the same period, favoring instead the putative boldness of style and content of German Expressionism. But whatever their sources, these artists want to make paintings that look fresh, but not too alienating, so they take recognizable styles and make them over, on a larger scale, with brighter color and more pizzazz. Their work may look brash and simple, but it is meant to, and it is altogether too calculated to be as anarchistic as they pretend.

Clemente and Schnabel are both more ambitious, seeking to accommodate a much broader range of references in their work. Both pick up on the neoromantic, pseudosurreal aspects of fashionable French and Italian art of the '30s and '40s, and make a great fuss about their wickedly outrageous taste in so doing. But that is only a starting point, albeit one that, with its emphasis on additive collage, sanctions an uncontrolled annexation of material. Renaissance and Baroque painting, Indian miniatures, cheap religious artifacts, a certain type of anything is fair game. And whatever is accepted becomes equivalent to everything else, all distinctions are merged as styles, images, methods, and materials proliferate in a torrent of stuff that is supposedly poetic, and thus removed from mere criticism.

This wider cultural cannibalism is the topic of another essay; the annexation of wide areas of modern art is problematic enough for my purposes here. Concentrating on that alone we have a surfeit of evidence. showing an historicism that pays court to a strain of 20th-century art that can, superficially, be identified as antimodern. Superficially, because any work produced in a certain period must share essential characteristics with other work of the same period; antimodern, because I am talking about the production of artists of the '30s and '40s who openly rebelled against the mainstream of radical modernism. In other words, the sophisticated if often rather mild-mannered art that was recently gathered together as part of the Beaubourg's Les Réalismes exposition. The same material also served as an introduction to the revisionist history presented at Westkunst. This was art that was difficult only in the sense that a naughty child is difficult; that is, art that misbehaved within a strictly defined and protected set of conventions. Art that misbehaved to demonstrate the need for discipline. Art that advocated a forced return to "eternal values," in both the esthetic and political realms. Art that often declared itself nationalist, always traditionalist. It is possible that recent work appropriating this art could have a critical import. The work of the pseudoexpressionists does play on a sense of contrariness, consistently matching elements and attitudes that do not match, but it goes no further. A *retardataire* mimeticism is presented with expressionist immediacy. The work claims to be personal, but borrows devices and images from others. There is a camp acknowledgment that what was once considered bad art can now be fun: however, that acknowledgment is couched in self-important terms that for the most part steer clear of humor. Appropriation becomes ceremonial, an accommodation in which collage is understood not as a disruptive agent, a device to question perception—but as a machine to foster unlimited growth.

This marriage of early modernism and a fashionable antimodernism can be characterized as camp, and there is definitely a strain of Warholism about the work. It is cynical work with a marketing strategy, and therefore extremely fashion-conscious. It is work that relies on arch innuendo and tailored guest lists—a perfect example is provided by Clemente's series of frescoed portraits of a chic demimonde, although the German's concentration on gay subject matter works in an equivalent manner.

But to dismiss this work as belonging to camp is too easy, for something more sinister is at hand. The forced unification of opposites is a wellestablished rhetorical tactic for rendering discourse immune from criticism. The capacity to assimilate anything and everything offers the prospect of combining the greatest possible tolerance with the greatest possible unity, which becomes a repressive unity. With this art we are presented with what amounts to a caricature of dialectics, in which the telescoping of elements cuts off the development of meaning, creating instead fixed images-clichés-which we are expected to associate with the proper attitudes and institutions (high art fit for museums). With great cynicism this work stands the modernist enterprise on its head, removing the anxious perception of nothingness at the heart of modernist expression, and replacing it with the smug acknowledgment that if the art means nothing it will be all the more acceptable to those who seek only entertainment. Such a debased version of modernist practice is vigorously opposed to the very idea of critical analysis since it is simply a declaration of presence signifying only the ambition of the artist to be noticed.

Being in love is dangerous because you talk yourself into thinking you've never had it so good.

—David Salle, ArtRite, Winter 1976/77

David Salle makes tremendously stylish paintings, paintings that will look good in the most elegant of rooms. His choice of color is brilliant pale, stained fields, highlighted with bright, contrasting lines and areas of paint. A look of high fashion. And yet the images he presents this way are emotionally and intellectually disturbing. Often his subjects are naked women, presented as objects. Occasionally they are men. At best these representations of humanity are cursory, offhand; at worst they are brutal, disfigured. The images are laid next to one another, or placed on top of one another. These juxtapositions prime us to understand the work metaphorically, as does the diptych format Salle favors, but in the end the metaphors refuse to gel. Meaning is intimated but tantalizingly withheld. It appears to be on the surface, but as soon as it is approached it disappears, provoking the viewer into a deeper examination of prejudices bound inextricably with the conventional representations that express them. Salle's work is seductive and obscure, and this obscurity is its source of strength, for when we attempt to bring light to the darkness, we illuminate much else as well. Salle follows a strategy of infiltration and sabotage, using established conventions against themselves in the hope of exposing cultural repression.

Salle occupies a central position in this polemic, for he appears to be balancing precariously between an empty formalism of the sort practiced by Clemente and Schnabel, and a critical subversion of such formalism. His work has long shared certain characteristics with the work of these artists, particularly in the deliberately problematic juxtaposition of heterogeneous styles and images. But whereas the worth of Clemente and Schnabel remains narcissistic at base, Salle's has always appeared more distant, a calculated infiltration aimed at deconstructing prevalent esthetic myths. Only now there seems to be a danger that the infiltration has become too complete; the seducer finds himself in love with his intended victim.

This infatuation has become more evident in the months following the so-called collaboration between Salle and Schnabel. This was a collaboration by fiat, a self-conscious gesture on the part of Schnabel (who had been given the painting in an exchange) in which he reversed the order of one of Salle's diptychs and partly covered one panel with a large, roughly painted portrait of Salle. The fabric of the original Salle was metaphorically ripped apart, literally wiped out, its meaning not so much altered as denied. The painting in fact became a Schnabel, a demonstration of the superior power of cannibalism over sabotage as a means of gaining control over one's subject. Lately Salle's paint has become thicker and more freely applied, some of the images clearly recognizable as taken from other art. In short, the ensembles seem less threatening.

Nevertheless, Salle's paintings remain significant pointers indicating the last exit for the radical artist. He makes paintings, but they are dead, inert representations of the impossibility of passion in a culture that has institutionalized self-expression. They take the most compelling sign for personal authenticity that our culture can provide, and attempt to stop it, to reveal its falseness. The paintings look real, but they are fake. They operate by stealth, insinuating a crippling doubt into the faith that supports and binds our ideological institutions. Nothing is more unfitting for an intellectual resolved on practicing what was earlier called philosophy, than to wish . . . to be right. The very wish to be right, down to its subtlest form of logical reflection, is an expression of that spirit of self-preservation which philosophy is precisely concerned to break down.

—Theodor Adorno, *Minima Moralia*, 1951

I believe that most of the serious critics who are at all interested in the problem of defining that clumsy term "post-modernism" would agree with the gist of my argument so far, would agree that, in the current situation, not only is the viability of any particular medium suspect, but that esthetic experience itself has been rendered doubtful. But it is precisely here that we begin to drift apart in the face of the unreconcilable difference. Basically it is a conflict between a certain logical, even doctrinaire, purity and the impurity of real life; a disagreement over what to do about the gap between what ought to be and what is.

A recent and succinct statement of the idealist position is Douglas Crimp's essay "The End of Painting," which appeared in October 16 (Spring 1981). Crimp describes the ennervation of modernist painting in terms similar to those I have used, but then attempts to close the argument, by demonstrating "the end." For this purpose he chooses to isolate the work of Daniel Buren as exemplary of the Conceptualism that ten years ago sought to contest the myths of fine art. Crimp allows that Buren's work runs the risk of invisibility, that since it is intentionally meaningless in a formal sense, it might fail to operate on a critical level. And indeed it is a problem that the work needs an explanatory text, a handbook of the issues raised, a guide to one's approach. But that is the least of it, for what Crimp fails to acknowledge is that Buren's strategy has, by this time, degenerated into little more than an elegant device, naturalized by the forces it sought to undermine. Worse than looking like decor, the photographic record of his activity makes his work now look very much like the art he despises, recalling as it does the kind of *decollage* popular in Paris in the '50s. So Buren actually finds himself in a quandary similar to that faced by Salle, but since he deliberately reduced his means so severely in the beginning, he now has less to work with, and so has less hope of escaping either failure or cooptation. As a result of this inevitable impasse a good deal of Conceptual art has lost its conviction, and thus its ability to provoke thought.

One simply does not believe repeated warnings that the end is nigh, particularly when those issuing the warnings are comfortably settling down as institutions in their own right. Much activity that was once considered potentially subversive, mostly because it held out the promise of an art that could not be made into a commodity, is now as thoroughly academic as painting and sculpture, as a visit to any art school in North America will quickly reveal. And not only academic, but marketable, with "documentation" serving as the token of exchange, substituting for the real thing in a cynical duplication of the larger capitalist marketplace.

In recognition of this state of affairs Sherrie Levine has decided to simply represent the idea of creativity, re-presenting someone else's work as her own in an attempt to sabotage a system that places value on the privileged production of individual talent. In doing so she finalizes Crimp's argument more conclusively than Buren, but that finality is unrealistic. It is also desperate. She articulates the realization that, given a certain set of constraints, those imposed by an understanding of the current situation as much as those imposed by a desire to appear "correct" in a theoretical and political sense, there is nothing to be done, that creative activity is rendered impossible. And so, like any dispossessed victim she simply steals what she needs. Levine's appropriations are the underside of Schnabel's misappropriations, and the two find themselves in a perverse lockstep. The extremity of her position doubles back on her, infecting her work with an almost romantic poignancy as resistant to interpretation as the frank romanticism of her nemesis.

So what is a radical artist to do in the current situation if he or she wants to avoid instant cooptation or enforced inactivity? A clue, paradoxically, is to be found in one of Crimp's passages on Buren: "It is fundamental to Buren's work that it act in complicity with those very institutions that it seeks to make visible as the necessary conditions of the art work's intelligibility. That is the reason not only that his work appears in museums and galleries, but that it poses as painting." It is painting itself, that last refuge of the mythology of individuality, which can be seized to deconstruct the illusions of the present. For since painting is intimately concerned with illusion, what better vehicle for subversion?

Cultivated philistines are in the habit of requiring that a work of art "give" them something. They no longer take umbrage at works that are radical, but fall back on the shamelessly modest assertion that they do not understand. —Theodor Adorno, Minima Moralia

Given the accuracy of Adorno's observation it is clearly necessary to use trickery to pry open that understanding, for the main problem today is to open the channels of critical discourse to a healthy skepticism. Established avenues of protest, the disturbances that are the usual remedies of the disenfranchised and the disenchanted are no longer effective. They are too easily neutralized or bought off by an official "inquiry." But by resorting to subterfuge, using an unsuspecting vehicle as camouflage, the radical artist can manipulate the viewer's faith to dislodge his or her certainty. The intention of that artist must therefore be to unsettle conventional thought from within, to cast doubt on the normalized perception of the "natural," by destabilizing the means used to represent it, even in the knowledge that this, too, must ultimately lead to certain defeat. For in the end some action must be taken, however hopeless, however temporary. The alternative is the irresponsible acquiescence of despairing apathy.

To an unprecedented degree the perception of the "natural" is mediated these days. We know real life as it is represented on film or tape. We are all implicated in an unfolding spectacle of fulfillment, rendered passive by inordinate display and multiplicity of choice, made numb with variety: a spectacle that provides the illusion of contentment while slowly creating a debilitating sense of alienation. The camera, in all its manifestations, is our god, dispensing what we mistakenly take to be truth. The photograph is the modern world. We are given little choice: accept the picture and live as shadow, as insubstantial as the image on a television screen, or feel left out, dissatisfied, but unable to do anything about it. We know about the appearance of everything, but from a great distance. And yet even as photography holds reality distant from us, it also makes it seem more immediate, by enabling us to "catch the moment." Right now a truly conscious practice is one concerned above all with the implications of that paradox. Such a practice might be called "post-modern" in a strict etymological sense because it is interested in continuing modernism's adversary stance, interested in the possibilities of immediate action, yet aware of the closure that that immediacy has imposed, in time, on genuine discourse. It is art that reintroduces the idea of esthetic distance as a thing of value, as something that will allow that discourse to open. It is art that pays attention to the workings of received ideas and methods, and in particular to those of the dominant media, in the hope of demonstrating the rigid, if often hidden, ideology that gives shape to our experience.

The most obvious procedure for this art that plumbs the dark secrets of the photographic question, the public trace of a submerged memory, would be to make use of the photographic media themselves, isolating pieces of information, repeating them, changing their scale, altering or highlighting color, and in so doing revealing the hidden structures of desire that persuade our thoughts. And indeed, it has been this kind of practice, the practice of such artists as Dara Birnbaum, Barbara Bloom, Richard Prince, and Cindy Sherman, working with video, film, and fashion photography, that has received the most considered attention from critics like Crimp and Craig Owens. And yet despite the success of this approach, it remains, in the end, too straightforwardly declarative. What ambiguity there exists in the work is a given of its own inner workings, and can do little to stimulate the growth of a really troubling doubt. The representation remains safe, and the work too easily dismissed as yet another avant-garde art strategy, commentary too easily recognized.

More compelling, because more perverse, is the idea of tackling the

problem with what appears to be the least suitable vehicle available, painting. It is perfect camouflage, and it must be remembered that Picasso considered Cubism and camouflage to be one and the same, a device of misrepresentation, a deconstructive tool designed to undermine the certainty of appearances. The appropriation of painting as a subversive method allows one to place critical esthetic activity at the center of the marketplace, where it can cause the most trouble. For as too many Conceptual artists discovered, art made on the peripheries of the market remains marginal. To reopen debate, get people thinking, one must be there, and one must be heard. One of the most important of Duchamp's lessons was that the artist who wishes to create a critical disturbance in the calm waters of acceptable, unthinking taste, must act in as perverse a way as possible, even to the point of seeming to endanger his or her own position. And it seems at this point, when there is a growing lack of faith in the ability of artists to continue as anything more than plagiaristic stylists, that a recognition of this state of affairs can only be adequately expressed through the medium that requires the greatest amount of faith.

For it is this question of faith that is central. We are living in an age of skepticism and as a result the practice of art is inevitably crippled by the suspension of belief. The artist can continue as though this were not true, in the naive hope that it will all work out in the end. But given the situation, a more considered position implies the adoption of an ironic mode. However, one of the most troubling results of the cooptation of modernism by mainstream bourgeois culture is that to a certain degree irony has also been subsumed. A vaguely ironic, slightly sarcastic response to the world has now become a clichéd, unthinking one. From being a method that could shatter conventional ideas, it has become a convention for establishing complicity. From being a way of coming to terms with lack of faith, it has become a screen for bad faith. In this latter sense popular movies and television shows are ironic, newscasters are ironic, Julian Schnabel is ironic. Which is to say that irony is no longer easily identified as a liberating mode, but is at times a repressive one, and in art one that is all too often synonymous with camp. The complexity of this situation demands a complex response. We are inundated with information, to the point where it becomes meaningless to us. We can shrug it off, make a joke, confess bewilderment. But our very liberty is at stake, and we are bamboozled into not paving attention.

The most challenging contemporary work using photography and photographic imagery remains illustrative. There is an indication of what might be considered, but no more; our understanding of the reverberations of the camera's picture-making is not advanced in a cohesive and compound form. Important issues are singled out, but they remain singular, strangely disconnected.

Radical artists now are faced with a choice—despair, or the last exit:

152 Thomas Lawson

painting. The discursive nature of painting is persuasively useful, due to its characteristic of being a never-ending web of representations. It does often share the irony implicit in any conscious endeavor these days, but can transcend it, to represent it. The following pages, a coda to the argument, reproduce the work of several such artists who have decided to present work that can be classified as painting, or as related to painting, but that must be seen as something other: a desperate gesture, an uneasy attempt to address the many contradictions of current art production by focusing on the heart of the problem—that continuing debate between the "moderns" and the "post-moderns" that is so often couched in terms of the life and death of painting.

[EDITOR'S NOTE: The artists and works of art that Lawson appended to his article as a "coda" were Walter Robinson, *Spy Story* and *Rescue Flight*, 1981; Jack Goldstein, *Untitled*, 1981; Troy Brauntuch, *Untitled*, 1981; Thomas Lawson, *Shot by the Fathers*, 1981.]

Signs Taken for Wonders

HAL FOSTER

What can we make of an artist like Jack Goldstein who, after performances, films and paintings that stressed spectacular effects, turns to "abstract" paintings—or, more precisely, to paintings of abstracted images or events (e.g., a star formation represented via a computer as a series of tiny spectra, a wisp of smoke specially photographed in a chamber, the rings of Saturn mediated by an electronic telescope, all painted on bright maroon, blue and green grounds)? What is the connection between his simulated works and his new abstract ones? What is the logic or dynamic of this turn?

Why, too, did James Welling pass from abstract photographs with representational effects (e.g., photos of aluminum foil or pastry dough on velvet that suggested Alpine landscapes) to "abstract" paintings—or, more precisely, to paintings of black dots on white grounds that seem randomly composed but are in fact based on computer graphics? What explains this passage?

How, also, did Sherrie Levine turn from inflected reproductions of modern master images (e.g., Edward Weston, Walker Evans, Kasimir Malevich, Egon Schiele), skeptical as these works seemed to be of the idea that any representation could be wholly original or symbolically total, to "abstract" paintings—or, more precisely, to paintings of generic abstract art (e.g., paintings of thin or broad vertical stripes, paintings on bare plywood with only the knothole plugs colored, checkerboard paintings)? What is the relationship between her serial repetitions and her new abstract ones?

This essay was originally published in *Art In America* (July 1986) and is reprinted with permission of the author and publisher.

154 Hal Foster

And, why, a few years after the Op paintings of Ross Bleckner, have younger artists like Phillip Taaffe and Peter Schuyff turned to this most outré form of abstract art: Schuyff to Op designs sometimes mixed with abstracted Surrealist motifs; Taaffe to Op sometimes paired with decorative pastiches of Barnett Newman paintings? What conditions these hybrid appropriations?

Finally, what are we to make of the work of Peter Halley, who paints rectilinear blocks and connective lines, which he respectively calls "cells" and "conduits," usually in Day-Glo arrangements on simulated stucco fields? Or of the work of Ashley Bickerton, who alternates between abstract paintings of pseudostone walls and standard design shapes and meticulous representations of quasi-sci-fi devices, structures and signs? Or of the work of Meyer Vaisman and Oliver Wasow, who, among other artists (e.g., Peter Nagy, Alan Belcher), seem obsessed with the abstractive effects of the reproductive techniques used to produce business logos and product displays? What prompts these "abstractions" and what (if anything) connects them?

I should say right away that I am concerned here with only one aspect of contemporary abstract art, one positioned at an ironic remove from its own putative tradition. The artists cited above are representative of this "new abstract painting," but any list makes three things clear at once: it is not new except sometimes in the sense of novel; it is not properly abstract except in the sense that it sometimes simulates or parodies abstract painting; and it is not monolithic—these artists are related by preconditions but diverse in practice.

The second point is the one of greatest possible misunderstanding. As suggested by the involvement of Goldstein and Levine, this new abstraction develops mostly out of appropriation art (i.e., art engaged in a sometimes critical, sometimes collusive reframing of high-artistic and masscultural representations). It is not at all derived, genealogically, from critical abstract painting—that of Stella, Ryman, Marden. The "irresponsibility" to this tradition is campy enough in the case of artists like Taaffe and Schuyff, who recycle the kitsch surrogate (Op) of this serious abstraction. With Goldstein and Levine, this irresponsibility, though no less evident, is more pointed.

For example, Goldstein makes his abstract paintings structurally as deep as early Stellas (4 to 12 inches thick) and often frames them with painted gold or silver bands; yet this stress on "objecthood" is beside any formalist point, and the metallic elements are formally gratuitous (the colors and chromatic schemes are precisely not "serious"). This gratuitousness is intentional: the stretchers and bands do not partake in any late-modernist reflection on the material presence of painting (Goldstein is only interested in mediated representations); rather, they serve as signs of such reflection. In effect, Goldstein suggests that critical abstract painting à la Ryman has become all but reified in its conventions, that it is, in short, a readymade. This is generally the position of all these new abstractionists. The question is: do they receive abstract painting as so reified, or do they participate in its emptying out?

Manifestly generic, the abstract paintings of Sherrie Levine are even more demonstrative about this readymade status. On the one hand, her two series of stripe works on board belie the perceptual inquiry into its own conventions of serious abstraction like Marden's (her bright "60s" colors are often optically rote, not at all the labored hues, evocative of the body in landscape, of early Marden). And, on the other hand, her series of plywood works with painted oval knots belies the aleatory freedom of Surrealist abstraction like Arp's (her ovals are mass-produced plugs machined into place, not at all chance elements, biomorphic forms or dream scripts). In short, her abstract paintings simulate modes of abstraction, as if to demonstrate that they are no longer critically reflexive or historically necessary forms with direct access to unconscious truths or a transcendental realm beyond the world—that they are simply *styles* among others.

This reduction to style, it should be noted, is most plain in the abstractions of the Neo-Opers; after all, Op was the first mass-cultural sign of modern abstract art in general, and, as Bleckner writes with just the right irony, "It is quintessentially twentieth century: technologically oriented, disruptive, 'about perception,' naive, superficial, and, by most accounts, a failure."¹ As such, despite (tongue-in-cheek?) claims by Taaffe of Newmanesque sublimity, its recycling now primarily reiterates this reduction, reification, "failure."

If this new abstract painting does not work within serious abstraction but rather comments on it at a remove, what conditions it? For some, who see this work mostly as a development of appropriation art, it appears as the next logical move in the match: to appropriate modern abstraction, to question its originary or sublime aspirations. Yet the nature of this move back to painting, province of the immediate mark—contradicts this critique; and today the argument that painting can be used deconstructively as a form of camouflage for subversion of other beliefs reads somewhat dubiously. Besides, such an account of abstraction-as-appropriation only holds for some of this work, such as the recent paintings of David Diao after the famous 1915 installation of Malevich paintings—an appropriation which may serve to confirm the mythical status of the original even as it cuts it loose from its place in history.

For the most part, the new abstractionists do not appropriate modern abstraction so much as they *simulate* it. The paintings are simulacra rather

156 Hal Foster

than copies, and as such they function in a strategically different way ("the copy is an image endowed with resemblance, the simulacrum is an image without resemblance"; whereas the copy produces the model *as* original, the simulacrum "calls into question the very notions of the copy and of the model").² The Levines, for example, do not reframe any original painting so much as they vaguely recall this Kenneth Noland, that John McLaughlin or that Brice Marden; thus insinuated into the paternal order of modern abstraction, her abstract frauds or "false claimants" are potentially in a position to disrupt its institutional canon and confuse its historical logic. (The problem is that her simulacra might not be good enough—deceptive enough as abstract painting—to be thus insinuated into its order.)³

For others, who see this abstraction as neither an appropriation nor a simulation of abstract art, it is simply a swing of the pendulum. Equally bored with Neo-Expressionism and Neo-Pop, artists are drawn back to the other pole: geometric abstraction. Yet such a reading of art as a mere matter of stylistic *reaction*, governed by generation, measured by decade, circumscribed by oppositions (like representation/abstraction and facture/finish), is banal in the extreme; an ahistorical model, it cannot account adequately for any art, let alone for all this painting. (Indeed, some of this work seems to play, parasitically, parodistically, on this yin-yang history of modern art, and some of it, I will argue, potentially supersedes categories of representation and abstraction—and not by any decorative mixing of the two.)

Nevertheless, these artists, driven in part by compulsive repetition, cannot help but be affected by this cyclical logic of style—inevitably so, as it is tied up with one dynamic of the art market as well as one model of art history. The swing between set poles is well designed for the market/history system, for it provides a modicum of the new without threat of real change or loss of order.⁴ The wagers of dealers and collectors, the categories of critics and curators, stand protected, as art alternates between familiar styles but within the prescribed exchange-form of the painting on exhibition. Unlike its predecessors in appropriation art which often underscored or contested this status, *all* of this abstract work complies with it.

However, stylistic oscillation alone is not enough to satisfy the market/history system: new forms must be expropriated (usually from popular or mass cultures) and obsolete modes retooled. In this continual retrieval of the outside and the outmoded (in a word, the outlandish), the cycle of set styles is elaborated into a sophisticated spiral that does much to describe recent art trends. Thus, though the new abstraction seems to oppose Neo-Expressionism, it opposes it only in terms of the market/history system: in fact, the two share much the same dynamic. Just as Neo-Expressionists like Sandro Chia recently mined the once outré work of de Chirico and Chagall, so now Neo-Opers like Taaffe appropriate the outré work of Bridget Riley (made all the more risqué by juxtaposition with kitschy renditions of Barnett Newman). There may be some historical redemption in this recycling, some transvaluation of esthetic values, but finally the posture of the artist remains the dandyism of Dali rather than the radicalism of Duchamp, and the logic of the art follows the given dynamic of the market/history system more than any new modus operandi.⁵

A readymade reduction of serious abstraction, a campy recycling of outré abstraction: much of this evinces a posthistorical attitude whereby art, stripped in the "museum without walls" of its material context and discursive entanglements, appears as a synchronous array of so many styles, devices or signs to collect, pastiche or otherwise manipulate—with no one deemed more necessary, pertinent or advanced than the next. This attitude, which is pervasive today, can be called "conventionalism,"⁶ according to which, for example, painting is produced as the sign of painting (rather than, as with Ryman or Marden, in historical involvement with its material practices). Now far from an authentic legitimation of the medium, much less an act of recovery through memory,⁷ this duplication of painting literally abstracts it—empties its historical form of content, reduces its material practice to a set of conventions (which then somehow stand, out of time, for painting in general). Moreover, this conventionalism does not contest our mass-media economy of the sign so much as play into it, for this economy performs a similar operation on all cultural expressions, whereby the specific, ambivalent content of an expression (e.g., graffiti) is first abstracted as a general, equivalent style (graffiti art) and then circulated as so many commodity-signs (graffiti boutiques).

Now to Ross Bleckner, apparently, such a duplication of abstract painting first occurred with Op. "It attempted to construct a conceptual relationship to abstract painting," he states. "It was a dead movement from its very inception."⁸ Yet, according to conventionalist logic, this demise is necessary: painting must die as a practice so that it might be reborn as a sign. And in this recycling, in which abstraction returns as its own simulation, there may well be (as Jean Baudrillard remarks about our age of simulacra in general) "no longer any God to recognize his own, nor any last judgment to separate true from false, the real from its artificial resurrection, since everything is already dead and risen in advance."⁹

Such is the posthistorical attitude that informs this abstract painting and much postmodern culture, an attitude which, if not resisted or, better, thought through, can lock artists into an indifferent pastiche or, as with some abstractionists, into a passive pessimism (which is not really leavened by irony). Thus the melancholy of Bleckner, for whom Op is an "appropriate metaphor" of a history which reduces out experience, memory, judgment; thus, too, the defeatism of Taaffe, who cites from Jean Anouilh's

158 Hal Foster

Antigone: "In a tragedy, nothing is in doubt. . . . There isn't any hope. You're trapped."¹⁰

There is, of course, more at stake in this new work than an ironic positioning of modern abstraction, a new inflection of art market/art history laws, or another symptom of posthistorical perspectivism. Though the different artists I have in mind here (Goldstein, Welling, Halley, Bickerton, Vaisman, Wasow and others) also develop out of appropriation art, they have less to do with modern abstraction than do artists like Levine, for they are involved in the *representation* of another sort of abstraction: the abstraction of technological modes of control of nature (Goldstein), of scientific paradigms of (dis)order (Welling), of late-capitalist social space (Halley), of cybernetic languages (Bickerton), of commodity and image production (Vaisman, Wasow).

Vaisman and Wasow do not appropriate media or art images so much as they simulate the abstraction that objects, images and events undergo when they are transformed into commodity-signs. (Thus, for example, the grounds of many Vaisman paintings look like exotic fabric but are in fact photostat simulations of burlap.) In the postnatural works of these two artists only a slight residue of any image remains, as representational content (use value) is subsumed under abstract "packaging" (exchange form). The viewer-consumer is seduced by this abstraction, invested in this mediation—in these works and in the media world at large. And Vaisman suggests this integration when he includes, along with abstract signs and color fields, images of the biological and the biographical (e.g., colored penis symbols on dirty white circles in *Polyester Set*, his own fingerprint blown up on a blue-yellow, four-square ground in *Under My Thumb*).

To Goldstein, this opposition between biological individual and technological society is all but moot, so intensive have its forms of mediation become. His motifs are not abstracted from the world but are generated as abstract (by computers, astral photography, etc.). Whether a snowflake under a microscope (its crystalline structure become a blurry splay of whitish lines on a black ground) or a constellation through a telescope (its complex formation registered as so many colored blips on a maroon ground), these objects or events do not exist "out there," in the world, in a way that can be represented perspectivally, nor are they produced "in here," in the subject, in a way that can be evoked abstractly; rather, they are effects of technical apparatuses which do not mediate reality and perception so much as transform them utterly. In short, these paintings have more to do with new modes of information than with either classical representation or modern abstraction.

Many of the same concerns govern the work of Halley and Bickerton. Halley assumes a drastic Baudrillardian perspective, according to which our new dynamic of electronic information and mass media has made of social space a total system of cybernetic networks, at all levels of which is repeated one model: "cells" connected by "conduits" (thus, according to Halley, the cell-and-conduit system of the computer, of the office with its electronic lines, of the city with its transportation network, etc.). It is this abstract field, this putative "formalism of the cell and the conduit,"¹¹ that Halley depicts with color-coded rectangles and "Cartesian" lines, painted iconically on partially stuccoed grounds.

Apart from his tautological "Wall Wall" paintings (colored reliefs of pseudo-stone walls) and generic "Abstract Paintings for People" (Day-Glo arrays of simple design shapes), Bickerton also produces paintings involved in the abstraction of contemporary social exchange. On these boxy works are painted "techno-scientific" images—part device, part structure, part sign—arranged so as to spell out different phonemes (GUH, GOH, UEH, UGH). These images suggest, on the one hand, a recomposition of alphabetic language into a new signal system or "postindustrial" esperanto and, on the other, an implosion of pre- and postliterate cultures.

Finally, Welling is also concerned with the abstraction of new scientific languages—in particular, fractal geometry, a mode of description of natural phenomena that cannot be reduced to (Euclidean) models or forms. Welling borrows his dot motifs from computer graphics generated to objectify such fractals as lunar craters and galactic formations.¹² Thus, though his paintings appear totally abstract and randomly composed, they are in fact methodical representations: abstraction and randomness are inherent in the model used. Welling's is perhaps the most logical (least opportunistic) work of the group, for it develops out of his abstract photography and addresses both principal concerns of this new art. Like the Levines, his paintings can operate as abstract-art simulacra (quasi surrealist, automatist or Opish); and like the work of the other abstractionists, they evoke the abstraction of contemporary languages—only not in an illustrational way.

In one way or another, most of these artists seek to picture abstractive tendencies in late-capitalist life: in science, technology, telecommunications, image and commodity production. That they represent such tendencies, which seem to defy representation, and that they do so in often beautiful paintings, which may reconcile us to them, is problematic. Today, Fredric Jameson has argued, the old "futurist icons" of modernity (e.g., the automobile, the airplane) are largely subsumed by new emblematic commodities (e.g., the computer), which "are all sources of reproduction rather than 'production,' and are no longer sculptural solids in space."¹³ As complex processes rather than discrete objects, they cannot, Jameson asserts, be readily represented (or abstracted), at least not in the manner

of modernist forms. This raises the question of the "representability" of late capitalism as a whole, a system apparently global in its reach, everywhere and nowhere at once.¹⁴ It also raises the stake of the art at hand, for in the attempt to represent this system or its processes, artists like Halley and Bickerton may also simplify them, render them innocuous (à la newspaper illustrations of new weapons systems). So, too, in the attempt to simulate the abstractive effects of this system, artists like Goldstein and Vaisman may also mystify them, render them spectacular (in the manner of Shuttle photos whose sheer beauty cannot quite conceal the costly, deadly militarization of space). Here, then, the most vexed question of all about this work emerges: can it seriously engage issues of a technoscientific, postindustrial society in a medium, like painting, based in preindustrial craft?¹⁵ Though concerned with systems of information, these artists still produce works of art in traditional mediums and formats, and though not oblivious to the contradiction here, they do not reflect on it in the paintings.

For example, can the everyday abstraction of objects and images into commodity-signs be simulated to any critical effect in painting, as the work of Vaisman suggests? Painting remains a necessary site of articulation for an artist like Sigmar Polke, involved as he is in the contradictory connections between mass culture and high art. But this is not entirely the case with Vaisman. Indeed, if the abstraction that concerns him is mostly a matter of mechanical reproduction and electronic information, surely film, video and computer work are more pertinent forms than painting for its critical exploration (as the work of an artist like Gretchen Bender demonstrates).

So, too, if we do inhabit a new social space of immanent flows and simulated effects, as Halley suggests, it is not at all clear that it can be painted, let alone represented, by a simple image of a cell and a conduit. His painted image, its metaphoric functions, its iconic placement on a Cartesian grid—all of these elements constitute a mode of representation incommensurate with the hypothesis of a new social network of cybernetic interconnection. Such a network demands instead both a new mode of apprehension and a new strategy of intervention (such as the one suggested by certain Keith Sonnier works of the '70s that hooked directly and diagrammatically into radio, telephone and television systems).¹⁶

Given that these artists develop out of (post)conceptual appropriation art, they must, in order to return to painting, repress its (often dubious) critique of the original art work, its subject positioning, commodity status and exhibitional format. And with Bickerton this "strategic inversion of many of the deconstructive techniques of the past decade or two" becomes programmatic.¹⁷ Thus, though he includes cryptic references in his work "to every station of its operational life" (e.g., jokes on its back for art movers, brackets on its sides to underscore its objecthood), these references turn the (post)conceptual analysis of the art object and its institutions into a closed Rousselian device, one that collapses autistically inward rather than (as with artists like Hans Haacke or Louise Lawler) proceeds discursively outward. It may be that, for Bickerton and others, such analysis is now a dead end. Yet, as with the reductive treatment of abstract painting in this new work, it is not clear whether these artists receive this critique as historically reified—as an "absurd, pompous, saturated and elaborate system of cul-de-sac meanings"—or whether they seek to render it so. In any case, the operation here is more nihilistic than dialectical.

In its conventional logic, some of this painting regards the material practice and history of abstract art as so many conventions and signs, and some of it suspends the critique of the art object, of institutional construction of meaning and subjectivity, of discursive entanglements with other discourses and institutions. So the question remains: if this new work is neither modern abstract painting nor (post)conceptual appropriation art, what type of art is it?

One way to respond is to consider its ambiguous relationship to both representation and abstraction. This work partakes of both, but does not combine them as opposed styles. Instead, it suggests that they are connected in a way that qualifies the conventional reading of 20th-century art in terms of simple paradigm shifts between "representation" and "abstraction." For abstraction does not undo representation (any more than a Beckett or Robbe-Grillet novel undoes narrative); rather, abstraction representation is preserved even as it is cancelled.¹⁸

Representation is not preserved, however, in simulation, which is what most of this painting is. In fact, in a social history of paradigms, representation may be superseded not by abstraction but by simulation, crucial as this mode is to the serial production of media images and commodities in late-capitalist society.¹⁹ For whereas abstraction may only *sublate* representation, simulation may *subvert* it, given that simulacra have representational effects but do not follow representational logic (i.e., they are not derived from referents in the world).²⁰

To take an example of these different modes in art: far from a return to representation after Abstract Expressionism, Pop was in fact a turn to *simulation*, to the serial production of images without originals—a mode which must be distinguished from both representational and abstract paradigms.²¹ This mode, announced by art in the '60s, was only used critically in art in the '70s and '80s—for example, in the serial simulations of artists like Cindy Sherman and Richard Prince whose Neo-Pop work is likewise less a return to representation than a critique of it by means of simulation. Now in this new abstract painting, simulation has penetrated the very art form that, with its insistence on immediacy and presence,

162 Hal Foster

resisted it most. Some of this work thus suggests a supersession (or at least a disruption) of both categories, representation *and* abstraction. For example, as serial abstract-art simulacra, the Levine paintings may confuse not only the historical logic of abstraction but also the conceptual order of representation—the hierarchy of originals, good copies and bad copies.

Yet the use of simulation in art remains tricky. Though this use may, on the one hand, transgress traditional forms of art and, on the other, connect the creation of art technically to the production of everyday images, it is hardly disruptive or critical of simulation as a mode. And this mode, though it may undercut representation or free us from its referential myths, is in no simple sense liberative. Along with the delirium of commoditysigns let loose into our world by serial production, the duplication of events by simulated images is an important form of social control, as important today as ideological representations. (Baudrillard: "Ideology only corresponds to a betrayal of reality by signs; simulation corresponds to a shortcircuit of reality and its reduplication by signs.")²² In fact, simulation, together with the old regime of disciplinary surveillance, constitutes a principal means of deterrence in our society (for how can one intervene politically in events when they are so often simulated or immediately replaced by pseudo-events?).

Like the critique of representation in appropriation art, then, the simulation of abstraction in this painting is a mixed enterprise, for finally both may be but ramifications of a much more practical and thorough "critique" and "simulation"—that of capital. "For finally it was capital which was the first to feed throughout its history on the destruction of every referential, of every human goal, which shattered every ideal distinction between true and false, good and evil, in order to establish a radical law of equivalence and exchange, the iron law of its power."²³ In short, more than this or any art, it is the abstractive processes of capital that erode representation and abstraction alike. And ultimately it may be these processes that are the real subject, and latent referent, of this new abstract painting.

Notes

- 1. Ross Bleckner, "Failure, Theft, Love, Plague," in *Philip Taaffe*, New York, Pat Hearn Gallery, 1986, p. 5.
- Gilles Deleuze, "Plato and the Simulacrum," trans. Rosalind Krauss, October 27 (Winter 1983), pp. 48, 47.
- 3. This is less the case with Charles Clough, who, like Gerhard Richter, simulates expressionist paintings by means of a collage of painting and photographed painting.
- 4. A good example of this system at work is the presentation, by Robert Pincus-Witten, of Julian Schnabel and David Salle as the new Rauschenberg and Johns; see his *Entries*, New York, Out of London Press, 1983.

- 5. "These paintings," Bleckner writes in the Taaffe catalogue, "are what happens... when 'the future is the obsolete in reverse" (p. 11). Here the Robert Smithson epigram is turned into a tactical play on the planned obsolescence of the market, whereby products like Op, first discarded in disdain, can be later recouped as outré.
- This term was suggested to me by Craig Owens. For more on conventionalism, see my Recordings: Art, Spectacle, Cultural Politics, Port Townsend, Wa., Bay Press, 1985; also see Jean Baudrillard, For a Critique of the Political Economy of the Sign, trans. Charles Levin, St. Louis, Telos Press, 1981.
- 7. This conventionalism was advocated in these terms by curator William Olander in his recent New Museum exhibition "The Art of Memory, The Loss of History."
- 8. Quoted in Jeanne Siegel, "Geometry Desurfacing," Arts, March 1986, p. 28.
- Baudrillard, "The Precession of the Simulacra," trans. Paul Foss and Paul Patton, Art & Text 11 (September 1983), p. 8; also available in Art After Modernism, ed. Brian Wallis, New York/Boston, Godine/New Museum, 1984, and Simulations, New York, Semiotext(e), 1983.
- 10. Philip Taaffe, pp. 5, 12.
- 11. Peter Halley, "On Line," *LAICA Journal*, Fall 1985, p. 35. This "formalism of the cell and the conduit" is parodied in the Terry Gilliam film *Brazil*.
- 12. See Siegel, p. 32.
- 13. Fredric Jameson, "On Diva," Social Text 5 (1982), p. 118.
- 14. See Jameson, "Postmodernism, or The Cultural Logic of Late Capitalism," New Left Review 146 (July-August 1984). It is not that this system cannot be conceived, Jameson argues, only that it cannot be figured. (It can, however, be evoked, as it is in the Goldstein paintings that suggest the systematic mediation of all reality.) Jameson calls for a new esthetic of "cognitive mapping." This is considered problematic by some because of its apparent paradoxical reliance on old models of representation and the subject. Yet, Jameson makes clear, this esthetic must rethink these terms entirely. (An instance of this esthetic at work may be Martha Rosler's videotape Global Taste, which begins to map out the late-capitalist penetration of both First-World psyches and Third-World markets.)
- 15. The term "technoscientific," developed by Jean-François Lyotard, describes the inextricability of modern science and technology. The term "postindustrial," popularized by Daniel Bell, describes the shift away from production of goods to that of services. A problematic concept, it is refuted by Ernest Mandel in *Late Capitalism* (London, Verso, 1978), who argues that, far from postindustrial, "late capitalism . . . constitutes generalized universal industrialization for the first time in history" (p. 387). Inasmuch as some of these artists pose postindustrial models, they abet this ideology, which tends to dismiss the working class and class struggle in general as anachronistic.
- 16. See Sanford Kwinter, "Keith Sonnier: Tracing Flows," in *Territory and Technique* (forthcoming).
- 17. Ashley Bickerton, exhibition statement, Cable Gallery, New York, 1986. The next two quotations are also from this source.
- For this argument regarding fiction, see Jameson, "Beyond the Cave: Modernism and Modes of Production," in *The Horizon of Literature*, ed. Paul Hernadi, The University of Nebraska Press, 1982, pp. 176–78.
- 19. In Noise (Minneapolis, University of Minnesota Press, 1985), Jacques Attali argues that representation is superseded by (serial) repetition. (Baudrillard makes a similar case in For a Critique: "That which was representation—redoubling the world in space—becomes repetition—an indefinable redoubling of the act in time" [p. 106].) Seriality and simulation are related in this new mode of production, which becomes integral to the production of art with Minimalism and Pop; see my "The Crux of Minimalism," Los Angeles Museum of Contemporary Art, forthcoming.

164 Hal Foster

- 20. Representation "starts from the principle that the sign and the real are equivalent.... Conversely, simulation starts... from the sign as reversion and death sentence of every reference" (Baudrillard, "Precession," p. 8).
- 21. Just as Pop and Minimalism must be regarded together—as different responses to the same moment in the dialectic of modernism and mass culture—so this new abstract painting must be seen with its contemporary counterpart: the cute-commodity "ready-mades" of such artists as Jeff Koons and Haim Steinbach. There is evidence that all this work will be challenged by art that *develops* rather than inverts "the deconstructive techniques of the past decade or two."
- 22. Baudrillard, "Precession," p. 30.

^{23.} Ibid, p. 28.

PART FOUR

Feminist Criticism

Today, the ideological functioning of representation as a support for social structures based on gender bias is a major concern of feminism. Reflecting the impact of psychoanalysis, this concern has evolved into a kind of psycho-Marxism/psycho-Structuralism and has become one of the main features of feminist art criticism. Feminist art criticism of this type, with its psychoanalytical features, is an amalgamation of ideas and methodologies (Marxist, Freudian, semiotic, Structuralist, and Poststructuralist) designed primarily to investigate the use to which images (especially images of women) are put in what feminists see as a patriarchal, male-dominated social structure.

Feminist art criticism, an outgrowth of the political activism of the 1960s, is relatively new. It can be said to have crystallized (at least in America) in the early 1970s when, in her important essay of the same title, Linda Nochlin asked "Why Have There Been No Great Women Artists?"¹ It is around this question that feminist critics and scholars began to study art made by women and, eventually, the role played by art vis-à-vis the status of women in society. This study has evolved through several phases, the earliest a scholarly demonstration of the existence of important women artists, Eleanor Tufts's book Our Hidden Heritage: Five Centuries of Women Artists (1974) and Linda Nochlin and Ann Sutherland Harris's exhibition catalogue Women Artists 1550-1950 (1976) being important examples. By the mid-1970s, a second phase featured what Joanna Frueh identified as an interest in "female sensibility." Female imagery, symbolized by what she referred to as the "central core" (vagina, womb) and decorative art became hallmarks of the art of women such as Judy Chicago, Miriam Schapiro, and Joyce Kozloff. This juxtaposition of craft and art revealed, feminists such as Frueh have contended, "the class aspect of art-world

166 Part Four

sexism in the distinction between high (men's) and low (women's) art."² A more recent phase, identified with current theoretical and psychoanalytical feminist criticism, goes beyond this reading. Dependent on the work of feminist literary critics, this latest phase engages wide-ranging interdisciplinary ideas that are heavily influenced by Sigmund Freud via the work of French psychoanalyst Jacques Lacan.

The beginnings of psychoanalysis are identified with Freud (1856–1939) in Vienna. His ideas were presented in a series of important works including *The Interpretation of Dreams* (1900), *Three Essays on Sexuality* (1905), and more systematically, the series of published lectures beginning with the *Introductory Lectures on Psychoanalysis* (1917) and ending with the posthumous *An Outline of Psycho-Analysis* (1940). Perhaps the most controversial aspect of Freud's ideas has to do with what was referred to as the Oedipus complex and the castration complex. In his *Introductory Lectures*, Freud wrote that,

while he is still a small child, a son will already begin to develop a special affection for his mother, whom he regards as belonging to him; he begins to feel his father as a rival who disputes his sole possession. And in the same way a little girl looks on her mother as a person who interferes with her affectionate relation to her father and who occupies a position which she herself could very well fill.³

This is the basis of the Oedipus complex, out of which grew Freud's notion of the castration complex.

Intimately linked with it [the Oedipus complex], we find what we call the "castration complex," the reaction to the threats against the child aimed at putting a stop to his early sexual activities and attributed to his father.⁴

Later, in a more developed state, the Oedipal complex (which came to encompass the castration complex) assumed central importance in Freud's ideas. According to this state, both boy and girl (who initially share the same sexual identity, an identity that Freud says is masculine) quickly come to desire the mother through the breast, the first object they encounter. What this means in fantasy, as Juliet Mitchell writes, is

having the phallus which is the object of the mother's desire (phallic phase). This position is forbidden (the castration complex) and the differentiation of the sexes occurs. The castration complex ends the boy's Oedipal complex (his love for his mother) and inaugurates for the girl the one that is specifically hers; she will transfer her object love to her father who seems to have the phallus and identify with her mother who, to the girl's fury, has not. Henceforth the girl will desire to have the phallus and the boy will struggle to represent it . . . this is the insoluble desire of their lives. . . .⁵

In Freud's lifetime, controversy arose because of the implications of incest in the Oedipal complex. Today the controversy revolves around the privileging or favoring of the phallus and the girl's (supposed) desire for the phallus (called "penis envy") resulting from her "lack" of it. Thus, in theory, the phallus has become the privileged signifier and signifier of privilege. Furthermore, as it did for Freud, sight (imaging) plays a major part in this scenario: the girl *sees* that the boy has it and the boy *sees* that she lacks it. For feminist art theory, this "seeing" is the basis of the male gaze, a gaze that dominates because it is a recognition of woman's inferiority.

Over years, other interpretations of these complexes reclaimed a position for the mother and reduced the emphasis upon the phallus.⁶ It was Lacan's intention to go back to the original concepts of Freud and to reconstruct and reformulate his ideas using the tools of linguistic science (semiotics and Structuralism).⁷

A feminism basing difference in sexuality on biology (that is, genitalia) and committed to a belief in an "ideal" woman has been called "Essentialism" and characterized feminist thought in the 1970s.⁸ It was against such ideas that Lacan had fought, arguing that male and female sexuality should not be confused with biological sex; sexuality (as opposed to sex) was not something biological (nature) nor something simply added sociologically to the individual. For Lacan, according to Mitchell, "a person is formed *through* their [sic] sexuality, it could not be 'added' to him or her." She goes on to explain that, "in the Freud that Lacan uses, neither the unconscious nor sexuality can in any degree be pre-given facts, they are constructions; that is, they are objects with histories and the human subject itself is only formed within these histories."⁹

For Lacan, the history of the human subject is constructed within the symbolic terms of language. As in the Structuralism of Lévi-Strauss, language here designates that structural complex of symbols and codes which are preexistent (that is, exist before the child/subject is born) and independent of the subject, but still shape the subject's (sexual) identity and guide the subject's (sexual) behavioral patterns. Thus, "underlying Lacan's theory," writes critic Kate Linker, "is the conviction that the human subject is never a discrete self, that it cannot be known outside of the terms of society and, specifically, of the cultural formations of patriarchy."¹⁰ Here patriarchy is referring to male-dominated society, a society in which the phallus is the privileged signifier and sight (the male gaze which recognizes the "lack" in woman) is the sense most implicated in male dominance over the female.

In this way, sight and the "male gaze" affect representation at the psychological level—especially representations of women. Through the "male gaze" representation and sight become entangled psychologically in female identity and work to help construct women's social role. According to British critic Lisa Tickner, "for the young child looking and being-looked-

168 Part Four

at are equally possible and pleasurable activities" for either sex. In the social world of the adult, however, because of the dominance of the "male gaze" with its implications of penis envy, this situation changes with the result that female identity is affected, both inwardly and outwardly.¹¹ As film theorist Laura Mulvey describes it,

the determining male gaze projects its phantasy on to the female figure which is styled accordingly. In their traditional exhibitionist role women are simultaneously looked at and displayed, with their appearance coded for strong visual and erotic impact so that they can be said to connote *to-be-looked-atness*.¹²

In this way, Mulvey believes, women both construct themselves and are constructed becoming objects of the male gaze in a very concrete, tangible way.

In his essay reprinted here, "The Discourse of Others: Feminists and Postmodernism," Craig Owens discusses the role of sexuality in Modernism and Postmodernism showing how Western European culture and its institutions legitimized themselves through constructed world views, views that are now in crisis. At stake is "not only the hegemony of Western culture, but also (our sense of) our identity as a culture." Owens goes on to investigate the causes within culture for these changes.

He recognizes that in the Modern period, the universalizing aesthetics of form (Kant, Fry, Bell, Greenberg) was the claim of art to represent an authentic, coherent vision of the world based on man's natural sensibilities. In the Postmodern period, the aesthetics of form are no longer accepted as universal truth and any claim to an authentic, coherent vision of the world is now believed to be a cultural construction which Postmodernist works of art seek to undermine. Furthermore, recent analyses of visual representation confirm, writes Owens, that to effect a coherent vision, "representational systems of the West admit only one vision—that of the constitutive male subject—or rather, they posit the subject of representation as absolutely centered, unitary, masculine." According to Owens, such representational systems of power function by authorizing certain representations while repressing or invalidating others. Among those who are prohibited or denied legitimacy by this system, believes Owens, are women:

Excluded from representation by its very structure, they return within it as a figure for—a representation of—the unrepresentable (Nature, Truth, the Sublime, etc.). This prohibition bears primarily on woman as the subject, and rarely as the object of representation, for there is certainly no shortage of images of women.¹³

In such a patriarchal system, women are represented as the object of the male gaze, they are always the "already spoken for." Owens sees the Post-

modern critique of representation and the feminist critique of patriarchy crossing at this point.

Owens goes on to show how representation is linked to mastery and domination through what French philosopher Jean-François Lyotard calls the *grands récits*—the dialectic of Spirit, the emancipation of the worker, the accumulation of wealth, the classless society. These *grands récits* or master narratives (as Owens calls them) are polemical, overarching ideas and projects; before they (like universalizing aesthetics) lost credibility, they were presented as the inevitable march of history and, as such, functioned to legitimize Western man's desire to dominate (master) and transform the world into his own image, to make it over into "a representation, with man as its subject."¹⁴

The capacity of representation to function so effectively in strategies of domination is connected to the belief that sight/vision provides an objective view of the world. Knowing this, representation (especially photographic) has become a target for an artist such as Martha Rosler who, through a work like *The Bowery in Two Inadequate Descriptive Systems*, "not only exposes the 'myths' of photographic objectivity and transparency," says Owens, but also "upsets the (modern) belief in vision as a privileged means of access to certainty and truth. . . .^{"15} This is an important issue for both Postmodernism and feminism. Belief in the primacy of vision was not only held by the nineteenth-century German philosopher Hegel, for example, but by Freud whose theory of sexual identity gives priority to sight because it is through sight of a phallic presence or a phallic absence that realization of sexual difference occurs.

By showing that vision/sight and representation are linked to patriarchy, feminists seek to expose the hidden means of domination in visual images. Thus, the emphasis Owens locates in the work of artists such as Sherrie Levine and Cindy Sherman differs from that of Crimp. While Crimp's emphasis focuses on Levine and Sherman as raising issues concerning copies and originality, Owens believes that Levine, by faithfully reproducing the photographs of Edward Weston, refuses to accept the male role of author/producer (in the traditional Marxist sense of production). And Sherman, by repeatedly photographing herself in the guise of grade-B Hollywood actresses, presents herself as a representation of male desire, the object of the male gaze. These works, then, become feminist critiques by calling attention to the apparatuses that construct sexual difference in society and afford the means of domination and mastery.

In Kate Linker's cogent discussion of feminine sexuality in the essay reprinted here and titled "Eluding Definition," she quotes Lacan's observation that "images and symbols *for* the woman cannot be isolated from images and symbols *of* the woman. It is representation, . . . the representation of feminine sexuality . . . , which conditions how it comes into play." This reiterates the belief that femininity and masculinity are "psychic"

170 Part Four

categories, not categories based on or reducible to biological difference as seen in anatomy. Earlier feminist ideas were constructed around notions of a humanism with overtones of an idealist, "natural" subject and a creative self. According to Linker, the rejection of these ideas was important because

recourse to the idea of a feminine nature, as presumed by the biological view, has had the effect of both mystifying Woman (of consigning her to a realm outside of culture, as the unknowable eternal feminine) and of installing her as an object to be domesticated or "mastered" in the masculine conquest of Nature.

The reason for the feminist turn to Freud, via Lacan, suggests Linker, was to demonstrate just how sexual difference is constructed. Freud insisted, according to Linker, that there "is no precultural real, no reality beyond representation," as Lacan's famous diagram which includes a tree and two identical doors labeled "ladies" and "gentlemen," respectively, is intended to show. The tree (symbolizing nature) indicates the biological realm, a realm defined by genitalia; the identical doors (which are human constructions) indicate not only that sexuality is a cultural construction, but that sexuality is defined by difference at the level of the signifier (that is, at the level of the terms "ladies"/"gentlemen"). In other words, as Saussure asserted in his study of language, it is the oppositional difference between the terms (in this case, "ladies"/"gentlemen") that creates meaning or at least makes meaning possible; there is no absolute reference, no absolute lady, no absolute gentleman. Each subject is split or divided by the terms and defined by the difference between them (thus neither subject is whole). And for the woman, this difference is her lack of the penis. Thus, she is defined by an absence.

It is around this point that hidden ideology is exposed. The term "lack" indicates a value judgment in which to have (a penis) is thought superior. This value, however, exists *before* and *outside of* the child's realization of having or lacking; it is a value that already must be existent in culture and communicated through language. Thus, the contention that phallic superiority is based on nature (genitalia) is a fraud which depends on a supposed inferiority in the female to function. Since there is no absolute reference, no absolute self, this fraudulence must be a cultural construction that is maintained through language and systems of communication and representation in which it is hidden. It is because of this that feminists employ various strategies to exploit and expose the ways representation (especially photographic) are used.

Barbara Kruger, whose work features images overlaid with short phrases, exploits words like "I," "me," "we," and "you" to show, as Linker notes, "that the place of the viewer in language is unsettled, shifting, indefinite, refusing alignment with gender." (These pronouns are all gender neutral; they assume the gender of the speaker.) On the other hand, artists such as Sherrie Levine concern themselves with showing how the "camera's falsifying monocular perspective constructs the viewed scene as subject to the central masculine position." She presents images of Otherness photographs of children, nature, the poor, women, the insane—against which the normal in society is defined. And finally, Linker raises the issue of how the photograph, by having a smooth and shiny surface, presents the illusion of coherence, centeredness to all that it captures. It is this that Sarah Charlesworth examines in her photographs as well as the idea of fetishes, "elements to which desire attaches to fulfill a fantasy of wholeness."

While most critics recognize the merits of a feminism based on Lacanian psychoanalytic theory, such feminism is not without detractors. Reprinted here is Maureen Turim's review of the Difference exhibition, "What Is Sexual Difference?" She notes that within the great strength of Lacanian theory—"its metaphorical abstraction that can theorize the intangible—is also an inherent weakness"; it does not offer a sociological and historical perspective on the origin of the position it outlines, nor does it recognize the possibility of variance in individual behavior.

Of even greater concern is the continued emphasis upon the phallus (whether symbolic or not) and its association with the male sexual organ. Because of this, writes Turim, feminists

have been proposing radical inversions of Lacan's formulas, such as Julia Kristeva's suggestion . . . that the phallus "is the mother." This not only loosens the phallus = penis association, but slyly proposes that the phallic mother or phallic woman found in Freud is not merely an imaginary fetish.

In discussing the exhibition and the catalogue essays, she alleges that Owens's essay (which is titled "Posing") "misses a crucial difference . . . between the notion of mimicry that 'strays' into the realm of effective satire or critique, and mimicry that simply 'coincides' and, therefore, duplicates." For Turim, one must be able to distinguish between images that "coyly and passively mimic sexist codes" and images that are designed to deconstruct these codes. Of Burgin's *Zoo 78* and *Olympia*, one recreating a West Berlin peep show and the other after Manet's famous nude painted in 1863, Turim notes, "I am willing to grant that the context of the imagery is a self-consciously theoretical one. Still, posing women is not something men can do freely these days. . . ." It seems, says Turim, that Burgin and Owens "are still trying to pose us . . . in a way we are to take as politically correct." Why, she asks, "are they not more self-critical about their position, here, where feminism is the issue?" In part, the question that Turim is raising is similar to that posed by Lucy Lippard regard-

172 Part Four

ing "The Times Square Show": Can context, whether that of the museum/gallery setting or of theoretical discourse, overcome the prurient interest elicited by certain images of women?

Turim also takes issue with British critic Lisa Tickner's essay for the Difference exhibition catalogue. She is critical of what she identifies as Tickner's implicit denunciation of earlier feminists for "exploring their female imaginations because that might involve 'essentialism', proclaiming some concerns to be female, 'fixing female signs'." While Turim believes any critique of essentialism must guard against the establishment of an "ideal" feminine nature, it should not prevent exploring "who women are and what women want at this moment in history."

To Turim, a modified "essentialism" (one that begins with the fantasized, not the real body) holds the prospect of solving the problem of the position of woman as "perpetual otherness." Jane Weinstock echoes these ideas in her essay for the "Difference" exhibition catalogue:

recent French psychoanalytic and post-psychoanalytic writings on sexual difference have focused on the female body, or "female specificy." Might not this attempt to return the body to the subject lead to a differentiated viewing subject? But how? This is the question.¹⁶

It is clear from the questions raised by Turim and Weinstock that theoretical feminism is not static. It is in question just as are the social structures in Western society that feminism investigates.

Currently there is a crisis of legitimization facing European cultural institutions. Postmodern works of art, as Owens noted, by investigating representational systems, are exposing this crisis as they undermine Western European artistic claims of an authentic, coherent world view emanating from Kantian aesthetics. Through such investigations, Postmodern works of art show that such views are selective, operating by suppressing other views—especially those of women.

That sexuality is constructed through language and representation is explored by Linker in her discussion of semiotic signs. She demonstrates how language invests terms like "presence" and "absence" with ideological meaning and value. Representation participates in this because the "real," the "natural" (including sexual identity) is constructed, in large part, through representations. Representations work ideologically by mediating access to the real through signifiers that ultimately affect sexual identity and define sexual roles for both men and women. Lacanian theory has been instrumental in demonstrating how the sexual being is shaped to fit into and to support a social structure. One result of this has been to make evident that the nature of social structures cannot be explained by recourse to any one simple factor. Society is a complex constructed of many interacting factors including economic, ideological, biological, and psychological. And, as Turim and Weinstock seem to be intimating, reliance upon any one theory should not be done uncritically.

It is also significant that feminist psychoanalytical art criticism, in its exploration of depictions of women, has done much to reveal how feminine sexuality is both constructed and reflected in visual art and in the mass media. It has likewise influenced understanding of the construction of male sexuality by raising questions concerning the role masculinity plays in shaping representations of women; and, it has broached the important issue, yet to be investigated in any depth, of how representations of men (visual and otherwise) also function ideologically in the social structure. If men are also in large part social constructions (i.e., products of a social as much as an individual will), then they, like women, stand outside of society as individuals but inside of society as members of the group. Any contemporary theory of ideological liberation and freedom must recognize this and acknowledge that the Postmodern world is an interaction of three bodies: the individual male body, the individual female body, and the group or social body. Such a theory must seek ways to hold the social body in check and prevent it from exploiting both the male and female bodies so that this interaction can be mutually beneficial to all three bodies.

The value to feminism of Lacanian theory has been called into question by critics such as Turim who speculate on whether or not the abstract quality of the theory sacrifices too much in not considering the historical and social perspectives and circumstances that surround the positions it outlines. Yet, despite these reservations, the Freudian/Lacanian basis of feminist art theory and criticism has basically gone unchallenged. Even Linker, who points out that phallic superiority (i.e., penis envy) is a culturally constructed value, does not draw any significant conclusions from her observations.

In Technologies of Gender, film critic Teresa De Lauretis suggests that if we follow "Foucault's theory of sexuality as a 'technology of sex'," then gender too can be seen as the "product of various social technologies, such as cinema, and of institutionalized discourses, epistemologies, and critical practices, as well as practices of daily life."¹⁷ If this is so, couldn't Freud's theory, especially regarding the Oedipus and castration complexes, be seen as such a technology, a product of the turn-of-the-century Austro-Hungarian Empire's sexual views, not to mention Freud's own personal life experiences? Already in the 1970s, early feminists like Betty Friedan and Kate Millet who were not in awe of French theory believed this to be the case. According to Rosemarie Tong, Friedan, writing in The Feminine Mystique (published in 1974) described Freud's culture as Victorian and rejected his emphasis on sex as excessive; she also rejected the biological destiny/determinism that resulted from his theory of penis envy. And, in Sexual Politics, published as early as 1970, Millet "found the concept of penis envy a transparent instance of male egocentricism."¹⁸ Perhaps, fol-

174 Part Four

lowing Friedan and Millet, it is time to move to a Post-Freudian (and Post-Lacanian) position in which the notion of penis envy is reconsidered.¹⁹

Notes

- Linda Nochlin, "Why Have There Been No Great Women Artists?" Art News (January 1971), pp. 22–39.
- Joanna Frueh, "Towards a Feminist Theory of Art Criticism," *The New Art Examiner* (January 1985), pp. 42–43. For a more detailed account of feminism in art and art history, see Thalia Gouma-Peterson and Patricia Mathews, "The Feminist Critique of Art History," *The Art Bulletin* (September 1987), pp. 326–357.
- Sigmund Freud, Lecture XIII: "Archaic and Infantile Features," *Introductory Lectures on Psychoanalysis*, The Standard Edition, trans. and ed. James Strachey (New York & London: W. W. Norton & Company, Inc., 1966), p. 207.
- 4. Freud, Lecture XIII, Introductory Lectures, p. 208.
- Juliet Mitchell, "Introduction I," Feminine Sexuality: Jacques Lacan and the 'école freudienne,' ed. Juliet Mitchell and Jacqueline Rose, trans. Jacqueline Rose (London & Basingstoke: The Macmillan Press Ltd., 1982), p. 7.
- For an introductory discussion of these theories, see Jack Spector, "The State of Psychoanalytic Research in Art History," *The Art Bulletin* (March 1988), pp. 49–76, but especially pp. 56–58.
- 7. For more on this and a cogent introduction to the issues involved, see *Feminine Sexuality*, especially the two introductions by Juliet Mitchell and Jacqueline Rose.
- 8. While "essentialism" lost favor in the early 1980s, today interest in it has returned in a modified form incorporating theoretical aspects of Lacanian ideas, but with social as well as biological difference as part of its definition. Lacanian ideas have had a great impact on feminism, yet this renewed interest in essentialism is partly a reaction by feminists to the overly theoretical thrust of Lacan and reflects beliefs held in the 1970s that identified "female sensibility" with intuition and "masculine sensibility" with rationalism. From this, some feminists have argued that the embracing of rational theory (as in Lacan) supports masculine world views and thus runs counter to feminist interests. Though still controversial, recent research seems to support essentialism by suggesting that there are differences between the sexes that may be biologically/genetically based. This is a new area for feminism to explore, an area that may drastically alter current theory.
- 9. Mitchell, Feminine Sexuality, pp. 2 and 4, respectively.
- Kate Linker, "Forward and Acknowledgments," Difference: On Representation and Sexuality, exhibition catalogue, The New Museum of Contemporary Art, New York, 1984, p. 5.
- 11. Lisa Tickner, "Sexuality and/in Representation: Five British Artists," *Difference: On Representation*, exhibition catalogue, The New Museum of Contemporary Art, New York, 1984, p. 23.
- 12. Laura Mulvey, quoted by Tickner in "Sexuality and/in Representation," p. 23.
- 13. Owens demonstrates how this view of woman is supported by Marxist theory which, he contends, has a patriarchal bias because it emphasizes the masculine activity of production (as opposed to female reproduction) as determining the difference between the human and the animal (nature). In this way, society is seen as masculine and women are assigned a place outside of it as symbols for the unrepresentable realm of Nature. Marx, of course, emphasized production to distinguish humans from animals because both humans and animals reproduce.

Marx's conception of labor was formulated from within the industrialized society of

nineteenth-century England. For him, labor as a social force acting through the "means of production" was not only industrial labor (as opposed to agrarian), but also predominantly male. Discussion of the "means of production" and related factors, by focusing on what were identified as basically male occupations, tended to distort Marx's model in that direction, giving his theory a masculine center outside of which both nature and woman came to reside. For this reason, Owens, Linker, and others are critical of the continuing emphasis placed upon Marx's original conception of "means of production" seen in the writings of authors such as Benjamin H. D. Buchloh, Fredric Jameson, and Hal Foster.

- 14. Lyotard, as Owens points out, also questions the validity of the basic structuralist conception of binary opposition, that is, thinking in terms of opposites. Owens sees this kind of oppositional thinking as being related to Freud's "presence/absence" of the phallus and something in need of change for it places male and female in confrontation.
- 15. Photography's sense of objective truth is based on its iconic and indexical relationship to the world.
- 16. Jane Weinstock, "Sexual Difference and the Moving Image," *Difference: On Representation and Sexuality*, exhibition catalogue, The New Museum of Contemporary Art, New York, 1984, p. 44, as quoted in Turim.
- 17. Teresa De Lauretis, *Technologies of Gender: Essays on Theory, Film, and Fiction* (Bloomington & Indianapolis: Indiana University Press, 1987), p. 2.
- See Rosemarie Tong, *Feminist Thought: A Comprehensive Introduction* (Boulder & San Francisco: Westview Press, 1989), pp. 142–43 and 144, respectively; also see Tong's discussion of the ideas of Alfred Adler on p. 147.
- 19. By doing this, it may be possible to develop a theory that not only recognizes the "law of the father" (that the son must not sleep with the mother), but also a "law of the mother" (that the daughter must not sleep with the father); these two laws, which would form a balanced equation (unlike the Freudian/Lacanian emphasis on phallus and male superiority through the gaze) could also be understood as a form of social contract between father and mother. Such a contract, which could be seen as the origin of the social body, would have its basis in the incest taboo, a much more universally accepted principle than Freud's Oedipal complex. This position would also undermine the theory of the male gaze as an objectifying instrument of patriarchal power, something allegedly inherent in all representations, a theory in which feminism has much invested. For a critique of Freud and a summary of alternative feminist psychoanalytical positions see Phyllis Grosskurth, "The New Psychology of Women," *The New York Review of Books*, (24 October 1991), pp. 25–32.

The Discourse of Others Feminists and Postmodernism

CRAIG OWENS

Postmodern knowledge [le savoir postmoderne] is not simply an instrument of power. It refines our sensitivity to differences and increases our tolerance of incommensurability.

—J.F. Lyotard, La Condition postmoderne

Decentered, allegorical, schizophrenic . . .--however we choose to diagnose its symptoms, postmodernism is usually treated, by its protagonists and antagonists alike, as a crisis of cultural authority, specifically of the authority vested in Western European culture and its institutions. That the hegemony of European civilization is drawing to a close is hardly a new perception; since the mid-1950s, at least, we have recognized the necessity of encountering different cultures by means other than the shock of domination and conquest. Among the relevant texts are Arnold Toynbee's discussion, in the eighth volume of his monumental Study in History, of the end of the modern age (an age that began, Toynbee contends, in the late 15th century when Europe began to exert its influence over vast land areas and populations not its own) and the beginning of a new, properly postmodern age characterized by the coexistence of different cultures. Claude Lévi-Strauss's critique of Western ethnocentrism could also be cited in this context, as well as Jacques Derrida's critique of this critique in Of Grammatology. But perhaps the most eloquent testimony to the end of Western sovereignty has been that of Paul Ricoeur, who wrote in 1962 that "the discovery of the plurality of cultures is never a harmless experience."

This essay was originally published in *The Anti-Aesthetic: Essays on Postmodern Culture*, edited with an introduction by Hal Foster (Port Townsend, WA: Bay Press, 1983). Copyright © 1983 Bay Press. All rights reserved.

When we discover that there are several cultures instead of just one and consequently at the time when we acknowledge the end of a sort of cultural monopoly, be it illusory or real, we are threatened with the destruction of our own discovery. Suddenly it becomes possible that there are just *others*, that we ourselves are an "other" among others. All meaning and every goal having disappeared, it becomes possible to wander through civilizations as if through vestiges and ruins. The whole of mankind becomes an imaginary museum: where shall we go this weekend—visit the Angkor ruins or take a stroll in the Tivoli of Copenhagen? We can very easily imagine a time close at hand when any fairly well-to-do person will be able to leave his country indefinitely in order to taste his own national death in an interminable, aimless voyage.¹

Lately, we have come to regard this condition as postmodern. Indeed. Ricoeur's account of the more dispiriting effects of our culture's recent loss of mastery anticipates both the melancholia and the eclecticism that pervade current cultural production-not to mention its much-touted pluralism. Pluralism, however, reduces us to being an other among others; it is not a recognition, but a reduction to difference to absolute indifference, equivalence, interchangeability (what Jean Baudrillard calls "implosion"). What is at stake, then, is not only the hegemony of Western culture, but also (our sense of) our identity as a culture. These two stakes, however, are so inextricably intertwined (as Foucault has taught us, the positing of an Other is a necessary moment in the consolidation, the incorporation of any cultural body) that it is possible to speculate that what has toppled our claims to sovereignty is actually the realization that our culture is neither as homogeneous nor as monolithic as we once believed it to be. In other words, the causes of modernity's demise-at least as Ricoeur describes its effects—lie as much within as without. Ricoeur, however, deals only with the difference without. What about the difference within?

In the modern period the authority of the work of art, its claim to represent some authentic vision of the world, did not reside in its uniqueness or singularity, as is often said; rather, that authority was based on the universality modern aesthetics attributed to the *forms* utilized for the representation of vision, over and above differences in content due to the production of works in concrete historical circumstances.² (For example, Kant's demand that the judgment of taste be universal—i.e., universally communicable—that it derive from "grounds deep-seated and shared alike by all men, underlying their agreement in estimating the forms under which objects are given to them.") Not only does the postmodernist work claim no such authority, it also actively seeks to undermine all such claims; hence, its generally deconstructive thrust. As recent analyses of the "enunciative apparatus" of visual representation—its poles of emission and reception—confirm, the representational systems of the West admit only one vision—that of the constitutive male subject—or, rather, they posit the subject of representation as absolutely centered, unitary, masculine.³

The postmodernist work attempts to upset the reassuring stability of that mastering position. This same project has, of course, been attributed by writers like Julia Kristeva and Roland Barthes to the modernist avantgarde, which through the introduction of heterogeneity, discontinuity, glossolalia, etc., supposedly put the subject of representation in crisis. But the avant-garde sought to transcend representation in favor of presence and immediacy; it proclaimed the autonomy of the signifier, its liberation from the "tyranny of the signified"; postmodernists instead expose the tyranny of the signifier, the violence of its law.⁴ (Lacan spoke of the necessity of submitting to the "defiles" of the signifier; should we not ask rather who in our culture is defiled by the signifier?) Recently, Derrida has cautioned against a wholesale condemnation of representation, not only because such a condemnation may appear to advocate a rehabilitation of presence and immediacy and thereby serve the interests of the most reactionary political tendencies, but more importantly, perhaps, because that which exceeds. "transgresses the figure of all possible representation," may ultimately be none other than . . . the law. Which obliges us, Derrida concludes, "to thinking altogether differently."5

It is precisely at the legislative frontier between what can be represented and what cannot that the postmodernist operation is being stagednot in order to transcend representation, but in order to expose that system of power that authorizes certain representations while blocking, prohibiting or invalidating others. Among those prohibited from Western representation, whose representations are denied all legitimacy, are women. Excluded from representation by its very structure, they return within it as a figure for-a representation of-the unrepresentable (Nature, Truth, the Sublime, etc.). This prohibition bears primarily on woman as the subject, and rarely as the object of representation, for there is certainly no shortage of images of women. Yet in being represented by, women have been rendered an absence within the dominant culture as Michèle Montrelay proposes when she asks "whether psychoanalysis was not articulated precisely in order to repress femininity (in the sense of producing its symbolic representation)."⁶ In order to speak, to represent herself, a woman assumes a masculine position; perhaps this is why femininity is frequently associated with masquerade, with false representation, with simulation and seduction. Montrelay, in fact, identifies women as the "ruin of representation": not only have they nothing to lose; their exteriority to Western representation exposes its limits.

Here, we arrive at an apparent crossing of the feminist critique of patriarchy and the postmodernist critique of representation; this essay is a provisional attempt to explore the implications of that intersection. My intention is not to posit identity between these two critiques; nor is it to place them in a relation of antagonism or opposition. Rather, if I have chosen to negotiate the treacherous course between postmodernism and feminism, it is in order to introduce the issue of sexual difference into the modernism/postmodernism debate—a debate which has until now been scandalously indifferent.⁷

"A Remarkable Oversight"8

Several years ago I began the second of two essays devoted to an allegorical impulse in contemporary art—an impulse that I identified as postmodernist—with a discussion of Laurie Anderson's multi-media performance Americans on the Move.⁹ Addressed to transportation as a metaphor for communication—the transfer of meaning from one place to another— Americans on the Move proceeded primarily as verbal commentary on visual images projected on a screen behind the performers. Near the beginning Anderson introduced the schematic image of a nude man and woman, the former's right arm raised in greeting, that had been emblazoned on the Pioneer spacecraft. Here is what she had to say about this picture; significantly, it was spoken by a distinctly male voice (Anderson's own processed through a harmonizer, which dropped it an octave—a kind of electronic vocal transvestism):

In our country, we send pictures of our sign language into outer space. They are speaking our sign language in these pictures. Do you think they will think his hand is permanently attached that way? Or do you think they will read our signs? In our country, good-bye looks just like hello.

Here is my commentary on this passage:

Two alternatives: either the extraterrestrial recipient of this message will assume that it is simply a picture, that is, an analogical likeness of the human figure, in which case he might logically conclude that male inhabitants of Earth walk around with their right arms permanently raised. Or he will somehow divine that this gesture is addressed to him and attempt to read it, in which case he will be stymied, since a single gesture signifies both greeting and farewell, and any reading of it must oscillate between these two extremes. The same gesture could also mean "Halt!" or represent the taking of an oath, but if Anderson's text does not consider these two alternatives that is because it is not concerned with ambiguity, with multiple meanings engendered by a single sign; rather, *two clearly defined but mutually incompatible* readings are engaged in blind confrontation in such a way that it is impossible to choose between them.

This analysis strikes me as a case of gross critical negligence. For in my eagerness to rewrite Anderson's text in terms of the debate over deter-

minate versus indeterminate meaning. I had overlooked something—something that is so obvious, so "natural" that it may at the time have seemed unworthy of comment. It does not seem that way to me today. For this is, of course, an image of sexual difference or, rather, of sexual differentiation according to the distribution of the phallus—as it is marked and then re-marked by the man's right arm, which appears less to have been raised than erected in greeting. I was, however, close to the "truth" of the image when I suggested that men on Earth might walk around with something permanently raised—close, perhaps, but no cigar. (Would my reading have been different-or less indifferent-had I known then that, earlier in her career, Anderson had executed a work which consisted of photographs of men who had accosted her in the street?)¹⁰ Like all representations of sexual difference that our culture produces, this is an image not simply of anatomical difference, but of the values assigned to it. Here, the phallus is a signifier (that is, it represents the subject for another signifier); it is, in fact, the privileged signifier, the signifier of privilege, of the power and prestige that accrue to the male in our society. As such, it designates the effects of signification in general. For in this (Lacanian) image, chosen to represent the inhabitants of Earth for the extraterrestrial Other, it is the man who speaks, who represents mankind. The woman is only represented; she is (as always) already spoken for.

If I return to this passage here, it is not simply to correct my own remarkable oversight, but more importantly to indicate a blind spot in our discussions of postmodernism in general: our failure to address the issue of sexual difference-not only in the objects we discuss, but in our own enunciation as well.¹¹ However restricted its field of inquiry may be, every discourse on postmodernism—at least insofar as it seeks to account for certain recent mutations within that field—aspires to the status of a general theory of contemporary culture. Among the most significant developments of the past decade—it may well turn out to have been the most significant—has been the emergence, in nearly every area of cultural activity, of a specifically feminist practice. A great deal of effort has been devoted to the recovery and revaluation of previously marginalized or underestimated work; everywhere this project has been accompanied by energetic new production. As one engaged in these activities—Martha Rosler—observes, they have contributed significantly to debunking the privileged status modernism claimed for the work of art: "The interpretation of the meaning and social origin and rootedness of those [earlier] forms helped undermine the modernist tenet of the separateness of the aesthetic from the rest of human life, and an analysis of the oppressiveness of the seemingly unmotivated forms of high culture was companion to this work."¹²

Still, if one of the most salient aspects of our postmodern culture is the presence of an insistent feminist voice (and I use the terms *presence* and *voice* advisedly), theories of postmodernism have tended either to neglect

or to repress that voice. The absence of discussions of sexual difference in writings about postmodernism, as well as the fact that few women have engaged in the modernism/postmodernism debate, suggest that postmodernism may be another masculine invention engineered to exclude women. I would like to propose, however, that women's insistence on difference and incommensurability may not only be compatible with, but also an instance of postmodern thought. Postmodern thought is no longer binary thought (as Lyotard observes when he writes, "Thinking by means of oppositions does not correspond to the liveliest modes of postmodern knowledge [*le savoir postmoderne*]").¹³ The critique of binarism is sometimes dismissed as intellectual fashion; it is, however, an intellectual imperative, since the hierarchical opposition of marked and unmarked terms (the decisive/divisive presence/absence of the phallus) is the dominant form both of representing difference and justifying its subordination in our society. What we must learn, then, is how to conceive difference without opposition.

Although sympathetic male critics respect feminism (an old theme: respect for women)¹⁴ and wish it well, they have in general declined the dialogue in which their female colleagues are trying to engage them. Sometimes feminists are accused of going too far, at others, not far enough.¹⁵ The feminist voice is usually regarded as one among many, its insistence on difference as testimony to the pluralism of the times. Thus, feminism is rapidly assimilated to a whole string of liberation or self-determination movements. Here is one recent list, by a prominent male critic: "ethnic groups, neighborhood movements, feminism, various 'counter-cultural' or alternative life-style groups, rank-and-file labor dissidence, student movements, single-issue movements." Not only does this forced coalition treat feminism itself as monolithic, thereby suppressing its multiple internal differences (essentialist, culturalist, linguistic, Freudian, anti-Freudian . . .); it also posits a vast, undifferentiated category, "Difference," to which all marginalized or oppressed groups can be assimilated, and for which women can then stand as an emblem, a pars totalis (another old theme: woman is incomplete, not whole). But the specificity of the feminist critique of patriarchy is thereby denied, along with that of all other forms of opposition to sexual, racial and class discrimination. (Rosler warns against using woman as "a token for all markers of difference," observing that "appreciation of the work of women whose subject is oppression exhausts consideration of all oppressions.")

Moreover, men appear unwilling to address the issues placed on the critical agenda by women unless those issues have first been neut(e)ralized—although this, too, is a problem of assimilation: to the already known, the already written. In *The Political Unconscious*, to take but one example, Fredric Jameson calls for the "reaudition of the oppositional voices of black and ethnic cultures, women's or gay literature, 'naive' or marginalized folk art *and the like*" (thus, women's cultural production is anachronistically identified as folk art), but he immediately modifies this petition: "The affirmation of such non-hegemonic cultural voices remains ineffective," he argues, if they are not first *rewritten* in terms of their proper place in "the dialogical system of the social classes."¹⁶ Certainly, the class determinants of sexuality—and of sexual oppression—are too often overlooked. But sexual inequality cannot be reduced to an instance of economic exploitation the exchange of women among men—and explained in terms of class struggle alone; to invert Rosler's statement, exclusive attention to economic oppression can exhaust consideration of other forms of oppression.

To claim that the division of the sexes is irreducible to the division of labor is to risk polarizing feminism and Marxism; this danger is real, given the latter's fundamentally patriarchal bias. Marxism privileges the characteristically masculine activity of production as the *definitively human* activity (Marx: men "begin to distinguish themselves from animals as soon as they begin to produce their means of subsistence");¹⁷ women, historically consigned to the spheres of nonproductive or reproductive labor, are thereby situated outside the society of male producers, in a state of nature. (As Lyotard has written, "The frontier passing between the sexes does not separate two parts of the same social entity.")¹⁸ What is at issue, however, is not simply the oppressiveness of Marxist discourse, but its totalizing ambitions, its claim to account for every form of social experience. But this claim is characteristic of all theoretical discourse, which is one reason women frequently condemn it as phallocratic.¹⁹ It is not always theory per se that women repudiate, nor simply, as Lyotard has suggested, the priority men have granted to it, its rigid opposition to practical experience. Rather, what they challenge is the distance it maintains between itself and its objects-a distance which objectifies and masters.

Because of the tremendous effort of reconceptualization necessary to prevent a phallologic relapse in their own discourse, many feminist artists have, in fact, forged a new (or renewed) alliance with theory-most profitably, perhaps, with the writing of women influenced by Lacanian psychoanalysis (Luce Irigaray, Hélène Cixous, Montrelay . . .). Many of these artists have themselves made major theoretical contributions: filmmaker Laura Mulvey's 1975 essay on "Visual Pleasure and Narrative Cinema." for example, has generated a great deal of critical discussion on the masculinity of the cinematic gaze.²⁰ Whether influenced by psychoanalysis or not, feminist artists often regard critical or theoretical writing as an important arena of strategic intervention: Martha Rosler's critical texts on the documentary tradition in photography-among the best in the field-are a crucial part of her activity as an artist. Many modernist artists, of course, produced texts about their own production, but writing was almost always considered supplementary to their primary work as painters, sculptors, photographers, etc.,²¹ whereas the kind of simultaneous activity on multiple fronts that characterizes many feminist practices is a postmodern phenomenon. And one of the things it challenges is modernism's rigid opposition to artistic practice and theory.

At the same time, postmodern feminist practice may question theory-and not only aesthetic theory. Consider Mary Kelly's Post-Partum Document (1973-79), a 6-part, 165-piece art work (plus footnotes) that utilizes multiple representational modes (literary, scientific, psychoanalytic, linguistic, archeological and so forth) to chronicle the first six years of her son's life. Part archive, part exhibition, part case history, the Post-Partum Document is also a contribution to as well as a critique of Lacanian theory. Beginning as it does with a series of diagrams taken from *Ecrits* (diagrams which Kelly presents as *pictures*), the work might be (mis)read as a straightforward application or illustration of psychoanalysis. It is, rather, a mother's interrogation of Lacan, an interrogation that ultimately reveals a remarkable oversight within the Lacanian narrative of the child's relation to the mother-the construction of the mother's fantasies vis-à-vis the child. Thus, the *Post-Partum Document* has proven to be a controversial work, for it appears to offer evidence of *female* fetishism (the various substitutes the mother invests in order to disavow separation from the child); Kelly thereby exposes a lack within the theory of fetishism, a perversion heretofore reserved for the male. Kelly's work is not anti-theory; rather, as her use of multiple representational systems testifies, it demonstrates that no one narrative can possibly account for all aspects of human experience. Or as the artist herself has said, "There's no single theoretical discourse which is going to offer an explanation for all forms of social relations or for every mode of political practice."22

A la recherche du récit perdu

"No single theoretical discourse . . ."—this feminist position is also a postmodern condition. In fact, Lyotard diagnoses *the* postmodern condition as one in which the *grands récits* of modernity—the dialectic of Spirit, the emancipation of the worker, the accumulation of wealth, the classless society—have all lost credibility. Lyotard defines a discourse as modern when it appeals to one or another of these *grands récits* for its legitimacy; the advent of postmodernity, then, signals a crisis in narrative's legitimizing function, its ability to compel consensus. Narrative, he argues, is out of its element(s)—"the great dangers, the great journeys, the great goal." Instead, "it is dispersed into clouds of linguistic particles—narrative ones, but also denotative, prescriptive, descriptive, etc.—each with its own pragmatic valence. Today, each of us lives in the vicinity of many of these. We do not necessarily form stable linguistic communities, and the properties of those we do form are not necessarily communicable."²³

Lyotard does not, however, mourn modernity's passing, even though

his own activity as a philosopher is at stake. "For most people," he writes, "nostalgia for the lost narrative [*le récit perdu*] is a thing of the past."²⁴ "Most people" does not include Fredric Jameson, although he diagnoses the postmodern condition in similar terms (as a loss of narrative's social function) and distinguishes between modernist and postmodernist works according to their different relations to the "'truth-content' of art, its claim to possess some truth or epistemological value." His description of a crisis in modernist literature stands metonymically for the crisis in modernity itself:

At its most vital, the experience of modernism was not one of a single historical movement or process, but of a "shock of discovery," a commitment and an adherence to its individual forms through a series of "religious conversions." One did not simply read D.H. Lawrence or Rilke, see Jean Renoir or Hitchcock, or listen to Stravinsky as distinct manifestations of what we now term modernism. Rather one read all the works of a particular writer, learned a style and a phenomenological world, to which one converted. . . . This meant, however, that the experience of one form of modernism was incompatible with another, so that one entered one world only at the price of abandoning another. . . . The crisis of modernism came, then, when it suddenly became clear that "D.H. Lawrence" was not an absolute after all, not the final achieved figuration of the truth of the world, but only one art-language among others, only one shelf of works in a whole dizzying library.²⁵

Although a reader of Foucault might locate this realization at the origin of modernism (Flaubert, Manet) rather than at its conclusion,²⁶ Jameson's account of the crisis of modernity strikes me as both persuasive and problematic—problematic because persuasive. Like Lyotard, he plunges us into a radical Nietzschean perspectivism: each oeuvre represents not simply a different view of the same world, but corresponds to an entirely different world. Unlike Lyotard, however, he does so only in order to extricate us from it. For Jameson, the loss of narrative is equivalent to the loss of our ability to locate ourselves historically; hence, his diagnosis of postmodernism as "schizophrenic," meaning that it is characterized by a collapsed sense of temporality.²⁷ Thus, in *The Political Unconscious* he urges the resurrection not simply of narrative—as a "socially symbolic act"—but specifically of what he identifies as the Marxist "master narrative"—the story of mankind's "collective struggle to wrest a realm of Freedom from a realm of Necessity."²⁸

Master narrative—how else to translate Lyotard's *grand récit*? And in this translation we glimpse the terms of another analysis of modernity's demise, one that speaks not of the incompatibility of the various modern narratives, but instead of their fundamental solidarity. For what made the *grands récits* of modernity master narratives if not the fact that they were all narratives of mastery, of man seeking his telos in the conquest of nature? What function did these narratives play other than to legitimize Western man's self-appointed mission of transforming the entire planet in his own image? And what form did this mission take if not that of man's placing of his stamp on everything that exists—that is, the transformation of the world into a representation, with man as its subject? In this respect, however, the phrase *master narrative* seems tautologous, since all narrative, by virtue of "its power to master the dispiriting effects of the corrosive force of the temporal process,"²⁹ may be narrative of mastery.³⁰

What is at stake, then, is not only the status of narrative, but of representation itself. For the modern age was not only the age of the master narrative, it was also the age of representation—at least this is what Martin Heidegger proposed in a 1938 lecture delivered in Freiburg im Breisgau, but not published until 1952 as "The Age of the World Picture" [*Die Zeit die Weltbildes*].³¹ According to Heidegger, the transition to modernity was not accomplished by the replacement of a medieval by a modern world picture, "but rather the fact that the world becomes a picture at all is what distinguishes the essence of the modern age." For modern man, everything that exists does so only in and through representation. To claim this is also to claim that the world exists only in and through a *subject* who believes that he is producing the world in producing its representation:

The fundamental event of the modern age is the conquest of the world as picture. The word "picture" [*Bild*] now means the structured image [*Gebild*] that is the creature of man's producing which represents and sets before. In such producing, man contends for the position in which he can be that particular being who gives the measure and draws up the guidelines for everything that is.

Thus, with the "interweaving of these two events"—the transformation of the world into a picture and man into a subject—"there begins that way of being human which mans the realm of human capability given over to measuring and executing, for the purpose of gaining mastery of that which is as a whole." For what is representation if not a "laying hold and grasping" (appropriation), a "making-stand-over-against, an objectifying that goes forward and masters"³²

Thus, when in a recent interview Jameson calls for "the *reconquest* of certain forms of representation" (which he equates with narrative: "Narrative,'" he argues, "is, I think, generally what people have in mind when they rehearse the usual post-structuralist 'critique of represent-ation"),³³ he is in fact calling for the rehabilitation of the entire social project of modernity itself. Since the Marxist master narrative is only one version among many of the modern narrative of mastery (for what is the "collective

struggle to wrest a realm of Freedom from a realm of Necessity" if not mankind's progressive exploitation of the Earth?), Jameson's desire to resurrect (this) narrative is a modern desire, a desire *for* modernity. It is one symptom of our postmodern condition, which is experienced everywhere today as a tremendous loss of mastery and thereby gives rise to therapeutic programs, from both the Left and the Right, for recuperating that loss. Although Lyotard warns—correctly, I believe—against explaining transformations in modern/postmodern culture primarily as effects of social transformations (the hypothetical advent of a postindustrial society, for example),³⁴ it is clear that what has been lost is not primarily a cultural mastery, but an economic, technical and political one. For what if not the emergence of Third-World nations, the "revolt of nature" and the women's movement—that is, the voices of the conquered—has challenged the West's desire for ever-greater domination and control?

Symptoms of our recent loss of mastery are everywhere apparent in cultural activity today-nowhere more so than in the visual arts. The modernist project of joining forces with science and technology for the transformation of the environment after rational principles of function and utility (Productivism, the Bauhaus) has long since been abandoned; what we witness in its place is a desperate, often hysterical attempt to recover some sense of mastery via the resurrection of heroic large-scale easel painting and monumental cast-bronze sculpture-mediums themselves identified with the cultural hegemony of Western Europe. Yet contemporary artists are able at best to *simulate* mastery, to manipulate its signs; since in the modern period mastery was invariably associated with human labor, aesthetic production has degenerated today into a massive deployment of the signs of artistic labor-violent, "impassioned" brushwork, for example. Such simulacra of mastery testify, however, only to its loss; in fact, contemporary artists seem engaged in a collective act of disavowal-and disavowal always pertains to a loss . . . of virility, masculinity, potency.³⁵

This contingent of artists is accompanied by another which refuses the simulation of mastery in favor of melancholic contemplation of its loss. One such artist speaks of "the impossibility of passion in a culture that has institutionalized self-expression"; another, of "the aesthetic as something which is really about longing and loss rather than completion." A painter unearths the discarded genre of landscape painting only to borrow for his own canvases, through an implicit equation between their ravaged surfaces and the barren fields he depicts, something of the exhaustion of the earth itself (which is thereby glamorized); another dramatizes his anxieties through the most conventional figure men have conceived for the threat of castration—Woman . . . aloof, remote, unapproachable. Whether they disavow or advertise their own powerlessness, pose as heroes or as victims, these artists have, needless to say, been warmly received by

a society unwilling to admit that it has been driven from its position of centrality; theirs is an "official" art which, like the culture that produced it, has yet to come to terms with its own impoverishment.

Postmodernist artists speak of impoverishment—but in a very different way. Sometimes the postmodernist work testifies to a deliberate refusal of mastery, for example, Martha Rosler's The Bowery in Two Inadequate Descriptive Systems (1974-75), in which photographs of Bowery storefronts alternate with clusters of typewritten words signifying inebriety. Although her photographs are intentionally flat-footed, Rosler's refusal of mastery in this work is more than technical. On the one hand, she denies the caption/text its conventional function of supplying the image with something it lacks; instead, her juxtaposition of two representational systems, visual and verbal, is calculated (as the title suggests) to "undermine" rather than "underline" the truth value of each.³⁶ More importantly, Rosler has refused to photograph the inhabitants of Skid Row, to speak on their behalf, to illuminate them from a safe distance (photography as social work in the tradition of Jacob Riis). For "concerned" or what Rosler calls "victim" photography overlooks the constitutive role of its own activity, which is held to be merely representative (the "myth" of photographic transparency and objectivity). Despite his or her benevolence in representing those who have been denied access to the means of representation, the photographer inevitably functions as an agent of the system of power that silenced these people in the first place. Thus, they are twice victimized: first by society, and then by the photographer who presumes the right to speak on their behalf. In fact, in such photography it is the photographer rather than the "subject" who poses-as the subject's consciousness, indeed, as conscience itself. Although Rosler may not, in this work, have initiated a counter-discourse of drunkenness-which would consist of the drunks' own theories about their conditions of existenceshe has nevertheless pointed negatively to the crucial issue of a politically motivated art practice today: "the indignity of speaking for others."37

Rosler's position poses a challenge to criticism as well, specifically, to the critic's substitution of his own discourse for the work of art. At this point in my text, then, my own voice must yield to the artist's; in the essay "in, around and afterthoughts (on documentary photography)" which accompanies *The Bowery* ..., Rosler writes:

If impoverishment is a subject here, it is more certainly the impoverishment of representational strategies tottering about alone than that of a mode of surviving. The photographs are powerless to *deal with* the reality that is yet totally comprehended-in-advance by ideology, and they are as diversionary as the word formations—which at least are closer to being located within the culture of drunkenness rather than being framed on it from without.³⁸

The Visible and the Invisible

A work like The Bowery in Two Inadequate Descriptive Systems not only exposes the "myths" of photographic objectivity and transparency; it also upsets the (modern) belief in vision as a privileged means of access to certainty and truth ("Seeing is believing"). Modern aesthetics claimed that vision was superior to the other senses because of its detachment from its objects: "Vision," Hegel tells us in his Lectures on Aesthetics, "finds itself in a purely theoretical relationship with objects, through the intermediary of light, that immaterial matter which truly leaves objects their freedom, lighting and illuminating them without consuming them."³⁹ Postmodernist artists do not deny this detachment, but neither do they celebrate it. Rather, they investigate the particular interests it serves. For vision is hardly disinterested: nor is it indifferent, as Luce Irigarav has observed: "Investment in the look is not privileged in women as in men. More than the other senses, the eye objectifies and masters. It sets at a distance, maintains the distance. In our culture, the predominance of the look over smell, taste, touch, hearing, has brought about an impoverishment of bodily relations.... The moment the look dominates, the body loses its materiality."40 That is, it is transformed into an image.

That the priority our culture grants to vision is a sensory impoverishment is hardly a new perception; the feminist critique, however, links the privileging of vision with sexual privilege. Freud identified the transition from a matriarchal to a patriarchal society with the simultaneous devaluation of an olfactory sexuality and promotion of a more mediated, sublimated visual sexuality.⁴¹ What is more, in the Freudian scenario it is by looking that the child discovers sexual difference, the presence or absence of the phallus according to which the child's sexual identity will be assumed. As Jane Gallop reminds us in her recent book Feminism and Psychoanalysis: The Daughter's Seduction, "Freud articulated the 'discovery of castration' around a sight: sight of a phallic presence in the boy, sight of a phallic absence in the girl, ultimately sight of a phallic absence in the mother. Sexual difference takes its decisive significance from a sighting."42 Is it not because the phallus is the most visible sign of sexual difference that it has become the "privileged signifier"? However, it is not only the discovery of difference, but also its denial that hinges upon vision (although the reduction of difference to a common measure-woman judged according to the man's standard and found lacking—is already a denial). As Freud proposed in his 1926 paper on "Fetishism," the male child often takes the last visual impression prior to the "traumatic" sighting as a substitute for the mother's "missing" penis:

Thus the foot or the shoe owes its attraction as a fetish, or part of it, to the circumstance that the inquisitive boy used to peer up at the woman's legs

towards her genitals. Velvet and fur reproduce—as has long been suspected the sight of the pubic hair which ought to have revealed the longed-for penis; the underlinen so often adopted as a fetish reproduces the scene of undressing, the last moment in which the woman could still be regarded as phallic.⁴³

What can be said about the visual arts in a patriarchal order that privileges vision over the other senses? Can we not expect them to be a domain of masculine privilege-as their histories indeed prove them to be-a means, perhaps, of mastering through representation the "threat" posed by the female? In recent years there has emerged a visual arts practice informed by feminist theory and addressed, more or less explicitly, to the issue of representation and sexuality-both masculine and feminine. Male artists have tended to investigate the social construction of masculinity (Mike Glier, Eric Bogosian, the early work of Richard Prince); women have begun the long-overdue process of deconstructing femininity. Few have produced new, "positive" images of a revised femininity; to do so would simply supply and thereby prolong the life of the existing representational apparatus. Some refuse to represent women at all, believing that no representation of the female body in our culture can be free from phallic prejudice. Most of these artists, however, work with the existing repertory of cultural imagery-not because they either lack originality or criticize it-but because their subject, feminine sexuality, is always constituted in and as representation, a representation of difference. It must be emphasized that these artists are not primarily interested in what representations say about women; rather, they investigate what representation does to women (for example, the way it invariably positions them as objects of the male gaze). For, as Lacan wrote, "Images and symbols for the woman cannot be isolated from images and symbols of the woman. . . . It is representation, the representation of feminine sexuality whether repressed or not, which conditions how it comes into play."44

Critical discussions of this work have, however, assiduously avoided skirted—the issue of gender. Because of its generally deconstructive ambition, this practice is sometimes assimilated to the modernist tradition of demystification. (Thus, the critique of representation in this work is collapsed into ideological critique.) In an essay devoted (again) to allegorical procedures in contemporary art, Benjamin Buchloh discusses the work of six women artists—Dara Birnbaum, Jenny Holzer, Barbara Kruger, Louise Lawler, Sherrie Levine, Martha Rosler—claiming them for the model of "secondary mythification" elaborated in Roland Barthes's 1957 *Mythologies*. Buchloh does not acknowledge the fact that Barthes later repudiated this methodology—a repudiation that must be seen as part of his increasing refusal of mastery from *The Pleasure of the Text* on.⁴⁵ Nor does Buchloh grant any particular significance to the fact that all these artists are women; instead, he provides them with a distinctly male genealogy in the

190 Craig Owens

dada tradition of collage and montage. Thus, all six artists are said to manipulate the languages of popular culture—television, advertising, photography—in such a way that "their ideological functions and effects become *transparent*"; or again, in their work, "the minute and seemingly inextricable interaction of behavior and ideology" supposedly becomes an "observable pattern."⁴⁶

But what does it mean to claim that these artists render the invisible visible, especially in a culture in which visibility is always on the side of the male, invisibility on the side of the female? And what is the critic really saying when he states that these artists reveal, expose, "unveil" (this last word is used throughout Buchloh's text) hidden ideological agendas in mass-cultural imagery? Consider, for the moment, Buchloh's discussion of the work of Dara Birnbaum, a video artist who re-edits footage taped directly from broadcast television. Of Birnbaum's Technology / Transformation: Wonder Woman (1978-79), based on the popular television series of the same name, Buchloh writes that it "unveils the puberty fantasy of Wonder Woman." Yet, like all of Birnbaum's work, this tape is dealing not simply with mass-cultural imagery, but with mass-cultural images of women. Are not the activities of unveiling, stripping, laying bare in relation to a female body unmistakably male prerogatives?⁴⁷ Moreover, the women Birnbaum re-presents are usually athletes and performers absorbed in the display of their own physical perfection. They are without defect, without lack, and therefore with neither history nor desire. (Wonder Woman is the perfect embodiment of the phallic mother.) What we recognize in her work is the Freudian trope of the narcissistic woman, or the Lacanian "theme" of femininity as contained spectacle, which exists only as a representation of masculine desire.⁴⁸

The deconstructive impulse that animates this work has also suggested affinities with poststructuralist textual strategies, and much of the critical writing about these artists—including my own—has tended simply to translate their work into French. Certainly, Foucault's discussion of the West's strategies of marginalization and exclusion. Derrida's charges of "phallocentrism," Deleuze and Guattari's "body without organs" would all seem to be congenial to a feminist perspective. (As Irigaray has observed, is not the "body without organs" the historical condition of woman?)49 Still, the affinities between poststructuralist theories and postmodernist practice can blind a critic to the fact that, when women are concerned, similar techniques have very different meanings. Thus, when Sherrie Levine appropriates—literally takes—Walker Evans's photographs of the rural poor or, perhaps more pertinently, Edward Weston's photographs of his son Neil posed as a classical Greek torso, is she simply dramatizing the diminished possibilities for creativity in an image-saturated culture, as is often repeated? Or is her refusal of authorship not in fact a refusal of the role of creator as "father" of his work, of the paternal rights assigned to

the author by law?⁵⁰ (This reading of Levine's strategies is supported by the fact that the images she appropriates are invariably images of the Other: women, nature, children, the poor, the insane . . .)⁵¹ Levine's disrespect for paternal authority suggests that her activity is less one of appropriation—a laying hold and grasping—and more one of expropriation: she expropriates the appropriators.

Sometimes Levine collaborates with Louise Lawler under the collective title "A Picture is No Substitute for Anything"—an unequivocal critique of representation as traditionally defined. (E.H. Gombrich: "All art is image-making, and all image-making is the creation of substitutes.") Does not their collaboration move us to ask what the picture is supposedly a substitute for, what it replaces, what absence it conceals? And when Lawler shows "A Movie without the Picture," as she did in 1979 in Los Angeles and again in 1983 in New York, is she simply soliciting the spectator as a collaborator in the production of the image? Or is she not also denying the viewer the kind of visual pleasure which cinema customarily provides a pleasure that has been linked with the masculine perversions voyeurism and scopophilia?⁵² It seems fitting, then, that in Los Angeles she screened (or didn't screen) *The Misfits*—Marilyn Monroe's last completed film. So that what Lawler withdrew was not simply a picture, but the archetypal image of feminine desirability.

When Cindy Sherman, in her untitled black-and-white studies for film stills (made in the late '70s and early '80s), first costumed herself to resemble heroines of grade-B Hollywood films of the late '50s and early '60s and then photographed herself in situations suggesting some immanent danger lurking just beyond the frame, was she simply attacking the rhetoric of "auteurism by equating the known artifice of the actress in front of the camera with the supposed authenticity of the director behind it"?⁵³ Or was her play-acting not also an acting out of the psychoanalytic notion of femininity as masquerade, that is, as a representation of male desire? As Hélène Cixous has written, "One is always in representation, and when a woman is asked to take place in this representation, she is, of course, asked to represent man's desire."54 Indeed, Sherman's photographs themselves function as mirror-masks that reflect back at the viewer his own desire (and the spectator posited by this work is invariably male)-specifically, the masculine desire to fix the woman in a stable and stabilizing identity. But this is precisely what Sherman's work denies: for while her photographs are always self-portraits, in them the artist never appears to be the same, indeed, not even the same model; while we can presume to recognize the same person, we are forced at the same time to recognize a trembling around the edges of that identity.⁵⁵ In a subsequent series of works, Sherman abandoned the film-still format for that of the magazine centerfold, opening herself to charges that she was an accomplice in her own objectification, reinforcing the image of the

192 Craig Owens

woman bound by the frame.⁵⁶ This may be true; but while Sherman may pose as a pin-up, she still cannot be pinned down.

Finally, when Barbara Kruger collages the words "Your gaze hits the side of my face" over an image culled from a '50s photo-annual of a female bust, is she simply "making an equation . . . between aesthetic reflection and the alienation of the gaze: both reify"?⁵⁷ Or is she not speaking instead of the *masculinity* of the look, the ways in which it objectifies and masters? Or when the words "You invest in the divinity of the masterpiece" appear over a blown-up detail of the creation scene from the Sistine ceiling, is she simply parodying our reverence for works of art, or is this not a commentary on artistic production as a contract between fathers and sons? The address of Kruger's work is always gender-specific; her point, however, is not that masculinity and femininity are fixed positions assigned in advance by the representational apparatus. Rather, Kruger uses a term with no fixed content, the linguistic shifter ("I/you"), in order to demonstrate that masculine and feminine themselves are not stable identities, but subject to exchange.

There is irony in the fact that all these practices, as well as the theoretical work that sustains them, have emerged in a historical situation supposedly characterized by its complete indifference. In the visual arts we have witnessed the gradual dissolution of once fundamental distinctions—original/copy, authentic/inauthentic, function/ornament. Each term now seems to contain its opposite, and this indeterminacy brings with it an impossibility of choice, or, rather, the absolute equivalence and hence interchangeability of choices. Or so it is said.⁵⁸ The existence of feminism, with its insistence on difference, forces us to reconsider. For in our country goodbye may look just like hello, but only from a masculine position. Women have learned—perhaps they have always known—how to recognize the difference.

References

- 1. Paul Ricoeur, "Civilization and National Cultures," *History and Truth*, trans. Chas. A. Kelbley (Evanston: Northwestern University Press, 1965), p. 278.
- 2. Hayden White, "Getting Out of History," *diacritics*, 12, 3 (Fall 1982), p. 3. Nowhere does White acknowledge that it is precisely this universality that is in question today.
- 3. See, for example, Louis Marin, "Toward a Theory of Reading in the Visual Arts: Poussin's *The Arcadian Shepherds*," in S. Suleiman and I. Crosman, eds., *The Reader in the Text* (Princeton: Princeton University Press, 1980), pp. 293–324. This essay reiterates the main points of the first section of Marin's *Détruire la peinture* (Paris: Galilée, 1977). See also Christian Metz's discussion of the enunciative apparatus of cinematic representation in his "History/Discourse: A Note on Two Voyeurisms" in *The Imaginary Signifier*, trans. Britton, Williams, Brewster and Guzzetti (Bloomington: Indiana University Press, 1982). And for a general survey of these analyses, see my "Representation, Appropriation & Power," *Art in America*, 70, 5 (May 1982), pp. 9–21.
- 4. Hence Kristeva's problematic identification of avant-garde practice as feminine-prob-

lematic because it appears to act in complicity with all those discourses which exclude women from the order of representation associating them instead with the presymbolic (Nature, the Unconscious, the body, etc.).

- 5. Jacques Derrida, "Sending: On Representation," trans. P. and M.A. Caws, Social Research, 49, 2 (Summer 1982), pp. 325, 326, italics added. (In this essay Derrida is discussing Heidegger's "The Age of the World Picture," a text to which I will return.) "Today there is a great deal of thought against representation," Derrida writes. "In a more or less articulated or rigorous way, this judgment is easily arrived at: representation is bad.... And yet, whatever the strength and the obscurity of this dominant current, the authority of representation constrains us, imposing itself on our thought through a whole dense, enigmatic, and heavily stratified history. It programs us and precedes us and warns us too severely for us to make a mere object of it, a representation, an object of representation confronting us, before us like a theme" (p. 304). Thus, Derrida concludes that "the essence of representation" (p. 314, italics added).
- Michèle Montrelay, "Recherches sur la femininité," Critique, 278 (July 1970); translated by Parveen Adams as "Inquiry into Femininity," m/f, 1 (1978); repr. in Semiotext(e), 10 (1981), p. 232.
- 7. Many of the issues treated in the following pages—the critique of binary thought, for example, or the privileging of vision over the other senses—have had long careers in the history of philosophy. I am interested, however, in the ways in which feminist theory articulates them onto the issue of sexual privilege. Thus, issues frequently condemned as merely epistemological turn out to be political as well. (For an example of this kind of condemnation, see Andreas Huyssens, "Critical Theory and Modernity," *New German Critique*, 26 [Spring/Summer 1982], pp. 3–11.) In fact, feminism demonstrates the impossibility of maintaining the split between the two.
- "What is unquestionably involved here is a conceptual foregrounding of the sexuality of the woman, which brings to our attention a remarkable oversight." Jacques Lacan, "Guiding Remarks for a Congress on Feminine Sexuality," in J. Mitchell and J. Rose, eds., *Feminine Sexuality* (New York: Norton and Pantheon, 1982), p. 87.
- 9. See my "The Allegorical Impulse: Toward a Theory of Postmodernism" (part 2), October, 13 (Summer 1980), pp. 59–80. Americans on the Move was first performed at The Kitchen Center for Video, Music, and Dance in New York City in April 1979; it has since been revised and incorporated into Anderson's two-evening work United States, Parts I–IV, first seen in its entirety in February 1983 at the Brooklyn Academy of Music.
- 10. This project was brought to my attention by Rosalyn Deutsche.
- As Stephen Heath writes, "Any discourse which fails to take account of the problem of sexual difference in its own enunciation and address will be, within a patriarchal order, precisely indifferent, a reflection of male domination." "Difference," *Screen*, 19, 4 (Winter 1978–79), p. 53.
- 12. Martha Rosler, "Notes on Quotes," Wedge, 2 (Fall 1982), p. 69.
- 13. Jean-François Lyotard, La condition postmoderne (Paris: Minuit, 1979), p. 29.
- See Sarah Kofman, Le Respect des femmes (Paris: Galilée, 1982). A partial English translation appears as "The Economy of Respect: Kant and Respect for Women," trans. N. Fisher, Social Research, 49, 2 (Summer 1982), pp. 383–404.
- 15. Why is it always a question of *distance*? For example, Edward Said writes, "Nearly everyone producing literary or cultural studies makes no allowance for the truth that all intellectual or cultural work occurs somewhere, at some times, on some very precisely mapped-out and permissible terrain, which is ultimately contained by the State. Feminist critics have opened this question part of the way, but *they have not gone the whole distance*." "American 'Left' Literary Criticism," *The World, the Text, and the Critic* (Cambridge: Harvard University Press, 1983), p. 169. Italics added.

194 Craig Owens

- Fredric Jameson, *The Political Unconscious* (Ithaca: Cornell University Press, 1981), p. 84.
- 17. Marx and Engels, The German Ideology (New York: International Publishers, 1970), p. 42. One of the things that feminism has exposed is Marxism's scandalous blindness to sexual inequality. Both Marx and Engels viewed patriarchy as part of a pre-capitalist mode of production, claiming that the transition from a feudal to a capitalist mode of production was a transition from male domination to domination by capital. Thus, in the Communist Manifesto they write, "The bourgeoisie, wherever it has got the upper hand, has put an end to all feudal, patriarchal . . . relations." The revisionist attempt (such as Jameson proposes in The Political Unconscious) to explain the persistence of patriarchy as a survival of a previous mode of production is an inadequate response to the challenge posed by feminism to Marxism. Marxism's difficulty with feminism is not part of an ideological bias inherited from outside; rather, it is a structural effect of its privileging of production as the definitely human activity. On these problems, see Isaac D. Balbus, Marxism and Domination (Princeton: Princeton University Press, 1982), especially chapter 2, "Marxist Theories of Patriarchy," and chapter 5, "Neo-Marxist Theories of Patriarchy." See also Stanley Aronowitz, The Crisis in Historical Materialism (Brooklyn: J. F. Bergin, 1981), especially chapter 4, "The Question of Class."
- Lyotard, "One of the Things at Stake in Women's Struggles," Substance, 20 (1978), p. 15.
- 19. Perhaps the most vociferous feminist antitheoretical statement is Marguerite Duras's: "The criterion on which men judge intelligence is still the capacity to theorize and in all the movements that one sees now, in whatever area it may be, cinema, theater, literature, the theoretical sphere is losing influence. It has been under attack for centuries. It ought to be crushed by now, it should lose itself in a reawakening of the senses, blind itself, and be still." In E. Marks and I. de Courtivron, eds., *New French Feminisms* (New York: Schocken, 1981), p. 111. The implicit connection here between the privilege men grant to theory and that which they grant to vision over the other senses recalls the etymology of *theoria*; see below.

Perhaps it is more accurate to say that most feminists are ambivalent about theory. For example, in Sally Potter's film *Thriller* (1979)—which addresses the question "Who is responsible for Mimi's death?" in *La Bohème*—the heroine breaks out laughing while reading aloud from Kristeva's introduction to *Théorie d'ensemble*. As a result, Potter's film has been interpreted as an antitheoretical statement. What seems to be at issue, however, is the inadequacy of currently existing theoretical constructs to account for the specificity of a woman's experience. For as we are told, the heroine of the film is "searching for a theory that would explain her life and her death." On *Thriller*, see Jane Weinstock, "She Who Laughs First Laughs Last," *Camera Obscura*, 5 (1980).

- 20. Published in Screen, 16, 3 (Autumn 1975).
- 21. See my "Earthwords," October, 10 (Fall 1979), pp. 120-32.
- 22. "No Essential Femininity: A Conversation between Mary Kelly and Paul Smith," *Parachute*, 26 (Spring 1982), p. 33.
- 23. Lyotard, La condition postmoderne, p. 8.
- 24. Ibid., p. 68.
- Jameson, "In the Destructive Element Immerse': Hans-Jürgen Syberberg and Cultural Revolution," October, 17 (Summer 1981), p. 113.
- See, for example, "Fantasia of the Library," in D. F. Bouchard, ed. Language, countermemory, practice (Ithaca: Cornell University Press, 1977), pp. 87–109. See also Douglas Crimp, "On the Museum's Ruins," *The Anti-Aesthetic: Essays on Postmodern Culture*, ed. Hal Foster (Port Townsend, WA: Bay Press, 1983), pp. 43–56.
- 27. See Jameson, "Postmodernism and Consumer Society," The Anti-Aesthetic, pp. 111-25.
- 28. Jameson, Political Unconscious, p. 19.

- 29. White, p. 3.
- 30. Thus, the antithesis to narrative may well be allegory, which Angus Fletcher identifies as the "epitome of counter-narrative." Condemned by modern aesthetics because it speaks of the inevitable reclamation of the works of man by nature, allegory is also the epitome of the anti-modern, for it views history as an irreversible process of dissolution and decay. The melancholic, contemplative gaze of the allegorist need not, however, be a sign of defeat; it may represent the superior wisdom of one who has relinquished all claims to mastery.
- Translated by William Lovitt and published in *The Question Concerning Technology* (New York: Harper and Row, 1977), pp. 115–54. I have, of course, oversimplified Heidegger's complex and, I believe, extremely important argument.
- 32. Ibid, p. 149, 50. Heidegger's definition of the modern age—as the age of representation for the purpose of mastery—coincides with Theodor Adorno and Max Horkheimer's treatment of modernity in their *Dialectic of Enlightenment* (written in exile in 1944, but without real impact until its republication in 1969). "What men want to learn from nature," Adorno and Horkheimer write, "is how to use it in order wholly to dominate it and other men." And the primary means of realizing this desire is (what Heidegger, at least, would recognize as) representation—the suppression of "the multitudinous affinities between existents" in favor of "the single relation between the subject who bestows meaning and the meaningless object." What seems even more significant, in the context of this essay, is that Adorno and Horkheimer repeatedly identify this operation as "patriarchal."
- 33. Jameson, "Interview," diacritics, 12, 3 (Fall 1982), p. 87.
- 34. Lyotard, *La condition postmoderne*, p. 63. Here, Lyotard argues that the *grands récits* of modernity contain the seeds of their own delegitimation.
- 35. For more on this group of painters, see my "Honor, Power and the Love of Women," *Art in America*, 71, 1 (January 1983), pp. 7–13.
- 36. Martha Rosler interviewed by Martha Gever in Afterimage (October 1981), p. 15. The Bowery in Two Inadequate Descriptive Systems has been published in Rosler's book 3 Works (Halifax: The Press of The Nova Scotia College of Art and Design, 1981).
- 37. "Intellectuals and Power: A conversation between Michel Foucault and Gilles Deleuze," *Language, counter-memory, practice*, p. 209. Deleuze to Foucault: "In my opinion, you were the first—in your books and in the practical sphere—to teach us something absolutely fundamental: the indignity of speaking for others."

The idea of a counter-discourse also derives from this conversation, specifically from Foucault's work with the "Groupe d'information de prisons." Thus, Foucault: "When the prisoners began to speak, they possessed an individual theory of prisons, the penal system, and justice. It is this form of discourse which ultimately matters, a discourse against power, the counter-discourse of prisoners and those we call delinquents— and not a theory *about* delinquency."

- Martha Rosler, "in, around, and afterthoughts (on documentary photography)," 3 Works, p. 79.
- 39. Quoted in Heath, p. 84.
- 40. Interview with Luce Irigaray in M.-F. Hans and G. Lapouge, eds., Les femmes, la pornographie, l'erotisme (Paris, 1978), p. 50.
- Civilization and Its Discontents, trans. J. Strachey (New York: Norton, 1962), pp. 46–47.
- Jane Gallop, Feminism and Psychoanalysis: The Daughter's Seduction (Ithaca: Cornell University Press, 1982), p. 27.
- "On Fetishism," repr. in Philip Rieff, ed., Sexuality and the Psychology of Love (New York: Collier, 1963), p. 217.
- 44. Lacan, p. 90.
- 45. On Barthes's refusal of mastery, see Paul Smith, "We Always Fail—Barthes' Last Writ-

ings," SubStance, 36 (1982), pp. 34–39. Smith is one of the few male critics to have directly engaged the feminist critique of patriarchy without attempting to rewrite it.

- 46. Benjamin Buchloh, "Allegorical Procedures: Appropriation and Montage in Contemporary Art," *Artforum*, XXI, 1 (September 1982), pp. 43–56.
- 47. Lacan's suggestion that "the phallus can play its role only when veiled" suggests a different inflection of the term "unveil"—one that is not, however, Buchloh's.
- On Birnbaum's work, see my "Phantasmagoria of the Media," Art in America, 70, 5 (May 1982), pp. 98–100.
- See Alice A. Jardine, "Theories of the Feminine: Kristeva," *enclitic*, 4, 2 (Fall 1980), pp. 5–15.
- 50. "The author is reputed the father and owner of his work: literary science therefore teaches *respect* for the manuscript and the author's declared intentions, while society asserts the legality of the relation of author to work (the 'droit d'auteur' or 'copyright,' in fact of recent date since it was only really legalized at the time of the French Revolution). As for the Text, it reads without the inscription of the Father." Roland Barthes, "From Work to Text," *Image / Music / Text*, trans. S. Heath (New York: Hill and Wang, 1977), pp. 160–61.
- 51. Levine's first appropriations were images of maternity (women in their natural role) from ladies' magazines. She then took landscape photographs by Eliot Porter and Andreas Feininger, then Weston's portraits of Neil, then Walker Evans's FSA photographs. Her recent work is concerned with Expressionist painting, but the involvement with images of alterity remains: she has exhibited reproductions of Franz Marc's pastoral depictions of animals, and Egon Schiele's self-portraits (madness). On the thematic consistency of Levine's "work," see my review, "Sherrie Levine at A & M Artworks," *Art in America*, 70, 6 (Summer 1982), p. 148.
- 52. See Metz, "The Imaginary Signifier."
- 53. Douglas Crimp, "Appropriating Appropriation," in Paula Marincola, ed., *Image Scavengers: Photography* (Philadelphia: Institute of Contemporary Art, 1982), p. 34.
- 54. Hélène Cixous, "Entretien avec Francoise van Rossum-Guyon," quoted in Heath, p. 96.
- 55. Sherman's shifting identity is reminiscent of the authorial strategies of Eugenia Lemoine-Luccioni as discussed by Jane Gallop; see *Feminism and Psychoanalysis*, p. 105: "Like children, the various productions of an author date from different moments, and cannot strictly be considered to have the same origin, the same author. At least we must avoid the fiction that a person is the same, unchanging throughout time. Lemoine-Luccioni makes the difficulty patent by signing each text with a different name, all of which are 'hers'."
- 56. See, for example, Martha Rosler's criticisms in "Notes on Quotes," p. 73: "Repeating the images of woman bound in the frame will, like Pop, soon be seen as a *confirmation* by the 'post-feminist' society."
- 57. Hal Foster, "Subversive Signs," Art in America, 70, 10 (November 1982), p. 88.
- 58. For a statement of this position in relation to contemporary artistic production, see Mario Perniola, "Time and Time Again," *Artforum*, XXI, 8 (April 1983); pp. 54–55. Perniola is indebted to Baudrillard; but are we not back with Ricoeur in 1962—that is, at precisely the point at which we started?

Eluding Definition

KATE LINKER

Among the tortuous texts of Jacques Lacan, several speak with unusual lucidity and pertinence about the constraints surrounding the very idea of women. In "Encore," an essay from the early '70s approaching the terra incognita of feminine desire, Lacan speaks "of all those beings who take on the status of the woman."¹ Lacan exposes the problem as one of authority, for "status" is a juridical term, denoting a condition or position with regard to the law. Woman's supposed "nature," he implies, is highly unnatural; it is not inherent but assumed (or imposed) from outside. But in another text Lacan goes further, as if to answer our inevitable question about sexual formation: "Images and symbols *for* the woman cannot be isolated from images and symbols *of* the woman. It is representation, . . . the representation of feminine sexuality . . . , which conditions how it comes into play." In a manner radical for feminism, Lacan discloses sexuality as a problem of language.

If this privileging of language is crucial, it is because it calls attention to the way feminism participates in a larger and more encompassing direction, the investigation of cultural constraints. Lacan's insights coincide with deconstructive theory, which views reality as the effect of systems of representation, as a product of codes authorized and empowered by the Western social apparatus. What is traced in his work is the distance traveled by the decentered subject, subjected to and through language, from the model of the previous period which was defined as unified, autonomous, and self-possessing "master" of its universe. Feminism is seen to exemplify the post-Modernist concern with the production of the subject rather

Copyright @ Artforum, December 1984, "Eluding Definition," Kate Linker. Reprinted with permission of the author and publisher.

than the Modernist preoccupation with the subject of production. Similarly, as part of a recognition of difference, of previously marginal or excluded discourses, feminism joins post-Modernism in exposing the legitimizing apparatus of Western representation, as it converges on the patriarchal white male.² As Lacan implies, the problem involves both the assumption of, and assumptions of, status. Or as Mary Ann Doane has remarked, it concerns the delineation of a "place" assigned by culture to women in a network of relations of power.³

In recent years these concepts have been articulated in the practice of a number of women artists, not all of them explicitly feminist. What I want to indicate is the radical split they define between a perspective constellated around the terms "expression," "identity," "self," and "meaning" and one that takes signification as its subject; a move from a personal, idealist viewpoint to one informed by system and structure. Despite divergences, they share a deconstructive thrust, a mission of dismantling the concept of the singular self which a more analytic consideration might stress. Another interpretation might lead us, through a chain of associations, from the centered and unitary subject to its decentered, heterogeneous forms, from essences or metaphysical entities to the varied social forces that determine them—from nature to culture, to employ an age-old opposition.

That our period has witnessed a striking restriction of the natural is hardly a new perception; abundant comment testifies to our artificial environment, defined by the proliferation of signs. Recent criticism, however, links such representations with privilege, exposing their regulation of subjectivity and their complicity with relations of power. Over the past decade an important body of theory has addressed the role of representation in shaping norms of behavior, sexual definitions, and more general effects, such as the regimes of pleasure experienced in the media. Much of this work has been in cinema studies, which has revealed the sexual control exerted through mainstream film; the play of dominance has also been examined in literature, advertising, and art. Central to this project is the work of Michel Foucault, conducted throughout the '70s on specific discourses that regulate different fields, sexuality most notable among them. Foucault's endeavor directs us toward the social and temporal limits that condition thought, accounting for the scope and play of meaning and explaining meaning's vigilance over the interests it guards. It has impelled the recognition that the singular self is not a natural fact but rather an ideological construction,⁴ produced by the humanist period.

Through a similar logic, feminist thought has questioned the notion of a natural sexuality as a mirage of language, a view of the world produced in and for patriarchy. By a strategy that is both generational and epistemological, women artists have contested a feminine essence reducible to anatomical difference, arguing for masculinity and femininity as psychic categories constructed in language's flow. The opposition, as Jane Gallop observes,⁵ contrasts an idealist to a materialist position, setting the subject's origin in biology against its production in history, in spatially and temporally varying contexts. The idealist "natural" subject pervades feminist politics of the '60s and early '70s, underlying its separatist stance, its slogan "the personal is the political," and its endorsement of a feminine sensibility. Its notion of a creative self underlies its search for authenticity in language, defining women's art as a reflection of women's experience, as the internalization of the female body. The humanist emblem of the period is found in the phrase *From the Center*, which titles Lucy Lippard's important book (1976) on feminist work. And its timeless and universalizing dimensions impel the metaphors of woman as landscape, nature, Great Goddess and Mother Earth. However, the strategic benefits that are derived from this designation of sex and sexuality as natural, rather than cultural, categories are questionable.

According to Claude Lévi-Strauss,⁶ the opposition between nature and culture is an elementary structure; it divides what is universal and unchanging from what, being dependent on a system of norms, is capable of variation from one society to the next. In the words of Edward Said, the opposition repeats the terms of a "conflictual economy," contrasting the vision of domination (demand for identity, stasis) with change, differencethe temporality of history. Not unpredictably, many women artists have objected to a naturalization of sexual difference that repeats established terms of definition, conferring on them an immutability which has been consistent with feminine oppression. Recourse to the idea of a feminine nature, as presumed by the biological view, has had the effect of both mystifying Woman (of consigning her to a realm outside of culture, as the unknowable eternal feminine) and of installing her as an object to be domesticated or "mastered" in the masculine conquest of Nature. As variously noted, the concept of woman as a dark continent to be pacified has an ample history, one that places her within the compass of colonial exploitation. For political reasons, feminists have refused such imperialistic and universalizing reductions. Many women artists have insisted that the female body be placed, as Doane comments, "within quotation marks"that it not be celebrated, but contextually described.⁷ They have protested a liberal perspective that in no way accounts for the ideological structures of which discrimination is but a symptom, which leaves untouched the integrated value system through which feminine oppression is enacted. It is with the aim of understanding the construction of sexed subjectivity in language that artists have turned to the theoretical priming of psychoanalysis.

This recourse by artists is not isolated, but belongs within a general movement in the social sciences to seek a model for the development of subjectivity different from the centered humanist model. Psychoanalysis, or one branch of psychoanalysis, has offered an account of the subject's development through interpersonal relations; the approach is generally associated with a "return to Freud" and, in particular, to Freud as reread by Lacan. Lacan's theory employs what is most forceful in Freud—his analysis of the construction of the psychological structures of sexuality—using the sciences of linguistics and semiotics, which were unavailable to him. Underlying Freud's importance is his focus on a primordially alienated subject which will make itself in culture through a continued series of provisional and unstable attempts at unity.

In this manner, as Gallop writes, Freud provides a description of the human being in culture, not of the natural animal, man⁸—nor of his complement, woman. Throughout his writings there is an insistence that there is no precultural real, no reality beyond representation. In a famous diagram, Lacan illustrates this social construction of sexuality, opposing it to the natural version, based on the immanence of meaning:

The first image designates the now-classic model for the linguistic sign as a correspondence between signifier and signified, by which the word substitutes for (stands in place of) the thing. As has been noted, "the only delimitable thing the signifier woman could possibly 'mean,'" according to this equation, "is the biological female."9 However, in the second image Lacan privileges the signifier over the signified, stressing, in particular, the bar that separates the two terms. For, in that the doors are identical, their meaning is produced only in, and through, signification; as Jacqueline Rose notes, "it is essential to . . . [Lacan's] argument that sexual difference is a legislative divide which creates and reproduces its categories."10 The structure of "ladies" and "gentlemen" is imposed from outside-that is, by culture-through the operation of a law which Lacan terms the Symbolic. Each individual must place itself on either side of this divide: one cannot be a subject in any other manner. Sexuality, then, does not come from within, as in the essentialist model, but is the signifier's "effect": it is in consequence of the Symbolic.¹¹

Lacan's diagram, however, is more complex still. For what is salient is not only its delimitation of a structure, but also the specific texture of

relations it describes. If we read it correctly, masculinity and femininity are not absolutes, but positions; sexuality has no content in and of itself, but is determined differentially, by reference to another term. In this, Lacan draws on Ferdinand de Saussure, who had criticized the notion of language as absolute reference, describing it instead as a chain that moves from link to link, producing meaning from the relationship between terms.¹² Through an elaborate conceit Lacan conflates sexuality with the structure of language, with its polarities of marked and unmarked terms, of presence opposed to absence. If the phallus is the privileged signifier in Western society and the penis its physical stand-in, then woman can only occupy the position of absence, or lack. For Freud, as for Lacan, the presence or absence of the penis is only significant insofar as it already has meaning within a system of difference; it is specific to patriarchy, to its particular attribution of values. And Freud's genius was to indicate, by insisting on psychic rather than somatic factors, the arbitrariness of the laws by which the initial bipolar drives are channeled into the polar structures of adult sexuality. The repressions revealed in the unconscious demonstrate this arbitrariness, its foundation in a cultural exaction that crosses Western civilization; in the symptoms produced through the unconscious operations we see the hesitance, the "imperfection" of that construction called sexuality.¹³ Much of Lacan's late writing is devoted to unmasking the fraudulence of phallic supremacy, revealing its dependence for power on subjection of the other (presence depends on, is *a function of*, absence); as Juliet Mitchell remarks, the phallus and, with it, the whole edifice of sexual constructions only figure because of what the woman lacks.¹⁴ Furthermore, if sexuality is structured in language there can be no fixed identity, for sexuality is continually restructured, revised in discourse. Lacan's last texts accentuate this instability, insisting on the plurality of positions that crosses language, countering conventional oppositions. But these texts also accentuate the strategies by which the masculine order employs Otherness, or complementarity, to secure a wholeness denied by the inherent partiality of subjecthood—a unity, then, that is a fantasy.

For Lacan the self lacks a point of truth or ultimate meaning to which it might appeal to heal division. What is significant in his own questioning of certainty is its correlation to, and coincidence with, a more general problematization of reference. In the most concise statement of this theme—a massive critique of the metaphysical apparatus underlying Western representation—Jacques Derrida has described our situation as one in which "the central signified, the original or transcendental signified, is never absolutely present outside a system of differences."¹⁵ As with the phallus, the privileged reference or centered self is only a relational construction; its value is determined by its position in a structure whose limits we cannot "transcend." Or as the philosopher Jean-François Lyotard has written, posing links between sexual politics and metaphysics: By no means can the question of masculine/feminine relations be reduced to a problem of the division of labor at the heart of the social body. The frontier passing between the two sexes does not separate two parts of the same social entity. Not only is it the border where the Empire comes into contact with barbarians, but also the line of demarcation between an empirical given, women, the great unknown, and a transcendent or transcendental order that would give them meaning. The complicity between political phallocracy and philosophical metalanguage is made here: the activity men reserve for themselves arbitrarily as *fact* is posited legally as the *right* to decide meaning.

With the result, Lyotard concludes, that "we Westerners must rework our space-time and all our logic on the basis of non-centralism, non-finality, non-truth."¹⁶

"True" to Lyotard's statement, the last years have witnessed a critique of signification based on immanent meaning before meaning's social production. Notable focuses include the inherence of meaning to specific structures of representation (the classical sign, the expressive subject), to narrative modes (such as the Modernist novel), and to the structures of dominant society. Within the latter area the assault on meaning has involved a critique of representation's ability to attain truth, as well as analysis of the ways in which "truth effects" are produced within discourses that—as Foucault observes—are neither true nor false in themselves.¹⁷ Such ideological maneuvers depend on "duplicated representation,"¹⁸ by which the idea of reality is taken for reality; they operate through processes of repetition and reinforcement that convey the illusion of universality. Recent art practice has protested this naturalization of culturally fixed meanings as the major support of ideology in society, noting its operation in institutions, norms, traditions, and stereotypes. And it has exposed their appeal to eternality as a function of specific investments. As Roland Barthes wrote, "If power is on its side, [language] spreads everywhere in the general and daily occurrence of social life, it becomes *doxa*, natural....^{"19}

For these reasons contemporary women artists have refused to be "identified," to be reduced to signs within the patriarchal order; notable among projects that question essentialism is Mary Kelly's *Post-Partum Document*, 1973–79, a six-section, 135-part work tracing the first six years of her son's life. As a compendium of materials and personal objects, Kelly's *Document* might seem a simple record of a child's development, following his inscription into language, sexuality, and society. But it is, most importantly, a demonstration of the construction of maternal femininity: through her analysis of the mother-child relationship, Kelly stresses the continuous production of sexual difference within specific systems of representation. The mother-child dyad, the family, the school, and varied other social institutions act to construct femininity in variable configurations, indicating its hesitance, its perpetual instability. Sexuality, Kelly states, cannot be mapped as a category onto biological gender, but is produced within an interdiscursive network.

In the latter part of his life Barthes repudiated much of his early methodology, stressing the implications of psychoanalysis for ideological analysis. In a corresponding way, much work primed by psychoanalytic theory has turned to his example, opposing jouissance or textual "play" to the sign conceived as closure. For Barthes, jouissance was both loss of identity and instability of meaning; pleasure is a function of the subject's mobility in language, and of the plurality of positions it fills. The concept of jouissance thus implies an economy of pleasure that would account for the multiplicity of sexuality. But it has also been useful in challenging signification's ideological character, for it is noted that all texts position their readers in relation to the production of meaning, allowing for active participation or literally subjecting them to meaning in an attitude of passive consumption. The argument runs that the closed text is ideology's prime instrument, serving to perpetuate its contents (Charles Levin: "As we 'consume' the code . . . we 'reproduce' the system.")²⁰ and produce normalized subjects, and for this reason some contemporary practice has opposed the expression of any message, no matter how oppositional. The problem is accentuated for women since it is they who, excluded by the structure of representation, usually figure in a subjected position, as passive (and pacified) object. Drawing on the figures of dominant discourse and their attendant power relations, many artists have attempted to erode this "place" assigned by culture to women; notable here are Barbara Kruger's dislocations of the "mastering" position, as inscribed in mass media texts. Kruger's deployment of the deictic terms "I," "me," "we," and "you" show that the place of the viewer in language is unsettled, shifting, indefinite, refusing alignment with gender.

Kruger's terms tally with those of Freud, who resisted the notions of the "masculine" and "feminine" ("among the most confused that occur in science"), arguing instead for "active" and "passive" relations, and connecting sexuality to the situation of the subject. In Dorit Cypis' work, which employs photomontages, superimposed image projections, and, often, sound, the conventional relationship between viewer and viewed is inverted; the spectator is encouraged to intervene and actively construct the narrative, and elude masculine and feminine roles. Others have investigated positioning from a more analytic view, showing its immanence to the representational structure laid down by patriarchy. Silvia Kolbowski's use of media images (specifically, images taken from fashion magazines) indicates their address to the viewer in terms of coded body representations, but these representations are only after-effects, echoes, ghosts of an earlier system. Much of her project depends on a double directive, exploring the masculine attempt to fix woman within a specular system (as object of the controlling gaze) and as object of fantasy (the paradoxically idealized and subjected Other). The sexual direction of visual pleasure which Freud located in the scopic drive is associated, here, with a phallic economy, as it is installed in difference and repeated in its figures (Nature/Culture, Other/One); woman's visual subordination, like her mystical elevation, is seen as a male project aimed at healing the division inherent in subjectivity.

Throughout Kolbowski's work the ways in which woman is looked at, imaged, mystified, and objectified indicate her exclusion from representation; denied access to language, she cannot "speak" but is, rather, "spoken." Several projects, like *Model Pleasure III*, 1982, articulate the position of the hysteric who, by refusing fixed divisions, oscillates between masculine and feminine, threatening phallocentric order. Hysteria's political dimension as a resistance to the symbolic has been emphasized in recent theory; it opposed universalizing reduction and the legitimizing function it implies. Hysteria also embodies Lacan's injunction to "dephallicize," to assume the phallus critically (and with it, a theoretical position denied to women in Western society), so as to expose the arbitrary privilege on which it stands.

Such re-presentations of representation examine and question their binding constraints; other practices have investigated how these constraints are executed in and through specific apparatuses of representation. In recent years a significant body of theory has addressed the mastering role of the photographic apparatus, exploring how the camera's falsifying monocular perspective constructs the viewed scene as subject to the central masculine position.²¹ A sense of controlling individuality, of mastery through technological, legal, and social means, informs the capitalist conquest of nature and, after it, humanity, so it is not surprising to find this perspective inscribed within those reproductive apparatuses—photography, cinema, and television-that coincide with and support the ideology of capitalism. Sherrie Levine, for example, has addressed this photographic theme; much of her work features images of Otherness-nature, women, the poor, the insane²²—as they are sighted through the lens of desire and fixed by the masculine "camera eye." Even when Levine rephotographs a painting by Ernst Ludwig Kirchner, she chooses an image whose emphatic triangular geometry focuses the position of the woman, accentuating her domination within, and through, the visual field.

Attention has also turned to the psychic effects of the photograph's visual allures—to the shimmering surfaces that recall the mirror stage, as recounted by Lacan, echoing our first mis-recognition of unity. Lacan calls such instances of false unity the Imaginary, and locates in them the sites of identifications by which subjectivity is constructed. The illusory coherence it offers has made the Imaginary ideology's aid, and its inherence in images has primed awareness to photography's role in social normalization. Thus when Sarah Charlesworth examines the seductive powers

of photographed images in a recent series, "Objects of Desire," 1983–84, the practice extends her exploration of the visual modalities inherent in the photograph. Glistening laminated surfaces bound by lacquered frames contrive a specular brilliance, creating images of images, exaggerations of the *effects* we attribute to photographs. Within them, a scarf, a mask, a bombshell-blond shock of hair present "... the forms and postures of seduction-the shapes, forms or gestures," as the artist remarks, "that are the exterior trappings of identity."²³ Such partial objects function as fetishes, elements to which desire attaches to fulfill a fantasy of wholeness. Furthermore, as Charlesworth adds, they are "embodiments in a social 'attitude"-the configurations of desire accounting for the (always historical) perpetuation of norms. But desire is not caused by objects, but in the unconscious; it can only be known through its displacements, through the substitutions it endures. Consequently, fetishism in its various forms only serves to repeat and reactivate the one, and primary, fantasy. What is at stake in our fascination with photographs, the artist seems to imply, may be their ability to restage (replay? re-present?) a fundamental striving for unity.

This inquiry into the system of sexuality is not confined by medium, as feminist work on literary narrative suggests. "In high school sex was a war, a conventional war about the conventions," writes Lynne Tillman in *Haunted Houses*, a novel-in-progress devoted (like her other work) to exploring the construction of sexual experience. When Tillman collaborates with Sheila McLaughlin, she joins a host of women filmmakers (Sally Potter, Bette Gordon, and Candace Reckinger among them) in challenging cinema's implication of image and code. Video as well contains a significant roster, including Dara Birnbaum and Judith Barry. Birnbaum's *Wonder Woman* and Barry's *Casual Shopper*,²⁴ for example, are figures of narcissism, the one "the phallic mother" of television spectacle, the other the ideologized consumer seeking personal completeness, and libidinal pleasure, through the purchase of material objects.

In its psychic and economic parallels, Barry's project suggests the existence of a total economy like that described by Hélène Cixous: "an ideological theater where the multiplication of representations, images, reflections, myths, identifications"²⁵ points to the phallus' sovereign power. Current practice has attended to this "insinuation" of politics into the "tissue of reality," where it comprises a network traversing the social body.²⁶ Significant, here, is Kolbowski's recent work, which explores the displacement of difference into advertising logos, illuminating the sexual investment of lines, forms, and supposed voids in (male) space. We find this approach, as well, in the links exposed by Kruger between women and money (Woman as Capitalized, as object of exchange) as sublimations of masculine interests. Most importantly, the approach argues, as Julia Kristeva remarks, the impossibility of sociopolitical transformation without a change in subjec-

206 Kate Linker

tivity, in our relations to constraints, to pleasure, and to language and representation themselves. $^{\rm 27}$

Among women's projects that do not address sexuality but explore the dimension of social prescription, several deserve mention. Annette Lemieux, for example, has studied state and institutional signs which elicit universal meanings, while Nancy Dwyer's work explores the subject's construction through material codes. For Dwyer, our most pedestrian responses are consequences of the signifier, of the languages of corporate capitalism (in one case) or urban racial strife. Forms, substances, colors develop the parameters of psychic space: black lacquer and leather, for example, speak a dialect alien to the subway formica drone. This sense of external regulation is strongest in work by Louise Lawler, who would challenge the very notion of the artistic text by indicating its dependence on institutional factors for meaning. Lawler's "arrangements of arrangements"-photographs showing artworks as they are privately, commercially, or institutionally displayed—point to the conditions surrounding the reading of art; they inquire into the role of placement or position in meaning's production, into the specific social inscription of the work. Meaning, Lawler implies, comes not from within, but from without. Nor is it fixed (natural? true?) but variable, cultural, a historical formation. And in this questioning of meaning's autonomy we recognize a dagger directed at a tenet of Western esthetics: that artworks are unified structures, enduring objects, expressions of the creative subject.

Considered within contextualist practice in general, Lawler's art suggests the implications of a perspective based on historical constructions and definitions; contesting the authority of categories, its premises collide, and coincide, with current feminism, which would find in it an analogue to woman's construction in relation to a complex of social texts. In a recent installation Lawler extended her approach, considering the multiple factors that determine art's reading within an interdiscursive network. Not only institutional and architectural context are questioned in these works, but also titles, labels, descriptions of materials—the shards of language that impose meaning, anchoring the inherent plurality of the text. Lacan might call it attention "to the letter"—to the material products of language rather than to their essentialized "spirit." Within these surroundings, determined by culture, the question of origin recedes, as in retreat, toward a vanishing point established by ideology's eye.

Notes

1. Jacques Lacan, *Encore*, Seminar XX as cited in Jacqueline Rose, "Introduction—II" in Juliet Mitchell and Rose, eds., *Feminine Sexuality. Jacques Lacan and the école*

freudienne, New York and London: W.W. Norton and Co. and New York: Pantheon, 1982, p. 27. All other quotes from Lacan, including the following from "Guiding Remarks for a Congress on Feminine Sexuality" (1958) are derived from this source.

- For a discussion see Craig Owens, "The Discourse of Others: Feminists and Post-modernism," in Hal Foster, ed., *The Anti-Aesthetic: Essays on Post-modern Culture*, Port Townsend, Wash.: Bay Press, 1983, pp. 57–82. For a treatment of questions of representation in general see my "Representation and Sexuality," *Parachute*, no. 32, Fall 1983, pp. 12–23.
- 3. Mary Ann Doane, "Film and the Masquerade: Theorising the Female Spectator," *Screen* 23, nos. 3–4 (September–October 1982), p. 87.
- 4. The formulation is an adaptation of Colin Mercer's. See "A Poverty of Desire: Pleasure and Popular Politics" in *Formations of Pleasure*, London: Routledge & Kegan Paul, 1983, p. 98.
- See Jane Gallop, The Daughter's Seduction: Feminism and Psychoanalysis, Ithaca: Cornell University Press, 1982, pp. 1–4.
- 6. See Leo Bersani, "Sexuality and Aesthetics," October 28 (Spring 1984), p. 27. My citations in this paragraph depend on a series of readings of specific texts, notably Claude Lévi-Strauss as read by Jacques Derrida in "Structure, Sign, and Play," Richard Macksey and Eugenio Donato, eds., *The Structuralist Controversy*, Baltimore: Johns Hopkins, 1972, p. 253; and Edward Said as discussed by Homi Bhabha in "Of Mimicry and Man: The Ambivalence of Colonial Discourse," October 28 (Spring 1984), p. 126.
- Mary Ann Doane, "Woman's State: Filming the Female Body," October 17, Summer 1981, p. 24.
- 8. Gallop, The Daughter's Seduction, p. 3.
- 9. Gallop, p. 11.
- 10. Rose, Feminine Sexuality, p. 41.
- 11. Stephen Heath, The Sexual Fix, London: Macmillan, 1982, p. 154.
- Rose, "Sexuality in the Field of Vision," essay in Kate Linker, ed., *Difference: On Representation and Sexuality*, catalogue published by the New Museum, New York, in conjunction with exhibition of the same name, December 1984–February 1985.
- 13. Ibid.
- Mitchell, in "Feminine Sexuality: Interview with Juliet Mitchell and Jacqueline Rose," m/f, no. 8, 1983, p. 7.
- 15. Derrida, op. cit., p. 249.
- Jean-François Lyotard, "Some of the Things at Stake in Women's Struggles," Sub-Stance, no. 20, 1978. Reprinted in Wedge, no. 6, Winter 1984, pp. 28-29.
- Michel Foucault, "Truth and Power," in Meaghan Morris and Paul Patton, eds., Michel Foucault. Power, Truth, Strategy. Sydney: Feral Publications, 1979, p. 36.
- See discussion by Josué V. Harari in "Critical Factions/Critical Fictions," Harari, ed., Textual Strategies, Ithaca: Cornell University Press, 1979, p. 52.
- 19. Roland Barthes, *The Pleasure of the Text*, New York: Hill & Wang, 1975; quoted in Colin Mercer, "A Poverty of Desire . . . ," p. 82.
- 20. Charles Levin, introduction to Jean Baudrillard, For a Critique of the Political Economy of the Sign, St. Louis: Telos Press, 1981, p. 5.
- For a discussion of this photographic construction of subjectivity see Victor Burgin, "Photography, Fantasy, Fiction," in Burgin, ed., *Thinking Photography*, London: Macmillan, 1982.
- 22. Owens, p. 81 n.
- 23. Sarah Charlesworth, interview with David Deitcher in *Afterimage*, Vol. 12, nos. 1 and 2, Summer 1984, p. 17.
- 24. As presented in Birnbaum's Technology/Transformation: Wonder Woman, 1978–79, and Barry's Casual Shopper, 1981.

208 Kate Linker

- Hélène Cixous, "Sorties," in Elaine Marks and Isabelle de Courtivron, eds., New French Feminisms, New York: Schocken, 1981, p. 96.
- 26. Foucault, Discipline and Punish, New York: Vintage Books, 1979, pp. 25-26.

27. Julia Kristeva, "Women Can Never Be Defined," New French Feminisms, p. 141.

What Is Sexual Difference?

MAUREEN TURIM

Sexual difference is a more basic and a more significant concept than many of us imagine. I remember a game my mother used to play with my older brother and me when we were very young children. "How are boys different from girls?" she would ask. The riddle would have two answers. One was the famous nursery rhyme, itself worthy of exegesis: "Boys are made of rats and snails and puppy-dog tails. Sugar and spice and everything nice, that's what little girls are made of." The other answer to the riddle was simpler: we would each point at our own genitals and then at each other's and say, "That's how," and laugh. Little did we know how important a lesson this was or why we laughed that nervous giggle.

Reading through the catalogue for the exhibition, "Difference: On Representation and Sexuality," at the New Museum of Contemporary Art, and remembering the selection of works, I couldn't help but feel ambiguous emotions. One was a mixture of interest in and gratitude for the mounting of a show and the gathering of a collection of writings raising such deeply theoretical questions about the relationship between art, psychoanalysis, and ideology. On the other hand, I felt shortchanged and depressed by many aspects of the endeavor, including the way it fudged on whether the analysis of sexual difference was, indeed, part of an ongoing feminist project, as opposed to being seen in a psychoanalytical frame that places itself outside of a feminist perspective.

Jacques Lacan looms large throughout the catalogue, and there are even some direct references to his writings in the texts of certain works in the show. In many ways his presence makes perfect sense. Lacan pre-

This essay was originally published in *Afterimage* 12, no. 9 (April 1985). Copyright © 1985 Visual Studies Workshop and the author, and reprinted with their permission.

210 Maureen Turim

sented a theory of sexual difference that was not only bold and innovative, but also deeply revealing of the profound ties between the concept of sexual difference and our notion of difference per se. For Lacan, the notion of difference is fundamental to the access to language, and by extension, to the formation of what he terms the Symbolic. In a very complex way, the Symbolic determines power relationships and is connected to the laws of patriarchy. Many feminists have seen in Lacan's theories a new way to develop feminist theory, one that would take into account not only the psyche's role in the formation of sexual ideologies, but also a way of speaking of the ideologies of language and power. These two concepts are often seen as ideologically neutral, applicable as much in the struggle against oppression as they have been used to oppress. Lacanian psychoanalysis is one of several recent theories that show us how far from "neutral" language and power are. Language and power themselves have become contemporary objects of investigation.

Lacan is, however, particularly problematic for women, since his flamboyant and theatrical style dramatizes the repercussions of sexual difference in the development of the subject from the very position of paternal and male power that the theory simultaneously critiques. Women are irrevocably the object and the Other; they do not exist as subjects. The historical causes of this difference are not systematically examined, nor is the possibility that some women achieve a different womanhood than the one Lacan assumes for "la femme."

When confronted with such objections, Lacan and his followers defend the validity of their model, emphasizing its metaphorical and symbolic value. They add that the individual human subject is psychically divided and, therefore, not limited to a single sexual identity. The polarization of male and female is hypothetical and explanatory. In practice, an individual never operates on a single side of this polarity, but rather through multiple determinations. Freud's generalizations about male and female identities are reread by Lacanians in this manner as well. The "biological" subject is a construction that builds sexual identities within the range of possibilities open to the psyche. There is much in this theoretical position that is provocative and useful. Yet contained within its great strength its metaphorical abstraction that can theorize the intangible—is also an inherent weakness. Feminism highlights this weakness when it offers a sociological and historical perspective and asks for that view to be considered and assimilated within Lacanian theory.

Feminists also object to the metaphors. No matter how much one insists that the phallus is symbolic, when a theory also defines it as that which women lack, we know that this can not just mean power as it has been construed and exercised historically. It reverts to an association with the male sexual organ and that association is within the "unconscious" of the theory. Increasingly in the last few years (is this tied to Lacan's physical death three years ago?) feminists formed within Lacanian theory have been proposing radical inversions of Lacan's formulas, such as Julia Kristeva's suggestion in *Polylogue* that the phallus "is the mother." This not only loosens the phallus = penis association, but slyly proposes that the phallic mother or phallic woman found in Freud is not merely an imaginary fetish.

I am hopeful that psychoanalysis will survive the period of doctrinaire Lacanianism into which it lapsed in recent years, and that it will progress to a more critical stage. I think feminism will be a major impetus behind the questioning of the doctrine along with other important efforts to create counter-memories. Meanwhile, film theory has been saturated with Lacan. Art theory on the other hand, contained as it is within the more traditional discipline of art history, has just begun to assimilate Lacan, following film theory's lead. It is this state of things that the *Difference* catalogue represents.

The catalogue contains five separate essays. It begins with an entry by Craig Owens titled "Posing," in which the author links some recent theoretical writing on the pose, imitation, and duplicity, to the strategies taken in several of the works in the exhibit. Of all the essays in the volume, Owens's writing makes the strongest links between various theories, as well as the most coherent case for the usefulness of evoking these theories in art. He opens his essays with a reference to Barbara Kruger's work on mimicry and masquerade as a strategy of women in a society dominated by male imperatives. He quotes her statement for the Documenta catalogue: "We loiter outside of trade and speech and are obliged to steal language. We are very good mimics. We replicate certain words and pictures and watch them stray from or coincide with your notions of fact and fiction." Then he makes an interesting connection between this statement and recent essays by Gayatri Spivak and Mary Ann Doane suggesting similar feminist strategies. His comparison misses a crucial difference, however, between the notion of mimicry that "strays" into the realm of effective satire or critique, and mimicry that simply "coincides" and, therefore, duplicates. This difference is made explicit in Spivak's and Doane's arguments. Spivak calls for the feminist literary critic to "produce useful and scrupulously fake readings in place of the passively active fake orgasm," while Doane's interest in "pose as position" is as deconstruction. A feminist approach must differentiate itself from the coded notion of fact and fiction, as well as from the poses women have traditionally adopted to perpetuate a game of seduction focused on male desire. When Owens returned to Spivak's trope of the fake orgasm later in his essay, he reveals an unfortunate fascination with this passively active "female" gesture, which arrests the radicality with which it is deployed in Spivak's essay. Spivak is not

212 Maureen Turim

merely reduplicating Nietzsche or even Derrida. She is critiquing Nietzsche's understanding of "impersonation" as women's only sexual pleasure by presenting the fake orgasm in an historical context. She then mobilizes it to different theoretical ends in a contemporary rereading. That Owens ignores this difference is important, for it reverberates in his essay as an inability to distinguish between images that coyly and passively mimic sexist codes and ones that deconstruct them. Take, for example, his discussion of Victor Burgin's works in the exhibition. He never considers that a notorious image from Burgin's "Zoo 78" might not effectively deconstruct the pornographic post that it imitates, a West Berlin peep show. Owens is only interested in the fact that Burgin juxtaposes his reconstituted womanas-sexy-animal-scenes with citations from Michel Foucault's Discipline and Punish (and he considers this juxtaposition inappropriate). Despite Burgin's intentions, this photo obsessively reduplicates oppression, while the text acts as confessional justification for the no longer justifiable image. In my view, Burgin is still whipping and taming the lion-woman, but maybe mine is just one of those fake feminist readings that Spivak suggests. It certainly is not authorized by the artist or critic. Another of Burgin's pieces, his otherwise interesting series on Olympia, ends with his mimicking Manet's painting by photographing a woman in the same pose. In the context of Burgin's other "Olympia" panels, perhaps there is a purpose to posing a model in an undershirt, as she tries to appear like the painted image. Unfortunately, I am left wondering whether Burgin's postmodern mimicry in this instance doesn't miss the point and settle into an embarrassing pastiche, not unlike ads that copy the great poses of art. Lisa Tickner in her catalogue essay, "Sexuality and/in Representation: Five British Artists." argues that "although at first sight the picturing of the naked woman in the surveillance panel of Zoo, or of Olympia and her stand in Tales from Freud, seems to enforce dominant relations of specularity, these images are placed within a network of references that begins to open up and challenge this very issue." I am willing to grant that the context of Burgin's imagery is a self-consciously theoretical one. Still, posing women is not something men can do freely these days, whether as theorists or artists. In some ways, it seems that both Burgin and Owens are still trying to pose us, position us, frame us, juxtapose us-or their image of us-in a way we are to take as politically correct. Why are they not more self-critical about their position, here, where feminism is the issue? Is the "interrogation of the 'male voice' as it is constructed across the specific discourses of photography," that Burgin proclaims to have undertaken, a feminist questioning?

The answer to my rhetorical question may be the emerging term, "postfeminism," a concept I find particularly naive and repugnant, but one that has been used to describe this exhibit. I fear that "beyond" feminism lies the same old sexism disguised as "punk" or "self-conscious" or "postmodern." There is a current chic to garter belts, high heels, sexist graffiti; pornography and high fashion are being rediscovered as dual pleasures by a young community that is not altogether conscious of its sexual politics. When sexual graffiti emerges in the context of a man's hands folding baby clothes and diapers in the photo groupings of Ray Barrie, is it wrong to ask if the baby care photos are there to justify the pornography to feminists, or are the sexist scribblings there to reassure men that this father has not been "feminized"? How profound is the thought behind Barrie's and Burgin's collage politics?

Tickner begins her essay with the statement that the work in this exhibit "is devoted neither to 'image-scavenging' alone (as the theft and deployment of representational codes), nor to 'sexuality' (as a pre-given entity), but to the theoretical questions of their interrelation: sexuality and/in representation." This claim is misleading and not applicable to all the work in the exhibit, some of which is clearly just about the politics of representation, or "image-scavenging." For example, one finds Sherrie Levine's "After" series, in which she photographically copies famous art works, Hans Haacke's "Les Poseuses" series, which traces the ownership of Seurat's painting, and Jeff Wall's Double Self-Portrait and Picture For Women. However, it is more meaningful when applied to the work which seems to interest Tickner the most: Mary Kelly's Post-Partum Document, Yve Lomax's "Open Rings and Partial Lives," and Marie Yates's photoroman, "The Missing Woman." Lomax's and Yates's series are paracinematic in that they annex the codes of image-text montage and narrative strategies of cinema. They are interesting to compare to some of the films and videotapes included in the exhibit, for they have brought to gallery space the concern with diaries, melodrama, and "scrapbook" documents that is found in the work of Martha Rosler, Yvonne Rainer, Chantal Ackermann, and others. Tickner's essay clearly develops the connection of these photo/document series to literary/film theories of fragmented narration as well as to Laura Mulvey's critique of fetishism and the male gaze-familiar ground for some of us, but new to a gallery context. Still to be explored is the issue of visual pleasures that are not the same as, or a critique of, those found in popular culture. It is here, in the section called "Pleasure," that Tickner's essay is weakest, for it does not imagine new images of pleasure. Calling Judy Chicago's The Dinner Party a "deployment of the fixed signs of femininity," as Tickner does in her only reference to other sorts of art made by women artists, ignores the way in which the female body was imaged quite differently by feminist artists in the '60s and '70s. She also overlooks the way that other women, working in a more abstract vein, found creative and playful images of their pleasure. The feminist artists of past decades are implicitly denounced for exploring their female imaginations because that might involve "essentialism,"

proclaiming some concerns to be female, "fixing female signs." Yet, despite Luce Irigaray's theories that see "woman as the not-vet," women have been and are. And some of us are interested in that historical difference, in those beings who had breasts, vaginas, wombs, and the capacity to bear children, and because of those bodies we shared an experience of the world. I want to see women's art and women's fantasies as they emerge out of the ending decades of this century, and I think it would be a mistake to bury that desire in a theory of androgyny that denies sexual difference and the sisterhood of the women's movement. Women are the daughters of our mothers, not the sons of our fathers, and anyone interested in psychoanalysis should know how significant a difference that is. The critique of essentialism should not be extended to encompass the very possibility of feminism. It should guard against notions that "all women are nurturing. emotional, etc.," but it should not prohibit us from exploring who women are and what women want at this moment in history. Nor should it prohibit us from finding strength in some of what we discover. We are born into history in a way that these essays deny, and we have the means to change history in a way that, sadly, they don't quite imagine.

Jacqueline Rose's essay, "Sexuality in the Field of Vision," is interesting to compare with Tickner's, for it takes as its major argument the notion that postmodernist representation is superior to modernist abstraction in posing theoretical issues of sexual identity. She summarizes her position against modernism with a chart that claims that the "purity of the visual signifier and the unconscious as mystique" equals "the absence of language," that "language as rupture of the iconicity of the visual sign" equals "no unconscious," and that "reading as supplement, process or fragment" equals "no sexual determinacy of the signifier or of visual space." There is, in Rose's position, no recognition that abstraction is a means of signification. If the icons aren't in place, they can't be read; abstraction for Rose is non-semiotic and, therefore, meaningless. Art must create easily readable images of things in order to be valid, according to her definition. Such dictums foreclose the exploration of visual pleasure beyond the already inscribed codes of popular culture. Insisting on the clear readability of images of things does not allow Rose to even consider something like an alternative visual pleasure. Art for her should serve a directly didactic function. If many of the images in the "Difference" show look like advertising images, it may be because they are contained within the same iconicity. If one limits one's images to the same icons, the only aesthetic variable is montage. And finally, for most of the images in this show, selection and juxtaposition is the central concern; the only other aesthetic principle is a conceptual textuality as in the projects of Hans Haacke and Mary Kelly.

As for the two essays on film-Peter Wollen's "Counter-Cinema and

Sexual Difference" and Jane Weinstock's "Sexual Difference and the Moving Image"—Wollen's is very funny: his chronology of important events in "counter-cinema" concludes with the parenthetical editor's comment, "[Note: It must be remembered that this is a first-person history, narrated and theorized by a participant in the story]." This note is so amusing largely because Wollen omits his name throughout the body of his chronology whenever he refers to the films he made with Laura Mulvey. It is sad to hear Wollen claim that it was "in England that the closer relationship between psychoanalytic feminism and film theory developed," while "in France film semiotics had remained separate." In fact, the issue of the French journal Communications, "Psychoanalyse et Cinéma," which contains profound examinations of the relationship between semiotics and psychoanalysis, was published in 1974, the same year Laura Mulvey's article "Visual Pleasure and Narrative" was published in Screen. Lacan, after all, was French and debated in France long before he was imported as the basis of Screen's positions. And as Wollen implicitly acknowledges, his counter-cinema is built on Godardian premises, including Godard's work on signs and sexuality. Granted, Wollen says "psychoanalytic feminism," but I wonder if his megalomania comes in for a feminist critique? Still Wollen gives us a useful chronology of important events: I only wish he were more open and generous to others' contributions, including filmmakers in the U.S.—Yvonne Rainer is not alone here, thank goodness.

Jane Weinstock's eclectic essay closes the catalogue. It starts out as a too-cute regurgitation of a feminist critique of Hollywood cinema, too precious and too imprecise at the same time, turning the theory into a caricature of itself. But midway through, Weinstock switches her approach to a series of questions that are quite serious and thoughtful.

And there are more dangers, theoretical dangers. Might not a strategy that relies upon conscious responses shift the emphasis from the viewing subject (a position) to the concrete individual (a permanent fixture)? Might not such a move blur the distinction between conscious and unconscious effects—here, between conscious feelings of pleasure and pleasures that lie beneath the surface? Hasn't recent theoretical work shown that the visible, the superficial, is not the only reality?

But there are other dangers as well, such as the psychoanalytic model that informs most contemporary film theory.

In defining the woman as "Other," doesn't it construct a single point of reference—the male? The woman is simply the opposite, the "non"—not the same, but not different either. Perhaps it is becoming necessary to move closer to what has been called the French "essentialism" in order to escape a position of perpetual otherness. Recent French psychoanalytic and post-psy-

216 Maureen Turim

choanalytic writings on sexual difference have focused on the female body, or "female specificity." Might not this attempt to return the body to the subject lead to a differentiated viewing subject? But how? This is the question.

These are precisely the kinds of questions that feminists need to address for the future as we continue to explore new directions for artistic expression.

PART FIVE

Psychoanalytical Criticism and Art

Psychoanalytic approaches to art in the form of psychosociology and psychobiography explore cultural context by examining the relationship between the individual and society in an effort to reveal the effect of unconscious factors in shaping the work of art and its perception. The work of art is not seen as an autonomous object with a hermetic meaning, but as the product of a multitude of factors ultimately based on the development of the human psyche of specific individuals or groups of individuals. In contrast to strict Lacanian theory in which the individual is primarily an abstraction whose place in society is primarily determined by language, in this approach, the history and biography of a particular artist or artists forms the material basis for the psychoanalytical art critic's investigations.

Application of psychoanalytic ideas to art is hardly something new. Like psychoanalysis itself, it started with Freud who began his investigation of visual art and artists with the studies *Leonardo da Vinci and Memories of His Childhood* (1910) and the anonymously published article "The Moses of Michelangelo" (1914). In his Leonardo study, Freud sought to explain what he felt was Leonardo's "combination of sexual inhibition and creativity." Examining Leonardo's childhood, Freud believed the origin of Leonardo's "presumed homosexuality and the blissful smile of [the figures in] his paintings" lay in Leonardo's childhood memory of a vulture striking him on the lips.¹

Though works like Freud's *Leonardo* have become models for psychoanalytical studies of art, they also have generated controversy and his method resistance. One reason for the resistance in the art community is that Freud's psychoanalytic account of artistic invention deflects emphasis from aesthetic forms (the art object) to hidden, unconscious subject matter. While Freud recognized the high aesthetic quality of the works of Leonardo and Michelangelo (this was probably the reason why he devoted

218 Part Five

attention to them in the first place), his psychoanalytical method was indifferent to formal and aesthetic values and seemed inherently unable to provide a basis upon which judgments of aesthetic value could be made. Freud himself realized that his method and interests represented a departure from established artistic and critical concerns. As he wrote in his Moses article, "the subject matter of works of art has a *stronger attraction* for me than their formal and technical qualities, though to the artist their [the work of art's] value lies . . . in these latter."²

Deflection of emphasis from formal, aesthetic values that were the basis of Modernist artistic theory was not the only reason for resistance to Freud's approach. Another was that the intention of the artist seemed not only irrelevant from this approach, but actually in jeopardy. As Jack Spector writes, Freud "provided the model for the *pathographic* [italics added] criticism of art, which looked down to the neuroses before finding a way back up to the art that presumably had spurred the critic's interest initially."³ In Freud's scenario, the work of art is analyzed more as a product of neurotic (pathological) forces in the unconscious mind of the artist than of the artist's conscious intentions—hence the use of the term "pathographic." The artist is reduced in this way to a kind of tool of forces beyond his or her knowledge or control.

In the introduction to her essay on graffiti reprinted here, "An Insubstantial Pageant Faded," Ellen Handler Spitz discusses some of the problems and fears involved in various projects merging psychoanalysis with art criticism. She reiterates that "in all of these efforts, the big fear on the part of art historians has been that psychoanalysis will work as a critical theory to dismantle the object." Though she goes on to say that "art objects continue to be exhibited, recorded, and discussed even psychoanalytically *as objects*," she admits that her essay does call the priority of the object into question just as her title, taken from a line in Shakespeare's *The Tempest*, emphasizes the transitory nature of graffiti by likening it to Prospero's magic.

The product of adolescents, New York graffiti art (especially that painted on subway cars) is a compelling project for psychoanalysis (in the form of psychosociology) because of its complex relationship to art, artist, and society. This relationship is not unlike the psycho-sexual-social complex referred to by the very term "adolescence."

Graffiti art, Spitz believes, has been praised by some as a genuinely creative effort to "transform and transcend environments" and condemned by others as "wantonly destructive, deviant, sociopathic behavior." This is a direct result of the circumstances under which it is made—illegally painted on public property, usually at night and at great personal risk. Because of the risk involved, attention (priority) shifts from the object to the process of creation.⁴ For Spitz, in graffiti the process of execution is of greater significance than style, content, or finished object. Spitz believes that emphasizing process as in psychoanalysis (which, she says, also has "essentially to do with means and not ends. . . .") challenges comfortable mental habits and "our deeply rooted craving for intellectual and physical certainty," thereby doubly problematicizing the material objects of art.⁵

Spitz sees "powerful, subversive dynamics" as structuring graffiti that are played out through "representation and the manipulation of signs," especially the name of the artist. For instance, usually graffiti images are literally the written name (tag) of the artist; thus, the image (the written name) becomes a sign of the subject (the one named). However, since the name (tag) is a self-given name (a kind of alias, not a family name), it is a rejection of the paternal order (represented by family names based on that of the father) and a challenge to the symbolic order of society into which it is projected. Thus, says Spitz, "while actively seizing the right to be named [as a subject], . . . they [graffiti artists] both grasp and refuse subjectivity" through use of what can be called aliases. That is, named in private, graffiti artists refuse to be named in public in the traditional sense. They remain anonymous to society; no one knows who these artists are.

Spitz believes that the implications of naming/identity (the use of tags or "aliases") for the psycho-sexual-social complex that adolescence denotes are numerous and significant. Among other things, inventing new names (tags) may be a rejection, Spitz contends, of parental control; painting one's name on subway cars may be to "claim possession"; watching cars with one's name on them may confer "an illusion of power over outside forces. . . ." And "on a deeper level of fantasy, the subway trains may carry both phallic and even more primitive anal signification" as they disappear into the "depths, the entrails, of the earth."

Citing Pop artist Claes Oldenburg's admiration for graffiti, Spitz believes a convergence between Oldenburg's themes and graffiti's might be important in probing the wider significance of various issues (i.e., process and performance, repetitive cycles of doing and undoing, and fantasied enactments of aggression, control, and ambivalence), showing their relevance to the making of art more generally. Spitz cites Oldenburg's view that in making art "the performance is the main thing. . . ." She also cites his desire for an art that continually rejects the established conventions of the museum, for an art "of scratchings in the asphalt, daubing at the walls," an art that is "abandoned with great contempt, like a piece of shit." In these views, Spitz sees psychoanalytical parallels to adolescence and graffiti. "Ambivalent and destructive wishes underlie these thoughts," writes Spitz, that fit the motives and practice of the adolescent graffiti artist.

Relating the anal themes she sees in Oldenburg and graffiti, Spitz suggests a connection between them and French psychoanalyst Janine Chasseguet-Smirgel's belief that the human desire to transcend the ordi-

220 Part Five

nary is linked to anality. Chasseguet-Smirgel chooses the Marquis de Sade as an example to show that the Sadian hero is one who "puts himself in the position of God, becoming, by a process of destruction, the creator of a new kind of reality." Ultimately, says Spitz, the relevance of this fantasy for the adolescent and the artist is evident, for both are involved in hubris and dare to defy convention, rule, and law; "creating themselves as demigods, daring to invent a universe, they must also wantonly and destructively (even if in fantasy alone) abandon the old in search of the new, bring forth form from chaos."

Finally, Spitz suggests a modification of Freud's view that psychoanalysis is drawn to art only because of pathographic interests. She believes that psychoanalysis, recognizing art's twin powers to undo and make new, "aligns art with health and with illness, with optimal functioning and with driven, repetitive, symptomatic behavior."

In the psychosociological approach to art taken by Spitz, observations focus on particular groups and group behavior rather than on specific individuals. By contrast, in the psychobiographical approach, a specific individual is the focus of study giving rise to specific hidden dangers against which scholars must guard. As analyst John E. Gedo warns, they

must constantly guard against the intrusive effects of their own unconscious responses (their "transferences," if you will) to the artists who form the special object of their attention, lest their overidealizations or unconscious dislike for their subjects as personalities significantly color and distort their conclusions.⁶

Mary Mathews Gedo's essay "An Autobiography in the Shape of Alabama: The Art of Roger Brown," which is reprinted here, follows the psychobiographical approach. However, she is attentive to the dangers involved and carefully avoids some of the obvious problems encountered by Freud. For unlike Freud, she chooses as her subject, not a long deceased artist like Leonardo da Vinci or Michelangelo, but the contemporary artist Roger Brown. Thus when Gedo contends that there is a "self-revelatory character" to Brown's oeuvre, this can be checked against facts and recollections of the artist himself. More importantly, Gedo's observations are shared with the artist, for they are based on extensive psychoanalytical interviews with him about his life. And as Brown himself has stated, the result has produced an analysis that has been "even at times illuminating to me."

Gedo scrutinizes Brown's life, especially his growing up "in the rural South in a close-knit family committed to fundamentalist religious beliefs and practices." Like Freud before her, Gedo concludes that childhood memories are important; the "enduring elements of Brown's personal style and iconography," writes Gedo, "remain rooted in early childhood memories." However, in contrast to Freud, she does not point to a single incident (the vulture in the case of Freud's *Leonardo*) as the key to an understanding of the artist's work; rather, she identifies the "event" of childhood itself.

Furthermore, Gedo refers not only to Brown's iconography, but also to his "personal style." Clearly she is interested not only in subject matter (iconography) as was Freud, but also in how style is affected by events in the artist's life. Gedo's approach, more open to the possibilities of art, recognizes style (what could be called aesthetic form) as a vehicle of personal meaning. In this, she is more sympathetic to traditional art thinking. She gives an important added dimension to psychobiographical art criticism, one that suggests a possible basis for judging aesthetic value.

Though the relationships Gedo establishes between childhood and later life are not based on dramatic incidents like Freud's vulture, they are, nevertheless, convincing. For example, she finds parallels to Brown's artistic feuds with critics Franz Schulze and Alan Artner in Chicago and childhood memories of feuding between Brown's grandmother and her mother-in-law in Alabama. Other parallels and "imprints" exist: trailer trucks in his art apparently symbolize a favorite uncle who was a truck driver; religious works relate to early church experiences and a brief period spent studying for the ministry.

After establishing these links to childhood experience, Gedo demonstrates that it is not childhood experience alone that affects the individual, but that the individual is influenced psychologically more or less continuously throughout life. She shows how events in Brown's mature life affected his work, in particular, his relationship with architect George Veronda, through whom Brown came to appreciate modern architecture. Soon after meeting Veronda, his paintings evidenced a more formal, patterned look and often abandoned the use of ground plane. Gedo plots the changes in style and subject in Brown's work to this relationship which ended tragically for the artist with Veronda's death from cancer in 1984.

Defending her method, Gedo writes that

critics of the psychoanalytic approach often complain that the method cannot be used to illuminate the formal aspects of an artist's oeuvre. Brown's own statements . . . give the lie to that criticism. As I have pointed out elsewhere, . . . style and content both form part of the seamless whole constituting the artist's private iconography.

Taking a different approach in his essay "Artist Envy" reprinted here, Donald Kuspit reverses the usual interrogatory format in which the psychoanalyst questions the motives of the artist. Echoing John E. Gedo's warning against unconscious transferences by the scholar to the artist, Kuspit contends that many psychoanalysts have misconceptions about art that are a result of their envy of the artist; hence, "artist envy" for the title

222 Part Five

of his essay—an obvious play on the psychoanalytical notion of "penis envy."

For artists, resistance to psychoanalysis is related to the belief that the psychoanalyst partakes of the conventional "view of art as at best a fortuitous pleasure and more often as the symptom of a maladaption to reality." Such views about art reflect the popular linking of art and madness, a linking that psychoanalysis also has made. This is something to which Freud has, at least in part, contributed because of his use of the term "pathographic" in his Leonardo study. As Spitz points out, the term implies "writing about suffering, illness, or feeling, with important overtones of empathic response on the part of the author for his subject." The conception of the artist implicit in Freud's term, Spitz believes, "grows solidly out of the Romantic tradition. . . ."⁷ It is this notion, unfortunately, that has retained currency in the minds of many people and has become the starting premise for psychoanalytic study of artists.

Kuspit's argument is that psychoanalysis, by reason of its empathic character, has a special relationship to art and artists. From the early days of the profession, he contends, psychoanalysts saw themselves and artists as being creative persons, but outsiders. Persisting today, this is an identification that, like most identifications,

involves admiration, empathy, and envy... At the same time, such "artist envy" is balanced by the most ordinary psychoanalyst's unconscious feeling of superiority to the greatest artist, for psychoanalysts see themselves as using the art of interpretation to apply a scientific understanding of the psyche—see themselves as scientists as well as artists.

Like scientists, they believe science the field of true discovery and, therefore, see themselves as superior to artists.⁸

Nonetheless, argues Kuspit, psychoanalysts such as Freud and W. D. Winnicott envied the artist's intuitive revelations of knowledge which they only arrived at through laborious research. This difference is only one source of the psychoanalyst's envy. Another is the supposed lack of guilt in the artist. Kuspit cites Winnicott's "Psychoanalysis and the Sense of Guilt," in which Winnicott writes:

Of the artist it may be said that some have no capacity for guilt and yet achieve a socialization through their exceptional talent. Ordinary guilt-ridden people find this bewildering; yet they have a sneaking regard for ruthlessness that does in fact, in such circumstances, achieve more than guiltdriven labor.

While a lack of guilt is also essential to psychoanalysts, as Freud had said (he compares them to the surgeon who must ruthlessly cut the body to heal it), psychoanalysts usually imagine that because of their silence and science, "they outdo the artist in coldness, raising themselves over the artist..." For reasons inherent to the nature of psychoanalysis and art, Kuspit argues, the psychoanalyst "is envious of the artist." It is this envy that informs the psychoanalyst's understanding of the artist.

Because of envy, the psychoanalyst attempts to spoil the artist's guiltlessness and ruthlessness by analyzing it as a human defect and the artist as amoral. This envy often leads to skepticism of art as an authentic endeavor. Still, the psychoanalyst appreciates art's power to describe human beings, their emotions and ideas, and to make these descriptions convincing to society.

Kuspit's final point in his analysis of what draws the psychoanalyst to art centers around art as illusion. Art is labeled by psychoanalysts such as Freud as a fraudulent illusion of healing, not the real thing. Behind this perception, argues Kuspit, lies the fear of psychoanalysts that theirs may not be an exact science either; that psychoanalysis too may be dealing in illusions. While wanting to free "itself and us of illusions, [psychoanalysis] knows that the life-world is pervaded with them." The life-world is a construction of the expectations projected onto it; "authentic psychoanalysis," writes Kuspit,

like authentic avant-garde art, is premised on enormous dissatisfaction with, even disbelief in, existing psychosocial illusions; but it is aware that the truth with which it replaces them is another kind of illusion that is also all too artistic.

The interaction of psychoanalysis and art, especially as conditioned by the model of psychoanalytical art criticism established by Freud in his Leonardo and Michelangelo studies, is not without its controversial aspects, particularly when seen from the vantage point of the artist. For artists, psychoanalysis seems to work, in the words of Spitz, "as critical theory to dismantle the object." While Spitz admits that her psychoanalytical essay on graffiti questions the priority of the physical object, her essay also sheds light on how graffiti, the product of a special urban environment, relates to society, to adolescence, and to the manipulation of visual signs. Drawing parallels to the drives that motivate professional artists to continue, usually under adverse and difficult circumstances, to produce art, she suggests ways in which to understand the functioning and meaning of the work of art in current society.

Unlike Freud's, Gedo's approach, in its focus on the artist Roger Brown, views both subject matter and art object with equal interest; her psychoanalytical method is sensitive to formal and stylistic aspects of the work, and she convincingly demonstrates that both can be shown by psychoanalytical methods to have deep personal meaning (though often unrecognized by the artist). Form, style, and subject matter of the work of art are

224 Part Five

revealed by Gedo to be interconnected features of the private iconography of the artist.

Kuspit's essay calls into question the motives behind the psychoanalyst's interest in art and the artist. By doing this, he explores the image that the psychoanalyst has of the artist and how this image corresponds to more popular ideas about artists and madness. Such romanticized notions of the artist, while fostered by misunderstandings and exaggerations rampant in the popular media, have played a role in shaping the psychoanalyst's view and, therefore, interest in the artist. Kuspit's essay, in being an analysis of psychoanalytical motivations vis-à-vis the artist, illuminates not only the dangers involved in psychoanalytical methods, but also the precariousness of uncritical acceptance of meaning.

Notes

- 1. Jack Spector, "The State of Psychoanalytic Research in Art History," *The Art Bulletin* (March 1988), p. 54. Spector also provides an informative outline of the controversies surrounding Freud's *Leonardo*, one of which involves the fact that the vulture turns out to be a mis-translation of the Italian word for kite.
- Freud as quoted in Jane Gallop, "Psychoanalytic Criticism: Some Intimate Questions," Art in America (November 1984), p. 10.
- 3. Spector, "Psychoanalytic Research," p. 58.
- 4. Spitz makes an analogy between the role of process in graffiti and in Harold Rosenberg's idea of "Action Painting." In 1952 Rosenberg wrote that "at a certain moment the canvas began to appear to one American painter after another as an arena in which to act—rather than as a space in which to reproduce, re-design, analyze, or 'express' an object, actual or imagined. What was to go on the canvas was not a picture but an event." While there are obvious similarities between the two, it should be remembered that the social, political, and moral overtones are quite different. Harold Rosenberg, *Art News* (December 1952), pp. 22–23+ and reprinted in Harold Rosenberg, *The Tradition of the New* (New York & Toronto: McGraw-Hill Book Company, 1965), pp. 23–39.
- 5. In the case of graffiti, when it is presented in galleries as an art object (easel painting), it is coopted, rendered ineffective. This is because its imagery (its style and formal elements) is emphasized while its politics of rebellion, a function of its location on subway cars and illegal manner of execution, are no longer relevant.
- John E. Gedo, "Introduction," Psychoanalytic Perspectives on Art, vol. 2, ed. Mary Mathews Gedo (New Jersey & London: The Analytic Press, 1987), p. xiii.
- Ellen Handler Spitz, Art and Psyche (New Haven & London: Yale University Press, 1985), p. 28.
- 8. Most scientists assume that truth which is verifiable through repeated testing is the only acceptable universal truth. To the extent that psychoanalysts claim to be scientists, they also claim universal truth. In this way, they come close to the intentions of Kant in his claims of universality of form.

An Insubstantial Pageant Faded A Psychoanalytic Epitaph for New York City Subway Car Graffiti

ELLEN HANDLER SPITZ

And is every new piece of reality... to be considered a contribution to art? —Arthur Danto, 1981

I want these pieces to have an unbridled intense Satanic vulgarity unsurpassable, and yet be art.

-Claes Oldenburg, 1967

Frames and Dichotomies

What kind of dialogue or parallel process is possible between art and psychoanalysis? I approach this question with a heady mixture of exhilaration and trepidation, due in part to a slippage and widening chasm between academic and clinical psychoanalysis—worlds in which (through training and teaching) I have placed one foot each. The sliding apart of these worlds produces a vertigo that is reflected in this essay and in its principal subject—although surely exhilaration and trepidation are not unusual emotions with which to encounter psychoanalysis, which disturbs for the same reasons it fascinates. I have chosen, in what follows, to accept this gap as given and to join ranks with the academic project of borrowing (and reflecting on) psychoanalysis as a critical theory.

Like trepidation and exhilaration, two terms, art and psychoanalysis, are implicitly linked in the subject of this paper. Although I prefer to

This essay was originally presented as a paper at the Mountain Lake Symposium "Making Psychoanalytical Sense of Art," Mountain Lake, Virginia, October 1987 and subsequently published in *Art Criticism* vol. 4, no. 3 (1988). Copyright © 1987 Ellen Handler Spitz, Ph.D. Reprinted with permission of the author.

construe their conjunction as indicating a mutual relation without a covert privileging of one term over the other, such a reading is not the only possible one, and the point of mutuality needs underscoring. Such underscoring might respond in part to a widely publicized critique of psychoanalysis that surfaced in a recent special issue of Critical Inquiry where psychoanalysis was chastised (although not without the leaven of genuine affection) and charged with an imperialistic invasion of other disciplines. an abnegation of the responsibility to come to terms with the secrets and suppressions of its own history (Rand and Torok, 1987), a disavowal of the tortuous implications of racial and religious prejudice in its self-proclamation as a species of medical science (Gilman, 1987), a misprisal of the feminine (Gallop, 1987), a failure to account for the defining differences of art-the literariness, for example, of literature (Riffaterre, 1987), and a refusal to allow the texts it appropriates to challenge the concepts it applies to them (Cavell, 1987)-in short, with aggrandizing itself into a "ubiquitous subject, assimilating every object into itself" (Meltzer, 1987).

Implicated in such a vortex of powerful interdisciplinary crosscurrents, any project of joining the terms *art* and *psychoanalysis* is bound to encounter danger, even attack—as is the parallel case of the subversive illustration I have chosen here—the phenomenon of urban adolescent graffiti (subspecies: New York City subway cars of the seventies and early eighties). This body of work, a borderline case on the slippery edge between art and non-art, serves as ready analogue for the project itself, which also straddles a tenuous border.

If we stipulate (in the customary manner) that psychoanalysis has to do with the embodied mind and that art has, likewise, to do with embodied mind in the sense both of objectified thought and feeling and the filtering of experience through mazelike defiles of signification—we seem to gain, by this twinning, a warrant for mapping one realm on to the other. We may assume, by such a move, that the structure of art mirrors in some sense the structure of mind—not of a specific mind, but of the dynamic organization of mind (this is a tack taken, for example, by psychoanalyst Rose in his 1980 book, The Power of Form). We may sense or expect or hope that there is or should be a correspondence between aesthetic form and psychic process. But is there any validity to such an assumption beyond the warrant it provides to play in both camps, so to speak, to borrow back and forth across the fence (barbed wire) between? What would it take to validate such a correspondence between art and mind? Would such a correspondence necessarily implicate us in a covert move from interpretation to explanation—a privileging of one term over the other (art construed by psychoanalysis)? Whereas, if such a correspondence could be permanently vitiated (if, say, the structures of metaphor and symptom could be proved radically incommensurable), would that not likewise vitiate the play altogether, replacing the and with a less friendly conjunction or even more

drastically dissevering the pair? Can there be a relation between the terms that transcends the mutual tyranny of master/slave? Turning to art history, can history, fact, and reality be severed (released) from fiction, fantasy, and representation? These are framing questions—too grand for short essays—but framing questions that seem necessary to pose in that they simultaneously ground and remove the ground from whatever else follows. A few more might be: How does critical practice bracket itself with respect to the theory on which it relies? Are, and if so, *how* are critics responsible for (as well as responsive to) the theories they draw upon? Are critics who toy with psychoanalytic notions and clandestinely cannibalize tasty morsels not guilty of a reverse imperialism—the very same imperialism for which clinical psychoanalysis has itself been put on trial?

My own theoretical orientation, following the thrust of contemporary academic postmodernism *and* clinical psychoanalysis, is unabashedly eclectic—that is to say, Freudian and post-Freudian. Joining these viewpoints bespeaks no naiveté concerning their points of divergence and want of common philosophic roots (see Cavell, 1987). It heralds the conviction that, despite their heterogeneity, they can and do belong together as overlapping fields of forces—and with no implicit unity. Such staging of referential contexts leads not to unified interpretations but rather to composites of diverse perspectives, each of which may illumine a dark corner or, more radically, allow us not only to *un*cover and to *re*cover but actually to *dis*cover.

It is worth noting that those of us engaged in efforts to apply psychoanalytic ideas and modes of understanding to the visual arts have sought recently to extend the range of these applications. We have cast our nets in ever-widening circles—as has been the case with critical theory more generally. Efforts began, of course, with a kind of auteurist approach (which I have elsewhere called *pathographic*, Spitz, 1985) that weaves together strands from an artist's life history and works (as in Freud's tediously overcriticized Leonardo paper). New horizons have extended to include the possibility of psychoanalytically informed studies of the history of critical responses (both to individual works and to an artist's oeuvre, see Sheon, 1987), the shifting positions of a body of works with respect to a given canon (Yang, 1987), and even, reflexively, of the very canons themselves. More radical are efforts to de-center the figure of the artist altogether (see Gouma-Peterson and Mathews, 1987), and putative dethronements of hallowed divisions of art works into periods and styles (Bryson, 1981, 1983), as well as attempts to de- and renarrativize objects (Clark. 1984; Fried, 1988; Nochlin, 1988) according to strategies not unlike those that lead, in the clinical sphere, to continuous realignments and regroupings-to new stories being told and strangle-grips loosened.

In all of these efforts, the big fear on the part of art historians has been that psychoanalysis will work as a critical theory to dismantle the

228 Ellen Handler Spitz

object (see Kuspit, 1987). In the main, however, the privilege of the object has remained inviolate. Postmodernism, feminism, and deconstruction notwithstanding, art objects continue to be exhibited, recorded, and discussed even psychoanalytically *as objects*. The example that follows, however, does call this priority into question.

Strategies

Graffiti art of the New York City subway cars and murals painted in the seventies and early eighties fascinates us in part because, like Prospero's magic, it appears and disappears—"an insubstantial pageant faded" (Shakespeare, *The Tempest*, Act IV, scene 1). Created by artists to whose very existence we give the name *adolescent*—that is to say, evolving, changing, developing—the subway car graffiti, in its coming into being, is charged with intensity and evanescent excitement. Executed in motion, it is likewise perceived in motion—swiftly arriving or departing. Currently, the spectacle itself has been slowly vanishing altogether from the New York scene its colorful designs dispelled in the wake, partly, of massive resistance by city government as well as by the fact that adolescence is itself a transient state: the generation of early writers having grown up. More ruinous to it has been its cooption by the establishment—its appropriation and cannibalization by commodity culture.

As counterpart of, but in contrast to, the reassertion of civic order with which Shakespeare terminates *The Tempest*—where Prospero voluntarily forswears his magic and resumes the duties of his dukedom—the City of New York has here forcibly imposed and reasserted its hegemony over this adolescent art by enforcing its illegality, by banishing it, and by disarming its rebellious spirits. For the radiance of its wild and tangled forms, the Transit Authority has substituted "graffiti-proof" trains—stark, silver cars imported from Japan—cars that blend without defiance (but equally without joy) into the grayness of the ghetto.

Ambiguities encircle this magnetic body of art. Its controversial reception/rejection has run the gamut from penalty to praise. The passion it evokes points up the fluid boundaries between genuinely creative efforts to transform and transcend environments and wantonly destructive, deviant, sociopathic behavior. Limited here to a collage of psychoanalytic perspectives, my paper can address only in passing the fascinating adjacent issues—historical, stylistic, aesthetic, and sociological. Themes that will surface include: the prioritizing of process relative to product; the intertwining of image and inscription, of marking with making; the foregrounding of a set of powerful developmental imperatives (psychosocial and psychobiological)—as motivation for this art and perhaps for all art; the role of aggression—both latent and manifest—as inextricable from artistic insertion into the cultural order; and the trajectory of graffiti, which follows an irresistible drift of art—from subversive start to conservative finish, from becoming to being, from maker to market or museum.

In considering these issues, the inquiry doubles back upon itself, with art informing psychoanalysis as well as the other way round—art teaching psychoanalysis not only about its own objects but about the dynamics of desire—which are constitutive of these very objects. And the issues themselves are entangled—a twisted skein.

Verbs

Graffiti shifts our focus from the object as beheld in its "finished" state to the process by which it comes into being—as well as that by which it is received. *Graffiti turns art into a verb*. It shifts our habitual arithmetic metaphor—art as product—to art as remainder. For what animates these marks and images are the traces of those exciting and dramatic performances through which they come into being. Kinaesthetic as well as visual in their origins, they link artistically with what critic Harold Rosenberg has labeled "Action Painting." Authenticity of gesture in part determines their quality and is read in traces of action—agility, boldness, spontaneity, angry sustained passages. Engaging large as well as small muscle movements and hand-to-hand encounters with metal walls, filling huge vertical spaces by spraying paint, solving drips, integrating accidents, the visual dynamics of graffiti evoke modified images of artists of the fifties, limning, stroking, spattering, and pouring—their internal impulses and external systems of control engaged in dubious battle.

Correspondingly, a focus on process lies at the heart of psychoanalysis—constitutes, we might say, the heartbeat of clinical depth psychology. Recently, in the theoretical literature of applied psychoanalysis, several authors have advanced brilliant arguments that Freud's originality and genius lay precisely in his radical questioning of the object—a deeply disturbing move the consequences of which he strove intermittently to reject (see Bersani, 1986, and Davidson, 1987). Psychoanalysis has essentially to do with means and not ends—with branching roads (as in *Oedipus Tyrannos*) rather than with destinations—but this is an attitude of mind extraordinarily difficult to maintain because it challenges the mental habits with which we have grown comfortable—not only the logic and linearity of our explanations, but our deeply rooted craving for intellectual and physical certainty.

The reification of such certainty, expressed through our investment in the material objects of art, is thus doubly problematized. It is called into question not only by the adolescent graffiti itself, which is an experiential, nonsurviving art, but by psychoanalysis which, in its radical and restless search, doubts every object, interrogating it relentlessly. Constituted by ruptures and sutures in a continual process of refinding, revoking, reworking, and remaking, the object generates questions that, no sooner asked, bring forth another wave of questions. Like Calvino's Palomar on the beach, we submit ungently to frustration. We are loathe to recognize the suffering and loss implicated in our very acts of representation—unwilling to accept the insight that we cannot contemplate, we cannot isolate, we cannot interrogate, even momentarily, an individual wave. What must come to matter, rather, is the process itself and the capacity to go on asking: *Truth itself, perhaps, as a verb*.

To reintroduce or reaffirm the priority of process in relation to object is, I suppose, to conflate visual with performing art. Yet, as twentieth-century art demonstrates, these categories can and have been suspended not without intriguing results. In this spirit my title alludes to theater via "The Tempest" and to Shakespeare's fleeting images of Prospero's magic— Prospero who, like the adolescent graffiti artists, is both conjurer and banished citizen—and whose art, self-described, is, as some would style postmodern texts, but "the baseless fabric of [a] vision."

The performance aspect of graffiti surfaces in a manifesto given me by a former "writer" who has requested anonymity: "The actual execution of a piece [he says] is more of a statement than its style or content." Clamoring, however, against what he now considers the *coup de grace* for graffiti art as well as its final corruption, namely, its removal from the original context of street and station yard and its cooption by the media, he rages especially against the attention it has provoked in cultural circles—particularly in the established art world which, he implies, radically misunderstands it—having appropriated its aesthetics without its politics.

This young man describes graffiti as a journey—and as an expression of social outrage. Its overriding motive is an intense desire on the part of crew or clique to gain recognition from an indifferent world. To say this, however, is to articulate its fundamental paradox. For, since the graffiti art, once executed, clearly and decisively *does* impact (whether negatively or positively) on the surrounding world, the metaphor must switch immediately from journey to destination. In this important sense, the aims of graffiti (as journey toward recognition denied) are revealed to be intrinsically self-contradictory—a point inextricable from any discussion of art as process as well as from the psychodynamics of (adolescent) rebellion.

Stagings

In a stunning paper on graffiti, John Carlin (1987) has focused on the way in which, as he puts it, this art "bombs history." In an effort to illustrate the radical restructuring of time and history that characterizes our era, he points to the media technique of juxtaposing images before us in sequences that disregard historic process. What is produced thereby he terms a kind of "feedback chamber of time"—a state of utter contemporaneity—which we experience both as insidiously lulling and as strangely disquieting. In a striking analogue, the bubble letters, flourishes, and tags of graffiti art also burn time. While initially rejuvenating the drab, they simultaneously reveal it; they refuse the old while making it older. They bring into visual awareness the rupture between generations; by inserting new signifiers, they disrupt the extant order of signification.

In this unremitting assertion of denied subjectivity and blatant demand for visibility (though, not equally for legibility—since making style inimitable, "hard to bite," is definitely part of the game), graffiti art stages an ambiguous drama of presence. Simultaneously proclaiming presence and absence, it declares provocatively to beholders that it is there but soon won't be there, and that its adolescent artist was there but *isn't* there any longer: It teases, like the saucy refrain of the children's rhyme: "Run, run, as fast as you can—you can't catch me . . ." and so on. Powerful, subversive dynamics structure this drama. Fascinatingly, however, they are played out by choice in terms not of violence to persons but in terms of representation and the manipulation of signs—and, in the best instances, of visual art.

Names, the most pervasive theme of graffiti, assume transcendent significance for a psychoanalytic approach that privileges the notion of subjectivity as over issues of self and identity (see Lacan, 1977). Untranslatable from one language to another, names both preexist and outlast bodies. The name, unlike our ever-changing face, figure, and physique, denotes and survives us and is, finally, engraved as our memorial. The inscription of one's name, therefore, counts as a paradigmatically significant act—a direct and unique engagement with the symbolic order (see Richardson's psychoanalytic study of the Vietnam war memorial, 1985).

In the case of the radically alienated young graffiti artist, however, this act bifurcates into charged ambivalence. Paradigm becomes paradox. For, while it proclaims the assumption of a subjectivity denied both to the unnamed and to the uninscribed named, this particular version of the act trenchantly challenges the very symbolic order to which it seeks to gain access. The tags are self-given (or, what is essentially the same for this point, peer-conferred). Thus while actively seizing the right to be named, they overtly reject the position of having been named: they both grasp and refuse subjectivity. And, the tags are (like nearly everything else about graffiti) impermanent. Impermanent not only in the ways previously mentioned—including the fact that, illegally sprayed on public subway cars, they travel under and across the City of New York—but impermanent more radically in that the tag of any particular artist may, unlike the parentally conferred name, actually change several times (often for social,

232 Ellen Handler Spitz

safety, and artistic as well as emotional reasons, cf. "Black Cloud" to "Semi-Soul," see Feiner and Klein, 1982). Hence the paradox: fetishistic naming here coincides with maximum public anonymity.

Developmental Imperatives

Psychoanalytically speaking, what needs and tasks are met, set, avoided, motivated, by this art in particular, by that of adolescents more generally, as well as by that of art more generally, and by that of these adolescents in particular? Such a developmental perspective, it could be argued, actually post-dates Freud. The notion of "adolescence" is absent from his *Three Essays on the Theory of Sexuality* as well as from the "Dora" case, where its omission has been as sorely lamented in both the clinical and scholarly literature. When Freud does, a few times in his *Studies on Hysteria*, mention adolescence, the term denotes puberty rather than the more complex psycho-sexual-social entity to which it currently refers, although cultural as well as biological factors are implied. (For a still fine interdisciplinary account of adolescence, see *Daedalus*, Fall, 1971.)

Yet, a possible position here (perhaps a covert return to Freud) is that adolescence, as defined in contemporary clinical discourse, involves imperatives so deeply and pervasively human that it might be more accurate to describe them as stage-intensive than as stage-specific. It may be that the imperatives we associate with adolescence bear such an intimate relation to artmaking in general that features associated exclusively with this developmental period retain a lifelong urgency for creative artists (cf. Greenacre, 1971).

Post-Freudian perspectives link adolescence with the theme of identity (see Erikson, 1959, 1968; Blos, 1952), and it is worth noting that Erikson himself, theorizing identity, actually renamed himself in a paradigmatically autogenous act. Likewise, names are endowed with privileged significance. Since early tags were nicknames followed by street numbers, they have been interpreted as reinforcing the transition from home to a wider turf. Cross-culturally, the assumption of new names has generally been associated with rites of passage. Replacing family surnames, rejected along with devalued parents, street numbers may be emblematic for the world at large, and, in some cases, mark a progression from foreign parental cultures to the allure of the modern American city—where numbers have replaced nouns (see Feiner and Klein, 1982).

Other adolescent developmental imperatives are implicated as well. To name is to tame—to claim possession. To inscribe one's name in gargantuan, savagely luxuriant, resplendent letters on the walls of trains that travel to places unknown and predictably return condenses urgent, ambivalent issues of separation. Vicariously, the young graffiti writer undertakes a (dangerous) journey to alien parts, always with the confident expectation of return—an "as-if" adventure par excellence. Issues of control are implicated. To gather in the stations and watch the names rumble past confers an illusion of power over outside forces that seem callous, threatening, and augmented in fantasy by the projection of inner turmoil.

The very choice of subway cars as a locus for painting bespeaks a craving for locomotion that, in contemporary American culture, with the death of formal rites of passage, assumes a symbolic meaning—the trains possibly analogous, for these urban youths, to the so-called "wheels" of their suburban counterparts. Driven by increased sexual and aggressive impulses and by wishes to establish independence from parental and societal authority—to defy, to escape, to explore, and to *be seen*—the wish for a means of locomotion is multiply determined. Experienced as extensions of the body, vehicles are embellished accordingly. Thus, graffiti art serves, in fantasy, as adornment and decoration as well as mutilation and desecration. On a deeper level of fantasy, the subway trains may carry both phallic and even more primitive anal signification in that they disappear in repetitive cycles into the depths, the entrails, of the earth.

Barring quilts and tapestries, graffiti art is singular in being performed in *groups*—"writing clubs"—a subspecies of peer culture that enables the adolescent to detach from earlier object ties. Writers with notably elegant styles, writers who "get up" in particularly dangerous locations, win respect and admiration. Thus, the activity, perilous and skilled, creates a theatre for both competition and cooperation in which bodies, momentously involved, are placed at risk—an exclusive world where old familial rivalries, risks, and passions can be displaced and defused.

Faced with outer turbulence, permeated by inner turbulence, youth seeks distraction by the frantic filling of both time and space. Graffiti writing, from this perspective, occupies the emptiness of hours as well as the barrenness of walls. As such, it invites comparisons with the familiar teenage passion for flooding consciousness with pulsating sound and accompanying kinaesthetic sensation. It takes the adolescent out of himself out in surroundings that fail to provide even minimal opportunities for socially approved activity—contexts where the problem of evading the discordant self becomes (and remains) acute.

Antisocial Artistry

What amazed some of us most about graffiti art was that, despite (and because of) the pervasive immediacy of a deteriorating city with crumbling, charred tenements, unrepaired streets, accumulating refuse, visual and auditory chaos, these young artists managed to mobilize color, line, shape, and design. Cloaking ugliness with bold imagery, vitalizing the

234 Ellen Handler Spitz

dreary, and, minimally, catapulting into our visual field that which had been previously ignored, their achievement gainsays (while being sustained by) its own destructiveness.

Rebellion is a complex issue here. Resisting authority, winning peer approval, attempting to achieve independence (albeit in some cases by a return to pregenital defenses that may betoken rather a denial of separation), and, secondarily, undergoing retaliation from authority-all of these are present in tandem. As psychoanalyst Donald Winnicott (1956) points out: "the organized antisocial defense is overloaded with secondary gain and social reactions which make it difficult for the investigator to get to its core." What is it, actually, that the graffiti artist wants? Graffiti teaches psychoanalysis about aspects of aggression that derive not solely from inner developmental imperatives but from particular external surrounds. from, in this case, a quantum of dehumanization that breeds violent feelings and hostile acts. Winnicott (1956) interprets further that openly aggressive feelings and acts may well be considered adaptive in such contexts. To perceive hopeful, self-curative undercurrents in what appears behaviorally destructive is to underscore the positive side to these youthful efforts to project an imagery that speaks both to and for its makers-that reflects back to them, as to the world, some semblance of their unacknowledged desires. Inscribed as graffiti, these desires can be read as intensely charged—positive/negative, artistic/delinquent, profoundly personal/blatantly political.

Satanic Vulgarities

One contemporary artist who admired graffiti from the start is Claes Oldenburg. A convergence between its themes and his own might probe the wider significance of process and performance, of repetitive cycles of doing and undoing, and fantasied enactments of aggression, control, and ambivalence—might show their bearing beyond adolescence, their relevance to the making of art more generally. Let us consider a few statements taken from *Store Days* (1967). This manifesto, written by Oldenberg in his midthirties, retains every iota of its refreshing and salacious irreverence:

Residual objects are created in the course of making the performance. . . . The performance is the main thing . . .

I am for an art . . . that does something other than sit on its ass in a museum.

I am for an art that grows up not knowing it is an art at all, an art given the chance of having a starting point of zero.

I am for an artist who vanishes . . .

I am for the art of scratchings in the asphalt, daubing at the walls.

I am for an art that is put on and taken off, like pants, which develops holes, like socks, which is eaten, like a piece of pie, or abandoned with great contempt, like a piece of shit.

At the completion of my work I'm afraid I have nothing to say at all. That is I have either thrown it away or used it up.

-Oldenburg, 1967, passim

Thus, Oldenburg (cannily) describes art not in terms of technique, convention, and style (derivatives of what psychoanalysts call ego function) but rather in terms that exploit the polymorphous incarnations of infantile sexuality. He evokes not only the instinctual regression (explicitly oral and anal) that may serve in adolescence as a defensive flight from genitality, but also its typical ambivalence—conveyed through images that abruptly juxtapose instinctual gratifications with corresponding renunciations. This abruptness has its counterpart in the sudden shifts endemic to adolescent behavior—its changeability and "as-if" interactions with the environment (e.g., putting things on and taking them off).

Oldenburg's words proclaim that art should be something absolutely new and different ("a starting point of zero") and, in addition, that we must not become too attached to it. His description implies a defiance of (parental) authority (i.e., the museum) and the wish for a chance to grow up without parents (i.e., without an artistic tradition). Such wishes evoke the reaction formation in adolescence that serves to defend against recrudescence of incestuous love for the first objects (the parents). His words point, by repudiation, to the Oedipal conflicts unconsciously implied in any creative endeavor—to make something new being, aggressively, to replace the old. But, at the same time, we must be able to abandon our own work with contempt—lest it be saved and incarcerated in a museum. Nothing less than perpetual revolution is advocated: art must be original and disposable—like the vulnerable traveling spectacle of graffiti.

No longer equated with any good sanctioned by society, art consists not of products made, cherished, and preserved, but of the acts of marking and making. Performances, not objects, are cathected. Ambivalent and destructive wishes underlie these thoughts, fitting the motives and practice of young writers who pilfer materials, cut wire fences to enter forbidden spaces, execute paintings at night, abandoning them at the whine of sirens. The very relish with which they greet peril fulfills Oldenburg's criteria.

Important adaptive needs are served by the destructive wishes expressed in this manifesto—principally the need to separate from (and deface) real, displaced, and fantasied parental objects and to create thereby a horizon for the emergence of the new—a need that clearly continues beyond adolescence to pervade the life cycle of the artist.

236 Ellen Handler Spitz

Psychoanalysis, however, postulates an intrapsychic museum—amuseum of the mind. This is a fate that can be escaped neither by rebellious youth nor by the artist of any age. For in such museums are eternally preserved the traces of each individual's earliest relations—all that has been loved and lost—which, unlike pants, cannot readily be taken off and which, unlike excrement, cannot easily be abandoned with contempt. For, as psychoanalysis teaches, this past, the contents of this metaphoric reliquary, even if split from consciousness, must always be, have always been, and continue to be, psychically metabolized—forever in the process of intruding and extruding, of becoming (however maddeningly) one with us. In this psychoanalytic sense, there is no possibility of starting from zero.

Perversities

It is difficult to evade anal themes in Oldenburg's manifesto as well as in the graffiti phenomenon itself. Besides the explicit comparison of art to feces in the above-quoted passage, Oldenburg has praised graffiti by calling it a "big bouquet from Latin America" (as quoted in Feiner and Klein, 1982). What has this particular aspect of fantasy to do with art and with wishes to transform reality?

In a brilliant paper, the French psychoanalyst Janine Chasseguet-Smirgel (1983) proposes a stunning link between anality and the human desire to transcend the ordinary. Pointing out that human beings have always sought to reach beyond the narrow limits of existence, "to push forward the frontiers of what is possible and unsettle reality," she speaks of such wishes as constituting a temptation in the mind that motivates an array of fantasies and acts. Such (perverse) acts may, she suggests, serve to overturn the "universal law" that distinguishes body parts from one another and separates human beings into the fundamental categories of gender and generation. This temptation is prompted, she proposes, by a retreat from the pain and loss that follows inevitably upon the recognition of sexual and generational differences and prompted also by a defiance of paternal authority (which forbids access to the mother). Such temptation may lead not only to perverse behaviors of wide-ranging diversity but also to a dazzling array of experiments in thought and act, including art.

As her principal example, Chasseguet-Smirgel chooses the Marquis de Sade and indicates that the Sadian hero puts himself in the position of God, becoming, by a process of destruction, the creator of a new kind of reality. In order to do this, all differences must be annihilated, until finally the fundamental difference between life and death, organic and inorganic, is denied. In this way, an anal universe is created, wherein all things erotogenic zones and functions, sexes, classes, siblings, ancestors—are intermixed in a crucible of undifferentiated matter. Emphasizing the hubris of the individual who dares take the place of Creator, Chasseguet-Smirgel links the sin of hubris with hybridization, with mixture, and with the transgression of boundaries. The anal-sadistic universe which thus results constitutes both a parody of and regressive flight from the repudiated adult genitality.

The relevance of this fantasy to adolescent and artist is clear: both stand accused, even guilty (not in fantasy alone) of hubris. They also dare while baring and transfiguring it—to defy convention, rule, and law. Creating themselves as demigods, daring to invent a universe, they must also wantonly and destructively (even if in fantasy alone) abandon the old in search of the new; they must bring forth form from chaos. Parenthetically, in a recent interview in *Dialogue* (1987), Chicago painter Roger Brown whose works are represented in MOMA, the Whitney, the Met, and Washington's National Gallery—is quoted as saying: "I'm not interested in recreating the world; I'm interested in transforming it. The goal is to evoke a parallel universe. I'm God and I'm going to create my own world."

Chasseguet-Smirgel unmasks our collusive denial of intimate links between anality and the aesthetic, art and aggression, creativity and destruction. When even in part, as in the case of subway car graffiti, the creation of art springs from roots nourished by deep human desires to reach beyond what we are, to devise new forms and meanings, new combinations and new sights—it provokes powerful resistance, both internal and external, as the New York City youths have, repeatedly, discovered.

Deconstructions

Graffiti has (almost) been tamed—its meanings confused and "hypocritized," to use the words of my previously cited correspondent. Its removal from the streets has been effected by caustic detergents—described recently in a *New York Times* article with the dramatic caption: "Doing Battle With the Scourge of Graffiti." Far more dramatic has been its success. No longer a raw, painfully brash, energizing effort to bridge the abyss between subjectivity and signification, between the imaginary and the symbolic order, graffiti art has been domesticated—its power caged and drained. Wildstyle spraypaint effects have assumed today a ubiquitous presence in American culture—in art galleries, magazine advertisements, ballet stage sets, children's T-shirts, fabric designs for linen and drapery. "Graffiti" is now the epithet for a fashionable boutique in New York suburbia.

Meaning has been deconstructed, appropriated, reassigned, and fixed. *Verb has become noun*. For, graffiti art was subversive: like psychoanalysis, it exposed what we did not want to see. While sabotaging, it revealed

238 Ellen Handler Spitz

an unpleasant dis/order of things. It gave us, like Prospero's magic, a fleeting pageantry—and not without its Calibans: Satanic and vulgar, like Oldenburg's credo—yet, it was art!

The ambiguity of art lies in its twin powers—terrifying and exhilarating—to undo and to make new. Psychoanalysis, grasping (and instantiating) this paradox, aligns art both with health and with illness, with optimal functioning and with driven, repetitive, symptomatic behavior. Such polar views of art, deeply embedded in our cultural heritage, are thrown into bold relief and de-dichotomized by the masterpieces on the trains.

By interpreting partly against a background of adolescent developmental themes, I have sought to contextualize this art with regard to some aspects of the subjective experience of its makers. But this whole enterprise could be called into question: Is such contextualization relevant to artistic valorization? The same phenomenon viewed from the outside (Is it [good] art?) and from the inside (How [well] does it function for the individual creating it?) may yield asymmetrical responses for, although both questions imply judgments of value, the systems of value brought to bear are discrepant. Paintings that signify a great deal emotionally or developmentally to an artist may later prove relatively ineffective in their capacity to move, delight, or interest spectators. Other works which, in their actual creating, have played a far less dramatic intrapsychic role for the artist, may, however, claim fervent attention from future viewers. A core (and too often unrecognized) problem for the psychoanalytic critic is to avoid conflating these discrepant systems of value.

My effort here has been to open avenues of identification between a marginal and ambiguous body of work and its (often hostile) beholders by highlighting psychological themes that, though especially powerful in adolescence, and in the urban environments where graffiti has flourished, recrudesce throughout the lifespan and throughout history to animate the experience of both creators and re-creators of art. I have tried to show that—*pace* the sacrosanctity of the aesthetic—psychoanalytic perspectives enrich rather than diminish our interpretive efforts. They augment our awareness of the complexity of art. They refuse to us the luxury of premature resolutions.

Acknowledgments

I am deeply indebted to Joel S. Feiner, M.D., of the Albert Einstein College of Medicine, whose sensitive firsthand study of adolescent graffiti art in the Bronx inspired this paper; to Gladys Topkis and Professor Bonnie Leadbeater who gave me the benefit of careful readings; to John Carlin whose stimulating reflections on graffiti have extended my own; and to the youthful schizophrenic patients at the Ittleson Center for Child Research who taught me to value process over product.

References

Bersani L. (1986). The Freudian Body. New York: Columbia University Press.

- Blos, P. (1962). On Adolescence: A Psychoanalytic Interpretation. New York: The Free Press.
- Bryson, N. (1981). Word and Image. Cambridge: Cambridge University Press. (1983). Vision and Painting. New Haven and London: Yale University Press.
- Calvino, I. (1985). Mr. Palomar, trans. W. Weaver. San Diego: Harcourt Brace Jovanovich.
- Carlin, J. (1986). Bombing History. Unpublished manuscript, read at the Symposium "Art Without History," CAA, Boston, February, 1987.
- Castleman, C. (1982). Getting Up. Cambridge: MIT Press.
- Cavell, S. (1987). Freud and Philosophy: A Fragment. Critical Inquiry, 13:386-393.
- Chasseguet-Smirgel, J. (1983). Perversion and the Universal Law. International Review of Psycho-Analysis 10:293–301.
- Clark, T. J. (1984). The Painting of Modern Life. Princeton: Princeton University Press.
- Cooper, M. and Chalfant, H. (1984). Subway Art. London: Thames and Hudson, Ltd.
- Daedalus. Twelve to Sixteen: Early Adolescence. Vol. 100, no. 4, of the Proceedings of the American Academy of Arts and Sciences. Fall, 1971.
- Davidson, A. L. (1987). How to Do the History of Psychoanalysis: A Reading of Freud's Three Essays on the Theory of Sexuality. Critical Inquiry, 13:252–277.
- Dialogue (1987). Roger Brown: A Universal Language of the Eye. Vol. 10, no. 5:25–29.
- Erikson, E. H. (1959). *Identity and the Life Cycle*. New York: International Universities Press.

(1968). Identity, Youth, and Crisis. New York: Norton.

- Feiner, J. S. and Klein, S. M. (1982). Graffiti Talks. Social Policy. Winter:47-53.
- Freud, S. (1905). Fragment of an Analysis of a Case of Hysteria. *Standard Edi tion*, 7:7–122.
- (1905). Three Essays on the Theory of Sexuality. *Standard Edition*, 7:125–243.
- (1910). Leonardo da Vinci and a Memory of His Childhood. Standard Edition, 11:59–137.

Freud, S. and Breuer, J. (1893–95). Studies on Hysteria. Standard Edition, vol. 2.

- Fried, M. (1988). Courbet's "Femininity." In *Courbet Reconsidered*, ed. S. Faunce and L. Nochlin. New Haven and London: Yale University Press.
- Gallop, J. (1987). Reading the Mother Tongue: Psychoanalytic Feminist Criticism. Critical Inquiry, 13:314–329.
- Gilman, S. (1987). The Struggle of Psychiatry with Psycho-analysis: Who Won? *Critical Inquiry*, 13:293–313.

240 Ellen Handler Spitz

- Gouma-Peterson, T. and Mathews, P. (1987). The Feminist Critique of Art History. The Art Bulletin, 69:326–357.
- Greenacre, P. (1971). *Emotional Growth*, Vol. II. New York: International Universities Press.
- Kuspit, D. (1987). Traditional Art History's Complaint Against the Linguistic Analysis of Visual Art. *Journal of Aesthetics and Art Criticism*, 45:345–349.
- Lacan, J. (1977). *Ecrits: A Selection*, trans. A. Sheridan. New York and London: Norton.
- Mailer, N. (1974). *The Faith of Graffiti*, ed. M. Kurlansky and J. Naar. New York: Praeger.
- Nochlin, L. (1988). Courbet's Real Allegory: Rereading "The Painter's Studio." In *Courbet Reconsidered*, ed. S. Faunce and L. Nochlin. New Haven and London: Yale University Press.
- Oldenburg, C. (1967). Store Days. New York: Something Else Press.
- Rand, N. and Torok, M. (1987). The Secret of Psychoanalysis: History Reads Theory. Critical Inquiry, 13:278–292.
- Richardson, W. (1985). Lacanian Theory, in Models of the Mind: Their Relationships to Clinical Work, ed. A. Rothstein, M.D. Workshop Series of the American Psychoanalytic Association. Monograph One. New York: International Universities Press.
- Riffaterre, M. (1987). The Intertextual Unconscious. Critical Inquiry, 13:371-385.

Rose, G. (1980). The Power of Form. New York: International Universities Press.

- Sheon, A. (1987). Van Gogh's "Sense of Self" and His Interpreters. Unpublished manuscript, read at the Symposium "Art History and Psychoanalysis," CAA, Boston, February, 1987.
- Spitz, E. H. (1985). Art and Psyche: A Study in Psychoanalysis and Aesthetics. New Haven and London: Yale University Press.
- Winnicott, D. W. (1956). The Anti-Social Tendency, in *Collected Papers*. New York: Basic Books, 1958.
- Yang, E. (1987). Letters of Mourning and Melancholy: The Case of Watteau Criticism. Unpublished manuscript, read at the Symposium "Art History and Psychoanalysis," CAA, Boston, February, 1987.

An Autobiography in the Shape of Alabama The Art of Roger Brown

MARY MATHEWS GEDO

Like Pablo Picasso, who described each of his canvases as the visual equivalent of a diary entry, Roger Brown forges his art directly from the stuff of his life.¹ But unlike Picasso, who forced his viewers to share his personal distress, Brown cushions his public—and maybe even himself—from the full brunt of his autobiographical revelations by rendering them in a quirky style, complete with bright colors, punning titles, and witty captions. Perhaps partially for this reason and partially because he is a much more modest, private person than Picasso, critics have not focused primarily on the self-revelatory character of Brown's oeuvre, as this essay proposes to do.

As I hope to demonstrate, Brown's character—and his art—have been deeply impregnated by the experience of growing up in the rural South in a close-knit family committed to fundamentalist religious beliefs and practices. Although transient events, such as sights observed during vacation trips, invariably invade his paintings, the enduring elements of Brown's personal style and iconography remain rooted in early childhood memories.

Brown, born in 1941, spent several crucial years of his early childhood at the home of his maternal grandmother in Hamilton, Alabama, where he lived with his mother and grandmother while his father served in the armed forces from 1943–45.² Brown's grandmother lived next door to her mother-in-law, Dizenia, in the larger of two homes the latter's son had built for them. Unfortunately, Dizenia never accepted her daughter-inlaw, and by the time Brown was born the two women did not even speak. This strange situation must have greatly puzzled the little boy, who loved

This essay was originally presented as a paper at the Mountain Lake Symposium "Making Psychoanalytical Sense of Art," Mountain Lake, Virginia, October 1987 and subsequently published in *Art Criticism* vol. 4, no. 3 (1988). Copyright © 1987 Mary Mathews Gedo. Reprinted with permission of the author.

both women, though they certainly did not love one another. His fascination as an adult artist with depicting the inhabitants of houses and high rises as minute figures silhouetted against their windows, as though perceived by an observer forever excluded from the life within, may reflect repeated early experiences of peering from one of these cheek-by-jowl homes into that of the "enemy" next door. Brown's mature propensity for engaging in artistic feuds may also stem from the tangled relationships to which he was exposed during those formative years.³ Since 1981, he has devoted considerable artistic time and energy to portraying his negative assessments of the criticism written by two prominent Chicago art critics, Franz Schulze and Alan Artner. The latter has gradually assumed pride of place as Brown's favorite enemy, and artist and writer have exchanged frequent painted and written barbs.⁴

In 1945 the artist's father rejoined his family, and they moved to Brown senior's home town, Opeleika, Alabama, where they lived in close proximity to several paternal relatives. The future artist's lifelong intimacy with these kinfolk has imprinted his artistic oeuvre in a variety of ways. To cite just one example: the images of trailer trucks that recur in so many of Brown's pictures apparently symbolize a favorite uncle, who drove such rigs professionally.

Although Brown did not spontaneously allude to any artistic interest on his father's part, a photograph taken when the future artist was two or three shows him seated in a delightful little painted wooden jeep, one of many objects of this type that his father made during Roger's childhood. The artist's enduring response to this paternal hobby can be measured by his extensive sculptural oeuvre, which dates from 1974 to the present.⁵ His witty objects range from those fabricated from scratch, like *Mask for the Chairman of the Board of Directors*, 1974, a painted wooden construction featuring suitably lofty-looking skyscrapers, to recycled objects that Brown transforms into works of art with a few deft touches. *UUFWI* (*United Universe Flying Waffle Iron*), 1976, consists in a reincarnated old appliance converted into a sleek space ship by the addition of appropriate openings, complete with glimpses of the passengers.

Throughout his childhood, Brown accompanied family members to revival meetings, and religion became such an important aspect of his adolescence that following high-school graduation, he briefly enrolled in a seminary to study for the ministry.⁶ Although he is no longer a devout church-goer, remnants of the artist's early religiosity continue to surface in his work, affecting both its form and content. Such consistent stylistic features as the glowing nocturnal light diffused through canvases like *Night Fishing in a Calm Lake*, 1980, commemorate dramatic sky effects glimpsed by the sleepy future artist on trips home from evening revival meetings. His religious background more obviously colors the iconography of Brown's art, both in relatively more respectful representations such as An Actual Dream of the Second Coming, 1976, a canvas that literally reproduces a vision of the Last Judgment that he experienced during sleep, or in more satiric compositions, like *The Devil's Surprise*, which shows the blessed pleasuring themselves in every indulgence of the flesh, while, below them the damned sit rigidly aligned in church pews, condemned forever to listen to the haranguing of a boring preacher. Though the latter painting subverts the meaning of its source, its imagery derives from the artist's vivid childhood memories of crudely painted religious charts depicting the horrors of hell that itinerant preachers carried with them from mission to mission on the revival circuit.

Of course, Brown's oeuvre does not derive solely from such personal experiences; it also reflects his reactions to art of the past, as well as to examples of influential teachers and peers. His responsiveness to a wide range of sources, from the paintings of the Italian and Northern "Primitives" at one extreme, to the work of tribal, outsider, and comic-book artists at the other, has been amply documented by critics.⁷ But it is important to remember that Brown's admiration for artists like Giotto and Duccio is intimately bound up with the fact that their art exerted such a profound impact on their world. He would like nothing better than to have his paintings produce the kind of social effect achieved by Duccio's *Maestà*, so admired by the artist's contemporaries that the entire citizenry of Siena followed it as it was carried through the streets en route to its future home in the town cathedral.

During Brown's student days at the School of the Art Institute of Chicago (SAIC), he remained singularly unresponsive to the art of the "Old Masters" and impressionists displayed in the museum with which the school was affiliated. "All those old landscapes" bored him, while the canvases of the contemporary Abstract Expressionist painters impressed him as merely decorative, their fabled "angst" as a mere artifact of the bravura technique used to produce them.⁸ Among 20th-century painters, he especially respects Diego Rivera, whose great public murals seem to Brown capable of exerting a socio-cultural impact comparable to that of the Italian and Northern Primitives. But not until Brown became acquainted with the work of Giorgio de Chirico and René Magritte did he recover from his indifferent response to modern easel painting. The major Magritte retrospective shown at the Art Institute of Chicago in 1966 especially excited and inspired Brown, along with many of his Chicago peers. As his SAIC classmate, the abstract painter Frank Piatek observed, "You can see Magritte's Golden Legend [a canvas depicting meticulously rendered loaves of French bread filling the landscape] in Roger's clouds and my tubular forms."9 Canvases such as Intermittent Showers and Land O'Lakes, both 1976, demonstrate that Magritte's example continued to exert an impact on Brown's cloud compositions long after the retrospective ended. More recently, the artist's fascination with Magritte resurfaced in This Is Not a Gun, 1984,

244 Mary Mathews Gedo

which derives its ironic motif from the Belgian master's famous series labeled "*Ceci n'est pas une pipe*." Of course, Brown's artistic development has also been shaped by his first-hand contacts with SAIC instructors especially Ray Yoshida, who urged him to paint about his own experiences—and classmates, as well as by local "naive" artists, like Joseph Yoakum.

But it is not the purpose of this essay to examine the role of such influences on Brown's artistic evolution. Rather, I hope to demonstrate some of the ways the psychoanalytic approach can be used to illuminate an artist's oeuvre. When one encounters a cooperative artist like Brown, willing to participate in a psychological exploration of his work, it is possible to draw fairly definite conclusions about connections that must remain mere speculations when they involve the character and career of a deceased artist. In my earlier work on Picasso, and more recently in an essay in Art Criticism, illustrated with examples drawn from interviews with the Chicago abstract painter William Conger, I have attempted to demonstrate why the psychodynamic approach seems best suited to explaining changes in an artist's style and productivity levels as well as in his iconography.¹⁰ In Picasso's case, every variation of this type was causally associated with changes in his most intimate relationships. In this respect, too, Brown demonstrates an affinity with Picasso. The Chicago painter's association with the late architect George Veronda, who became his close companion from 1972 until Veronda's death in 1984, exerted just such a profound effect on Brown's work and world.

Success came quickly to Roger Brown, whose extraordinary talent was universally recognized while he was still an undergraduate student at SAIC. By the time he met Veronda in 1972, the young artist had already participated in several successful group shows and had formed the affiliation with the Phyllis Kind Gallery that he still maintains. His work was featured in a highly acclaimed solo exhibition at the gallery in 1971, just a year after he received his M.F.A. The relationship with Veronda quickly became very important for both participants, and the measurable impact on Brown's style was immediate. Veronda greatly admired the work of Mies van der Rohe, whose buildings Brown had previously dismissed as mere "ugly, boring glass boxes." Under his architect friend's guidance, the artist began to appreciate their beauty, especially the care with which Mies invariably worked out the patterning of his curtain walls. Brown soon realized the relevance of such rhythmic repetitions to his own artistic goals, and his canvases quickly began to reflect the fascination with patterning that has remained a constant in his art ever since. One of the first canvases Brown painted in this new style, Curtain Wall Going Up, 1972, depicts the O'Hare Hilton during the course of construction; the composition grew out of Brown's frequent visits to the building site, for which Veronda served as project manager. It seems paradoxical, but Brown also began his "disaster paintings" around the time of his meeting with Veronda. Although the artist's own description suggested that the initiation of this new stylistic and iconographic phase must somehow be associated with Veronda in Brown's mind, he insisted, to my surprise, that he had begun this series *before* he met Veronda, rather than after. Brown did mention, however, that soon after they met, Veronda had acquired A View of the Auroral Drapery, a picture that directly preceded the disaster series.

The artist's reconstruction of the chronology of his disaster series aroused my scepticism, though I cannot offer any conscious rationale for my response. Consequently, I was not at all surprised to find that the catalogue published in conjunction with Brown's 1980 exhibition at the Montgomery, Alabama Museum of Fine Arts noted that he had, indeed, embarked on this series after, rather than just prior to, meeting Veronda.¹¹ This incident points up the type of problem that can arise when an art historian with a psychoanalytic bent works with a living artist. Brown had been both courageous in agreeing to undertake interviews that he realized would involve psychological probing on my part, and unusually frank and thoughtful in his responses. Nevertheless, in this situation, interviewer and artist found themselves at odds. Moreover, even if the chronological reconstruction provided by the 1980 exhibition catalogue was accurate, what was its significance? Clearly, his meeting with Veronda had been anything but a disaster for the artist, so why did the initiation of this group of canvases follow so closely on the beginning of that relationship? The complete answer to this question may not be available to Brown's conscious recall, nor could relevant associations be elicited by the type of questions appropriate for our interview situation, which certainly made no attempt to solicit material not readily accessible to the artist. The only speculation I can offer-surely an incomplete answer if on the mark at all-is that from the secure vantage point of this wonderful new partnership, the artist could finally examine the disastrous aspects of earlier relationships, including those of his more distant as well as his more recent past. Evidence that the etiology of Brown's new artistic program was somehow closely associated with Veronda is supported by the artist's own observation that the Auroral Drapery painting was one of his first to omit the ground plane. "Before that I always worked with the ground plane; everything came off it, and nothing got cut off at the bottom. It was a challenge for me to see if I could make it come off-that's what really led to those disaster pictures: not having a ground plane at all, but just backgrounds and sky and stuff." This comment evoked another association on my part: young lovers often compare their sensation of elation to floating in the air or dancing on the clouds. A similar reaction may have determined this new development in Brown's art. However, the frequency with which the disaster pictures also show airborne skyscrapers in the process of disintegration-bursting into flames, crumbling in earthquakes, and the like-sug-

246 Mary Mathews Gedo

gests that the motif must have cloaked an underlying anxiety. A thematic relationship between the scenes Brown portrayed in this series and enduring memories of revival meeting sermons describing the end of the world and the Last Judgment seems entirely possible. Why such associations should have been evoked at that moment in his life remains far from clear.

The autumn after Veronda and Brown began their relationship, they took a driving trip through the American West. On their return, the artist extended his new fascination with patterning to the creation of entire landscapes filled with repetitive motifs. In retrospect, he perceives this revised landscape style as a direct outgrowth of conversations with Veronda, reinforced by visual experiences garnered during their journey.

A few years later, he enlarged this patterned treatment to include cloud formations. However, he considered his first cloud painting awkward and unsatisfactory. In retrospect, he realizes that the awkwardness resulted from the depiction of all the clouds as possessing "the same intensity of color," rather than suggesting the atmospheric gradation of tones produced by the mist and recession of the more distant sky. Once again, he arrived at the solution to this problem during the course of another long motor trip: "I got this idea down South, visiting my parents, going through the mountains, [observing] the mist, and how the mountains disappeared and each successive mountain disappeared more and more. . . . Afterward, I realized I could use this in cloud paintings." *Misty Morning* from 1975 constitutes a fine example of Brown's fully developed cloud style. Its stylized, scalloped cloud formations also mirror the similarly decorative treatment that he admired in a Chinese embroidery from his private collection.¹²

During 1973, the artist made another long driving trip, this time to the deep South and his parental home in Opeleika. This visit inspired the Autobiography in the Shape of Alabama (Mammy's Door), 1974, a picture that evolved into a complex commentary on his personal and family history. Unlike those artists who typically embark on a painting without a firm idea of its composition, much less its title in mind, Brown usually works out the theme and the name of each picture in advance. But the evolution of the Autobiography began more serendipitously. As Brown recalls it, this work grew out of his new-found interest in making objects, a development that he attributes to his growing fascination with the Art Deco architecture and artifacts of Florida. It really seems more cogent, however, that his visit home would lead Brown instinctively to recall-whether consciously or not—the objects his father had fashioned for him during childhood.¹³ In any case, he was aware of the highly personalized nature of the Autobiography from the start, and he soon decided to dedicate it to his greatgrandmother, Dizenia, also known as "Mammy" by her fond family.

The *Autobiography* quickly evolved into a double-sided piece. On its recto side the artist painted a stylized representation of the state of

Alabama with its major public and personal landmarks. The latter include Hamilton, with the two adjacent homes (shown at the upper left), where Brown spent his early years, and Opelika (depicted at the right center), where he lived from 1945 until his graduation from high school in 1960. At the bottom of the picture the artist portrayed Mobile Bay and the Gulf of Mexico, the latter shown as a painted wooden extension, complete with a little boat labeled "Mammy." "I got so intense working on this painting that I realized I was even going to go around on the back and do sculptural 'dohigs,' and I really started dedicating the painting to [my greatgrandmother], and for some reason I dedicated the boat to her too." The artist turned the reverse side of the painting into a constructed mock-up of the wooden door to his great-grandmother's home. Relief letters attached to the door identify it as the entrance to "Dizenia's" house. Four framed personal photos incorporated into the construction portray the artist's great-grandmother, her brother and his son; his maternal grandparents; and the artist himself, shown both with his parents and alone, seated in that little painted wooden jeep his father had made for him when he was two or three. A box labeled "PS Chicago" contains letters, cards, and other personal memorabilia including a hand-written history of Alabama executed in the shape of the state and a reconstruction of the artist's personal history and family genealogy, again in a cursive script, fashioned in the form of a spiral. Six metal clothes hooks fastened to the door symbolize Dizenia's six grandchildren; a shirt she made for the future artist when he was fifteen hangs from the hook presumably representing his mother.

As soon as he had completed this complex work Brown made another trip back home to Alabama, to revisit the places he had painted or written about in the Autobiography, and to extend his genealogical investigations by tracing down distant relatives and other family contacts. The completion of this landmark work heralded major changes in the artist's personal life and attitudes. "I always felt the ties to my great-grandmother and her memory. After I finished that piece-the intensity of making ita lot of that sentimental attachment to the South and to my family sort of disappeared." It surely cannot be a coincidence that Brown executed this highly personal work around the time he bought a Halsted street storefront building and began planning with Veronda to convert it into a studio and joint residence. With the creation of his double-sided painted construction, the Autobiography in the Shape of Alabama (Mammy's Door), Brown literally and figuratively closed the door on his personal past, committing himself to an independent life with his new "family" partner, George Veronda, who now claimed first place in his affections.

During the thirteen years since he finished the *Autobiography*, Brown's art has continued to mature and evolve. His increasing renown has played a major role in Chicago's growing recognition as the center for an internationally famous group of quirky figurative artists, the so-called "Imagists," among whom Brown and Ed Paschke share top rank. Throughout this period, Brown has continued to be highly fertile, producing pictures in his unique manner from sources merging personal experiences and reactions with art historical associations. For example, his "crucifixion series" of 1975–76 grew directly out of a three-month sojourn alone in New Mexico, where he painted these pictures.¹⁴ The artist recalls that the religious art of the region, especially the numerous crosses dotting the landscape, helped to inspire this series. However, these crucifixion pictures also recall such works by Georgia O'Keeffe as her *Black Cross, New Mexico*, 1929, a well-known fixture in the Art Institute of Chicago. Brown, who pays tribute to O'Keeffe as an important influence, must have been intimately acquainted with this painting from his student days at SAIC.

Brown's cruciform canvases, however, with their frequent representations of suffering and martyrdom, convey a far grimmer message than O'Keeffe's more lyrical abstractions. Perhaps Brown's compositions again recall his vivid childhood memories of revival meetings and the crude painted charts used by the revival-circuit preachers to dramatize their hellfire-and-brimstone messages. But the dramas depicted in Brown's crucifixion pictures also tie them thematically to his earlier disaster series of 1972. Did the artist's physical separation from Veronda during this New Mexico interlude—even though unrelated to any problems in their relationship—trigger the re-emergence of such themes? However this 1975–76 series looks forward as well as backward in Brown's oeuvre, for the Assassination Crucifix from this group, with its stylized yet moving depiction of Kennedy's tragic death in Dallas, prefigures an important aspect of his later work: his growing preoccupation with creating works conveying strong social messages, an interest increasingly evident in his oeuvre of the 1980s.

During 1979-80, Brown had a studio-residence built according to Veronda's design in an idyllic spot on the Lake Michigan dunes.¹⁵ The tranquil beauty of this new setting had an immediate impact on Brown's style, stimulating him to produce the most lyrical paintings of his entire career. Memory of Sandhill Cranes, 1981, for example, renders the birds in flight as large, dark silhouettes echoing against a background of vegetation and a sky filled with the semi-circular, concentric clouds that would become a prime feature of many canvases dating from the early 1980s. Typically for Brown, the cranes composition derived both from the actual experience of seeing a group of the birds swoop down between the separate structures housing his studio and residence, and from studying reproductions of Japanese paintings with their stylized, decorative repetitions of animals, plants, and clouds. Brown soon extended this new style to the depiction of biblical scenes, such as the *Expulsion from the Garden of Eden* and the trial of Daniel in the Lion's Den, both 1982; these biblical pictures all show the protagonists as large-scale dark figures looming against stylized landscape backgrounds. This change in scale notable in pictures from the early eighties represented another stylistic innovation for the artist, perhaps inspired by experiences of seeing isolated forms highlighted by the vast dune landscapes in which they appeared.

Beginning in 1983, the threat of tragedy invaded Brown's personal paradise, interrupting this idyllic painted dialogue with his new environment: Veronda developed the first symptoms of the lung cancer that would cause his death in the spring of 1984. This ominous force immediately invaded Brown's paintings, expressing itself in powerful new images. The Beast Arising from the Sea, 1983, an early example of this type, portrays the seven-headed beast of the Apocalypse surging from the watery depths to loom against a Brownian sky. Art's Folly: The Artist Working with His Critics, Dealer, Patron, and Student Admirer Looking on, 1983, represents the assembled company as a gathering of skeletal figures, in a wryly comic rendition of a scene clearly related to Holbein's engravings of the endless dance of death. This picture, created in a moment of false optimism following an incorrect assessment of Veronda's symptoms as benign, soon gave way to far grimmer compositions, as the disease rapidly ate away Veronda's life. Cancer, 1984, uses continuous narration and running inscriptions to describe the course of the architect's final illness, from diagnosis through a course of treatment whose wished-for favorable effects, suggested by the last panel, titled "Hope," failed to be mirrored in reality.¹⁶ Soon after. Brown painted an allegorical representation of the actual outcome, again using Apocalyptic imagery to portray The Final Arbiter as a gigantic, skeletal horse and rider silhouetted against a sky dramatically rendered in alternating bands of deep color and glowing light. Acid Rain, executed during these same weeks, depicts a forest of dead, denuded trees projected against an increasingly dark sky, its wide strips of black and grey banding relieved only by narrow gleams of light. The grimmest and most powerful of Brown's artistic responses, Agoraphobia, painted soon after the architect's death, renders a scene in the Western desert. But in place of the blinding sun and light one might anticipate in such a setting, Brown presents us with a world of darkness mirroring that of Calvary, a vast expanse of blue-black sand bisected by a thin light-colored ribbon, a solitary road across which a single minute car makes it way. Off in the distance—represented Oriental style as the top portion of the canvas one glimpses mesas and other rock formations. The narrow strip of glowing sky that highlights these forms is interrupted by three ominous vertical bands, dark hammer-blows of fate that propel jagged lightning bolts earthward. This picture memorializes an actual experience that Brown had undergone a decade earlier: "It was done right after George died, and agoraphobia really describes the feeling I had. It was like-well, it reminded me of an experience I had when I was in New Mexico, driving through the desert; a lightning storm struck, and I felt really alone-a very frightening experience."¹⁷ Brown portraved this same sensation of utter loneliness in

250 Mary Mathews Gedo

less awesome form in the beautiful *Whistling Swan*, which shows the elegant black bird swimming in solitude, his form highlighted against a sky featuring concentric dark blue and black clouds.¹⁸

The artist's mourning also found expression in a number of pictures that seem almost like sequels to the disaster series he had painted during the initial phase of his relationship with Veronda. *Malibu*, 1984, for example, represents that ocean-front community under siege from "almost everything nature has to offer—the far stars, the earthquake, the ocean eating away and eroding the cliffs." *Contemporary Crucifixion*, 1985, uses the imagery of uprooted skyscrapers familiar from the disaster series. But the buildings have been anthropomorphosized into concrete-and-steel representations of Jesus, Mary, and John. While these all-too-human structures undergo the agony of Calvary, their inhabitants—represented by typical little stylized Brownian silhouettes—carry on their ordinary lives, oblivious to the tragedy in which they unwittingly participate.

Although Brown has successfully passed through the acute stage of his mourning, feelings of underlying sadness and loss continue periodically to perfuse his art. Thus, Passing Generations, 1986, shows a cemetery whose eternal tranquility contrasts with the busy highway traffic zooming past it. Many of the artist's other recent canvases, by contrast, deal with art-world topics (particularly his ongoing battle with Artner) or social and patriotic issues that frankly portray his conservative political beliefs. Thus, The Latinization of North America, 1983, illustrates a host of the artist's pet peeves in a single large canvas that uses his favorite continuous narration device to portray simultaneously his irritation with protesters, special interest groups, and Latin American anarchists who would transform the United States into a third-rate third-world country. Although the messages inherent in Brown's social and political paintings often seem quite conservative, they do not fit comfortably into any preconceived ideological mold. The increasingly frank sexual references evident in many of his recent canvases, for example, would scarcely be acceptable to many conservative viewers. As the spokesman for his own particular ideology, Brown seems to have come full circle. The artist who as an adolescent briefly entertained the idea of entering the ministry has now become a kind of lay minister of international stature. As such, he uses his art to confront the public with his vision of the world to come-a vision that transforms the biblical story of the Apocalypse into a stern commentary on human follies and their potential consequences for our existence.

Conclusions

This essay focuses on Roger Brown's ability to transform his life experiences into artistic expressions of great originality, and attempts to interpret the psychodynamic significance of these intimate connections between his public art and his personal past. But it addresses only the most important emotional issues, those requiring few speculative inferences beyond the themes inherent in the works themselves and the comments about their significance supplied by the artist.

Critics of the psychoanalytic approach often complain that the method cannot be used to illuminate the formal aspects of an artist's oeuvre. Brown's own statements about the intensely personal roots of his major stylistic changes give the lie to that criticism. As I have pointed out elsewhere, within the oeuvre of an individual artist, style and content both form part of the seamless whole constituting the artist's private iconography.¹⁹ The validity of this contention is amply demonstrated in Brown's oeuvre, for major stylistic changes in his art have almost invariably been accompanied by significant changes in his subject matter, or way of portraying his themes. The most dramatic parallel transformations of this type in Brown's career occurred in 1972, when his meeting with George Veronda triggered sweeping changes in the artist's style and iconography. However, it should be noted that other important innovations in the artist's oeuvre followed trips to the Southland that included stopovers to visit his family and the town where he grew up.

Perhaps in this concluding section I can add some more tentative interpretations about the meaning of his partnership with Veronda for the artist. It seems likely, for instance, that the temporal coincidence between the initiation of Brown's relationship with Veronda and that of his disaster series reflected the artist's superstitious fear of punishment for being in love and happy. The re-emergence of similar themes in the crucifixion series the artist painted in New Mexico during his brief separation from Veronda in 1975–76 suggests that this sojourn may have triggered a similar type of anxiety. One could also speculate that Veronda's death twelve years later may have reawakened Brown's childhood memories and feelings of being without a father, as well as his more age-appropriate mourning reactions. In love relationships, the beloved typically assumes complex symbolic meanings, becoming the focus not only of mature emotional responses, but of unresolved conflicts and attitudes stemming from childhood—as I suggest may have been the case in this example. But in dealing with a living artist, it seems both inappropriate and unnecessary to indulge in too many speculations of this type, and I shall not carry my interpretations beyond this stage.

In closing, however, I should like to point out that Brown's growing interest in producing pictures with strong socio-political messages capable of influencing his fellow citizens demonstrates the fusion of motivations derived from his personal past and his adolescent desire to become a minister with those deriving from his identification with major figures in art history. In assuming the role of a modern-day painter-priest, Brown

252 Mary Mathews Gedo

follows a tradition that includes many great predecessors who regarded the creation of art as a sacred task.²⁰ By aligning himself with such titans, the artist reveals his growing artistic self-confidence, his increasing conception of himself as a potential leader of men as well as a major force among contemporary painters.

Notes

This essay is based on six hours of taped interviews held with the artist during June, 1986. Although he had not asked to read or approve this essay prior to its publication, I sent Brown a copy of the completed manuscript. He responded with an enthusiastic, undated, eight-page letter that I received on August 25, 1987. In his introductory paragraph, Brown wrote: "I think [your essay] is very insightful about all the personal relationships and of course really shows the powerful effect George [Veronda] had on my work. You explained very well how his architectural influence affected my work (which people often can't see when I try to explain it). But your analysis of the personal influence I think is very accurate and even at times illuminating to me." The letter contained additional information about Brown's history and career that has been incorporated in the footnotes that follow.

- 1. Quoted in Françoise Gilot and Carleton Lake, *Life with Picasso* (New York: McGraw-Hill, 1964), p. 123.
- 2. In the letter mentioned above, Brown wrote that he was born in Hamilton, Alabama, but that his mother and he later rejoined his father in Childersburg, Alabama, where the latter was working in a defense plant. From approximately mid-1943 to mid-1945, Brown senior served in the army, while Roger and his mother again lived with his maternal grandmother in Hamilton. The artist's father, severely wounded in battle, spent the last year of the war in various hospitals, finally being moved to a facility near Hamilton, from which he was discharged.
- 3. In his letter, the artist commented, "I want to tell you that your connection of my childhood response to my grandmother and great-grandmother's relationship, to the kind of isolation aspect of people in the city streets and dwellings is a particularly insightful analysis on your part and one that had not occurred to me." In a parenthetical comment, Brown added, "also the artistic feuds—you may be absolutely right."
- 4. Let me cite just one example of such an exchange. In a review that appeared in the *Chicago Tribune* on September 23, 1984, Artner discussed the exhibition at the American pavillion of the Venice Biennale, noting: "Not much could be as agonizing as getting trapped for an hour by a sudden storm in the same room as an apocalyptic painting of Roger Brown's." Brown responded to this provocative statement with an equally provocative painting, *Large Bearded Sky: Portrait of a Would Be Art Critic Caught up by Nature in One of My Apocalyptic Paintings*. As the title suggests, the "portrait" depicts the bewhiskered Artner as a gigantic, faceless beard hovering just above the flames of hell.
- 5. Brown incorporated this photograph of himself in the jeep in the key work, Autobiography in the Shape of Alabama (Mammy's Door), discussed below. In his letter he

specifically mentioned that the snapshot was taken in Childersburg, before his father left for the service.

- 6. In the fall of 1960, Brown attended the David Lipscomb College affiliated with the Church of Christ, where he remained for only two quarters.
- 7. For an excellent discussion of the multiple aspects of Brown's art, as well as his varied sources of inspiration, see the three essays written for the exhibition catalogue, *Roger Brown*, by Mitchell Douglas Kahan, with contributions by Dennis Adrian and Russell Bowman (Montgomery Museum of Fine Arts, Montgomery, Alabama, 1980). See also the catalogue for the artist's 1987 one-man show, *Roger Brown*, by Sidney Lawrence, with an essay by John Yau (George Brazillier: New York, in association with the Hirshhorn Museum and Sculpture Garden, Smithsonian Institution, 1987).
- 8. During the last few years, Brown has developed a new-found admiration for the art of J.L. David, especially the latter's full-length paintings of public figures, such as his portrait of *Napoleon in His Study*, c. 1810–12, now in the National Gallery in Washington, D.C. Certain of Brown's recent canvases, for example, the large-scale *America Landscape with Revolutionary Heroes*, 1983, reflect this admiration.
- 9. Personal communication with the artist during an interview recorded in May, 1982.
- See M.M. Gedo, *Picasso—Art as Autobiography* (Chicago: The University of Chicago Press, 1980) and "The Meaning of Artistic Form and the Promise of the Psychoanalytic Method, *Art Criticism*, 1986, vol. 3:2, pp. 1–16.
- See the "Chronology" section, pp. 82-85, of the 1980 catalogue (cited in note 7). In his 11. letter received on August 25, 1987, the artist noted: "I, too, find it inexplicable that I led you to believe that I had begun the disaster series before meeting George.... Now, what may have caused me to lead you to think I was claiming to have started them before George was this: I had completed two paintings before I met George which made the 'disaster' paintings possible." The letter continued with a lengthy discussion of these innovative works that enabled him to eliminate the ground plane and portray movement, elements that became prime features of the disaster pictures. Brown also described the "real 'disaster' pictures" as following directly after the creation of Auroral Drapery, whereas I had mistakenly assumed that this picture formed part of that series. His expanded account of the disaster paintings also emphasized the important role in their genesis played by the innovative new Chicago theater productions that Brown and Veronda regularly began to attend together soon after their meeting. Seeing these productions inspired the artist "to want to depict buildings as isolated actors against a solid backdrop, and my idea was to have the buildings moving, rather than static as I have always presented them before."
- 12. But Brown's stylized clouds also reflect his interest in the art of Georgia O'Keeffe, whose Sky above Clouds, IV, 1965, is in the collection of the Art Institute of Chicago. Brown described his Georgian Overview, as "a take-off on Georgia O'Keeffe's cloud paintings, plus a trip I had taken to Atlanta, Georgia . . ."
- 13. I regard the fact that Brown selected the photo of himself in the jeep his father had constructed for inclusion in the *Autobiography* as an indication of the special significance of this toy, and perhaps other similar objects crafted by his father as well, for the artist's creative life.
- 14. Exhausted by the physical and mental effort involved in the conversion of the Halsted Street studio-residence, the artist felt that he just had to "get away" for a while and embarked on one of those marathon driving trips which he unaccountably finds relaxing. When he got to New Mexico he immediately felt very attracted to the region (which he had actually visited briefly once before) and its artistic possibilities, but also torn by his ties to Chicago and Veronda. With the latter's encouragement, Brown decided to establish a studio in Albuquerque, where he remained for three months while creating the crucifixion series. It should be noted that the connection I make between the iconography of these pictures and that of the 1972 disaster series occurred

254 Mary Mathews Gedo

to me as an afterthought and did not form part of the version of the manuscript that Brown read; I do not know what his reaction to my proposed connection between the two series might be.

- 15. The residence and studio consist of two adjacent but separate buildings. Although such a plan is not at all uncommon, it also recalls the living arrangement the artist knew from early childhood, when he lived with his grandmother and mother in a dwelling immediately adjacent to that of his great-grandmother.
- 16. Brown recalled that *Cancer* was one of the first pictures he painted after learning that Veronda had a malignancy. Despite his own distress, the architect accepted this "pretty horrible painting" with equanimity, commenting, "Well, you have to do that." This interchange touchingly reveals Veronda's empathy for his painter companion.
- 17. Brown had experienced the frightening storm memorialized in *Agoraphobia* during his 1975–76 sojourn alone in New Mexico. His visual and verbal associations to that period during the weeks immediately following the death of Veronda support my speculation that the crucifixion series somehow referred to the latter, just as the earlier disaster series had seemed to do.
- 18. As one might anticipate, the artist's productivity declined significantly during the months following Veronda's death. Brown recalls that the summer of 1984 constituted a particularly sterile period for him. However, in the absence of a complete catalogue raisonné of the artist's oeuvre, I have not attempted any detailed comparisons of his production during these months and his usual level of creativity.
- 19. For more extensive comments about this point, see the essay on "The Meaning of Artistic Form" (cited in note 10).
- For an interesting discussion of the artist as priest, see A. W. G. Poseq's essay, "Five Allegorical Self-Portraits of Igael Tumarkin," in the *Journal of Jewish Art*, 1986–87, vol. 12–13, p. 335.

Artist Envy

DONALD B. KUSPIT

There is no denying psychoanalysis' fascination with the artist as a "special case." As the psychoanalyst John Gedo has shown, by now the "artist type" has been put through every conceptual and theoretical apparatus invented by psychoanalysis.¹ Typically, these studies reflect more about the character of psychoanalysis, and about its attitude to the artist and by implication to art, than they tell us about the nature of making art, or about the psychological reasons for making art rather than doing something else. And when they do engage works of art they have almost always regarded them as self-reflexive, symbolic acts of the artist's psyche rather than as possessing, despite their case-historical dimension, a creative integrity of their own.

For someone in whose life the arts play a serious part—without necessarily being fetishized or overidealized—the whole psychoanalytic understanding of art seems far removed from the experience of it. For example, although that experience is not exclusively esthetic, and certainly has a strong psychological dimension, over and beyond that dimension is a sense of creative reconstruction and reconsideration of reality that is often missed from the psychoanalytic viewpoint. Because of this felt discrepancy between the psychoanalytic approach to art and art's self-understanding, many artists have been reluctant to accept the psychoanalytic gambit toward art as even minimally heuristic. This is more than the common resistance to analytic understanding, more than the patient's repression of his or her inner life. It is a defense of art against what seems to be a misunderstanding of it committed by people with no real conviction in it. To the

Copyright © Artforum, November 1987, "Artist Envy," Donald Kuspit. Reprinted with permission of Artform and the author.

artist, the psychoanalyst adds a twist to the conventional, vulgar attitude to art, the view of art as at best a fortuitous pleasure and more often as the symptom of a maladaptation to reality. Thus it makes sense for the artist to resist psychoanalysis as a threat to his or her very existence: if art is a symptom, surely the cure would mean the elimination of art. This is the artist's understandable anxiety, but clearly there are many misunderstandings between the two fields, and many points to the paradoxical story.

Successful psychoanalysis really wants to liberate psychic energy, which is essentially creative, from its bondage in symptoms. It has no intention of hindering the artist from making his or her art but rather recognizes that art is a major indicator of creativity, and thus of health. It respects art as a civilized and civilizing source. It sees that if the artist does not live up to his or her own artistic potential, that may be because of common place or specific psychic dysfunctions, and it seeks to free the artist-and the art-from those dysfunctions. As Susan Deri remarks, though psychoanalysis "can elicit patients' authentic form-creative potentials and liberate them from functioning under the auspices of a 'false self' and from repetitious fixation on the traumatizing aspects of the past," it "cannot produce artists."² The good psychoanalyst recognizes this, and deals with the artist's person, and, no doubt, with the meaning to that person of being an artist. Sometimes, during the analytic process, people whose calling is not art may indeed opt not to be artists. In fact, psychoanalysis may strengthen the commitment of convinced artists to their art in the face of "realistic" odds, and it may help them understand more clearly the goals of their art.

In general, however, both psychoanalysts and artists, each in their different ways, have repeated W. B. Yeat's idea that perfection of the life or of the work is possible, but not both. As Ellen Handler Spitz has pointed out, psychoanalysis generally follows Plato in believing that the artist's psychopathology, or "madness," is intense and intractable, "inspiring" him or her to art yet making for a damaged life.³ But psychoanalysis is not alone here; many people follow Plato in this view. This preconception has led to the psychoanalytic correlation of art and madness, a correlation with profound implications yet also a great potential for shallow misuse. Psychoanalysis often seems to suggest that art does not so much overcome madness as intricately reflect it, and that the artist has a more intimate, aware experience of madness than any other human type, apart from the outright mad.

The considerations stretched out so far here on the relations of art and psychoanalysis could take off in a seemingly infinite number of possible examinations of this intricate theme. One could, for example, examine why psychoanalysts seem more attracted to grand literary figures such as Sophocles, Shakespeare, and Goethe than to visual artists, despite the fact

that the most influential psychoanalytic theorizing on art is to be found in Freud's essays on Leonardo and Michelangelo. For Freud, despite his extensive citation of literary artists, visual artists seemed ultimately more interesting, because the visual medium resembles the dream more than the literary narrative does. One could also write about why certain artists hold a special interest for psychoanalysts-why in visual art. for example, expressive, angst-driven work tends to attract more analysis than the Duchampian "art about art" tradition. Or one could proceed through the vast jungle of psychoanalytic literature on art, acknowledging its brilliantly ingenious interpretations here, its peculiar insensitivity to art and artists there. A number of extraordinary examinations of particular artists have been written, such as that of Goethe by Kurt Eissler, of Michelangelo by Robert Liebert, and Freud's own on Leonardo. A number of writers have in fact worked their way critically through this literature: among the most interesting recent discussions are those by Gedo, Spitz, and Elizabeth Wright.⁴ These are all important topics. They are not, however, the raison d'être of this essay.

Since its birth, psychoanalysis as a branch of knowledge has been fascinated with the figure of the artist. And basically for just as long, paradoxes have pervaded its discourse on artists. On the one hand the artist has been the model, as it were, for the healthy human being, the person whose mysterious ability to create is made concrete and actual. But the artist has also been seen as more fixated on infantile or primitive processes, in effect more traumatized, than other people. The paradox echoes the psychoanalyst's ambivalence toward the artist, and ambivalence is the tip of the iceberg.

Freud's term for his inquiry of 1910 into the unconscious of Leonardo was "pathography," and as Spitz points out, "pathography implies writing about suffering, illness, or feeling, with important overtones of empathic response on the part of the author for his subject."⁵ While Freud never claimed psychoanalysis could "give an account of the way in which artistic activity derives from the primal instincts of the mind," and asserted that "pathography does not in the least aim at making the great man's achievements intelligible,"⁶ the fact is that pathography was the jumping-off point for the development of a theory of artistic creation. Moreover, by reason of its empathic character, pathography implies the special energy—the energy of identification—with which psychoanalysts have pursued artists.

This relationship has many levels. It began in the early days of psychoanalysis, and its roots are partly historical. Psychoanalysis then was deeply suspect intellectually, and unacceptable socially, while art, even if often controversial, was an ingrained, time-honored part of culture. Psychoanalysts saw artists as more socially acceptable than they themselves, yet they also recognized artists as outsiders like themselves. Psychoanalysts also defined themselves as a kind of artist, masters of the "art of interpretation," as Freud called it.⁷ The identification persists today, though the social condition of psychoanalysis has changed. Like most identifications, this one involves admiration, empathy, and envy, both the desire to incorporate in oneself a quality one is drawn to in someone else and an uneasy, often unconscious feeling of one's own lack of that quality. At the same time, such "artist envy" is balanced by the most ordinary psychoanalyst's unconscious feeling of superiority to the greatest artist, for psychoanalysts see themselves as using the art of interpretation to apply a scientific understanding of the psyche—see themselves as scientists as well as artists. To scientists, after all, art is a way not so much of gaining new knowledge as of expressing in socially novel ways the already known: it is science that they believe to be the field of true discovery. Thus to the psychoanalyst's artist envy is added the scientist's implicit contempt for the artist, going back, at least to Plato's banishment of poets from the Republic and his degradation of art as inferior knowledge—an illusion of knowledge hardly worthy of the name.

Freud praised Michelangelo as an "artist in whose works there is so much thought striving for expression," an artist who "has often enough gone to the utmost limit of what is expressible in art." Yet Freud's talk of "the obscurity which surrounds his work" cannot help but imply that Michelangelo has not expressed enough.⁸ And this extends to the idea that he has not understood enough: how could he have, when obscurity is endemic to his art, and to art in general. The implication is that Michelangelo's art does not express as much as artful yet scientific psychoanalytic interpretation, which is devoted to eliminating the obscurity surrounding the workings of the human psyche.

Freud admired the playwright and novelist Arthur Schnitzler, who seemed to Freud to intuit truths about the psyche that he himself only discovered through laborious scientific work with patients. Similarly, in his essay "Fear of Breakdown" D. W. Winnicott writes, "Naturally, if what I say has truth in it, this will already have been dealt with by the world's poets [artists], but the flashes of insight that come in poetry [art] cannot absolve us from our painful task of getting step by step away from ignorance toward our goal."9 Psychoanalysis, then, has to struggle for its revelations, while art, whatever the inadequacy of its expressions, achieves its understanding spontaneously, at least in this view. (It is, however, referred to as just a "flash," and in practical opposition to the idea of actually getting away from ignorance.) This supposed disparity is one source of the psychoanalyst's envy of the artist, but an even more crucial issue than that of intuition is relevant here. In a letter to Oskar Pfister, a pastor and psychoanalyst, Freud took his correspondent to task "for being 'overdecent' and insufficiently ruthless to his patient," and advised him "to behave like the artist who steals his wife's household money to buy paint and burns the furniture to warm the room for his model."¹⁰ It is revealing here that Freud justifies the necessary "coldness in feeling in the analyst"¹¹ that he recommends elsewhere by allusion to the artist, and the artist's hypothetical criminality. An apocryphal story—told by an anonymous psychoanalyst—illustrates this supposed criminal coldness; the sculptor Benvenuto Cellini, casting a statue, is said to have needed some calcium for the bronze alloy, and, finding none in the studio, to have thrown a little boy into the pot for the calcium in his bones. "What was the life of a little boy to the claim of art?"¹²

On more or less the same subject, in a telling passage on the artist in his article "Psycho-Analysis and the Sense of Guilt" (1958), Winnicott writes,

It is interesting to note that the creative artist is able to reach to a kind of socialization which obviates the need for guilt-feeling and the associated reparative and restitutive activity that forms the basis for ordinary constructive work. The creative artist or thinker may, in fact, fail to understand, or even may despise, the feelings of concern that motivate a less creative person; and of artists it may be said that some have no capacity for guilt and yet achieve a socialization through their exceptional talent. Ordinary guilt-ridden people find this bewildering; yet they have a sneaking regard for ruth-lessness that does in fact, in such circumstances, achieve more than guilt-riven labor.¹³

The tough-minded, amoral attitude that Winnicott finds in the artist is found professionally essential and admirable in psychoanalysis. It is the attitude that the psychoanalyst must maintain in his or her practice, an attitude that Freud, in a famous metaphor, compared to that of a surgeon.¹⁴ Guiltless ruthlessness is often presented in the service of a higher cause (perhaps its quintessential sign), whether for art or for psychoanalysis. But psychoanalysts usually imagine that through their silence and science they outdo the artist in coldness, raising themselves over the artist, just as the artist, in this view, is assumed to be higher than the ordinary, less creative person. The psychoanalyst, I would argue, is envious of the artist—for reasons inherent to the nature of psychoanalysis and art—and this envy informs the psychoanalytic understanding of the artist.

In her brilliant analysis of envy, Melanie Klein describes it as "the angry feeling that another person possesses and enjoys something desirable—the envious impulse being to take it away or to spoil it."¹⁵ Furthermore, as Klein points out, envy tends to feed on itself, to increase by its own momentum; and so, as the artist becomes more envied, he or she becomes at once more begrudged. The psychoanalyst envies the artist's guiltless ruthlessness, and at the same time wants to spoil it by analyzing it as a defect in humanity. (In doing so, of course, the analyst, who sees in the artist's supposed ruthlessness his or her own, raises the question of his or her own defectiveness—another troubling unconscious recognition.) Part of that spoiling is to conceive the artist as amoral. Excessive envy is especially pernicious, for it tends to devalue what it envies. As Klein says,

The fact that envy spoils the capacity for enjoyment explains to some extent why envy is so persistent. For it is *enjoyment* and *gratitude* to which it gives rise that mitigate destructive impulses, envy, and greed. To look at it from another angle: greed, envy, and persecutory anxiety, which are bound up with each other, inevitably increase each other. The feeling of the harm done by envy, the great anxiety that stems from this, and the resulting uncertainty about the goodness of the object, have the effect of increasing greed and destructive impulses.¹⁶

The envy of psychoanalysts for artists has often led them toward skepticism of it, an eternal nagging doubt that it can ever really be wholly authentic as an endeavor. Their skepticism is mitigated by their appreciation of art's power to describe human beings and human ideas and emotions, and to convince society of the validity of its descriptions, but their ambivalence toward art makes their appreciation of it more disturbing rather than less. Their position resembles, in Klein's words, the criticism of "the envious patient [who] grudges the analyst the success of his work," and who even comes to doubt the validity of the analytic enterprise as such.¹⁷ Psychoanalysis can devalue the artist's work the way this kind of patient's criticism can devalue the psychoanalyst's work. As Klein says, "There are very pertinent psychological reasons why envy ranks among the seven 'deadly sins."¹⁸

The psychoanalyst claims a power of resurrection greater than that of the artist, far greater, in fact, since from the psychoanalytic perspective the resurrection offered by art, however ecstatic, is a deceptive, transient high, the fraudulent illusion of healing rather than its reality. Envy of the artist's guiltless ruthlessness is only a part of the psychoanalyst's anxious, envious "understanding" of the artist. The analyst cannot help but envy the artist, who supposedly lets his or her sense of omnipotence run loose, and may even use it as the emotional basis of creativity. The psychoanalyst has to confront his or her own sense of omnipotence—or, as Winnicott calls it, the "area of omnipotent control"¹⁹—since it may threaten the patient, whose feeling of vulnerability is a sine qua non of the psychoanalyst's work. As Freud wrote in *Totem and Taboo* (1912), in a chapter entitled "Animism, Magic and the Omnipotence of Thoughts,"

In only a single field of our civilization has the omnipotence of thoughts been retained, and that is in the field of art. Only in art does it still happen that a man who is consumed by desires performs something resembling the accomplishment of those desires and that what he does in play produces emotional effects—thanks to artistic illusion—just as though it were something real.

People speak with justice of the 'magic of art' and compare artists to magicians. But the comparison is perhaps more significant than it claims to be. There can be no doubt that art did not begin as art for art's sake. It worked originally in the service of impulses which are for the most part extinct today. And among them we may suspect the presence of many magical purposes.²⁰

What astonishes Freud is the way the artist can be socially operational and successful yet retain intact the antisocial narcissistic principle of omnipotence of thought. But the artist, of course, is not entirely narcissistic. Works of art, Freud writes, "differed from the asocial, narcissistic products of dreaming in that they were calculated to arouse interest in other people and were able to evoke and to gratify the same unconscious wishes in them [as in the artist] too." While "the artist, like the neurotic, had withdrawn from an unsatisfying reality into [the] world of imagination . . . unlike the neurotic, he knew how to find a way back from it and once more to get a firm foothold in reality."²¹ In the end, however, Freud must repudiate art in the name of science, and he does so in the last chapter of the New Introductory Lectures on Psycho-Analysis (1933). Here, declaring "religion alone" as science's "really serious enemy," he dismisses art as "almost always harmless and beneficent, [for] it does not seek to be anything else but an illusion. Save in the case of a few people who are, one might say, obsessed by Art, it never dares to make any attacks on the realm of reality."22 (Freud's description of such an art-obsessed person is worth quoting in this context: "A clever young philosopher, with leanings towards aesthetic exquisiteness, hastens to twitch the crease in his trousers into place before lying down [on the couch] for the first sitting; he reveals himself as an erstwhile coprophiliac of the highest refinement, as was to be expected of the developed aesthete."23)

Behind psychoanalysis' envy of art lies the fact that the psychoanalyst is afraid of becoming the same kind of dealer in illusion-"confidence man"-that he or she believes the artist to exemplify. Psychoanalysis is haunted by the thought that it may be an inauthentic science (as, in fact, has been cogently argued²⁴). As long as this suspicion remains, psychoanalysts cannot help but unconsciously fear that they are illusionists like artists. To psychoanalysts, art's magical illusions have their value, but they are a form of subjective expression, no doubt with piecemeal insights but lacking genuine, scientific validity. (Since Freud, psychoanalysis has of course been reconceived by philosophers as a hermeneutics and phenomenology of the dialectics of feeling, its "scientism" supposedly being a selfmisunderstanding. This view aims to overcome the idea that the only legitimate kind of science is modeled on one kind of supposedly solid knowledge. At the same time, it tilts psychoanalysis toward art, which, like psychoanalysis, can be regarded as an interpreter of the illusions inherent in life, it by way of the creation of "counter-illusions.") However, psychoanalysis,

while wanting to free itself and us of illusions, knows that the life-world is pervaded by them; understands that because we are always in a condition of projecting our unconscious expectations on the world we are always in a condition of illusion; knows that they must be perpetually worked through. Authentic psychoanalysis, like authentic avant-garde art, is premised on enormous dissatisfaction with, even disbelief in, existing psychosocial illusions; but it is aware that the truth with which it replaces them is another kind of illusion that is also all too artistic. Thus, for all its disdain of illusion, and its fear of being regarded as merely art, psychoanalysis in effect finds itself in a kind of dependent relationship with art. It knows it needs knowledge of illusions in all their various cultural manifestations.

This awareness is implicit in Freud's avant-garde proposal that in "a college of psychoanalysis, . . . analytic instruction would include branches of knowledge which are remote from medicine and which the doctor does not come across in his practice: the history of civilization, mythology, the psychology of religion and the science of literature. Unless he is well at home in these subjects, an analyst can make nothing of a large amount of his material."²⁵ Freud implies an essential relationship between psychoanalysis and art, one that gives psychoanalysis access to art's insights licenses psychoanalysis to bring up from the artistic netherworld such ideas as those embodied in the very name of its perhaps most salient discovery, the Oedipus complex.

A major formulation of this "dependent" relationship between art and psychoanalysis is Heinz Kohut's "hypothesis of artistic anticipation," which gives the "great artist" credit for being "ahead of his time in focusing on the nuclear psychological problems of his era,"26 but argues that "the investigative efforts of the scientific psychologist"²⁷ comprehensively and coherently realize the goal of understanding that the artist recognizes only intuitively. Winnicott says something similar when he remarks that "the intuitive flashes of the great, ... and even the elaborate constructs of poets and philosophers, are lacking in clinical applicability," and that psychoanalysis makes scientifically and usefully available-clinically operational—"much that was previously locked up" in such intuitive flashes.²⁸ In the very act of praising artists for their intuitions, Kohut and Winnicott dismiss them by regarding them as "anticipatory" but inoperational in the actual circumstances of life or therapy. They credit the artist, the object of envy, who is acknowledged as offering the seminal intuitive flashes that start thought moving, but they also claim that these insights are impractical in the end, remaining merely "artistic."

One last word about the psychoanalyst's envy of the artist, particularly the visual artist. For Freud, visual art is necessarily more erotic than literary art, since after touch the visual is the major medium of communication of sexual excitement and ideas.²⁹ For the psychoanalyst, the visual

in general is more primitive than the verbal, particularly because it implies "the earliest closeness with the mother in the pre-verbal state," the "understanding [that] needs no words to express it."³⁰ Thus more sexual pleasure lies in the visual artist's work than in that of the psychoanalyst, who works in words, and is a kind of literary artist. To the analyst, the visual artist seems closer to the source of primal enjoyment than the literary artist. This is another reason for the psychoanalyst's confused attraction to the artist: the analyst suspects that it is in the very nature of art's effort that it can establish an enviable state of preverbal closeness with the viewer. The analyst desires this state, for preverbal closeness is the optimum condition toward which the relationship between patient and analyst drifts, a regressive condition reparative of the damage each does to the other by reason of each's unconscious envy of the other. As in Kafka's A Country Doctor, the psychoanalyst in effect must empathetically lie on the couch with the patient. Without that empathy, the analyst will not be cured of his or her delusion of omnipotence. (Empathy takes one out of that delusion.) Nor will the patient be cured, since he or she needs the analyst as a part of him- or herself. Perhaps the final reason for the psychoanalyst's envy of the artist is that the artist seems spontaneously to have this empathy or unconscious closeness with his or her public, or at least creates the illusion of having it. Just as psychoanalysis has worked woman's "penis envy" into the ground, up pops its own artist envy.

Notes

- John E. Gedo, *Portraits of the Artist*, New York: Guilford Press, 1983, section 1, pp. 1–40.
- Susan K. Deri, Symbolization and Creativity, New York: International Universities Press, 1984, p. 346.
- 3. Ellen Handler Spitz, Art and Psyche, New Haven: Yale University Press, 1985, p. 28.
- 4. Gedo and Spitz are cited above; Wright is Elizabeth Wright, *Psychoanalytic Criticism: Theory in Practice*, London and New York: Methuen, 1984.
- 5. Spitz, p. 28.
- 6. Quoted in ibid.
- Among other places, Freud alludes to the "art of interpretation" in "Further Recommendations in the Technique of Psychoanalysis" (1914), collected in Philip Rieff, ed., *Freud: Therapy and Technique*, New York: Macmillan Publishing Co., Inc., Collier Books, 1963, p. 158.
- 8. Sigmund Freud, "The Moses of Michelangelo" (1914), collected in Rieff, ed., Freud: Character and Culture, New York: Collier Books, 1963, p. 106.
- 9. Quoted in Murray Cox, Structuring the Therapeutic Process: Compromise with Chaos, Oxford, England: Pergamon Press, 1978, pp. 280–81.
- Quoted in Janet Malcolm, Psychoanalysis: The Impossible Profession, New York: Alfred A. Knopf, Borzoi Books, 1982, p. 80.
- 11. Freud, "Recommendations for Physicians on the Psychoanalytic Method of Treatment" (1912), in *Freud: Therapy and Technique*, p. 121.

- 12. Malcolm, p. 80.
- D. W. Winnicott, "Psycho-Analysis and the Sense of Guilt" (1958), *The Maturational Processes and the Facilitating Environment*, New York: International Universities Press, 1965, p. 26.
- 14. Freud, "Recommendations for Physicians on the Psychoanalytic Method of Treatment," p. 121. Freud wrote: "I cannot recommend my colleagues emphatically enough to take as a model in psychoanalytic treatment the surgeon who puts aside all his own feelings, including that of human sympathy, and concentrates his mind on one single purpose, that of performing the operation as skilfully as possible." Such "coldness in feeling," he said, "is the condition which brings the greatest advantage to both persons involved, ensuring a needful protection for the physician's emotional life and the greatest measure of aid for the patient that is possible at the present time." That is, "coldness" represses the psychoanalyst's own psychopathology so that he or she can fully attend to the patient's.
- 15. Melanie Klein, "Envy and Gratitude" (1957), Envy and Gratitude and Other Works 1946–1963, New York: Macmillan Publishing Co., Inc., Free Press, 1984, p. 181.
- 16. Ibid., pp. 186-87.
- 17. Ibid., p. 184.
- 18. Ibid., p. 189.
- Quoted in Arnold H. Modell, "Object Relations Theory," in Arnold Rothstein, ed., Models of the Mind: Their Relationships to Clinical Work, New York: International Universities Press, 1985, p. 97.
- Freud, Totem and Taboo, New York: W. W. Norton & Company, Norton Library, 1950, p. 90.
- Freud, An Autobiographical Study, New York: W. W. Norton & Company, Norton Library, 1963, pp. 122–23.
- Freud, New Introductory Lectures on Psycho-Analysis, New York: W. W. Norton & Company, 1933, p. 219.
- 23. Freud, "Further Recommendations in the Technique of Psychoanalysis," p. 151.
- 24. See Adolf Grünbaum, *The Foundations of Psychoanalysis, A Philosophical Critique*, Berkeley: University of California Press, paperback edition, 1985.
- 25. Quoted in Peter Loewenberg, "Why Psychoanalysis Needs the Social Scientist and the Historian," in Geoffrey Cocks and Travis L. Crosby, eds., Psycho/History: Readings in the Method of Psychology, Psychoanalysis, and History, New Haven: Yale University Press, 1987, p. 30. More recently, Richard Chessick has made a somewhat similar recommendation: see his "Education of the Psychotherapist," Why Psychotherapists Fail, New York: Science House, 1971, pp. 35–49.
- Heinz Kohut, The Restoration of the Self, New York: International Universities Press, 1977, p. 285.
- 27. Ibid., p. 296.
- 28. Winnicott, p. 15.
- 29. Freud, "Three Essays on the Theory of Sexuality" (1905), *Standard Edition*, vol. 7, p. 156.
- 30. Klein, p. 188.

²⁶⁴ Donald B. Kuspit

PART SIX

Marginality and the Other

It is a sign of our times that what was once considered private and personal (e.g., religious belief, sexual preference, cultural and ethnic background, personal tragedy, and illness) has now moved to center stage as an important part of the wider public discourse, something clearly visible from tabloids to talk shows. In this environment, questions of personal identity and individual difference have assumed major significance with the result that the boundary between public and private persona has virtually disappeared. Similarly, in the realm of theory, the idea of a cohesive, autonomous self has been under attack for over a decade, while the belief that the subject has multiple identities belonging to different "communities." often with competing allegiances and interests, is now being given priority.¹ And, whether the identities in question be political/economic, ethnic/racial, or class/gender, they all are believed to be, at least in part, social constructions rather than strictly natural formations. These social constructions, in one sense or another, involve the body and, by extension, its representation. Because of this, questions of difference and identity formation are being framed around issues of cultural representation in order to understand how the portraval of any group in the media, visual art, literature, history, etc., affect that group's identity and position in society. Questions such as "Who has power?" "Who speaks as the dominant voice?" "Who is relegated to the margins of society as the 'Other'?" have now become central to discussions of cultural representation regarding race, gender, and power in American society.

By the late 1980s, all these questions seem to have coalesced under the rubric "multiculturalism" as an alliance, at least in principle, of women, gays, and ethnic and racial minorities. One of the most contentious and pervasive topics in the debate about identity, multiculturalism is not a monolithic whole, but is a complex of attitudes and ideas first framed primarily around issues of ethnicity and race. In the area of education, multiculturalists raised questions about the value of bilingual teaching, how to include a wider range of non-Western perspectives and cultural topics in the curriculum, and the value of popular culture in relation to the so-called canon (those works of Western art and literature considered to be masterpieces). On another level, besides addressing the basics of curricular reform, some multiculturalists also focused on the idea of role models as a way to promote self-esteem and achievement among minority students. If teaching and administrative staff include minorities, it is argued, minority students will view them as exemplary role models: this will foster selfesteem in minority students and lead to greater achievement.² In a more controversial form, other multiculturalists argue that, since teachers are role models, they should be required to meet ethnic and racial qualifications before being allowed to instruct certain subjects. This argument, which also maintains that only ethnic/racial minorities are capable of understanding and teaching "ethnic/racial" subjects, has been broadened to include gender requirements for "gender-sensitive" subjects as well. Academically, the unfortunate result of this has been to shift attention away from scholarly competence and the requirements of the discipline being taught.

As these arguments have gained greater sway in academia, they have led to the enactment of constitutionally questionable speech and conduct codes and the requirement of "sensitivity training" courses directed mainly at white males. Because of such actions, multiculturalism has become highly politicized in many educational institutions and in much of the national media where it has been characterized as "politically correct" thinking and behavior and the product of tenured '60s-style radicals. This politicization has encouraged both proponents and antagonists of multiculturalism to bring educational and cultural issues into a debate that has related them to a much wider range of topics including affirmative action, hiring quotas, entrance qualifications, performance standards for achievement and promotion, welfare reform, even illegal immigration, postcolonialism, and United States foreign policy toward Third World nations including those of Africa and Latin America.³

Despite being politicized in this way, multiculturalism has become important within the arts and humanities by continuing to broaden the theoretical/critical and practical/artistic examination of the role of culture in the formation of identity. However, even here much controversy surrounds it. This is because in some forms multiculturalism rejects not only the quotidian failures of Western society (e.g., racism and sexism), but also its more idealistic intentions in favor of cultural segregation. It is this multiculturalist doctrine that asserts that every minority has inherent rights to its own culture or subculture, to heroic narratives that provide it with its sense of self-esteem and empowerment, and that such cultures need to be better reflected or represented in (but not integrated or melted into) the larger dominant culture.⁴

This assertion, which the organizers of "The Identity in Question" symposium at *October* magazine called "simplistic," leads to an adversarial stance toward the larger culture that, in its extreme form, precludes any possibility of ever establishing a "culture of inclusion." In this extreme form, multiculturalism developed a binary system of oppositional thought identifiable with Structuralism and some forms of Marxist and feminist theory in which a category is defined by its opposite (e.g., "Capitalism is bad therefore Socialism is good" or "Patriarchy is bad therefore Matriarchy is good"). This extreme ideological model of multiculturalism maintains the West is a corrupt monolithic whole with the non-West as its opposite.⁵ The result, as the organizers of "The Identity" symposium have pointed out, has

led to a rejection of Eurocentrism, and indeed of a Western cultural tradition thought to be inherently riven with racism, sexism, heterosexism, and imperialism, a civilization whose truth lies alone with those it has excluded or marginalized.⁶

This view does not seek to accommodate factual historical evidence, in part because of the belief that history itself is a social construction and in part because the promotion of a version of history that offers "heroic narratives" that can generate self-esteem has come to take precedence over other concerns. The most contentious results of this have led to "heroic narratives" that intentionally locate non-Western cultures at the top of a hegemonic hierarchy rather than questioning the idea of hierarchy itself, something that is central to *true* multiculturalism and any culture of inclusion. For example, Senegalese writer Cheikh Anta Diop argues for an Afrocentricism in which, according to art critic Thomas McEvilley, ancient Egypt was in fact a black African society. And, by ignoring ancient Near Eastern influence, he

can assert that to black Africa belong the laurels of creating civilization in all its modes—artistic, scientific, governmental, literary, religious, mathematical, spiritual. It is European scholars, in the interest of European cultural hegemony, who have robbed Africa of the credit, falsely attributing it to the ancient Greeks.⁷

On the other hand, Indian writer Paramesh Choudhary proposes a similar "heroic narrative," but one that is Indocentric. In his narrative India plays the central role and Egypt is "merely a colony sent out from the Indus Valley, the Bronze Age culture of India." Both share an anti-Western position while presenting a hegemonic view of their own non-Western culture, though at the other's expense. Neither of these, as McEvilley points out, are actually true multicultural models, though they are oftentimes regarded as such. They are less interested in presenting a model for *shared multicultural interaction and coexistence* than in establishing monocultural dominance. What they reveal are some of the problems and pitfalls of ignoring factual evidence when using the "heroic narrative" approach to culture and identity formation.⁸

A more fruitful and important result of multiculturalist developments has been the examination of identity formations and the issue of representation, especially visual representation in the art museum. As a site where "representation" takes place and narratives are played out, the art museum is now viewed as not only the place where fine art culture is displayed, but more importantly, a place where "cultures" meet, abut, and clash in attempts at validation within the larger, dominant society. Focus on the museum began with feminists who first questioned museum exhibition policies pointing out the exclusion of women artists from museum group exhibitions and retrospectives.⁹ Also, following recent Marxist theory, feminists explored the idea that one of the most important ways in which the self is constructed is through representation in fine art, literature, advertising, and popular culture. In doing this they examined how political power operates by using such representations, especially literary and visual images of women, to construct a socially acceptable identity for women. Multiculturalism has built on this line of thinking, even using the more extreme feminist notion that all power is held by white, heterosexual, Eurocentric males; therefore everyone else—including women, children, gays and lesbians, and all ethnic and racial minorities-must be marginalized on the fringes of society as the "other." The erasing of such margins or boundaries, one of the main goals of multiculturalism, has allied it to feminism and the gay liberation movement leading curator Lowery Sims to identify the "ubiquitous 'other' in society [as] . . . women, gays, and 'hyphenated' Americans of African, Latin, Asian, and Native descent."10

While feminism has been important in terms of representation, it is multiculturalism that has been the most instrumental in calling into question the nature of art and the art museum. The Western art museum has evolved, as art historian Svetlana Alpers has noted, as a place to exhibit visually interesting objects. Unfortunately, as she also points out, "some cultures lack artifacts of visual interest"; but, she hastens to add, "cultures are not the sum of their materials."¹¹ However, multiculturalists disagree and argue that all cultures must be given equal representation in the art museum. This position, which stems from the desire to ensure opportunities for excluded minority artists, has been bolstered by the belief that the very idea of quality in art (i.e., what is visually and aesthetically interesting) is itself a social construction and that museum representation gives validation to such constructions. These attitudes, which indicate the high status given to art in our society, have resulted in a questioning of the art museum's unique function, that of showing visually and aesthetically interesting objects. The effect has been to blur the lines between art/artifact and art museum/anthropological museum. When these attitudes are combined with the widely held idea that art cannot be socially responsible unless it is overtly political, the differences between art and propaganda are blurred and the value of aesthetic quality and artistic form are called into question.

Many of these issues gained wide public attention with the Museum of Modern Art's 1984 exhibition "Primitivism in 20th-Century Art: Affinity of the Tribal and the Modern." Organized by William Rubin and Kirk Varnedoe, the show was attacked for de-contextualizing "primitive" art in order to emphasize the abstract formal elements "primitive" art shares with Modern art. The idea that cultural background was not necessary for aesthetic appreciation, McEvilley and anthropologist James Clifford argued, universalized Western formalism as a transcending aesthetic principle shared by all art, regardless of its origin or maker.¹² The show also tended to suppress what Clifford called "the concrete existence of tribal cultures and artists" in order to present "authentic,' traditional worlds or of appreciating their products in the timeless category of 'art'."¹³ That is to say, the moment when a tribal culture is considered "authentic" is arbitrarily fixed at some point in the past suggesting that any recognition that they too change—whether from Western contact or not—would be to admit they are not timeless, but historical.

The 1989 "Magiciens de la Terre" exhibition at the Pompidou Center in Paris came to be called the "Whole Earth Show" because it included an equal number of artists from the First and Third Worlds, fifty from each. Organized by a team headed by Parisian curator Jean-Hubert Martin, they attempted to avoid the issues of de-contextualization, transcendental aesthetics, and hierarchical ranking associated with the "Primitivism" exhibition by simply identifying all works in a like manner regardless of maker, origin, type, or "artistic" intent. However, the show still became embroiled in controversy. The labels tended to homogenize what was vastly different work in terms of motivation and influences; the show's title also betrayed a Western romanticized view of Third World artists as primitive "magicians" connected to the earth. Added controversy erupted around the issue of artistic/aesthetic quality when Martin was interviewed by critic Benjamin H. D. Buchloh. When Martin said he would try to proceed to select artists by visual criteria (aesthetic quality?) alone, Buchloh retorted that the abstract concept of quality is "the central tool which bourgeois hegemonic culture (that is, white, male, Western culture) has traditionally used to exclude or marginalize all other cultural practices. . . .^{"14} Soon after in an article inspired by the show and provocatively titled "Is Quality An Idea Whose Time Has Gone?" *New York Times* critic Michael Brenson wrote that for some people the word "quality" now "links together form, European esthetics and white heterosexual male rule." He went on to defend the importance of aesthetic emotion, saying it "is an expression at once personal and impersonal, specific and general. It is rooted in the object but it also suggests something beyond the object. It suggests the depth of feeling and knowledge of which human beings are capable."¹⁵

Brenson's pleas that form is part and parcel to content and that in the art of all cultures "esthetic emotion" results from artistic quality have not really entered the dialogue. Instead, attitudes against artistic form and aesthetic quality have continued in multicultural debates about identity formation into the '90s, most visibly in "The Decade Show: Framework for Identity in the 1980s," organized in 1990 collaboratively by several New York museums, and the "1993 Biennial Exhibition" at the Whitney Museum of American Art which was framed around the theme of "Know Thy Self." In a sense, both shows pitted form and aesthetic quality against content by presenting what they considered art with content—i.e., art that raised politically sensitive subjects like AIDS, racism, poverty, sexism, and Western imperialism (cultural and otherwise); they did this through the *literal* use of photographs, artifacts, texts, and other documentary materials.

"The Decade Show," as Eunice Lipton describes it in the catalogue, is a "show of art by African Americans, Asian Americans, Latin Americans, Native Americans, gays, women, and more. At the very least such an exhibition . . . calls [European, white male] ethnocentricism into question." She goes on to say that "with its panoply of voices, forms, formats, and modes of address, the exhibition means to jolt spectator-certainties and unseat conventional forms of evaluation."¹⁶ About the "1993 Biennial Exhibition," David A. Ross, Whitney Museum director, wrote, artists weary of "cynical formalism" are insisting on "reinscribing the personal, political, and social back into the practice and history of art." He went on to describe our time as one heavy with "issues of nation and nationality, ethnic essentialism, cultural diversity, dissolution, and the *politics* of identity. . . .^{"17}

These are some of the issues addressed by curator Thelma Golden in her essay for the "Biennial" catalogue, which is reprinted here. Titled "What's White . . . ?" it discusses work in the exhibition in relation to the cultural/racial concept of "whiteness." To Golden, "whiteness" signifies power, and all difference—whether it be race, class, or gender—is "positioned as different from whiteness. . . ." Many works in the exhibition, writes Golden, are trying to "deconstruct and de-center the politically constructed site of whiteness, . . ." often using the body as a point of entry as in Byron Kim's *Synecdoche*. A grid of what appears to be mono-chromatic paintings, it is actually a collection of color swatches matching the skin tones of over 200 people. This work, says Golden, "operates as a collective group portrait, banishing notions of reductiveness implicit in terms like black, white, red, and yellow—words commonly used when discussing race." In *Lineup*, a work by Gary Simmons, "bronzed" sneakers are used to represent African-American men in a police lineup. According to Golden, it reflects the inequities of the criminal justice system for African-Americans, a system in which "questions of guilt, innocence, and due process become irrelevant, . . ." and justice a "farce." But also, because sneakers are signs of prestige and standing among ghetto youth, she sees this work as a critique of the "black on black" crime committed over them.

Among other relevant work, she cites Glenn Ligon's Notes in the Margin of the Black Book, a photo-and-text installation which uses Robert Mapplethorpe's Black Book (a collection of photographs of gay African-Americans) to identify with gayness as well as to critique the portrayal of blackness. Issues of gender and class are engaged by Karen Kilimnik in her drawings taken after the print media and in Shu Lea Cheang's performance-installation that explores individual notions of sexuality and desire through videos and dial-a-porn telephone conversations that museum visitors can initiate. Golden also cites Fred Wilson's installation Re: Claiming Egypt which she says deals with the African past by juxtaposing "Egyptian objects with African-American popular cultural materials that appropriate Egyptian imagery." What she only hints at is that the subtext of this work seems to support the controversial claims of writers like Cheikh Anta Diop for a hierarchical Egypto-Afrocentric view of history. Unlike Wilson's work, Daniel J. Martinez's work was intentionally confrontational; he changed the logo (WMAA) on the museum's admission buttons to read "I can't imagine ever wanting to be white." Spread over five buttons, visitors only became conscious of the text they were wearing when they saw the buttons of other visitors. This work, according to Golden, is about reversing "decades of negativism about all things not white."

While Golden's discussion of specific works often supports a kind of essentialism, one that stands in opposition to white, male, Western culture (what she calls "whiteness"), in her more theoretical passages her argument is more truly multicultural: "artists in the nineties have begun to fully deconstruct the marginality-centrality paradigm. Marginality, in effect," she says, "becomes the norm while the center is increasingly undefinable and perhaps irrelevant." Citing fellow "Biennial" essayist Homi Bhabha, she suggests the word "boundaries" be used instead of "marginality" since "boundary"

suggests the self-induced yet unfixed definitions that insinuate the multileveled associations which give communities breadth as well as specificity. One is not simply African-American, Native-American, Hispanic-American, Euro-American or Asian-American, but also male or female, straight or gay, rich or poor, urban or rural.

While this is something with which critic Eleanor Heartney would agree, she was not sure that the exhibition fulfilled these ideals. In her review of the "Biennial" titled "Identity Politics at the Whitney," which is reprinted here, she notes its intent to present a political art for the '90s by featuring artists concerned "with racism, sexuality, gender, ethnic identity and multiculturalism." About half the artists, as she points out, come from marginalized populations and their inclusion was part of a drive for social veracity; this drive was something Heartney saw reflected in their use of non-artistic "photographs, documentary material, texts, objects and artifacts charged with explicit social and political messages." In the most extreme instance, as she notes, "this literalism extended to the inclusion [as art?] of George Holliday's camcorder tape of the Rodney King beating...."

Heartney saw the politics of representation as one of the show's sustaining themes as artists explored questions such as "Who speaks for whom? How is identity constructed? How may marginalized groups muster the power to define themselves?" Although she gives credit to head curator Elisabeth Sussman for getting the Whitney to grapple with such issues. she laments the "strident tone that dominates this exhibition...." and the way "many of the most prominent works simply target the white male power elite as the source of all evil. They offer," says Heartney, "a litany of wrongs-among them neocolonialism, domestic violence and ethnic stereotyping-but because they do not transcend the dichotomy of victim/oppressor," these works seem unable to move "beyond the powerlessness of the victims to the possibility of action and change." An example is Pat Ward Williams's photo mural which features a group of black youths staring at the visitor "behind a scrawl of graffiti which demands, 'What you lookn at?" To Heartney it suggests racism "is best countered by the tactic of reciprocal intimidation." Another example is Fred Wilson's Re: Examining *Egypt*, which purports to critique the imperialistic practices of museums but, according to Heartney, actually seems to promote a dubious Afrocentric version of history.

Heartney was also disturbed by the "simplistic" attitudes toward sexism, racism, culture, and even childhood that many of the works made. While she found much good work in the exhibition, she also found troubling "the tendency of artists, curators and art educators to reduce contemporary art to the role of social work or therapy." This privileging of "social message over esthetic considerations" she saw as paralleling demands from the religious right. Ultimately, Heartney felt that, "instead of representing 'cultures at the borderlines,' as Homi Bhabha suggests in his catalogue essay, or the 'artworld . . . as a collectivity of cultures,' in Sussman's phrase, the 1993 Biennial ends up trivializing the notion of political art."

In "Circumventing the Center: Identity Politics and Marginalization," which is reprinted here, art historian Jennie Klein reviews several exhibitions that also engage issues of race, ethnicity, and gender. Of "Partial Recall," an exhibition of nineteenth and early twentieth-century photographs of Native-Americans initiated by critic Lucy Lippard, Klein commends Lippard for collaborating with several Native-American writers and artists; however, she raises concern about Lippard's "quasi-mystical and ahistorical approach . . . towards her 'subjects,' an approach that ultimately freezes them in Ur-time prior to the invention of writing." And, of Lippard's attempts to circumvent the barriers of culture in order to find commonalities between cultures, Klein wonders if this isn't another "universalizing approach towards the 'Other' that Lippard [at least in theory] seems eager to overturn."

Another exhibition, "La Frontera/The Border," presented similar issues, but framed them around the concepts of marginality, the border, and territorialization. In her catalogue essay, co-curator Madeleine Grynsztejn discusses the idea of border based on theories of bell hooks and Emily Hicks, cultural critics "who have advocated a conscious embrace of the margin as a means of countering dominant Eurocentric and patriarchal ideologies." To them, the border subject is "someone simultaneously deand reterritorialized, moving between inside and outside." Unfortunately, says Klein, these ideas didn't carry over into the exhibition. Too much of the work was simplistic, presenting "overly reductive treatments of the ways Mexican-Americans are stereotyped and/or brutalized by Anglo society" while carefully avoiding feminist, lesbian, and gay issues as they pertain to the Chicano community.

Many of the pitfalls of romantic essentialism and reductive politics were avoided in "Theater of Refusal: Black Art and Mainstream Criticism," an exhibition that attempted to create a dialogue about marginality. Organized and curated by Charles Gaines, "Theater" sought to explore the way "essential and marginalized identities are constructed" through art and criticism. The work Gaines selected, says Klein, is "deterritorialized work that does not so much offer a unified theory of ethnicity as it problematizes and is problematized by discourses of race." This is something typified by Adrian Piper's *Cornered*, a video work discussed by Gaines in his essay, but not in the exhibition. In this work Piper addresses the audience in a monologue that is meant to challenge, reinscribe, assert, and contradict stereotypical ideas upon which notions of race are founded.

"Counterweight: Alienation, Assimilation, Resistance" was similar to "Theater" in that it presented a variety of border subjects that, according to cultural critic Emily Hicks in her catalogue essay, "encompass multiple identities and multiple subject positions." However, "Counterweight"

274 Part Six

also viewed a border subject, as Klein writes, as one that "maintains an alienated stance in relation to both assimilation, or loss of identity, and an essentializing nationalism, or frozen identity." To this end the exhibition avoided obsessing on "victimization or straight-white-male bashing" and even raised gay and lesbian gender issues.

As these exhibitions show, cultural representations and identity formation are clearly important issues in our society. They also show how antagonisms, victimization, and romanticized notions about the "Other," notions that have been attacked as being essentialist views indulged in by the dominant culture, are also engaged in by the so-called marginalized. It is these contradicting attitudes that have made cultural representation a battleground in which individual identity, with all its continuously changing levels of complexity, is most often the victim. However, what these essays also suggest is that a more sophisticated conception of the self/identity is developing. This new conception-whether spoken of in terms of borders or margins-is based on the recognition that the individual self is actually a complex of many differing and even competing interests. These interests-cultural, ethnic/racial, political, sexual, economic, geographical, national, familial, etc.—all have a role in the formation of the individual and continue to share a place in the psychological make-up of what we call "the self."

Notes

- 1. While it is true that attacks on the autonomous self are occurring in the realm of theory (as the following essays show), in the "real" world of economic and political competition, marginalized groups often attempt to reconstruct the "new subject" as not only one in opposition to dominant culture, but also as one with fixed ethnic, racial, religious, or gender identities. The result remains an essentialist view of identity in which the individual is still stereotyped by a single characteristic of race or gender or religion or class.
- 2 Self-esteem theory argues that poor scholastic performance and behavioral attitudes are the result of poor self-esteem; thus the promotion of self-esteem through role models and "heroic narratives" is deemed essential to solving these problems. However, as reported by John Leo, recent studies like the Califormia Task Force on Self-Esteem suggest that there is little correlation between low self-esteem and failure to learn (see John Leo, "Self-Esteem Gurus Have No Magic Mantra," *Richmond Times Dispatch*, June 16, 1996, p. F5). Multicultural advocate Jim Sleeper argues that "a more enduring form of self-esteem [than simple ethnic identity and role model emulation] comes from personal achievement" (Sleeper quoted in Andrew Hacker, "Trans-National America," *New York Review*, Nov. 22, 1990, p. 21).
- 3. For a discussion of these issues and references to the literature, see Howard Risatti, "Culturally Correct Criteria," *New Art Examiner* (Oct. 1991), pp. 25–28.
- 4. See "Appendix," October (Summer 1992), p. 121. While symposium organizers John

Rajchman, Rosalind Krauss, and Stanley Aronowitz called this the "simplistic" version of multiculturalism, it unfortunately seems the most widely accepted one today.

- 5. Interestingly, the binary thinking inherent in this multicultural model leads to a stereotyping not only of the West as corrupt, but also of the non-West as a utopian, blissful paradise. Unfortunately, racism, imperialism, and sexism are hardly unique to the West as the ancient Egyptian invasions of the upper Nile and the Middle East, the Persian invasions of ancient Greece, the Islamic invasions of Egypt, North Africa, and Spain, the Aztec and Inca invasions in Pre-Columbian America, and the Mongol invasion of China indicate. Sadly, even closer to our own time are the massacres in Iran, Iraq, Uganda, Rwanda and Burundi, Tiananmen Square, Tibet, and the former Yugoslavia. These are all non-Western counterparts to Western imperialism.
- 6. "Appendix," October, p. 121.
- 7. Thomas McEvilley, "A Time To Choose," Artforum (Feb. 1992), p. 89.
- 8. McEvilley, "A Time To Choose," p. 90. It is worth pointing out in regard to Diop's argument that, beginning with the earliest art history survey text (Helen Gardner's *Art through the Ages*, 1926), ancient Egypt and the ancient Near East have always been presented as important cultures formative to the development of ancient Greece and, as a consequence, Western culture. What the arguments of Diop and Choudhary also betray is the all too common tendency in the wider culture to look to ancestral roots (i.e., someone else's achievements rather than our own) as vehicles for our identity formation.
- 9. As the Guerrilla Girls pointed out, from 1980 to around 1987, shows at the Guggenheim and Whitney Museums have been predominantly one-man shows, 52 to 2 and 51 to 4, respectively. For more on this see my "The National Museum of Women in the Arts," New Art Examiner (Summer 1987), pp. 25–27. Feminists also first raised questions about which works should comprise the canon of masterpieces of Western art and literature.
- See Lowery Stokes Sims, "Cultural Pluralism versus the American Canon: The Aesthetic Dialogue for the 1990s," *The Decade Show: Framework for Identity in the 1980s*, exhibition catalogue, Museum of Contemporary Hispanic Art, The New Museum of Contemporary Art, and The Studio Museum in Harlem, 1990, p. 141.
- Svetlana Alpers, "A Way of Seeing," *Exhibiting Cultures: The Poetics and Politics of Museum Display*, ed. Ivan Karp and Steven D. Lavine (Washington, D.C. & London: Smithsonian Institution Press, 1991), p. 30.
- 12. See Thomas McEvilley, "Doctor, Lawyer, Indian Chief," first published in Artforum (Nov. 1984) and reprinted in his Art and Otherness: Crisis in Cultural Identity (New York: McPherson & Co., 1992), pp. 27ff; see his endnotes, especially note 15, for more details of the debate. For Clifford, see his "Histories of the Tribal and the Modern," Art in America (April 1984), pp. 164ff.
- 13. Clifford, "Histories of the Tribal and the Modern," p. 171. The origin of the MOMA's position comes out of early Modernism's view of the primitive—following Rousseau's concept of the "noble savage"—as representative of the ahistorical, the timeless. Wanting to avoid the transience of the historical that was associated with the European academic tradition, Modernism sought a timeless Eden in the pre-historical past or in the ideal of a utopian future. Multiculturalists do something similar to the MOMA exhibition when they idealize things like "traditional culture" and "ancestral ways" as if they were somehow outside of history.
- 14. Benjamin H. D. Buchloh, "The Whole Earth Show, An Interview with Jean-Hubert Martin," Art in America (May 1989), p. 158. Echoing this in her book Mixed Blessings:

276 Part Six

New Art in a Multicultural America (New York: Pantheon, 1990), Lucy R. Lippard writes that "Ethnocentrism in the arts is balanced on a notion of Quality that 'transcends boundaries'—and is identifiable only by those in power. . . . The notion of Quality has been the most effective bludgeon on the side of homogeneity in the modernist and postmodernist periods, despite twenty-five years of attempted revision" (p. 7).

- 15. Michael Brenson, "Is Quality an Idea Whose Time Has Gone?" *New York Times*, July 22, 1990, Arts & Liesure, pp. 1 and 27.
- 16. Eunice Lipton, "Here Today. Gone Tomorrow? Some Plots for a Dismantling," *The Decade Show* catalogue, pp. 20 and 29, respectively.
- David A. Ross, "Preface: Know Thy Self (Know Your Place)," 1993 Biennial Exhibition, exhibition catalogue, Whitney Museum of American Art in association with Harry N. Abrams, Inc., New York, 1993, p. 9. Also in this catalogue see Lisa Phillips, "No Man's Land: At the Threshold of a Millennium," pp. 53ff.

What's White ...?

THELMA GOLDEN

A current commercial for a popular brand of beer poses the question "What's Hot?" The question is flashed across the screen in huge block letters and then jump cut with scenes of what its makers consider hot. The fast-paced visual images include a group of gyrating bikini-clad blondes, a water skier riding the crest of a major wave, and then, finally, a barrel chock full of sweating iced cans of the beer in question. Through its juxtaposition of image and text, the commercial answers its own question—this beer is hot. The viewer is left to equate the images shown with hotness. Objects of desire are simply displayed, the beer becomes one of these objects; the elusive (hotness is really "coolness") is attainable if you drink this brand of beer. Hot is heterosexual male desire, water sports, and a good cold beer.

If only all of life's burning questions were so easily answered or as blatantly asked. This moment in contemporary culture cries out for resolution of another pressing question—"What's White?" If Madison Avenue were to answer this question with a similar commercial, it would be hard to find visual images. This is because "whiteness" is a signifier of power. The meaning of whiteness actually encompasses very few people, including many who consider themselves white. So this commercial would have to encompass images that acknowledge whiteness as an embodiment of power. Perhaps George Bush, Bill Clinton (better yet, Al Gore), and Wayne and His World? The harder you ask this question, the more possible definitions come to mind. Madonna? No. Clarence Thomas? Maybe. Jeffrey Dahmer? Notions of blackness (and the varying permutations of otherness) have been constructed and deconstructed *ad nauseum*. Popular culture often

Golden, Thelma, "What's White...?" in *1993 Biennial Exhibition*, Elisabeth Sussman (New York: Whitney Museum of American Art, 1993), pp. 26–35. Reprinted with permission of author and publisher.

278 Thelma Golden

gives us poles for quantifying blackness. X is the most current definition; it doesn't get much blacker than Malcolm.

This discussion is not simply about race, but about relations to power. Race is about legal classification and when pragmatically deconstructed, according to cultural critic Lisa Jones, is really about hair texture. Easier, however, to discuss is what is not white, the realm referred to as difference. Difference, in the words of Cornel West, concerns itself with issues of "exterminism, empire, class, race, gender, sexual orientation, age, nation, nature, region. . . ." Yet difference is still positioned as different from whiteness, which, as we enter this discourse, is almost impossible to define. Much of the work in this exhibition concerns itself with what West further describes as the "new cultural politics of difference," whose "distinctive features"

are to trash the monolithic and homogeneous in the name of diversity, multiplicity and heterogeneity; to reject the abstract, general and universal in light of the concrete, specific and particular; and to historicize, contextualize and pluralize by highlighting the contingent, provisional, variable, tentative, shifting, and changing.¹

Many of the artists in the "1993 Biennial Exhibition" work consciously to deconstruct and de-center the politically constructed site of whiteness and its relation to the ever-changing definition of Americanness. The strategies they use to enter this discourse differ greatly. The body provides an immediate site for discussions of cultural, gender, class, and sexual specificity. It allows traditional practice to be infected with transgressive ideals.

Byron Kim's works use skin as a metaphor for the body, cultural diversity, and formalist concerns. In Synecdoche and the Belly Painting series, he interrogates the formal and political meanings of color. Synecdoche, an ongoing project, is a grid of two hundred abstract monochrome paintings. Each 8 x 10-inch panel is a portrait of an individual's skin color. Kim refers to the piece as "a strange project because I am making abstract paintings, but their subject matter is so concrete. In a sense these paintings are representational, even figurative." The paintings are hung in alphabetical order by the surname of the person whose skin color is documented, creating a random combination of beiges, pinks, and browns. While working closely with the strategy of cosmetic companies, which offer an array of colors for all skin tones (most notably the new, heavily advertised Perscriptives line-All Skins, 115 shades), Kim selects subjects at random without a conscious plan of representation. He created the *Belly* paintings by pouring three gallons of latex paint between a rubber skin and a support panel. The weight of the paint makes the container sag like a pregnant belly. The paintings take their colors from the Crayola Multicultural set of crayons that was produced after the elimination of the "flesh" (now renamed peach) crayon. Now, in a move which is part politically correct sincerity and part big business, consumers can buy a set of eight ethnically correct skin-colored crayons as a supplement to the traditional assortment. Both of Kim's works fuse the traditions of monochrome painting with the discourse on race. *Synecdoche* operates as a collective group portrait, banishing notions of reductiveness implicit in terms like black, white, red, and yellow—words commonly used when discussing race.

The human form has always been at the center of Alison Saar's artistic concerns. The new work in this exhibition continues her exploration into figurative sculpture as a means of expressing the human condition. Working intensely in the arena of sculptural installation, Saar speaks about the passages of the life cycle and the resonance of cross-cultural hybridity. Her figures, through their titles and vestments, are all products of a diasporic journey. Her process and materials indicate an interest in and anxiousness about alternate idioms and the shifting planes between high and low art. Her sculptures seek to create a narrative which speaks to the lives of the often silenced.

Notions of the body, a particular body, inform Gary Simmons' work, although the human form is almost entirely absent except for totemic markers of its presence. His new installation *Lineup* appropriates the New York City Police Department lineup used for identifying crime suspects. The piece references the questionable practice of law enforcement agencies who pick up young African-American men to serve as filler (fodder?) for lineups. Given the genericness of evewitness descriptions (Male, Black, 6 ft. 180 lbs.; variation: Male, Hispanic, 6 ft. 180 lbs.), these suspects become pawns in the machinations of the criminal justice system. Questions of guilt, innocence, and due process become irrelevant, as the subjects in this farce of justice become interchangeable. Simmons' work presents eight disembodied men whose presence is marked only by their shoes-actually sneakers. The sneakers embody a host of popular cultural references, from vintage Puma Clydes to ubiquitous Air Jordans to some of the flyest sneakers on the street today. In the criminal justice system (and American society as a whole), the identity of these men remains generic; it becomes specific in Simmons' installation because the sneakers are markers of position and status in ghetto youth culture. The work operates on an additional level of irony and critique as Simmons also acknowledges the number of crimes perpetrated against young black men by other young black men over these consumer objects of desire.

In another installation *Wall of Eyes*, Simmons creates a field of eyes on a wall. The imagery is related to his earlier erasure drawings, in which he drew in chalk on paper or walls painted with blackboard finish. These drawings commented on the presence of stereo-typical imagery in seemingly benign cartoons and children's animated movies. The drawing in the Biennial uses the eyes as a more specifically metaphoric device. In conception it is dependent on the stereotypical representation of the darkness

280 Thelma Golden

of black skin in relation to the inordinate brightness of the eyes. Presenting hundreds of disembodied presences peering out from the darkness, the drawing invokes images as innocuous and common as a darkened movie theater full of people peering out toward the screen or as potent as the hull of a slave ship full of human cargo staring out of the darkness into the unknown.

The conceptual impulses of appropriation in the visual arts and of sampling in rap music converge in the free-form subventive practices of many of the artists in this exhibition. Sources both high and low are merged in an examination of contemporary culture. Glenn Ligon's Notes in the Margin of the Black Book is an intervention into the homoerotic gaze. Ligon encountered Mapplethorpe's infamous Black Book, a collection of portraits of black men, in a gallery presentation years ago. He wanted to simultaneously identify with the portrayal of gavness and critique the portraval of blackness. The piece acknowledges the inextricability of these two states. It presents reproductions of Mapplethorpe's photographs with texts taken directly from a variety of sources, including Jesse Helms, museum visitors, and the poet Ntozake Shange. Interspersed with the texts is Ligon's voice, in the form of written texts, which says "a brother, a lover," etc. His voice explicates the complicated realm these photographs exist in-objects of desire, pornography, subjects to be feared or controlled, images to be liberated from the oppressive reductivity of passive posed portraits.

The work of Hillary Leone and Jennifer Macdonald also explores modes of sexuality through texts. The artists use symbols in the Gregg stenography system to create branding irons representing words or phrases that refer to sexuality. Then they burn these symbols onto canvases and paper, producing impenetrable abstract marks. Without knowledge of this language, the viewer reads these symbols as merely visual marks bereft of meaning. Their power is conferred with the translation of the symbols, which investigates the terms that form and deform ideas about sexuality.

Lorna Simpson's installation *Hypothetical*? takes its text from a *Los Angeles Times* article from the time of the insurrection last spring. The *Times* reporter (probably white) asks Mayor Tom Bradley (black): if he were not mayor would he be afraid to be a black man at that moment? Bradley answered, in what one could only assume was an exasperated tone, that he would not be afraid, he would be angry. Simpson's phototext work always explores not only the meanings of words but their intention. This text embodies a multitude of readings which Simpson encourages the viewer to interrogate: the conventional, implicit notion that power removes one from the liability of race (mayor and black man become diametrically opposed); the media assumption about response (that post-Rodney King black men should be afraid) in confrontation with the reality of the situation (that post-Rodney King black men are very angry). Flanking this text, which Simpson leaves in its original newsprint form, are a photograph of a pair of lips and on the opposite wall a configuration of trumpet mouthpieces. Filling the room is the sound of a modulating breath that links the lips to the mouthpieces—the indication of the sound before the fury.

Like race, issues of gender and class and the critique of dominant culture inform much contemporary art practice. Karen Kilimnik makes drawings of images and texts directly from her examination of newspapers and magazines. Her fascination with celebrity and home design publications is evidenced in her direct transposition of their content and the people photographed in them. Kilimnik engages the bizarre attraction the public (American and international, since her sources include French and German publications) has with the misery of others and our desire for impractical things. Her subjects include Carolyn Warmus and the extremely subjective text that accompanied her media presence, Delta Burke, Father Ritter, and the greatest media construction of all, Madonna. Drawing directly from the images and texts as they are presented, Kilimnik intervenes into the compositions, changing or translating words at will, creating a diaristic visual reportage of popular culture.

Re-positioning communities is another strategy in the quest to gain visibility. Pat Ward Williams' dot-screen print *What You Lookn At*? is a large-scale mural of a group of young black men. Marked by pose and attitude, they create the menacing tableau usually mediated by the media. Williams adds text, which functions specifically as voice, giving her subjects the ability to subvert the proverbial gaze and pierce their societal silencing.

Another explication of community is Julie Dash's *Daughters of the Dust*, presented in the film and video section of the Biennial. This film provides a view of a community of African-Americans residing on the Sea Islands on the coast of Georgia at the turn of the century. Through a nonlinear narrative, Dash unveils an important facet of American history and the presence and persistence of the African diaspora in the New World. Also in the film and video section is the work of the video collective Not Channel Zero. NCZ uses the accessible medium of video and public access television as a forum to present corrective information to communities of color in New York City. Using the news show format, NCZ seeks to overcome the ineffectiveness of the traditional news media in relating the concerns of diverse communities. Characterized by their non-traditional technique and hip-hop inspired aesthetic, NCZ exemplifies the impulse for selfdetermination in sites outside of the mainstream.

Shu Lea Cheang's *Those Fluttering Objects of Desire* takes a communal approach to giving voice to female desire. Engaging a group of performance and visual artists, Cheang allows her collaborators to create video- and audiotapes that explore personal notions of sexuality and desire. Giving voice to intense personal narratives, this work critiques and displaces stereotypical notions of women of color and the claims to their bod-

282 Thelma Golden

ies. Using the devices of pornographic peep show booths and 900 telephone lines, Cheang subverts conventional notions of race and sexuality with beauty, irony, humor, and self-defined sensuality.

Robbie McCauley's performance reclaims community in its reconstruction of a volatile point in American history, the Mississippi bus boycotts. Working in Mississippi, McCauley collaborated with an interracial cast of local actors to create a revisionist drama and oral history out of the memories, both personal and public, of the civil rights movement.

Revisionist approaches to history and received information are at the heart of the discussion of diversity. Our understanding of culture is mediated by the presentation of "fact" in print or media or "object" as presented in museums. The recontextualization of such data is explored in the work of Renée Green, Fred Wilson, and Robert Gober. Using artifacts and popular cultural material, Fred Wilson's *Re: Claiming Egypt* treads on sensitive ground, the ever expanding dialogue about the African past and its application in the present. The installation, a companion to one presented at the 1992 Cairo Biennial, juxtaposes reproductions of Middle Kingdom Egyptian objects with African-American popular cultural materials that appropriate Egyptian imagery. The result is a commentary on the complicated project of Afrocentricity refracted through the prisms of history and myth.

Renée Green's installation *Import/Export Funk Stations* uses the critical discourse around hip-hop music as a location to discuss crosscultural and theoretical issues and the transposition of cultural property across national boundaries. Green's informant is a German music critic. The installation consists of his books, as well as videotaped interviews with German and American music critics, artists, disc jockeys and hip-hop enthusiasts, which provide an essential locus for a discussion of the critic's (and Green's) interests in African-American musical forms. Also incorporated in the installation, on the wall, is a lexicon of slang from hip-hop lyrics ("skins," "bug," and "hoe"). The words are literally translated into German, pointing to their cultural specificity and mainstream impenetrability.

Robert Gober's newspaper bundles question notions of the subjective. Appropriating the format of *The New York Times*, Gober alters the relationship of text and images to extrapolate a personal definition of importance and meaning from the printed media. In an advertisement which says "having it all," Gober replaces the face of the bride with his own, yielding an irony fused with the currency of identity politics. On another paper, he respositions the late painter Moira Dryer's obituary to the front page, foregrounding the personal importance of that loss. Information and articles about AIDS are also moved to the front from their typical positioning in the middle of the paper. Gober presents these papers in the form most familiar in our increasingly ecologically correct society in the bundles required for curbside recycling.

Daniel J. Martinez's project employs an existing element of the Museum. In addition to a new installation in the gallery, Martinez will use the Museum's admissions buttons to intervene into the notion (or fallacy) of whiteness. The multi-colored buttons, familiar to museum-goers, are typically emblazoned with the identifying logo WMAA. Martinez has changed the text on the buttons to read "I can't imagine ever wanting to be white." The text is spread out over five buttons that only form the full sentence when they are brought together. Visitors will randomly receive the buttons, deciphering the complete meaning only when they become conscious of the buttons other visitors are wearing. Martinez is working with the notion that this statement has radically different connotations depending on the wearer's race and attitude toward race. The button is an affirmative declaration that reverses decades of negativism about all things not white. It also requires museum visitors to acknowledge the level of control inherent in museum practice and presentation and absolve themselves of some of the privilege of cultural imperialism. Because the buttons are required for admission, visitors have little choice in determining their position in relation to Martinez's intervention. Such subversion of individual choice and institutional objectivity determines Martinez's art making.

Everyone has "identity"—if we acknowledge that the state of whiteness is a definitive category as different (or as specific) as those we label "other." Artists in the nineties have begun to fully deconstruct the marginalitycentrality paradigm. Marginality, in effect, becomes the norm while the center is increasingly undefinable and perhaps irrelevant. Although many may call this Biennial the "multicultural" or "politically correct" Biennial, it should be read as a larger project which insists that decentralization and the embracing of the margins have become dominant. Indeed, margins, as they once existed, even seem inappropriate because they indicate a hierarchical relation that belies the importance of their position in relation to the center. Boundaries, used to describe this condition by theorist Homi Bhabha, seems more applicable. The word boundaries suggests the self-induced yet unfixed definitions that insinuate the multileveled associations which give communities breadth as well as specificity. One is not simply African-American, Euro-American or Asian-American, but also male or female, straight or gay, rich or poor, urban or rural. This exhibition acknowledges the varied personal and aesthetic strategies that inform this unfolding dialogue, this creation of a narrative which acknowledges the post-national, post-essential identity.

284 Thelma Golden

Notes

 Cornel West, "The New Cultural Politics of Difference," in Russell Ferguson, Martha Gever, Trinh T. Minh-ha, and Cornel West, eds., Out There: Marginalization and Contemporary Cultures (New York: The New Museum of Contemporary Art; Cambridge, Massachusetts: The MIT Press, 1990), p. 19.

Identity Politics at the Whitney

ELEANOR HEARTNEY

Rejecting the frivolity of Biennials past, with their Day-Glo bathrooms and stainless-steel bunnies, the 1993 Whitney Biennial declares itself as sober and instructive as the times demand. This first Biennial organized under the directorship of David Ross was put together by a curatorial team headed by Ross-appointed curator Elisabeth Sussman. Rejecting the old pretense of inclusivity, the team has instead produced a tightly focused exhibition which returns again and again to contemporary artists' concern with racism, sexuality, gender, ethnic identity and multiculturalism. Seeking what Sussman refers to as a "representation of a refigured but fragmented collectivity," this show purports to bring us political art for the '90s.

Can this really be the same exhibition which the Guerilla Girls targeted in 1987 for its long-standing practice of racial and sexual exclusion? The vast majority of the 87 participants—half of them video or performance artists—are members of "marginalized" populations: women, African-Americans, Asian-Americans, Latinos and gays. They are, as a group, far younger than the usual Biennial crew, and many are connected to galleries not usually represented in the show. Along with essays from museum insiders Sussman, Thelma Golden, John Hanhardt and Lisa Phillips, catalogue texts were commissioned from Homi Bhabha, Avital Ronell, Coco Fusco and B. Ruby Rich, all thinkers known for their interest in cultural diversity. Like Clinton's cabinet, this was an exhibition carefully tailored to look more like America.

The drive for social veracity was also reflected in the artists' choices of materials and media. While painting was in scant supply, much of the work incorporated photographs, documentary material, texts, objects and

Originally published in ART IN AMERICA, Brant Publications, Inc., May 1993.

artifacts charged with explicit social and political messages. In the most extreme instance, this literalism extended to the inclusion of George Holliday's camcorder tape of the Rodney King beating as one of the video offerings. In a slightly more artful vein, bundles of newspapers, tied as if for recycling, were scattered throughout the building. Reprinted from actual New York newspapers onto archival paper, the headlines, articles and advertisements on their exposed pages were slightly modified by Robert Gober to highlight such issues as sexuality, AIDS and gay rights. Other installations offered readings on the nation's current preoccupations through arrangements of dog-eared paperbacks, video rental boxes and museum-shop reproductions.

If, as it would seem, the purpose of this Biennial was to take the pulse of America, its vision is of a nation mired in racial, ethnic and sexual conflict, still reeling from the L.A. riots and the Clarence Thomas hearings and deeply ambivalent about "difference" at the same time that the fact of social diversity becomes ever more inescapable. One of the show's sustaining themes is the politics of representation. Artists explored such questions as: Who speaks for whom? How is identity constructed? How may marginalized groups muster the power to define themselves? Of course, this is hardly uncharted territory. The terms of this debate were initially set by feminist thinkers during the '70s. Their explorations of the social construction of femininity laid the groundwork for the expansion, during the '80s, of the notion of "difference" into considerations of ethnic and sexual as well as gender identity. Though these issues are widespread in the galleries and in the world at large, this is the first time the Whitney has attempted to grapple with them in a sustained fashion, and Sussman is to be credited with attempting to open the museum to voices rarely heard there.

Less to her credit is the strident tone that dominates this exhibition. While some of the artists offer complex visions of social relations and the human personality, many of the most prominent works simply target the white male power elite as the source of all evil. They offer a litany of wrongs among them neocolonialism, domestic violence and ethnic stereotyping but because they do not transcend the dichotomy of victim/oppressor, they cannot look beyond the powerlessness of the victims toward the possibility of action and change.

The problem in many cases is a simplistic psychology that views identity as something which is externally imposed. An installation by Leone and McDonald gives the notion of cultural encoding a literal twist by hanging a set of branding irons from the ceiling. Burned into sheets of paper hung on surrounding walls, the brands imprint apparently abstract marks which are in fact notations from the Gregg shorthand system for words relating to sexuality. Another kind of cultural determinism, this time originating in the trauma of childhood, is suggested by Robert Gober's sculpture of a crib made into a giant mousetrap. Even works which take a more complex view of the human personality tend to view it in isolation from larger political and economic forces, so that larger inequities are viewed as extensions of interpersonal relationships.

Thus Sue Williams's angry scrawlings critique women's unequal place in society by raging at the abuse visited upon women by their partners in heterosexual relationships. Her raw, cartoonish paintings are augmented here by a large installation which includes a wall drawing dominated by what appears to be a Roman emperor's head and, on the floor, a sprawling circle of plastic vomit. Thus she links bulimia to the antifeminist values of Western civilization, seeing female self-abuse as a natural reaction to oppressive social pressures. This is not the only work which relies on bulimia to critique the skewed values of contemporary society. Janine Antoni chews the edges off huge blocks of lard and chocolate and spits the material out. The gnawed blocks form one part of her sculptural installation. The installation also included a boutique corner where chewed lard was transformed into lipsticks, and chocolate into candies in heart-shaped containers, emblems of the conflicting demands of beauty and consumption which lead women to binge and purge.

A related theme is the pervasiveness of racial stereotyping in a whitedominated society. Again, this tends to be viewed apart from the historical and economic forces which bring groups into conflict. Pat Ward Williams's blown-up photograph in the museum's front window depicts a group of black youths who stare at the viewer behind a scrawl of graffiti which demands, "What you lookn at?" Presumably addressed to the primarily white passersby who frequent Madison Avenue, this work seems to reduce racism to a matter of relationships between individuals and suggests that it is best countered by the tactic of reciprocal intimidation.

The division of the world into powerful and powerless continues in other works. Fred Wilson's *Re: Examining Egypt* is a museum-style display in his by-now-familiar mode which purports to be an attack on the imperialistic practices of museums. In fact, consisting of a scattered assortment of Egyptian museum-shop replicas and printed T-shirts, it only obliquely makes its point, which seems to be the promotion of an Afrocentric version of history. According to this unsubstantiated but highly popular dogma, the originating contributions of black Egyptians have been purposely withheld from the narrative of Western history by racist historians. Gary Simmons's police lineup of golden running shoes takes on racism in the criminal justice system. Also somewhat confused in its mix of references, it points, on one hand, to racism as the ultimate reason for the disproportionate incarceration rate for young black men, and, on the other, to a consumer-mad society which inculcates the kind of value system that leads young men to kill for a pair of running shoes. In a similar spirit, Daniel Martinez has contributed two works designed to reveal the hidden assumptions about race and identity which underlie the elite's worldview. An installation recreates a child's playhouse littered with an inventory of objects of adverse influence—violent cartoons, toy guns, cowboy figurines, etc.—which shape the lamentable male psyche. Martinez also designed the admission buttons for Biennial visitors, which require them to wear all or part of the words from the phrase, "I can't imagine ever wanting to be white."

Other works seem designed to enforce a simplistic notion of diversity. Mike Kelley's mock campus banners salute a variety of collegiate groups ranging from Christian dramatists to the African Student Union. Byron Kim presented an installation of small monochrome canvases matched to the skin tones of various friends and acquaintances. Placed in random order to form an elegant, minimalistic grid on the wall, they illustrated the rather unremarkable fact that people come in many different colors.

These and other artists often take the tone of hectoring schoolmarms, humorlessly admonishing their charges on their moral and behavioral failings. Meanwhile, another group of artists here seems to celebrate a kind of aimless abandonment to adolescent daydreams. Karen Kilimnik's tabloidinspired musings on the vices and virtues of various celebrities, Raymond Pettibon's desultory scribblings about religion, the possibility of afterlife and how we got here, and Jack Pierson's snapshot-quality photographs of friends and surroundings celebrate an esthetic of narcissism and antimastery. It is instructive to compare Pierson's vacant images of his milieu with Nan Goldin's compelling depictions of her AIDS-devastated world. What is missing in Pierson's work (deliberately so, it would seem) is the passion and engagement which give Goldin's photographs their tragic beauty. A similar indifference to communication (despite some words imbedded in the paint) characterizes Suzanne McClelland's tangled paintings, among the very few examples of that medium in the show.

The work of these first-time Biennial participants seems little related to the larger theme of the show. Instead, it celebrates the return of the artist-child. However, this incarnation seems markedly less entertaining than many earlier ones. These *Slacker* artists, as they have been dubbed in homage to Richard Linklater's 1991 film, are less innocent than simply vacuous. One wonders if their affectless acceptance is a kind of avoidance of complexity not so dissimilar from their sterner associates' fondness for finger-shaking and victim-finding.

Still, it would be wrong to give the impression that none of the artists in this Biennial are capable of nuanced reflection. There are some complex and powerful works here. Cindy Sherman's Hans Bellmer-inspired photographs of reconfigured mannequins touch on the primitive impulses which underlie human sexual expression. The power and honesty of these genuinely shocking works makes the cartoon vision of a Sue Williams pale by comparison. The complicity of victims in their own violation is also suggested by Ida Applebroog, whose painting installation spills out onto the floor with small propped canvases scattered willy-nilly in the viewer's path. Inverting the moralistic message of traditional fairy tales, she evokes their dark terrors while debunking the mythical innocence of childhood. Her children are both victims and future perpetrators, entwined in vines, wielding guns, growing up to be Nazis.

Myth-debunking is also a mission of Glen Ligon's extensive photoand-text installation devoted to a consideration of Robert Mapplethorpe's *Black Book.* The latter, Mapplethorpe's portfolio of photographs devoted to the black male nude, has racist undercurrents which do not mesh well with the prevailing myth of Mapplethorpe as liberator of gay sexuality. But rather than simply bash Mapplethorpe, Ligon intersperses the photographs with texts gathered from Mapplethorpe's critics, his supporters and casual viewers of the portfolio. Thus he is able to pose some challenging questions about the nature of human desire, which is not always rational, politically correct or reducible to predetermined categories.

Another work which is provocative rather than polemical is Charles Ray's *Family Romance*. In this realistic figural tableau, father, mother, young son and toddler daughter stand nude in a row, like one of those charts of human development. However, parents have been scaled down and children scaled up so that they are all the same size—just slightly smaller than the average adult. Like the best work in this exhibition, this piece suggests multiple readings—ranging from a meditation on a child's fantasy of mastery over its parents to a revelation of the suppressed sexuality of the family unit.

Pepón Osorio's elaborate installation recreated a murder scene in an unbelievably kitschified Hispanic home. The purpose of the work, at least according to the wall label, was to offer a critique of pop culture's clichés about Latino life. In fact, however, the installation's vitality and visual seductiveness overshadowed any such dour academic point. Similarly engaging was *The Year of the White Bear*, a performance work by Coco Fusco and Guillermo Gómez-Peña which ran for a few days during the opening of the exhibition. The two performance artists outfitted themselves as gorgeously show-biz "natives" and occupied an elaborately decorated cage while guides explained their antics and culture for a white Eurocentric audience's entertainment. Though it covered familiar ground, the performance's playfulness and flashy appeal lifted it above other works devoted to an exposé of the neocolonialist attitude.

Meanwhile, the exhibition's video section was removed this year from its usual ghetto and situated instead in two prominently placed viewing rooms on the third and fourth floors. The video medium is in many ways

290 Eleanor Heartney

more amenable to a multifaceted view of the issues of the show. Of the videos on display early in the biennial's run, Mark Rappaport's witty "discovery" of a gay sexual subtext in Rock Hudson's films was particularly engaging.

There are also several successful works in the show which seem to have nothing to do with the Biennial's declared theme. It seems to be really stretching it to suggest, as Sussman does in her catalogue essay, that Gary Hill's remarkable installation, *Tall Ships*, embodies a sense of community. The piece consists of a dark tunnel whose walls are lined with a series of ghostly interactive video figures which walk toward and then away from the viewer who, by moving through the space, triggers their approach mechanism. This work is more evocative of a fantasy realm of spirits and doppelgängers than of the embattled social milieu explored by other artists. Similarly, Chris Burden's *A Fist of Light*, which overwhelms the downstairs lobby gallery, is a mysterious aluminum apparatus that seems to lock away a dangerous potential energy. A metaphor both for a bomb and, perhaps, a barely contained social fury, it relates only tangentially to the rest of the work on display.

One curious curatorial decision involves the reinstallation of works just recently seen in New York galleries. Shu Lea Cheang's enormous, space-consuming dial-a-porn telephone installation, Maureen Connor's curtained booths, Antoni's wax and chocolate sculptures, Leone and McDonald's branding irons, Gober's newspapers and Sherman's horrific photofantasies were all familiar to any reasonably conscientious member of New York's downtown art audience. While there is nothing in principle wrong with a few such encore performances—in fact, sometimes a change of context will bring out new aspects of a work—the presence of so many recently exposed large-scale works gave the show a secondhand quality which ran counter to its rhetoric of experimentation and innovation.

Taken as a whole, the 1993 Biennial is noteworthy not so much for the quality of the art it presents as for the way it mirrors certain disturbing trends within and outside the art world. One such trend is the tendency of artists, curators and art educators to reduce contemporary art to the role of social work or therapy. Much of the work here is numbingly didactic, easily summed up in a sentence or two. In a curious way this tendency to privilege social message over esthetic considerations parallels the attitudes of the religious right in its demand that art be morally uplifting.

Even more disturbing, however, is the way that the Biennial mirrors a widespread tendency today to reduce complex social issues to a politics of identity. Borrowing from the victim language of pop psychology and the therapy industry, identity politics ignores economic and social determinants like class, religion and nationality, offering instead a reductive model of society as a battle between victims and oppressors. Lacking more complex explanations for current conflicts, its simplistic psychology tends to see inequities as problems of attitude. Gober's mousetrap-crib is emblematic here, appearing to locate the cause of a dysfunctional society in a dysfunctional childhood. In the most simpleminded examples on view at the Whitney, racism, sexism and homophobia are presented as voluntary prejudices which can be eradicated by proper reeducation.

By focusing on the psychology of hatred and oppression, this Biennial gives short shrift to crucial political issues like poverty, homelessness and crime, to say nothing of larger global problems like war, ethnic cleansing and incipient fascism which coexist with or lie behind many of these conditions. In fact, questions of global politics arise only in works by Allan Sekula and Francesc Torres, whose presentations are, unfortunately, not among the more effective in the show. Instead, space allotments ensure that bulimia emerges as one of our major social problems.

Thus, instead of representing "cultures at the borderlines," as Homi Bhabha suggests in his catalogue essay, or the "artworld . . . as a collectivity of cultures," in Sussman's phrase, the 1993 Biennial ends up trivializing the notion of political art. Adhering to the increasingly questionable notion that "the personal is political," it opts for a myopic view of the social realm. As a result, issues like urbanism, environmentalism, labor, nationalism and religious conflict are seen as outside a narrowly conceived notion of community. In fact, communities are as much a function of shared values and common interests as they are sites of contest. But these issues have no place in a show which seems to view community only as a collection of angry, irreconcilable interest groups.

Trend-conscious as its predecessors, this Biennial would have us believe, as Lisa Phillips puts it in her essay, that "today, everyone's talking about gender, identity, and power." In fact, there are scores of artists dealing with social issues of a very different sort. Some commentators have used this show as a referendum on political art and have seen its failings as symptomatic of the tendency as a whole. But the problem here isn't that politics has once again strangled art. The problem is that there really wasn't much here in the way of substantive politics in the first place.

Circumventing the *Center* Identity Politics and Marginalization

JENNIE KLEIN

The Civil Rights Movement, feminism, gay pride, and the growth of global economics and politics have finally impacted on the art world, which celebrated last year's Columbian Quincentenary by mounting a number of exhibitions of work by artists whose ancestors were the victims of Columbus's genocidal impulses. All of this culminated in the now notorious 1993 Whitney Biennial, which was the first Biennial to include more than a token number of artists of color and gay and lesbian artists, and was strenuously criticized from both the left and the right.¹

The 1993 Whitney Biennial raised interesting questions, such as how one mounts a show about currently marginalized identities that is neither trendy nor simplistic. While the Biennial was guilty (to some extent) of jumping on the multicultural bandwagon only after it was clear that the politics of Postmodernity had opened a space for a difference other than *différence*, curator Elisabeth Sussman at least made a genuine attempt to select artists whose work explores the construction of identity within the messily overlapping categories of gender, race, ethnicity, and class. The same cannot be said for many other recent exhibitions that have claimed to be about expanding the notion of identity while in fact fixing and essentializing the artists included into static categories of culture or ethnicity.

There were many shows mounted on a smaller scale in which complex and important issues of gender, sexuality, and miscegenation were elided in favor of an essentialized nationalism and an overly determined rhetoric of victimization. Two 1993 exhibitions that fell headlong into this trap either originated or passed through Southern California, an ethnically

[©] Jennie Klein 1994. This essay was first published in *The New Art Examiner*, December 1994 and is reprinted with permission of the author.

diverse border region whose art community has been particularly concerned with issues of identity and nationality far longer than those issues have been in style: "Partial Recall: Photographs of Native North Americans" was curated by Lucy Lippard and first exhibited at Tyler School of Art in Philadelphia, and "La Frontera/The Border: Art About the Mexico/United States Border Experience," curated by Patricio Chávez and Madeleine Grynsztejn, was first shown at the Centro Cultural de la Raza and the Museum of Contemporary Art, both in San Diego.

"Partial Recall"

Lippard's "Partial Recall" juxtaposes photographs by and of Native Americans with essays about these photographs by contemporary Native-American writers and artists such as Jimmie Durham and Rayna Green. The show also includes contemporary photographs by Jolene Rickard, David Neel, Hulleah Tsinhnahjinnie, and Richard Hill. Partial Recall has been published as a book as well, with extended versions of the essays that accompanied the photographs in the exhibition.² The premises behind both the book and the exhibition seem admirable; it is clear from Lippard's introductory essay to the book that she had good intentions when she organized this collection of non-canonical photographs of Native Americans from the nineteenth and early twentieth centuries. Her motive was to assemble images that contradict the stereotypical image of Native Americans as a vanishing race. She originally intended to write a series of essays; however, she realized that "I should practice what I've been preaching. . . . So this book became a collaboration with those for whom these images had more intimate meanings."³ Lippard is to be commended for this, rather than simply speaking for marginalized artists as she did in her 1990 book Mixed Blessings: New Art in a Multicultural America (New York: Pantheon Books, 1990). She is also to be commended for including the work of the four contemporary Native American artists/photographers named above, whose art is rarely seen outside the contemporary section of ethnographic museums. Less commendable is the quasi-mystical and ahistorical approach that Lippard takes toward her "subjects," an approach that ultimately freezes them in Ur-time prior to the invention of writing.

In her review of the book for *Afterimage*, Cylena Simonds characterized *Partial Recall* as "more similar to the coffee-table book genre of photography texts than to art criticism texts, in that it does not provoke the reader to challenge preconceived notions of the magic or 'mysticism' of photographic images."⁴ Simonds's criticism of the book may be applied to the exhibition as well for the catalogue chiefly consists of an edited version of Lippard's introductory essay from the book, which betrays her romantic and nostalgic approach toward Native Americans. "Many contemporary Euro-Americans (myself included) see in the hundreds of native cultures of this continent spiritual and ethical values that have gone unnoticed or been neglected in our own culture," Lippard writes wistfully. She then suggests that it is "useful when looking at photographs . . . to circumvent the barriers set up by unfamiliar culture" and search for "the things we might have had in common . . . like . . . the touch of a buckskin dress against bare skin."⁵ Leaving aside the rather astonishing idea of Lippard, a native New Yorker, decked out in nothing but a buckskin dress, the viewer is still left to ponder whether the circumventing of cultural barriers is not simply more of the same universalizing approach toward the Other that Lippard seems so eager to overturn. Fortunately, the viewer of the exhibition (unlike the reader of the book) is spared the worst of Lippard's excesses, such as her account of various dreams and spiritual connections that accompanied her organizing "Partial Recall."

The nineteenth-century photographs might have been more interesting had they been viewed in the historical context. Instead, they were accompanied by essays which were, by and large, based on the authors' unmediated, visceral responses to the photographs. Lippard and her collaborators could have analyzed the relationship of race and gender to the ideology of the West in American consciousness, as well as to the constructed nature of all representation. Lippard and some of the other essayists do attempt to discuss the ways notions of race and racial purity are constructed by Anglo society; however, no attempt is made to analyze the ways in which hierarchies of gender are completely imbricated within hierarchies of race. A photograph such as Frank Matsura's *Two Girls on a Couch*, from 1910, cries out for such an analysis, especially given that the two "girls" are Native American and the photographer Japanese. Instead, Rayna Green's essay speculates about the character of the two women.⁶

To those of us who admired Lippard's early commitment to feminism, her seemingly complete disregard for feminist issues and issues of gender when writing about the art of people of color is disappointing. While cultural critics such as Trinh T. Minh-ha and bell hooks argue for an interrogation of oppression that takes into account gender, class, and race, Lippard seems to feel that the first two categories are white issues.

"La Frontera/The Border"

Unlike "Partial Recall," the show "La Frontera/The Border" did not fall into the trap of romanticizing people of a particular ethnic descent. Instead, it was the overly reductive and simplistic nature of much of the art in the show that made "La Frontera" a disappointment. Co-curators Madeleine Grynsztejn (of the Museum of Contemporary Art; now at the Art Institute of Chicago) and Patricio Chávez (of the Centro Cultural de la Raza) are clearly well versed in contemporary theories of marginality, the border, and the notion of territorialization. Grynsztejn's essay, which is chiefly devoted to a discussion of the objects included in the show, opens with a definition of the border that combines the theories of bell hooks and Emily Hicks, both cultural critics who have advocated a conscious embrace of the margin as a means of countering dominant Eurocentric and patriarchal ideologies.⁷ Both critics see the border as a liminal region wherein stereotypical notions of identity and gender construction can be challenged, and the border subject as someone simultaneously de- and reterritorialized, moving between inside and outside. It is thus doubly disappointing that the complex cultural theory informing Grynsztejn's essay does not carry over into the exhibition.

Visually, at least, "La Frontera/The Border" is a feast. Many of the artists employ the deliberately campy style combining influences of Tijuana kitsch, the Mexican muralists, and pre-Columbian art that Tómas Ybarra-Frausto has dubbed *rasquachismo*.⁸ Conceptually, however, much of the art treads the same ground Chicano and Chicana artists have been covering since the early '70s, and way too much of it is more or less about the same thing: the brutality and racism of the United States toward Mexico. The work (with a few exceptions, such as Deborah Small's *Ramona's Mission* and Small and David Avalos's *mis.ce.ge.NATION*, two pieces that are very funny) is overwhelmingly didactic and simplistic, consisting of one-liners on a single subject.

It is unquestionably true that Mexicans and Mexican Americans have been and continue to be exploited, oppressed, and mistreated by their Anglo neighbors, and in certain works—some of the overtly political art originally designed for public settings, for example—the didactic approach is appropriate. This is the case with the bus and bench ads promoting "America's Finest Tourist Plantation" that expose police brutality and immigrant exploitation, a series designed by Small, Avalos, Elizabeth Sisco, Scott Kessler, and Louis Hock. More typical of the show was *Bodies Pending*, an installation by the Border Art Workshop that presented overly reductive treatments of the ways Mexican Americans are stereotyped and/or brutalized by Anglo society.

One of the borders crossed during the organization of "La Frontera" was, as Chávez stated, that of two very different institutions, one, Centro Cultural de la Raza, an ethnically specific organization with very little money, and the other, The San Diego Museum of Contemporary Art (SDMCA), a mainstream institution based in a wealthy beach community.⁹ Perhaps it was the collaboration between the two spaces that prevented a more radical exploration of the implications of borders, the United States/Mexico border in particular. Chávez and Grynsztejn made a conscious decision not to include a vast range of "indigenous art" that is manifested on the border, such as Tijuana velvet paintings and the murals associated with the Chicano resistance movement. The show might have been considerably more interesting if some of those indigenous art forms had been included, along with examples of other activities, such as paraphernalia and images from the "performances" staged by right-wing groups like Light Up The Border and Wake Up Washington, later renamed Coalition For Immigration Law Enforcement. In addition, "La Frontera" includes very little work from the real outlaws in the Chicano community-gays. lesbians, and feminists, the only exception being The Reading Room, a piece by Las Comadres from the "La Vecindad/Border Boda" exhibition of 1990. In spite of, or perhaps because of the fact that Las Comadres-of which Hicks is a member-was founded to counteract the sexism that its members encountered in The Border Arts Workshop, the group's more directly challenging work was passed over in favor of this relatively mild reading room, which, like much of the other work in the show, takes predictable cracks at the oppressive United States government. Meanwhile, the Chicana lesbian, as personified by writer Gloria Anzaldúa, is relegated to the pages of the catalogue, a space where only a diligent few will encounter her.

Given the way "La Frontera" shies away from controversial explorations of border identities, it seems the exhibition feared offending the white middle-class museum visitor. Much of the art was made specifically for the gallery context and retains the veneer of high-art respectability that garishly painted crucifixions and Chicano placas or graffiti do not have. Most people who visit museums are appalled by the racist excesses that govern this country's policy toward the Mexico/United States border. and Anglo museum visitors can commiserate here with the injustice depicted in "La Frontera" without feeling as though they are directly implicated. Meanwhile, the Chicano visitor is given an essentialized view of Border Art that embraces a frozen notion of Chicano nationalism and does little to suggest the possibility of new identities or the legitimacy of other aspects of Chicano cultural production, such as barrio murals or militant protest posters. Certainly much of the Chicano movement has been about overcoming continuing Anglo indifference and oppression. However, as the movement has matured, it has, like the feminist movement, produced a variety of artists who identify themselves as Chicano, yet produce work that varies considerably from one artist to the next. Staging "La Frontera" gave the SDMCA a risk-free, and much-needed, coating of multicultural respectability that it might otherwise have lacked. In this context, it seems significant that Guillermo Gómez-Peña, one of the most recognized artists asked to participate, declined, ostensibly because he viewed it as yet another instance of opportunistic appropriation on the part of a mainstream institution.

In her essay for "La Frontera/The Border," Grynsztejn suggests that "the border has long experienced the dominant culture at a distance, and has thus cultivated its own peculiar policies, ethos, and expression."¹⁰ The same thing could be said about the way the San Diego art community experiences Los Angeles-at a distance. The radical and innovative work about identity and culture that appears regularly in Los Angeles at alternative spaces such as Beyond Baroque and the Los Angeles Institute of Contemporary Arts (LACE), and in scores of university and community college art galleries, rarely trickles down to San Diego, and when it does it seldom reaches mainstream institutions like the SDMCA. What "La Frontera/The Border" presented was a narrative of oppression made palatable and nonthreatening to its San Diego audience by its focus on relatively well-known work and preaccepted methods of addressing issues, rather than fostering progression of the dialogue to include broader notions of identity. Here, work exploring feminist issues was given only a passing nod, queers were invisible, and the non-middle-class Chicano was only spoken for, not with. It is telling that none of the artists listed by Grynsztein who refused to participate in the exhibition¹¹ was a Chicana, a queer-identified Chicano/a, or a non-Mexican/non-Anglo. These truly marginalized border subjects were not even given the opportunity to turn down a request for their work.

"The Theater of Refusal"

Is it even possible to avoid the pitfalls of romantic essentialism or overly reductive politics when organizing a show of work by marginalized artists? It seems that the most successful exhibitions of such work are those that attempt to create a dialogue about marginality. This was certainly true of Charles Gaines's "The Theater of Refusal: Black Art and Mainstream Criticism," which proved to be as much about criticism as it was about art. When first assembling the show in 1989, Gaines wanted to give exposure to significant African-American artists whose work was unknown, as well as to address the paucity of Postmodern criticism concerning the work of African Americans overall. By the early '90s, when critics had realized that the person of color was the ideal Postmodern subject, the careers of the formerly obscure artists had taken off, accompanied by a corresponding amount of critical discourse. Working with Catherine Lord, director of the Fine Arts Gallery at the University of California (UC) Irvine and dean of the School of Art, Gaines decided to shift his focus from the paucity of criticism to the nature of that criticism.

"The Theater of Refusal" opened at UC Irvine in April 1993 and included the work of 11 artists: Jean-Michel Basquiat, Renée Green, David Hammons, Ben Patterson, Adrian Piper, Sandra Rowe, Gary Simmons, Lorna Simpson, Carrie Mae Weems, Pat Ward Williams, and Fred Wilson. Although all the work selected is concerned with the construction and expression of African-American identities, the aesthetics and styles range from the faux neo-primitivism of Basquiat to the Fluxus work of Patterson. Gaines's decision to not limit the show to narrow aesthetic criteria was a canny one. Too often the work of people of color is expected to be exotic and colorful; even a deliberate re-appropriation of "primitivism"—as with Basquiat—is often read as an unproblematic expression of an essential black identity. In "The Theater of Refusal" there *were no* essential identities, although there was a lot of work that foregrounds the way essential and marginalizing identities are constructed, including Gaines's contribution—excerpts from reviews of the artists' work by various and sundry critics, displayed on the wall.

"The Theater of Refusal" was as much about criticism's role in constructing the reception of art work as it was about the work itself. According to Gaines, much of the criticism written about African-American artists serves to reify their positions as marginal. Like Grynsztejn, Gaines articulates a theory of marginality-originally proposed by Deleuze and Guattari-that challenges the way in which the Hegelian dialectic polarizes discourse.¹² Moving beyond the narrow notion of a margin as fixed in relation to a center, Gaines argues that race is what Deleuze and Guattari would call a "trope of deterritorialization."¹³ The notion of race problematizes a universalizing discourse, yet is problematized in turn by a (Hegelian) discourse which is unable to maintain the territorialized, or essentialized. subjectivity of race, and thus must resort to mutually exclusive and incompatible stereotypes. The work that Gaines selected for this show is deterritorialized work that does not so much offer a unified theory of ethnicity as it problematizes and is problematized by discourses of race. This is particularly true of Piper's Cornered, a piece that Gaines discusses at great length in spite of the fact that it was (unfortunately) not included in the exhibition. In Cornered, a videotaped Piper very earnestly explains to the (presumably white) viewer that she is "black." After strategically reterritorializing herself, Piper proceeds to deterritorialize the white viewer by logically arguing that given the history of conquest and domination in the West, everyone is really black as everyone has at least one black ancestor.

The title of the exhibition was thus derived from the manner in which the critical environment surrounding the art "intentionally and unintentionally limits these works." The intent of the exhibition was, according to Gaines, to "reveal the strategies of marginalization in the critical writing about a group of contemporary black artists, and to propose an alternative."¹⁴ What Gaines encountered when he began reading the reviews and catalogue essays about the artists was not so much an overt marginalization of the work as two approaches to marginality: one valorizing marginality and viewing it as a positive force for social change, the other limiting the notion of marginality by employing racist language and stereotypes in order to contain the African-American artists at the margins. Critics sympathetic to the undertakings of African-American artists and sensitive to the issue of marginality, such as Maurice Berger and Elizabeth Hayt-Atkins, are located in the former camp, whereas critics such as Peter Plagens, who slammed the 1993 Whitney Biennial, are located in the later.

What both positions share is an analysis of marginality that serves to polarize the art of African Americans. As Gaines notes, marginality is a double-edged sword, one that simultaneously disrupts the universalizing effects of Hegelian discourse and reinscribes the binary opposition of center and margin. This is a necessary condition of deterritorialization, and the alternative that he proposes is for critical writing to embrace—as does Piper's *Cornered*—this paradox, to create a discursive field in which notions of race are simultaneously challenged and reinscribed, asserted and contradicted.

"Counterweight: Alienation, Assimilation, Resistance"

Another, equally provocative exhibition was "Counterweight: Alienation, Assimilation, Resistance," curated by Joan Hugo and Sondra Hale for the Santa Barbara Contemporary Arts Forum last winter. Like the Whitney Biennial, "Counterweight" included a broad spectrum of artists and media. Packed into the small exhibition space were large interactive installations that required the viewer to walk through them, such as Mark Niblock-Smith's gently humorous Tales From a Boyhood, and Deborah Small's wonderfully funny wall installation Our Bodice, Ourselves, a montage of Harlequin Romance covers that illustrates steamy miscegenation between white women and Native-American men. The show also included more traditional media-painting, sculpture, and photography-by not-so-traditional artists (including Charles Gaines), and a video/reading room that presented video works by well-known artist duos such as Marlon T. Riggs/Essex Hemphill and David Avalos/Deborah Small and relatively unknown artists such as Cheng-Sim Lim. Scheduled performance artists included James Luna, John Malpede and the Los Angeles Poverty Department (LAPD).

"Counterweight," which closed two months before "La Frontera" opened, shared several artists and works with that exhibition, among them Small, Avalos, Yolanda López, and Aaron Anish/Rubén Ortiz. It did not share, however, the latter show's monolithic presentation of border identities, or rather border *identity*, that pitted the United States against Mexico in the most reductive terms. "Counterweight" presented, as Emily Hicks suggested in the essay she wrote for the accompanying catalogue, a variety of border subjects, which Hicks defines as subjects that encompass multiple identities and multiple subject positions.¹⁵ A border subject is a subject that maintains an alienated stance in relation to both assimilation, or loss of identity, and an essentializing nationalism, or frozen identity. Citing the example of James Luna, a Luiseño/Diegueño Mexican-American performance artist who "exhibited" himself and his "artifacts" at the Museum of Man in San Diego several years ago, Hicks suggests that Luna, by actively transforming himself into the passive image of the Other frozen in time, could thus be viewed as "the active, deterritorialized, or border subject." Luna's active reterritorialization of the image of the Native American, his strategic stance behind an essential "identity" that he himself sees in quotes, is for Hicks the paradigmatic example of the production and representation of a border subject.

What set "Counterweight" apart from "passively reterritorializing" exhibitions like "La Frontera," "Partial Recall," and even, to a degree, "The Theater of Refusal" was the way in which multiple subject positions, identities, and borders were re-presented, re- and deterritorialized, transgressed, and adopted as active, political stances. The photographer Laura Aguilar is a Chicana artist who grew up in a Spanish-speaking neighborhood speaking only English, was forced into remedial classes in school because of her dyslexia, is a Protestant who attended Catholic services, and came out as a lesbian in 1987 in spite of her prior belief that only white people could be lesbian and gay. In her work, which often takes the form of documentary-like photographs, Aguilar moves from one subject position to another, producing, in Hicks's definition, "meaning from multiple identities." Aguilar has done a series of portraits of Chicana lesbians, triptychs that deal with bicultural identity and AIDS, and work that renders Chicano identity visible simply by recording it, such as her 1991 "Clothed/ Unclothed Series," which was included here. Aguilar's photographs are far removed from the rhetoric of victimization and oppression that characterizes much of the work in "La Frontera." Indeed, curators Hugo and Hale went out of their way to select work for "Counterweight" that was not about victimization or straight-white-male bashing.

Unfortunately, the exhibition was itself a victim of the sort of artworld marginalization and exclusion that Hugo and Hale attempted to subvert by including young, not-yet-established artists. At the same time that "Counterweight" opened, "Mistaken Identities," curated by Abigail Solomon-Godeau, opened at the art gallery of the University of California Santa Barbara (November 11 to December 20, 1992). Not surprisingly, "Mistaken Identities," comprising the work of well-established artists and curated by an academic star, received much more attention than "Counterweight," which was not even reviewed in *The Los Angeles Times*. The scant attention paid to an exhibition as complex and interesting as "Counterweight," the way in which it was marginalized by silence on the part of the art world, might lead one to wonder how much the acceptance and acknowledgment of the cultural production of minority artists has really changed since the Columbian Exposition. Certainly the blatant racism and misogyny that festered there are no longer evident in the art world. Instead, the remaining racism and sexism are more insidious, partly because they are unwittingly expressed, as in "Partial Recall," with patronizing good intentions. As Charles Gaines demonstrated in "The Theater of Refusal," what initially appears to be a long-awaited critical mainstreaming of the marginal might simply be the means by which the margin and the center are reified as unchanging, fixed categories that ultimately reinforce racist patriarchal hegemony.

Notes

- 1. See Eleanor Heartney, "Report from New York: Identity Politics at the Whitney," *Art in America*, May 1993, pp. 43–48, for a review that makes a genuine attempt to weigh the pros and cons of this exhibition.
- Lucy Lippard, ed., Partial Recall: with essays on Photographs of Native North Americans by Suzanne Benally, Jimmie Durham, Rayna Green, Joy Harjo, Gerald McMaster, Jolene Rickard, Ramona Sakiestewa, David Seals, Paul Chaat Smith, Jaune Quick-To-See Smith, Gail Tremblay, and Gerald Vizenor (New York: The New York Press, 1992).
- 3. Lippard, p. 13.
- 4. Cylena Simonds, "Serious Reservations," Afterimage, January 1994, p. 14.
- 5. "Partial Recall," (exhibition catalogue), p. 10.
- 6. Rayna Green, "Rosebuds of the Plateau: Frank Matsura and the Fainting Couch Aesthetic," Lippard, p. 47.
- See bell hooks, "marginality as a site of resistance," Out There: Marginalization and Contemporary Cultures, Russell Ferguson, Martha Gever, Trinh T. Minh-ha, Cornel West, eds. (New York: The New Museum of Contemporary Art, 1990); and D. Emily Hicks, Border Writing: The Multidimensional Text (Minneapolis and Oxford: The University of Minnesota Press, 1991).
- Tómas Ybarra-Frausto, "The Chicano Movement/The Movement of Chicano Art," *Exhibiting Cultures: The Poetics and Politics of Museum Display*, Ivan Karp and Steven Lavine, eds. (Washington, D.C.: Smithsonian Institution Press, 1991), pp. 128–150.
- 9. Patricio Chávez, "Multi-Correct Politically Correct," La Frontera / The Border (exhibition catalogue, 1993), p. 6.
- 10. Madeleine Grynsztejn, "La Frontera/The Border," La Frontera/The Border (exhibition catalogue, 1993), p. 24.
- 11. The artists who declined to exhibit their work in "La Frontera/The Border" are Guillermo Gómez-Peña, Richard A. Lou, James Luna, Robert Sanchez, and Michael Tracy.
- 12. Charles Gaines, *The Theater of Refusal: Black Art and Mainstream Criticism* (exhibition catalogue, 1993) pp. 12–21. It makes sense that Grynsztejn's and Gaines's theories of marginality are articulated along the same lines: Grynsztejn's theory is indebted to Emily Hicks, who in turn has looked carefully at the writing of Gilles Deleuze and Félix Guattari, who are cited by Gaines.
- Gilles Deleuze and Félix Guattari, A Thousand Plateaus: Capitalism and Schizophrenia (Minneapolis: University of Minnesota Press, 1987), pp. 291–292.
- 14. Gaines, p. 13.

302 Jennie Klein

15. Emily Hicks, "Boundaries To Which One Is Tied and From Which One Is Restrained From Traversing," *Counterweight* (exhibition catalogue), 1992. Hicks's definition of the border subject has many similarities to the "minor(ity)/marginal" subject articulated by Gaines and the multiple subject positions that Homi K. Bhabha discusses in "Beyond the Pale: Art in the Age of Multicultural Translation," which was included in the 1993 Whitney Biennial catalogue.

Postscript

It seems reasonable to locate the core, the essence of Modernism within industrialism and Post-Enlightenment ideas of rational thought (two factors interconnected and operating in tandem) which have dominated Western society in a theoretical and practical sense for over a century. Material prosperity generated by industrialism worked to give credibility and prestige to the belief that by application of logic and rational thought, any situation or problem could be solved. These factors were so influential on thought and material life in the modern period that, despite resistance at various times and from various sectors, there was an inescapable tendency to codify and organize all experience and action along rational lines.¹

German sociologist Max Weber identified this process as the rationalization of society. As Andrew Arato has observed, rationalization,

for Weber the key to all modernization and industrialization, represents the historical . . . penetration of all spheres of social life: the economy, culture (art, religion and science), technology, law and politics, and everyday life by a single logic of *formal rationality*. This "logic" is defined by the principle of orientation of human action to abstract, quantifiable and calculable, and instrumentally utilizable formal rules and norms.²

Codification and organization of all experience and action along the lines of formal rationality had profound effects on society and led to what Weber called "de-magicization."³ This was "the elimination of all that is unpredictable, 'irrational,' qualitative, sensuous and mysterious from both theoretical explanation and the practical conduct of life."⁴ This is not to say, however, that the mysterious, sensuous, and irrational no longer existed; rather, it is to say that the center of thought in modern society shifted perceptibly in the direction of "formal rationality." The result was that anything that could not be made to conform to rational thought was eventually discredited, either by direct refutation or by subtle suppression by being pushed to the social and intellectual periphery.⁵

Rationalization and "de-magicization" resulted in the development of autonomous spheres of knowledge under the control of experts. These experts patterned their theories on the "scientific model" of empirical, rational thought based on verifiable and therefore what was believed to be objective truth. Kant, who emphasized form in order to establish more objective criteria upon which to make judgments about art, reflects the initial development of autonomous spheres of knowledge and, because of this, was praised by Greenberg as the first real Modernist. Other projects attempting to provide verifiable, absolute truth developed in the early Modernist period and together came to typify a major thrust of Modernist thinking.⁶

Because of the economic benefits they provided, rational, scientific methods and ideas had gained the center stage of intellectual discourse by the Late Modern period, symbolizing the path to a future utopian world. Greenberg, in attempting to regain a position for art in this center-ground of intellectual discourse, had to demonstrate that art too relied upon objective, rational standards, as did science. To do this he turned to Kant's selfcritical method and applied this method to art theory and criticism. In essence, Greenberg accepted the rationalization process as the aesthetic basis of art, articulating an art theory paralleling the rational tendencies of the Late Modern age so closely that it came to be applied widely to all of Modern art.

Once again the center of thought in society has shifted. Today, a "line" of demarcation between the Modern and the Postmodern can be defined as a condition in which universals and absolute, verifiable truth are no longer accepted uncritically. The "master narratives" that Craig Owens alluded to in his essay—those attempts to discover overarching designs guiding historical, social, psychological, biological, natural, and artistic forces—no longer elicit the support and prestige they once did. Today, many writers and artists do not regard these "master narratives" as descriptions of the "natural course of events," but as attempts to legitimize logocentric (logic/word-centered) theory and ethnocentric (Western) cultural views. As a result, both the autonomy of meaning and the autonomy of art as espoused in the Modern period are now regarded as cultural constructions or, at worst, instruments of social control.

By increasingly questioning the possibility of absolute, objective truth, as Kate Linker writes, Postmodernism directed a dagger "at a tenet of Western esthetics: that artworks are unified structures, enduring objects, expressions of the creative subject."⁷ Greenberg's formalism, in emphasizing form and media (through his concept of self-criticality), gave a logical, "scientific" character to his theory. This encouraged the view that art

was autonomous, that it was an activity based on truths verifiable through formal analysis. What Linker and other Postmodern writers and artists now contend is that the meaning of the work of art is not something eternal, but variable; that the work of art is not constructed outside of culture as an absolute, but through and within culture.

T. J. Clark's argument with Greenberg makes clear that for art to have a meaningful role in society in the Postmodern period, it can no longer be considered an autonomous realm of activity. Now it must be recognized that art participates in political and social issues in spite of the artist's wishes or intentions-for as Lucy Lippard emphatically observes, all art is ideological; there is no neutral zone. Critics such as Buchloh and Kuspit, pointing to the art of Lonidier and Sekula, Golub, Holzer, and Stevens, recognize this and show that works of art participate in ideology not only passively but actively by supporting and even creating world views. However. Kuspit and Kramer also wonder about the aesthetic aspect of art, that aspect that has to do with how subject matter (representational or abstract) is rendered. They are concerned that the expressive and communicative potential of such elements as shape, line, color, and composition (elements that distinguish art from documentation or reportage) are being ignored or, worse yet, swept aside in favor of political subject matter as a result of the wholesale attacks on Greenbergian formalism. As Kuspit points out, the aesthetic in art has an important role to play in art's potential for change, political or otherwise, a role that should not be ignored.

Structuralists and Poststructuralists, influenced by Marx's idea of base/superstructure interrelationships and Saussure's semiotics, also recognize that art doesn't have meaning autonomously; they see art as having meaning only as part of a system of communication, a system that is always imbedded in the social structure.⁸ Crimp argues that the key to meaning in the work of photographic artists such as Levine and Sherman is the recognition of this as evidenced in the way they explore the relationship between copy and original. A similar case is made by Lawson for the work of Salle; however, Lawson emphasizes the advantage of painting over photography in this project because painting is so deeply institutionalized a conception of art. Foster focuses on the paintings of a group of "new abstractionists" who he believes are engaged in issues of signification through representation, appropriation, and simulation.

According to these writers, the functioning of art as a communicative system constructing meaning and perceptions of reality can be exposed and exploited through manipulation of the concepts of copy/original and representation/appropriation/simulation. However, under the weight of Poststructuralist and Deconstructive thinking, such theories tend not to question the premises upon which they are built—that is, that reality is a construction of signs in a system in which we go from free-floating signifier to free-floating signifier. Closer attention needs to be given to the possi-

306 Postscript

bility that signs are anchored in reality or, at the very least, that we exist in a system of interactive "feedback" in which signs affect perception of reality, but reality also affects the construction of signs. In such a system, signs would be recognized as *pointing* to reality rather than simply being perceived as substitutes for reality.

When feminist artists and critics, influenced by theories of Freud and Lacan, confront the role of sexuality in society, they are also questioning the meaning of sexuality. By asserting that sexuality is not dictated by biology, but is culturally constructed, critics like Owens and Linker argue that through representations of women, sexuality is made to serve the social order. Artists such as Rosler, Kruger, and Charlesworth, and Kelly, Yates, and Lomax use their art to show how representations, especially those of women, work in complicity with the formation of meaning in patriarchal systems through manipulation of sexual identity. However, Turim and others have raised some questions about the absoluteness of this position. After all, there are such things as history, culture, and the biological self. What is the connection, one must now ask, between these factors and the biological self (that tangible reality generated by genetics) in the formation of the psychological self? The old "nature/nurture" dichotomy simply doesn't allow this or the possibility of individual "free will" to be taken into account.

Using psychoanalytical methods in a manner similar to feminists, art writers such as Spitz, Gedo, and Kuspit explore the meaning of art (and art making) and attempt to show how it is connected to the individual's personal life-experience in contemporary society. While Spitz compares graffiti to adolescence, Gedo parallels Brown's art and personal life; both, however, try to explain psychological behavior by making connections to the "real" world in which participants exist. Kuspit is more theoretical in his writing in that he analyzes the perception of art and artists held by the profession of psychoanalysis.

Of late, discussions about the formation of the self have been taken up by multiculturalists who argue about how dominant culture shapes all "representation." Central to this debate, as Golden makes clear, is how ethnic and racial minorities seem to be restricted socially, economically, and culturally to the fringes or margins of what appears to be a society exclusively dominated by what Golden calls "whiteness"—white, heterosexual, Eurocentric males. Aligning themselves with feminists and other marginalized groups (including gays and lesbians), multiculturalists have used Postmodern theory to "deconstruct" Western society and expose what they believe are racial biases that reside at its structural core. Often this process has led multiculturalists, and even other marginalized groups, to champion non-Western societies as utopian models or to take what seem to be reductive, simplistic approaches that place blame for all social ills on the dominant culture, something Heartney and Klein question. All of these projects reiterate, in one way or another, the belief that there is no absolute meaning, that perceptions of reality and the self are, if not totally controlled, at the very least mediated by social structures and conventions dominated by mainstream culture. In this way, they all share in the deconstruction of autonomous meaning and in the dismantling of the notion of universal truth, something that has come to characterize Postmodernist thinking in a larger sense.

Perhaps it is because of the Modernist obsession with the idea of discovering absolute, verifiable truth, that Postmodernists have taken the opposite position, not only believing this is not possible, but that all truth is culturally contingent. This has had the effect of causing a crippling doubt to enter the Western psyche, undermining the sense of direction and purpose of contemporary life. As critic Suzi Gablik notes, the inability to give credence to meaning is a widespread symptom of Postmodern society. "We are experiencing in our culture," she writes, "a sudden radical break with the will-to-meaning which until now has always been understood as a fundamental drive of human life." ⁹ The destabilization of the symbolic order through the deconstruction of signs betrays not only this, but an even greater loss, that of "a basic ground of meaning: that belief in a fundamental psycho-spiritual truth that transcends institutional assumptions and socio-historical circumstance."¹⁰

Gablik's assessment of the situation, unfortunately, seems correct, making one wonder if the kind of thinking that has led to this situation should not itself be scrutinized. It not only entertains the notion that there is no truth (neither historical nor scientific), but has also produced a social discourse that is often too confrontational-because too simplistic and too reductive-to be a productive force for change. Yet there are powerful, synergistic effects at work in the Postmodern psyche that support this kind of thinking. For example, the reaction to what Weber characterized as the bureaucratization and rationalization of Western society has-in a myriad of ways-led to attacks on Post-Enlightenment reason, offering in its place a return to the irrational, mystical, and magical as the solution to ills as diverse as the economic, social, and ecological. These reactionary approaches (which appear on the political Right in the form of religious convictions based on fundamentalist readings of the Bible and the Koran and on the Left in the form of "politically correct" notions of the non-West that defy factual data) are actually attempts to flee the problems of the present. Their power of attraction resides in the fact that they dispel doubt by providing reassuring patterns of thought in an age increasingly beset by change. In response to the equivocable, the complex, and the uncertain that characterizes our age, they offer the unequivocable, the simple, and the certain. Unfortunately, theirs generally are romanticized views of the past-both Western and non-Western-that have little credence in fact when carefully analyzed, views that are unable to confront the ethical and

308 Postscript

moral dilemmas of our scientific/technological age. Yet they are honestly being proffered as social models for the all too real problems of gender, race, and environment as well as those caused by the rapid changes that our society faces.¹¹

Perhaps it is time for Postmodern critical and artistic projects to begin exploring ways in which to move beyond Deconstruction, beyond critique, and seek a constructive mode of thought that recognizes human achievement as a foundation upon which to reconstruct and reestablish belief in what Gablik calls "a basic ground of meaning." To do this it is necessary for society to once again establish a value system that does not link all experience, all activities, and all perceptions—even self-worth to monetary equivalents; it must seek to establish broad principles with which to "order" the life-world, principles that can overcome doubt and function once again with the ring of truth. This is, undoubtedly, the major challenge confronting Western society today, a challenge in which culture and the artist still have important roles to play.

However, the artist can no longer automatically assume that the old Modernist adversarial/avant-garde position toward society (re-tooled as Postmodern Deconstruction) is the only or the best course of action possible today. Of late such actions have become rhetorical and ritualized reducing culture in the eyes of many to a form of entertainment or a brand of politics. Artists need to avoid this oversimplification of their role and, instead, look deep within the cultural tradition to seek a common ground of meaning which would allow them to move beyond the Postmodern dilemma. Pessimists would say this is impossible given the increasing diversity and complexity of our society. But since we all share a human existence, exploring the question of what it means to be human would certainly be a place to start. To do this art must first recognize that to be a human being in society today is not a simple matter; it entails a complex psychic existence in which economic, social, political, environmental, biological, and many other demands all come into play at the same time. As human beings we simply cannot be reduced to some kind of "either/or" dichotomy, nor can the issues we face. As we enter the next millennium, if art is to continue to play a meaningful role in society, artists must understand this and find new ways to bring the power of the aesthetic dimension to bear on this issue.

Notes

1. Some obvious examples of resistance to the consequences of rational, objective thought are to be found in the area of natural philosophy and religious beliefs, especially when confronted with Darwin's writings on natural selection and evolution. That controversy over this issue has resurfaced more than a century later in the guise of Creationism indicates the extent to which Modernist ideas have not been completely accepted.

In the realm of art, the work of Dada artists in Zurich around 1916 was a rejection of rational thought in art and society in favor of chance and even chaos; this was a direct confrontation with modern beliefs and stemmed from the mechanized (industrialized) destruction of World War I.

- Andrew Arato, Introduction to "Esthetic Theory and Cultural Criticism," The Essential Frankfurt School Reader, ed. Andrew Arato and Eike Gebhardt (New York: Continuum Publishing Co., 1982), p. 191.
- 3. In contrast to enlightening and emancipating reason, instrumental reason (instrumental rationality) derived from the logic of formal rationality merely provides, without reflection or concern for human welfare, effective means to execute any proposed task. For more on this, see Michael Landmann, Introduction to Zoltan Tar, *The Frankfurt School: The Critical Theories of Max Horkheimer and Theodor W. Adorno* (New York: Schocken Books, 1985), p. ix.
- 4. Arato, Introduction to "Esthetic Theory," p. 191.
- 5. Not only is Freud's use of the term "pathographic" to describe his method of studying art an indication of this, but so is his view of the artist as an unsatisfied person who "turns away from reality and transfers all his interest, and his libido too, to wishful constructions of his life of fantasy, whence the path might lead to neurosis." Freud believed, according to Craig Owens, that the artist turns to art as a way of gaining attention "without pursuing the circuitous course of creating real alterations in the outer world." For Freud's comments, see his Lecture XXIII, "The Paths to Symptom-Formation," *Introductory Lectures on Psychoanalysis*, trans. James Strachey (New York & London: A Liveright Book, W. W. Norton & Company, 1966), p. 376. For Owens's, see his "Honor, Power, and the Love of Women," *Art in America* (January 1983), p. 7.
- 6. Marx's belief that economic factors were the key to understanding material existence and the structure of society was—like Freud's investigations explaining the motivations of human behavior through the Oedipal complex—as the basis of human sexuality an attempt to account for events in the world logically and rationally.
- 7. Kate Linker, "Eluding Definition," Artforum (December 1984), p. 67.
- 8. Structuralism, especially as conceived by Claude Lévi-Strauss, was similar to other Modernist projects in that it also attempted to provide a master plan explaining human behavior; its template was, of course, language.
- 9. Suzi Gablik, "Dancing with Baudrillard," Art in America (June 1988), p. 27.
- 10. Gablik, "Baudrillard," p. 27. As the title to Suzi Gablik's book—*The Re-enchantment of Art* (New York: Thames and Hudson, 1991)—indicates, she believes that spiritual qualities of art, qualities that Weber identified as generally being suppressed during the rationalization of modern society, must somehow be reactivated. If and how this can be done, of course, remains a question.
- 11. The most disturbing aspect of this situation is the way the non-Western and the primitive are evoked as social models for current gender and racial problems; the implication, which stems from French philosopher Rousseau, is that these problems are somehow unnatural and that looking to more natural or less developed societies (i.e., more primitive societies) will reveal the errors of our civilized (and corrupt) society. In reality, the fact that sexism and racism are just as prevalent outside of the West proves that in human nature—as in raw nature—the strong devour the weak. Because of this, it is especially important to recognize that the development of such things as individual freedom and minority rights, universal suffrage, and the abolition of slavery are not pre-ordained, but are *hard-won human victories*; they are hallmarks of civilization standing in opposition to nature (especially human nature). To deny this is not only to deny the potential of humanity to rise above its circumstances, but also to ignore humanity's greatest achievements.

Index

Abel, Lionel, 23 Abstraction, 127, 153, 157, 161 new, 128 outré, 128, 157 Acconci, Vito, Sub-Urb, 117 Ackermann, Chantal, 213 Adolescence, 219, 228, 230, 232-33, 235 Adorno, Theodor, W., 60, 64, 96, 115, 148 - 49Aesthetic Theory, 60, Aesthetics, x, 4-7, 19, 69-71, 73, 93, 98, 100, 103-6, 135, 142, 150, 168, 180, 269-70, 297, 304-5 anti-, 71, 92 desire, 71, 94 European, 270 Hegel, 188 Kantian, 88, 172 Modern, 177 pleasure, 71, 91, 94 Western, 206 Afrocentrism, 271, 276, 272, 287 Aguilar, Laura, 300 Alienation, 67 Alpers, Svetlana, 268 Althusser, Louis, 92, 93, 104 Americans, Native, 293-94 Anderson, Laurie, 132, 179-80 Americans on the Move, 179 Anish, Aaron, 299 Anouilh, Jean, 157 Antoni, Janine, 287 Applebroog, Ida, 289

Appropriation, 127, 146, 155-56, 162, 305 post-conceptual, 161 Arato, Andrew, 303 Aristotelianism, Neo, 63 Art academic, 17 activist, 73, 74, 108-9, 117 aesthetic, 70, 87, 132, 269 avant-Garde, 16, 29, 55, 83, 223, 262 bourgeois, 33, 62, 94 critical, 111 European, 53 folk, 4, 182 formalist, 73, 108, 116-17 French, 22 ideological, 65, 70, 87 Late Modern, x-xi Modernist, x non-Western, 2, 9 paleolithic, 17 photography as, 125, 135-36 political, 71, 85, 90, 93 post-avant-garde, 56 pre-Modern, 9, 18 punk, 83 realism, 95 Renaissance, 17 retrochic, 83 schlock, 83 Social Realism, x, 68 vanguard, 142 Western, 15, 142 Artner, Alan, 242

Arvatov, 94 Atget, 63, 124, 133-36 Avalos, David, 295, 299 Avant-Garde, 4, 16, 20, 21, 22 24-26, 28, 29, 32, 33, 55, 56, 90 American Neo-, 88 Modernist, 88-89, 91 Post-, 8 Productivist, 89 Balzac, 26 Baroque, 145 Barr, Alfred, 88-89, 104, 106 Barrie, Ray, 213 Barry, Judith, Casual Shopper, 205 Barthes, Roland, 123-25, 136, 178, 202-3 Jouissance, 203 Mythologies, 189 S/Z, 123Basquiat, Jean-Michel, 297-98 Bataille, Georges, 63 Battock, Gregory, 19 Baudelaire, 20, 30, 43, 54, 60 Baudrillard, Jean, 157, 162, 177 Bauhaus, 186 Beckett, 161 Belcher, Alan, 154 Bell, Clive, xi, 2, 4, 5, 168 Bell, Daniel, 56, 163 n15 The Cultural Contradictions of Capitalism. 56 Bender, Gretchen, 160 Benjamin, Walter, 55, 63, 89, 124-25, 131, 133-34, 136 Jetztzeit, 55 Benn, Gottfried, 64 Benton, Thomas Hart, 110 Bergson, Henri, 55 Bhabha, Homi, 271-72, 283, 291 Bickerton, Ashley, 154, 158-61 Birnbaum, Dara, 150, 189–90 Wonder Woman, 205 Bleckner, Ross, 154-55, 157 Bloom, Barbara, 150 Bochner, Mel, 143 Bogosian, Eric, 189 Bolshevik Revolution, 68, 89 Borderlines, 271–72 Borders, 274 Borofsky, Jonathan, 144 Boundaries, 283 Bradley, Mayor Tom, 280 Braque, 42

Brecht, 23, 25, 28, 34, 45, 63, 89, 98 Penny for the Poor, 23, The Threepenny Opera, 23 Brenson, Michael, 270 Breton, André, 22 Brown, Roger, xii, 220, 223, 241-52, 306, 237Brown, James, 85 Buchloh, Benjamin H. D., 70-74, 104-5, 111, 127, 189, 190, 269, 305 Burden, Chris, A Fist of Light, 290 Buren, Daniel, 148-49 Bürger, Peter, 56, 298 Burgin, Victor, 171, 212 Zoo 78, 212 Olympia, 212 Burke, Delta, 281 Café Voltaire, 54 Carlin, John, 230 Caro, Anthony, 37-39, 42, 46-48 Table Piece XXII, 47-48 Prairie, 38 Castelli, Luciano, 144-45 Castration Complex, 166-67, 173, 188 Cellini, Benvenuto, 259 Cézanne, 2, 13, 15, 20, 31, 39, 143 Gulf of Marseilles Seen from L'Estaque, 38 Chagall, Mark, 145, 156 Chardin, 26 Charlesworth, Sarah, 171, 205, 306 Objects of Desire, 205 Chasseguet-Smirgel, Janine, 219-20, 236 - 37Chávez, Patricio, 293-95 Cheang, Shu Lea, 271, 281-82, 290 Those Fluttering Objects..., 281 Chia, Sandro, 126, 144-45, 156 Chicago, Judy, 113, 165, 213 Choudhary, Paramesh, 267 Cimabue, 15 Cixous, Hélène, 182, 191, 205 Clark, T. J., 6, 7, 9, 10, 37-48, 70, 305 Clement Greenberg's Theory of Art, 6, 37 Clemenceau, Georges, 28 Clemente, Francesco, 126, 144-47 Cliché, 146, 289 Clifford, James, 269 Co-Lab, 78, 80 Coe, Sue, 117 Communism, 66

Conger, William, 244 Connoisseur, 136 Connor, Maureen, 290 Consciousness, 67, 75, n8, 113 American, 294 false, 67-68, 74 historical, 126 industry, 90-91 political, 6 social, 72, 106 Conservatives, Young, 63 Neo, 57-58, 63-64 Old. 63 Constable, 26 Copy, 123, 125, 128-29, 131-33, 135. 137-38.191.305 Corot, 17 Counterweight, 299 Courbet, 20, 31 Craft, Pre-Industrial, 166 Crimp, Douglas, 124-25, 129, 148-50, 169, 305 Cubism, 15 Cucchi, Enzo, 144-45 Culture, non-Western, 267 popular, 268 tribal, 269 Western, 267, 271 Cypis, Dorit, 203 Dada, 32, 82, 115, 114, 144 Dalí, 157 Dash, Julie, Daughters of the Dust, 281 David, 15, 117-18 Death of Marat, 74, 117-18 Oath of the Horatii, 27 De Laurentis, Teresa, 173 De Chirico, Giorgio, 156, 243 De La Tour, Georges, 18 Deconstruction, 130 n6, 308 Defoe, Daniel, 26 Degas, 30 Deleuze, Gilles, 127, 190, 298 Denis, Maurice, 1 Deri, Susan, 256 Derrida, Jacques, 63, 122, 176, 178 190, 201, 212 Desire, 166, 169, 191 Diao, David, 155 Diderot, 30 Diop, Cheikh Anta, 267, 271 Doane, Mary Ann, 198-99, 211 Dryer, Moira, 282 Duccio, 243

Duchamp, Marcel, 33, 38, 92, 143, 151, 157 Dupuy, 29 Durham, Jimmie, 293 Dwyer, Nancy, 206 Egypt, 267-68, 271, 282 Eisenstein, 89 El Greco, 18 Eliot, T. S., 23, 28, 38 Ellul, Jacques, 74, 109, 112-13 Eluard, Paul, 23 English, Deirdre, 83 Enlightenment, 8, 12, 13, 54, 59-61 Envy, 259-63 Essentialism, 167, 172, 174 n8, 213-14 French, 215 Ethic, Protestant, 56 Eurocentrism, 267, 273, 274 n8, 295 Evans, Walker, 153, 190 Evergood, Philip, 110 Expressionism, neo-, 127, 157 Factographic, 71, 96 Fantasy, 219 feminist, 116 Fashion Moda, 82, 83 Faulkner, 32 Feminism, 103, 165-74, 268 post-, 212 radical. 101 Fénéon, Félix, 30 Fetish, 75 n6 bourgeois, 95 commodity, 67, 139 Fetishism, 188, 205, 255 female, 183 Fetting, Rainer, 126, 144-45 Flaubert, 184 Form, aesthetic, 221 Formalism, x-xi, 2-7 cynical, 270 Greenbergian, 305 Foster, Hal, 125, 127-29, 305 Foucault, Michel, 63, 173, 177, 184, 190, 198, 202 Discipline and Punish, 212 Fragonrd, 15 Frankenthaler, 42, 48 Freud, Sigmund, xii, 166-67, 169-71, 173, 188, 200, 201, 203, 217-18, 210, 204, 220-23, 227, 229, 232, 256-62, 306 Castration Complex, 166 Leonardo da Vinci..., 217, 257 Michelangelo, 217, 257-58 New Introductory Lectures..., 261

Oedipus Complex, 166 Totem and Taboo, 260 Fried, Michael, 7, 127 How Modernism Works: A Response to T. J. Clark, 7 Friedan, Betty, 173-74 Frueh, Joanna, 165 Fry, Roger, 2, 4, 5, 168 Fuller, Peter, 66 Fusco, Coco, 285, 289 Gablik, Suzi, 307-8 Gaines, Charles, 273, 298-99, 301 Theater of Refusal, 297-98, 300-301 Gallop, Jane, 188, 199–200 Gambetta, Léon, 28 Gaze, 188, 191 cinematic, 182 controlling, 203 male, 166-67, 169 Gedo, John E., 221, 255 Gedo, Mary Mathews, 220-21, 223, 306 Géricault, 26-27 Giotto, 2, 4, 18, 243 Glier, Mike, 189 Gober, Robert, 282, 286-87, 290-91 Godard, 215 Golden, Thelma, 270-71, 285, 306 Goldin, Nan, 288 Goldstein, Richard, 82–83, 127, 129, 133, 153-55, 158, 160 Two Fencers, 132 Golub, Leon, 74, 110, 115, 305 Gombrich, E. H., 191 Gómez-Peña, Guillermo, 289, 296 Goodman, Sam, 82 Gordon, Bette, 205 Goya, 74, 113-14 Los Desastres de la Guerra, 113 Disparates, 113 Graffiti, 78, 80, 128, 157, 218-19, 223, 225, 228-34, 236-38, 287 sexual, 213 Gramsci, Antonio, 144 Green, Rayna, 293-94 Green Renée, 282, 297 Import / Export Funk Station, 282 Greenberg, Clement, xi, 3-7, 9, 10, 20-24, 26-29, 31-34, 38-46, 69, 72, 143,168, 304 Art and Culture, 20 Avant-Garde and Kitsch, 4, 20-27, 29 Towards A Newer Loacoon, 20-24, 26 - 27

Grosz, George, 82, 114 Grynsztejn, Madeleine, 273, 293-98 Guattari, Félix, 190, 298 Guerilla Girls, 285 Haacke, Hans, 72, 73, 91, 93, 104, 111, 116, 161, 213 - 14Habermas, Jürgen, 7-9 Modernity versus Postmodernity, 7 Hale, Sandra, 299, 300 Halley, Peter, 128-29, 154, 158, 160 Hambleton, Richard, 115 Hammons, David, 297 Hanhardt, John, 285 Haring, Keith, 115 Harris, Ann Sutherland, 165 Hawks, Terrence, 121-22, 129 Hayt-Atkins, Elizabeth, 299 Heartfield, John, 93, 114 Heartney, Eleanor, 272, 306 Hegel, 169, 188 Hegelians, Young, 61 Heidegger, Martin, 185 Helms, Jesse, 280 Hemingway, Andrew, 68 Hempill, Essex, 299 Herzfeld, Weiland, 114 Hicks, Emily, 273, 299-300 Hill, Gary, 290 Hill, Richard, 293 Hitchcock, 184 Hitler, 3, 66 Höch, Hannah, 114 Hock, Louis, 295 Hoelderlin, 93 Hogarth, 26 Holbein, 249 Holliday, George, 272, 286 Holzer, Jenny, 74, 112, 116, 189, 305 Skulptur Projekte in Münster 1987, 115 Homosexuality, 217 hooks, bell, 273, 294 Hugo, Joan, 299-300 Hysteria, 204 Ideology, 70, 71, 87, 90, 93, 100, 101, 162 patriarchical, 295 Imagery, female, 165 Impressionism, 13, 15 India, 267–68 Indocentricism, 267 Ingres, 15 Irigaray, Luce, 182, 188, 190, 214 James, Henry, 132 Jameson, Fredric, 159, 181, 184-86

Jauss, Hans Robert, 53 Jonas, Hans, 64 Jones, Lisa, 278 Judd, Donald, 104, 143 K. O. S., 117 Kafka, Franz, 263 Kandinsky, 14 Kant, Immanuel, xi, 1, 3, 5, 9, 16, 12, 13, 46, 70, 72, 89, 91, 168, 177, 304 Kelley, Mike, 115, 288 Kelly, Mary, 183, 202, 214, 306 Post-Partum Document, 183, 202, 213 Kessler, Scott, 295 Kilimnik, Karen, 271, 281, 288 Kim, Byron, 271, 278-79, 288 Belly Painting, 278 Synecdoche, 271, 278-79 Kind, Phyllis, 244 King, Rodney, 73, 272, 280, 286 Kirchner, Ernst Ludwig, 204 Kitsch, 4-5, 9, 20-22, 27, 69, 141, 154 Tijuana, 295 Klein, Jennie, 273–74, 306 Klein, Melanie, 259-60 Kohut, Heinz, 262 Kolbowski, Sylvia, 203-5 Model Pleasure III, 204 Kosuth, Joseph, 143 Kozloff, Joyce, 165 Kramer, Hilton, 5, 71, 72, 73, 74, 305 Krauss, Rosalind E., 123 Krims, Les, 138 Kristeva, Julia, 171, 178, 205, 211 Kruger, Barbara, 111, 170, 189, 191, 203, 205, 211, 306 Kuspit, Donald, B., 73, 74, 105, 221-24, 305 - 6La Frontera, 294-97, 299-300 Lacan, Jacques, xii, 170-71, 178, 183, 189, 197-98, 200-201, 204, 206, 209-11, 215, 306Laocoon, 20, 22 Lautréamont, 23 Lawler, Louise, 161, 189, 191, 206 Lawrence, D. H., 184 Lawson, Thomas, 125-27, 129, 305 Leavis, F. R., 28, 38 Lemieux, Annette, 206 Lenin, 23, 68 Leonardo, 18 220, 222 Leone, Hillary, 280, 286, 290 Lévi-Strauss, Claude, 122, 167, 176, 199 Levin, Charles, 203

Levine, Sherrie, 129, 137-38, 149, 153-55, 162, 169, 171, 189, 190-91, 204, 213, 305 Ligon, Glenn, 271, 289 Notes in the Margins..., 271-72, 280Lim, Cheng-Sim, 299 Linker, Kate, 167, 169-72, 304 Linklater, Richard, 288 Lippard, Lucy R., 65-66, 69-71, 74, 100-101, 104, 171, 273, 293-94, 305 From the Center, 199 Mixed Blessings, 293 Partial Recall, 293-94 Lippmann, Walter, 28 Lipton, Eunice, 270 Lisitzky, 89 Lomax, Yve, 213, 306 Longo, Robert, 133 Surrender, 132 Lonidier, Fred, 70, 71, 72, 73, 89, 92, 93, 97-98, 305 The Health Safety Game, 97 L. A. Public Workers..., 97, 105 López, Yolanda, 299 Lord, Catherine, 297 Louis, Morris, 42, 48 Luna, James, 299-300 Lyotard, Jean-François, 163 n15, 169, 176, 181-84, 186, 201-2 MacDonald, Dwight, 22 MacDonald, Jennifer, 280, 286, 290 Madonna, 281 Magiciens de la terre, 269 Magicization, de-, 303-4 Magritte, René, 81, 82,, 243 Malemich, Kasimir, 88, 153, 155 Mallarmé, 33, 38 Malpede, John, 299 Manet, Edouard, 7, 13, 15, 38-39, 41, 44, 171, 184 Le Déjeuner sur l'herbe, 7, 38 Mapplethorpe, Robert, 271, 280, 289 Black Book, 280, 289 Marat, 117-18 Marden, Brice, 154-57 Marginality, xii, 271, 273, 283, 298 Marginalization, 297, 300 Martin, Jean-Hubert, 269 Martinez, Daniel J., 271, 283, 288 Marx, Karl, xii, 24, 61, 66-67, 69, 162, 194 n17, 305

Marxism, 4, 9-10, 21-23, 61, 65-69, 72, 75 n5, 75 n14, 130 n12, 174 n13, 182, 267 - 68base/superstructure, xii, 66, 68, 70, 74 surplus value, 67 Maslow, Abraham, 114 Matisse, Henri, 2, 31-33, 39, Blue Nude, 38 Matriarchy, 267 Matsura, Frank, 294 McCarthy, Joseph, 66 McCauley, Robbie, 282 McClelland, Suzanne, 288 McEvillev, Thomas, 267-69 McLaughlin, John, 156 McLaughlin, Sheila, 205 Melville, Herman, 32 Metropolitan Museum of Art, 82 Michaels, Duane, 138 Michelangelo, 220, 222 Millet, Kate, 173-74 Minh-ha, Trinh T., 294 Minorities, 266 Miró, Joan, 33 Mitchell, Juliet, 166, 201 Modernism, ix, x aesthetic, 8 anti-, 8, 64, 145 Late, 3, 5 Modernity, pre, 64 icons of, 159 Mona Lisa, 124, 133 Mondrian, 14, 16 Monet, Claude, 16, 28 Nymphéas, 33, 38 Monroe, Marilvn, 191 Montrelay, Michèle, 178, 182 Morality, 58, 59, 61, 63-64 Morris, Robert, 117, 143 Multiculturalism, xii, 265-74, 285, 306 Mulvey, Laura, 168, 182, 213, 215 Museums, 268-69 Myers, Bernard S., 114 Nagy, Peter, 154 Narrative, heroic, 268 Neel, David, 293 Neo-Impressionism, 16 Neoconservatives, 57-58, 63-64 Neue Sachlichkeit, 114–15 Newman, Barnett, 40, 154, 157 Niblock-Smith, Mark, 299 Nietzsche, 212 Nochlin, Linda, 165

Noland, Kenneth, 42, 48, 156 Oedipus Complex, 166-67, 173 Oedipal conflicts, 235 Oldenburg, Claes, 82, 219, 225, 234-36, 238 Olitski, Jules, 42, 48 Ortega y Gasset, José, 112 Ortiz, Rubén, 299 Orwell, George, 101 Osorio, Pepón, 289 Otherness, xii, 180, 191, 201, 204, 210, 215, 265-74, 294 Owens, Craig, 150, 168-69, 171-72, 211-12, 304, 306 O'Keeffee, Georgia, 248 Partisan Review, 20-21, 22, 23 Paschke, Ed. 248 Pater, Walter, xi, 2 Pathographic, 257, 309 n5 Pathographic criticism, see Psychoanalysis Patriarchy, 167, 169, 181, 201, 203, 267 Patterson, Ben, 297-98 Paz, Octavio, 8, 56, 60, 141 Peirce, C. S., 122 Penis envy, 222, 263 Pfister, Oskar, 258 Phallic mother, 205 Phallus, 201 mother as. 211 Phillips, Lisa, 291 Photography, 97, 124, 131, 133-38, 150-51, 153, 169-70, 187-88, 190-91, 204, 206 as Art, 125 Piatek, Frank, 243 Picasso, 33, 39, 42, 151, 241, 244 Glass of Absinthe, 47 Ma Jolie, 38 Piero della Francesca, 2, 18 Pierson, Jack, 288 Piper, Adrian, 273, 297-99 Pissarro, Camille, 29-30 Plagens, Peter, 299 Plato, 256, 258 Pleasure, 213 Pluralism, 131, 140, 177 Politically correct, 266, 283, 307 Polke, Sigmar, 160 Pollock, Jackson, 32, 33, 39, 42, 44, 48 Lavender Mist, 38 Poons, Larry, 42, 48 Pornography, 83-84, 213 Porter, Elliot, 138

316 Index

Poststructuralism, xii, 130 n9 Potter, Sally, 205 Praxiteles, 137-38 Primitivism, 274 n13, 309 n11 in Modern Art, 269 20th century, 95 Prince, Richard, 125, 127, 129, 138-39 150, 161, 189 Proletariat, 67-68, 114 Proust, Antonin, 28 Pseudoexpressionists, 126 Psychoanalysis, xii, 199-200, 217-25, 306 desire, 166 Freud, 166-67, 169 Jacques Lacan, 166-67, 169 Lacanian, 182 male gaze, 166-67, 169 mother as phallus, 171, 190 pathographic criticism, 218, 222 penis envy, 166, 168, 170, 173-74 post-Freudian, 227 Psychobiology, 220, 228 Psychology, Pop, 290 Punk, 128 Purity, 5, 13, 19, 26, 40 Quality, artistic, 269-70 Rahy, Philip, 22 Rainner, Yvonne, 213, 215 Raphael, 4, 18 Rappaport, Mark, 290 Rasquachismo, 295 Rationalism, anti-, 308 n1 Rationalization, 303-4 Rauschenberg, Robert, 125, 134 Ray, Charles, Family Romance, 289 Readymade, 127-28 Reagan, Ronald, 66, 72, 95, 103-4 Reaganism, 103 Reckinger, Candace, 205 Reification, 61, 67, 127, 161, 191, 229, 298 Reinhardt, Ad. 38, 86 n4 Rembrandt, 18, 133 Renaissance, 59, 145 Renoir, Jean, 184 Representation, 185, 200, 202, 268, 305 Western, 201 Ressentiment, 114, 116 Ricard, René, 140 Rich, B. Ruby, 285 Richardson, Samuel, 26 Richter, Paul, 1 Rickard, Jolene, 293 Ricoeur, Paul, 176-77

Riggs, Marlon T., 299 Riis, Jacob, 187 Riley, Bridget, 157 Rilke, 184 Rimbaud, 33, 38 Ritter, Father, 281 Rivera, Diego, 22, 110, 243 Robbe-Grillet, 161 Robespierre, 55 Rodchenko, 89 Rohe, Mies van der, 244 Rollins, Tim, 117 Ronell, Avital, 285 Rose, Barbara, 125, 135, 141, 143 Rose, Jacqueline, 200, 214 Rosenberg, Harold, 108, 110-11, 224 n4, 229Rosler, Martha, 74, 93, 111, 180-82, 187, 189, 213, 306 The Bowery..., 169, 187-88 Ross, David A., 270, 285 Rothko, Mark, 40 Rowe, Sandra, 297 Rubens, 18 Rubin, William, 269 Ryman, Robert, 127, 154-55, 157 Saar, Alison, 279 Sade, Marquis de, 220, 236 Said, Edward, 199 Salle, David, 126, 140, 146-48, 305 Salomé, 126, 144–45 Saussure, Fredinand de, 122, 201 Schapiro, Miriam, 165 Schapiro, Meyer, 22 Scharf, Kenny, 115 Schell, Jonathan, 101 Schiele, Egon, 153 Schiller, 60 Letters on the Aesthetic Education of Man, 60 Schmitt, Carl, 64 Schnabel, Julian, 126, 141, 144-45, 147, 151Schoenberg, 33, 38 Schultz, Franz, 242 Schuyff, Peter, 154 Schwartz, Delmore, 23 Science, 8-10, 16, 17, 54, 58, 63, 186, 222 Scrutiny, 28 Sekula, Allen, 4, 9-10, 21-23, 61, 70, 71, 73, 95-97, 291, 305 School is a Factory, 97 Self-Esteem, 266, 274 n2

Semiotics, 121-30 Serge, Victor, 22 Seurat, Georges, 30, 213 Sexuality, 166-74, 199-202, 213-14 infantile, 235 Shahn, Ben, 110 Shakespeare, 218, 228, 230 Shange, Ntozake, 280 Shelley, 114 Sherman, Cindy, 114, 125, 127, 129, 138, 150, 161, 169, 191-92, 288, 290, 305 Significant Form, 2 Signs, 121-30, 206, 305-6 commodity, 128, 157-58 free-floating, 129 iconic, 122, 124 indexical, 122, 124 linguistic, 200 symbolic, 122 Simmons, Gary, 271, 279, 287, 297 Lineup, 271, 279 Wall of Eyes, 279-80 Simonds, Cylena, 293 Simpson, Lorna, 280-81, 297 Hyothetical?, 280 Sims, Lowery, 268 Simulation, 127-28, 155-57, 161-62, 186, 305 abstraction, 159 Sisco, Elizabeth, 295 Small, Deborah, 299 Smith, Alexis, 111 Smith, David, 42, 48 Zig IV, 38, Smithson, Robert, 143 Society, Post-Industrial, 186 Solomon, Maynard, 67 Solomon-Godeau, Abigail, 300 Sonnier, Keith, 160 Souvarine, Boris, 22 Spaemann, Robert, 64 Spector, Jack, 218 Spero, Torture of Women, 117 Spero, Nancy, 72, 73, 105 Spitz, Ellen Handler, 218-20, 222-23, 256-57, 306 Spivak, Gayatri, 211 Stalin, 3, 22, 66, 68, 72 Steinfels, Peter, 57 Stella, Frank, 41 Stendhal, 26-27 Le Rouge et le noir, 27 Stevens, May, 74, 113, 305

Mysteries and Politics, 116 Stevens, Wallace, 23 Still, Clyford, 40 Strauss, Leo, 64 Stravinsky, Igor, 184 Structuralism, xii, 121-22, 129 n3, 167, 267 Surplus value, 67 Surrealism, 60, 61 Sussman, Elisabeth, 272-73, 285-87, 291 - 92Taafe, Phillip, 154-56 Taboo, incest, 175 n19 Tags, 231-32 Tate, Allen, 23 Taylor, Mark C., 122 Territorialization, Re, 300 Territorialization, de, 298-99 Theory, Lacanian, 172-73 post-Freudian, 175 n19 psychoanalytic, 203 Thomas, Clarence, 286 Tickner, Lisa, 167, 172, 212-14 Tillman, Lynn, Haunted Houses, 205 Titian, 18 Tong, Rosemarie, 173 Torres, Francesc, 73, 105, 291 Toynbee, Arnold, 176 Tretyakov, 89, 97 Trilling, Lionel, 106-7 Trotsky, Leon, 23, 28, 68, 75 n12 Their Morals or Ours?, 23 Tsinhnahjinnie, Hulleah, 293 Tufts, Eleanor, 165 Turim, Marueen, 171-73, 306 Uccello, 18 Vaisman, 128-29, 154, 158, 160 Polyester Set, 158 Under My Thump, 158 Van Gogh, 26 Varnedoe, Kirk, 269 Vermeer, 18 Veronda, George, 221, 244-51 Vertov, 89 Victimization, 292 Viola, Bill, Reasons for Knocking..., 117 Wachtel, Julie, 115 Wall, Jeff, Double Self-Portrait, 213 Picture for Women, 213 Warhol, Andy, 125, 134 Warmus, Carolyn, 281 Wasow, Oliver, 128, 154, 158 Watteau, 18 Weber, Max, 8, 56, 58, 303, 307

318 Index

Webern, Anton, 33, 38 Weems, Carrie Mae, 297 Weinstock, Jane, 172-73, 215 Weintraub, Linda, 103-4 Weiss, Peter, 62, The Aesthetics of Resistance, 62 Welling, James, 153, 158-59 Wellmer, Albrecht, 62 West, Cornell, 278 Weston, Edward, 137-38, 153, 169 Weston, Neil, 190 "Whiteness," 277, 306 Whitney Biennial, 270, 278, 285-86, 288, 290 - 92Williams, Pat Ward, 272, 281-287, 297 What You Lookn At?, 281 Williams, Sue, 287, 289

Wilson, Edmund, 22 Wilson, Fred, 271-72, 282, 297 Re: Examining Egypt, 271, 282, 287 Winnicot, W. D., 222, 234, 258-60, 262 Wittgenstein, 29, 46, 64 Philosophical Investigations, 45 Wolfe, Bertram, 22 Wollen, Peter, 214-15 Women, images of, 165, 197 representations of, 167-70, 178, 306 symbols of, 189 Wright, Elizabeth, 257 Yates, Marie, 213, 306 Photoroman, 213 Ybarra-Frausto, Tómas, 295 Yeats, W. B., 256 Yosida, Ray, 244